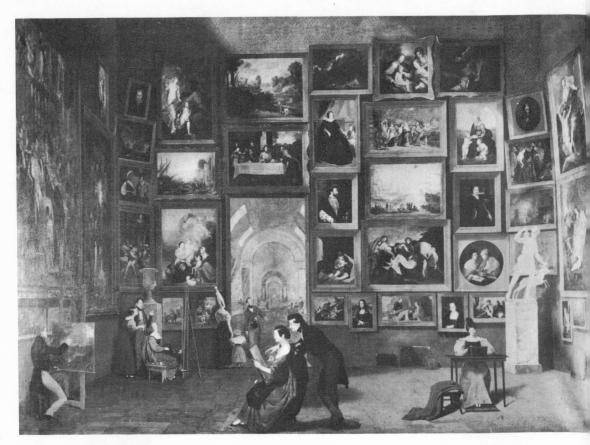

The Interior of the Louvre. Painting by Samuel Finley Breese Morse. *Courtesy Syracuse University.* "Morse is painting an exhibition picture that I feel certain must take. He copies admirably, and this is a drawing of the Louvre, with copies of some fifty of its pictures."

A HISTORY OF
THE RISE AND PROGRESS OF

The Arts of Design

in the United States

BY

WILLIAM DUNLAP

A REPRINT OF THE ORIGINAL 1834 EDITION
WITH A NEW INTRODUCTION BY
JAMES THOMAS FLEXNER

NEWLY EDITED BY RITA WEISS
WITH 394 ILLUSTRATIONS

IN TWO VOLUMES BOUND AS THREE
VOLUME 2, PART 2

DOVER PUBLICATIONS, INC.
NEW YORK

Published in Canada by General Publishing Company, Ltd.,
30 Lesmill Road, Don Mills, Toronto, Ontario.
Published in the United Kingdom by Constable and Company, Ltd.,
10 Orange Street, London WC2.

This Dover edition, first published in 1969, is an unabridged re-publication of the first (1834) edition, as published by George P. Scott and Company. This edition also contains a new introduction by James Thomas Flexner, new biographical notes, new illustrations, and a new index prepared especially for this edition, and a preface by the editor.

Standard Book Number: 486-21697-7
Library of Congress Catalog Card Number: 69-16810

Manufactured in the United States of America
Dover Publications, Inc.
180 Varick Street
New York, N.Y. 10014

List of Plates

v

CONTENTS

CHAPTER XXVI.

CHAPTER XXVII.

CHAPTER XXVIII.

CHAPTER XXIX.

CHAPTER XXX.

A HISTORY OF
THE RISE AND PROGRESS OF

The Arts of Design

in the United States

CHAPTER XXI.

Revival of the American Academy of the Fine Arts at New-York—Mr. Trumbull appointed president—Jarvis—Vanderlyn—John Rubens Smith—First exhibition—Purchase of some of Trumbull's pictures, afterwards returned to him—Circumstances which led to the formation of the National Academy of Design; a real academy, composed of artists alone, with schools taught by artists. S. F. B. Morse, president.

ACADEMIES—1816.

CHANCELLOR LIVINGSTON had been a president of the association for promoting the fine arts in New-York, and after him Charles Wilkes and others. The institution was almost forgotten for several years. In 1816, De Witt Clinton was the president, and under his influence and that of his friend Doctor Hosack, together with Cadwallader D. Colden, John R. Murray, Charles Wilkes, and William Cutting, an effort was made to revive an institution, the object of which was to cultivate taste, forward the progress of civilization, and all the refinements on which man depends for his enjoyments in life.

The time was propitious in some respects, and by the liberality of Dr. Hosack and the influence of De Witt Clinton, the object was accomplished to a certain extent.

Fortunately, a long building, facing on Chamber-street, which had been erected for, and occupied as an alms-house, was at this time empty. The paupers had been transferred to a palace at Bellevue. Application was made to the corporation, and the place was appropriated in part to the American Academy of the Fine Arts. Money was borrowed from the Bank of New-York, by Dr. Hosack, to fit the centre portion of the building for exhibitions. Galleries for pictures and statuary were made ready. The casts were removed, repaired, and put up. Preparations were made for borrowing pictures, and otherwise collecting them for an exhibition in imitation of Philadelphia, for the purpose of furnishing funds to repay the loan, and, as some persons hoped, to establish schools for designing.

De Witt Clinton, the present presiding officer, having used his influence to give this impulse to the body, proposed that Mr. Trumbull should succeed him in the office, and declared his determination to resign it.

Previous to this time, Mr. Jarvis had gained a name justly as a painter of eminence, and Mr. Vanderlyn had recently returned from a residence on the continent of Europe, and had

exhibited his noble picture of Marius, and his unrivalled picture of Ariadne, besides many fine copies from the Italian masters. In the formation of this intended accademy, Jarvis seems never to have been thought of, and Vanderlyn, though at first associated with the founders, very soon retired; and when afterwards asked by De Witt Clinton, (Trumbull being president, and the society in operation,) to become a director answered, " It is too late." This application was made to Mr. Vanderlyn in presence of the writer, who was then a director, he and Clinton having gone to Vanderlyn's room for the purpose.

Mr. Vanderlyn was right. Previously to the first exhibition, an apartment adjoining the gallery had been allotted to Mr. Vanderlyn for his pictures. It was that afterwards called the library and director's room. And another apartment had been appropriated to Mr. John Rubens Smith, of London, as a private drawing school, (he being a drawing master,) in addition to his compensation for services as keeper. This man had knowledge in his profession; but was in his manners abrupt, pretending, at times dictatorial, and at times disgustingly obsequious. He was chosen by the president; but he, was unmanageable.

At a public meeting of organizers, Smith rose and stated that he could not occupy the apartments allotted to him for his school, as the parents of his pupils would not allow their children to come to a room adjoining to which a number of indecent pictures were exhibited, making use of a term respecting them still more improper. All present stared at the speaker. He repeated, and concluded by saying that if these pictures were not removed " he declined the office of keeper." Silence ensued. At length a director said, " Very well, Mr. Smith." Smith was confused—again repeated—and stood hesitating. The words were repeated, " Very well, Mr. Smith." " Then I resign the office." " Very well, Mr. Smith." And Dr. Hosack rose, and bowed as he repeated the words. Smith was bowed out of the room, and out of office. The consequence of some silent influence, however, was, that Vanderlyn removed his pictures, and never would associate or take part with the institution. Mr. Trumbull was thus left dictator.

In the autumn of 1816, about the middle of October, the first exhibition of the revived American Academy of fine arts was opened. New pictures and old were borrowed, and all lent gratuitously; except that two hundred dollars were paid to the president for the use of his paintings. The reciepts were

far beyond expectation, and the directors began to make expenditures, as if they had opened a never-failing mine. On the eighteenth of December 1816, a code of by-laws was adopted. The laws provided that the present board of directors should elect from the stockholders, " a number not exceeding twenty academicians, artists by profession. That after the election of January the seventh, 1817, twenty associates shall be elected, artists by profession. That " there shall not be more than three academicians in the board of five directors." The duties of the officers were pointed out. The law relative to exhibitions, says, " all artists of *distinguished merit* shall *be permitted* to *exhibit* their works." " Amatuers shall be *invited* to *expose* in the gallery of the academy, any of their performances which may be thought worthy of exhibition." " That at each stated monthly meeting, two directors shall be appointed visitors," to see that all duties are performed, and *report on the affairs of the academy.*

It was enacted by the legislature, that eleven directors instead of five, should govern the academy. It will be found that the directors of 1817 consisted of three lawyers, two physicians, one hardware merchant, one professor of mathematics, one architect, one drawing master, and two portrait painters. Dewitt Clinton delivered an address, and resigned.

At the election of January the seventh, the return of officers of the academy was, John Trumbull, *president*, John R. Murray, *vice-president*, Cadwallader D. Colden, William Cutting, John G. Bogart, David Hosack, Archibald Bruce, Archibald Robertson, Benjamin W. Rogers, William Dunlap, John Mc Comb, Samuel L. Waldo, and James Renwick, *directors.* John Pintard, *treasurer* ; Alexander Robertson, *secretary* ; William Dunlap, *keeper* and *librarian.* Of these, including the president, four were artists : seven were lawyers, physicians, and merchants.

Several of the president's pictures were offered to the academy at $3500 each, for the two largest, (" The Woman taken in Adultery, "and " Suffer little children,") and others at lower prices. A committee was appointed, consisting of Murray, Hosack, and Dunlap, to purchase, and a debt incurred which could ultimately only be paid by returning the pictures.

This purchase, or debt, was one cause of the failure of the Institution to fulfill its intents. The other was, that the president opposed the opening of schools.

After it was found that the reciepts of the exhibition *could* be exhausted, and money could be wanted, subscribers or shares were solicited, and a person employed and paid to obtain them. They were honoured with the title of *patrons.*

During some months of summer weather in 1817-18, the gallery of the statues, or saloon of the antique, was regularly attended by the keeper, and irregularly attended by some few students, and one artist, (Mr. Durand) who then was an excellent draftsman; as the casts were made part of the exhibitions, students could only be admitted early in the morning, and the whole business declined.

I will pass over rapidly what I fear may prove to the general reader uninteresting, (but what must stand recorded) and come to those events which led to the formation of a real academy of fine arts. In the year 1824-5, the American Academy again invited students to draw from the casts, provided they came between the hours of six and nine, A. M. The opportunity was eagerly sought, but it was soon found that the hope of advantage to be derived from the treasures of ancient art, was illusory. There was no keeper or instructor. The young men who attended at six o'clock—at seven o'clock—were sometimes admitted, and sometimes excluded, and generally had to wait at the door for hours, if admitted, and then were frequently insulted—*always*, if they had presumed to knock. At length a scene occurred which seemed to put an end to the pretence of an academy being open to students. Of this scene the writer happened to be a witness.*

I had been accomodated by the common council of the city, with a painting-room in the building, and coming to the place generally before breakfast, to prepare for the labour of the day, witnessed the treatment which those who wished to instruct themselves received. On the occasion alluded to Messrs. Cummings and Agate, even then artists, although young, came to the door and found that it was closed; they were turning away, when I advised them to speak of the exclusion to the directors.—They replied, " that it would be useless," and at that moment one of the directors appeared, coming from Broadway towards them. I urged the young gentlemen to speak to him: but they declined; saying, they had so often been disappointed, that they " gave it up." The director came and sat down by the writer, who mentioned the subject of the recent disappointment, pointing to the two young men, who were still in sight. The conduct of the person whose duty it was to open the doors at six o'clock, A. M. was promptly condemned by this gentleman, and while speaking, the president appeared coming to his painting-room, which was one of the apartments of the academy. It was unusually early for him,

*At this period some of the gentlemen who afterwards became members of the National Academy of Design, attended for a short time at the gallery, and their names are to be found in the matriculation book, as if regular students of an academy, although there was no teacher and, frequently no admission.

although now probably between seven and eight o'clock. Before he reached the door, the curator of the academy opened it, and remained. On Mr. Trumbull's arrival, the director mentioned the disappointment of the students; the curator stoutly asserted that he would open the doors when it suited him. The president then observed, in reply to the director, " When I commenced my study of painting, there were no casts to be found in the country. I was obliged to do as well as I could. These young men should remember that *the gentlemen* have gone to a great expense in importing casts, and that they (the students) have no property in them;" concluding with these memorable words for the encouragement of the curator, " They must remember that beggars are not to be choosers."

We may consider this as the condemnatory sentence of the American Academy of the Fine Arts.

During the autumn of 1825, S. F. B. Morse, Esq. was an active agent in forming what was called a drawing association. He, as well as his brother artists, and all who wished to study the arts of design desired that schools might be established for the purpose. They saw that the institution called the American Academy of the Fine Arts, had nothing in common with any existing academy for the teaching of art, and that from its construction and direction there was no hope that it could be made to answer the purposes of an academy. They saw that it was a "joint stock company," composed of persons of every trade and profession, who thought the privilege of visiting the exhibitions an equivalent for twenty-five dollars—such persons were the *electors* of the directors, and entitled to be themselves elected directors. Artists could only share these privileges by purchasing stock, and might be controlled in every thing respecting their professions by those who were ignorant of the arts. Artists had sprung up who might challenge competition with any in the world, and maintain the challenge.*

* Artists returned from Europe, who had devoted years to the study of their profession, amid the splendid galleries and collections of England and the continent, where their minds had become filled with devotion to the art, and earnest and anxious wishes for its advancement in their own country; with them they also brought experience, and an intimate acquaintance with the principles and systems on which the flourishing institutions of the old world are conducted. They saw, with regret, the deficiencies of the academy; the total inaptitude of the system upon which it was conducted; the want of energy in its management; and the little probabili.y that, burdened as it was with debts, and governed by men who knew nothing practically of the arts for whose encouragement it professed to be established, the institution would ever prove a source of good to them, or the community. They saw that in fact the institution was not an academy of arts; that it was merely a company formed for the purchase and exhibition of pictures; that even this purpose was not fulfilled, for there were no funds wherewith to purchase, and the exhibitions were notoriously of the same pictures every ye' ; and that in reality it was to them, as if no academy existed.

So circumstanced, Mr. Morse suggested to some artists that an association might be formed " for the promotion of the arts, and the assistance of students." It was merely a plan for improvement in drawing, to be called *the drawing association;* the members to meet a certain number of evenings each week, for mutual instruction and the promotion of union. Each member furnished a small sum for expenses, officers were appointed, and an organized body formed. Casts were produced by the members, and borrowed from the old institution, no enmity was thought of, and the meetings took place in the unoccupied apartments of the Philosophical Society.

The members of this association soon found that it was considered *as dependent* upon the American Academy of Fine Arts, and a director of that institution suggested that the gentlemen should sign the matriculation book, thus connecting themselves as pupils in drawing, painting, sculpture, architecture, and engraving, to the very worthy lawyers, physicians, and merchants who composed and directed the *old* academy, as it began now to be called.

This proposition caused the suggestion of forming *a new academy.* It was proposed by some, immediately to return the casts borrowed from the old institution, but it was thought that it would indicate hostility. All were unwilling to be looked upon as dependent upon an institution which had neglected them, and was inefficient in its present form to the ends they desired. It was suggested that perhaps a plan might be fallen on which the artists might unite with the academy : " and that by becoming parties to a revision and re-modelling of its constitution and by-laws, the practical knowledge and experience of the artists, and the valuable collection of the academy, might be rendered reciprocally subservient to the promotion of the art, for whose cultivation they were associated. This was cordially received, and it was the general wish, that it might be found practicable. But before taking any measures to ascertain whether any plan of this nature could be devised and carried into execution, it was thought advisable by several of the members of the association, that some method should be resorted to, of uniting the views, and concentrating the opinions of all upon the subject of their situation. It was therefore proposed that a committee should be appointed, to draw up and lay before the association, a distinct statement of its views, and of the exact relation in which it stood to the American Academy of Fine Arts."

It was the wish of the associates to have an union with the academy, for though they felt themselves competent to form

a new academy to be governed by themselves, they knew the advantages that would be derived from the use of the casts of the old institution, (expressly intended by the original founders for the use of students,) and the disadvantages of being in appearance, hostile to the gentlemen who composed the body of stockholders of the American Academy. Therefore "it was their wish that there should be but one institution : and they held themselves ready to join, heart and hand, in building it up, so soon as it should be placed on such a footing, that they could unite in it with confidence and with well founded hopes of such a management, that the energies of all might be directed to the attainment of the noble ends of an Academy of Fine Arts." This wish was communicated to the American Academy, and the hope expressed that means should be found to admit the artists to such share in the direction, as should be for the benefit of all. This wish was reciprocated by the directors, and they transmitted a resolution, which " appointed a committee of three to meet a similar committee of the association, and to confer with them, upon the subject matter of the report, which had been laid before the board."

Committees were appointed, met, conferred and adjourned " leaving the form of the report to be adjusted by the two chairmen."

The result was, that the committee of directors, " engaged or guaranteed to exert all their influence to effect the election of six artists into the board of directors," and six artists were chosen from the artists of the city, " who, if not already qualified," by being stockholders, " should qualify themselves by the purchase of a share each, and be recommended to the electors as representatives of the whole body of artists."

Six artists were unanimously chosen by the associated artists, and four of them not being stockholders of the old institution, one hundred dollars was paid from the treasury of the associated artists for the shares necessary to qualify them.

The associated artists, and those elected to represent them, looked upon the affair as settled, and left the election to take its course; but the evening previous to the election they were informed by an anonymous letter that some of the names given in by them as candidates, would by the intrigues of certain directors be struck off the ticket. They announced that none of their candidates would serve, unless all were chosen. They considered themselves as the judges of their representatives, and of those fit to direct an academy. The election took place, and two of the six candidates chosen by the artists were *alone elected.* They immediately resigned. Here was not

only a breach of faith—an injury inflicted by taking the money of the association, (which was never returned)—but at the time of the election, the most contumelious expressions were used by members of the directory. The artists were declared unnecessary to the institution; and the writer heard one of the directors, whose name is spared, proclaim that " artists were unfit to manage an academy—were always quarrelling among themselves—and conclude with these words, explanatory of the transaction " Colonel Trumbull says so."

" It is worthy of remark, that the names of the six candidates were given in to the officers of the academy, *seventeen days* before the election took place; and so far from any official objection being made to the *mode* or *purpose* of presenting them, that when a difficulty appeared which seemed likely to prevent the acquisition of the hundred dollars, which by agreement were to be paid to render them eligible, that difficulty was removed by a special vote of the directors, which the artists were certainly justified in considering as a tacit assumption of the agreement entered into by their committee, and a pledge for its fulfilment—else, why take the money of the association? That it was so intended, in my opinion there can be no doubt; nor do I believe that the intention was frustrated through the agency or with the concurrence of the directors; but that there was an agency within the government of the academy, hostile to the union; and that this agency was successfully exerted, is established by the facts.

The artists now resolved to organize a new academy, for their own instruction and the forwarding of the arts; and to govern it, as all other academies of fine arts are, and have been governed, by artists alone.

The National Academy of Design was formed—the officers were elected eighteen days after the repulse which the desire for harmony had experienced. Samuel F. B. Morse was elected president.

Immediately after the organization of the new institution, measures were taken to open its first exhibition; and notwithstanding the many difficulties under which they laboured in this commencement of their undertaking, such as the want of a convenient and properly lighted room, &c. the artists succeeded in collecting together such a display of talent as surprised every visitor of their newly-formed gallery, consisting of works of *living artists* only; which had never before been exhibited, and which, by the rule of the institution, can never be included in any future exhibition; a plan which insures *novelty* at least. The expenses of this, their first year of existence as an

academy, were somewhat greater than the proceeds of their exhibition, and the deficit was provided for by a small assessment upon the members, which was promptly and cheerfully paid. Not discouraged by this result, they immediately determined on another effort in the ensuing year; and to defray the expenses of the school, they concluded to receive from every student a small sum, sufficient to meet the expenses of lights and fuel. In their second annual exhibition (in which was found a more splendid display of living talent than had ever before been presented in this city,) they were more successful; their receipts not only defrayed their expenses, but left them something in their treasury. Now, however, their greatest difficulty arose—the room in which the students assembled to prosecute their studies, had been, till this time, loaned to them; but the society which had so generously befriended the Academy, could spare the room no longer. No alternative, therefore, was left to them, but to hire a room, or break up their school. An application for assistance to the Common Council, was not listened to; they therefore resolved to incur the risk of hiring for the year, the room in which they had made their exhibition, over the Arcade baths in Chambers-street.

They afterwards removed their schools and statuary to Clinton-hall. A noble collection of casts have been opened to students, and the eighth annual exhibition proudly announced and universally acknowledged as the most encouraging proof of the progress of the fine arts in the country, and of the propriety of the measures adopted by those who organized, and in despite of misrepresentation and obliquy, support the National Academy of Design.

SOUTH CAROLINA—ACADEMY OF FINE ARTS.

" In January 1821, my friend Morse had several conversations with me about the practicability of establishing an academy," (this is from Mr. Cogdell.) "We agreed to have a meeting—we solicited the Main Hall of the city. Mr. Morse moved that the honourable Joel R. Poinsett take the chair; Mr. Jay, that Mr. Cogdell act as secretary. Mr. Morse then submitted a resolution asking of the council a site in the public square for the building, and we adjourned.

" A number of artists and amateurs were requested to meet at my office, where the first organization was made of the academy of fine arts. Gentlemen were named officers and direcors, on my writing to them, they accepted. Thus was brought into existence the South Carolina Academy of Fine Arts.

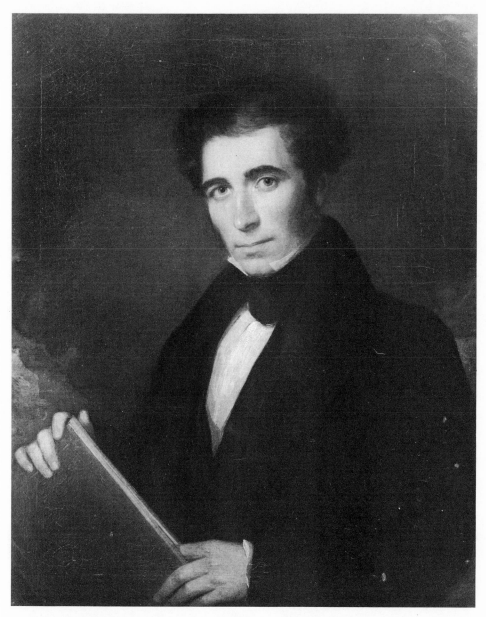

243 SELF-PORTRAIT. Painting by Asher Brown Durand. *Courtesy The New-York Historical Society.*

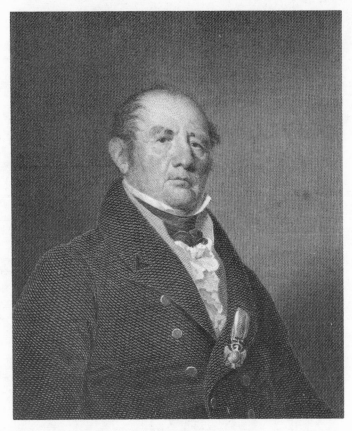

244 AARON OGDEN. Engraving by Asher Brown Durand after his own painting.
Courtesy Dover Archives.

" JOEL R. POINSETT, President.

Directors.

Samuel F. B. Morse,	Charles Fraser,
Joshua Cantir,	John S. Cogdell,
John B. White,	Wm. Jay, architect,
Charles C. Wright, die-sinker,	William Shields,
James Wood, engraver.	Chs. Simmons, engraver.

" The legislature granted a charter, but my good sir, as they possessed no powers under the constitution to confer taste or talent, and possessed none of those feeling which prompt to patronage—they gave none to the infant academy. We have had as splendid exhibitions as I have seen in any other city. On the presentation of my bust of Dr. J. E. Holbrook, I received, from the directors, under the eleventh rule, the title of academician; but *cui bono?*

" The institution was allowed, from apathy and opposition, to die, and the property has been sold recently to pay its debts ; but Mr. Poinsett and myself, with a few others, have purchased with a hope of reviving the establishment."

———

CHAPTER XXII.

Mr. Durand—his early attempts—apprenticed to P. Maverick—his partner—engraves the Declaration of Independence—great success—his engraving of Vanderlyn's Ariadne—Chester Harding—his extraordinary commencement in life—various occupations—commences painting—success—great success in Boston—goes to England and great success there—return home and establishment—Hugh Reinagle—James Herring—Mr. Herring's union with Mr. Longacre in the splendid works of the National Portrait Gallery—G. Dixey—John V. Dixey—Ithiel Town—G. S. Newton—Leslie's letter on the subject of Newton ; Washington Irving's letter and opinions given in conversation respecting his works—Monro Gondolfi—John Evers—Coffee—Scarlett—Quidor—Jouett, the great painter of the west.

ASHUR B. DURAND—1817.

Asher Brown Durand, 1796–1886.

THIS gentleman, although our first engraver, by universal acclamation, has passed so far on the journey through life with so few of those struggles or vicissitudes which give pungency to the tale of the biographer, that I have little more to say of him, than that he is one of the most amiable men I have known as well as one of the best artists.

Ashur B. Durand, engraver and painter, was born at Springfield, New-Jersey, in 1776. His father being a watchmaker, gave him a very early opportunity of scratching on

copper, which, with drawing, was his delight from infancy. Finding that he could produce pictures from the plates of metal he worked on, by a process of his own in printing, he beat out pieces of copper, made tools to suit his hands and his notions of what such things should be, and finally, before his apprenticeship to an engraver, arrived at making something like an engraver's plate, and producing a print from it. One of the evidences of his propensity to engraving at a very early age, is a powder-horn, which he ornamented with figures and flowers, and is still preserved by him as a curiosity.

We all know that the most laborious patience is a necessary qualification for excelling in the art of engraving, but this qualification was denied by nature to young Durand, and only acquired by the effort of a superior mind. The first exercise of his patience occurred thus: A French gentleman who employed the elder Durand in his business of repairing watches, saw some of the boy's prints, and much pleased with the evidence of talent, requested him to engrave a portrait of a friend which he had on the lid of his snuff-box. This was a task which Ashur perceived to be beyond his power, but he was ambitious and was persuaded to undertake it. He procured a proper plate—made a drawing from the snuff-box—transferred it to the copper and began. Two days he worked incessantly, and then became impatient. Two whole days, and yet but little progress made on one piece of copper. He then in some sort, by anticipation, found how tiresome it is to work months and years on one plate. He was about giving up the portrait, but his better genius prevailed, and he persevered until he produced a work that excited the admiration of the owner of the snuff-box and encouraged himself.

During this early period of his existence books were sought after with avidity, but it was to examine and study the pictures in them, rather than for the information to be derived from letter-press. The images presented to his mind by the painter and engraver, filled it with a delight that almost excluded the ideas of the author as given by the printer.

In the year 1812, he was apprenticed to Mr. Peter Maverick, above-mentioned, the son of Peter R. Maverick. During this apprenticeship his principal employment was copying from English book-engravings for publishers—illustrations for Scott's works making a part. But becoming intimate with Mr. Samuel Waldo, he received advice and instruction from that gentleman respecting portraiture, which led to his execution of his first engraving in that department, where he now stands pre-eminent. Mr. Waldo had made a study from a

beggar, hired for the purpose, which gained him much credit on its exhibition; and young Durand engraved a plate from it, following the dictates of his own judgment and evincing his powers in original engraving.

In the year 1817 Mr. Durand's term of apprenticeship expired, and he entered into partnership with Maverick. At this period Durand attended at the school of the Antique belonging to the American Academy of the Fine Arts, which for a short time assumed the character of a real academy. I was a director and the keeper, but Durand's skill in drawing far surpassed the keeper's. He was an artist before he came to the school, which indeed was only opened to students before breakfast, or from six to nine in the morning, and that for a short period. While the partnership with Maverick lasted, the usual employment of Durand was similar to that of the apprenticeship; copying prints from English books and working on plates for banknotes.

The preference which Trumbull gave to Durand by employing him to the exclusion of Maverick, broke up the partnership, and Mr. Durand opened a separate establishment. The skill displayed by the engraving of the plate of "The Declaration of Independence," placed Durand at the head of his profession in America. The engraving was made from the miniature portraits in the painter's small finished picture, and happily the likenesses are admirably preserved, and some of the defects of the original in the drawing, amended.

Soon after the completion of this three years' work, for which he received the very inadequate sum of three thousand dollars, he designed and engraved his Musidora; but his graver was in constant demand from that time to this for portraits of various dimensions.

A few years ago Mr. Durand became the purchaser of Mr. Vanderlyn's beautiful picture of the Sleeping Ariadne, and he has at intervals employed his burin in engraving a plate from it, which I have seen nearly finished, and which will immortalize him as an engraver. In the mean time, the engraver has solaced himself for the tedious operations of the burin, by employing the more rapid agency of the pencil and palette. The first effort he made with these instruments was a portrait of his mother. The next, and the first that I saw, was a portrait of John Frazee, since eminent as a sculptor. In portrait painting Mr. Durand has gone on in rapid improvement until his pencil may be said to rival his graver. I will mention as I recollect them at the moment; his portrait of Governor Ogden, of his native state, a worthy revolutionary veteran who

never deserted the cause of his country, and that of James
Madison, one of the sages of that revolution and a framer of
our federal constitution, who has defended it with his pen,
and as chief magistrate, supported its dignity by a war with
Great Britain declared in opposition to the great aristocratical
interest of the nation. This last portrait was made by Mr.
Durand in 1833, and for the purpose he visited the ex-presi-
dent at his residence in Virginia, experiencing the pleasure of
the conversation of the veteran statesman, and that flowing
from the first approbation elicited by his picture.

Mr. Durand was an original member of the National Aca-
demy of Design, and has long been one of the council, and is
now likewise the secretary of the institution. The exhibitions
of this academy have been uniformly enriched by his engrav-
ings and paintings. A group of his three children I remem-
ber with pleasure, and lately a group of two ladies, small full
lengths, of still greater merit. But, not confined to busts or
full-length portraits, Mr. Durand has produced several land-
scapes of unquestionable excellence.

He has lately been called upon by the president of the nomi-
nal American Academy of the Fine Arts, to cut an inscription
upon a brass sword, which, as it seems to contradict the state-
ment made to Mr. Herring, which I have inserted in this work,
calls for my notice. This inscription runs thus :—

" This sword was taken from a German soldier,
by John Trumbull,
In a skirmish near Butt's Hill, Rhode Island,
August 29th, 1778."

The reader will find, p. 350, vol. i. of this work, the following
words : " A few days before the battle of Trenton," (that is,
in Dec. 1776,) "news was at that time received that the
British had landed at Newport, Rhode Island, with a con-
siderable force. General Arnold was ordered to proceed to
Rhode Island to assume the command of the militia, to oppose
them ; and Trumbull was ordered to proceed with him as
adjutant-general. The head quarters were established at
Providence for the winter ; and there, in the month of March,
Colonel Trumbull received his commission as adjutant-gene-
ral, with the rank of Colonel ; but dated in the month of Sep-
tember instead of the month of June."

This was copied from a MS. written by Mr. Herring, and
dictated by Mr. Trumbull. It proceeds to state that the com-
mission was returned to congress declining the service, and
the resignation accepted. I have shown that this acceptation

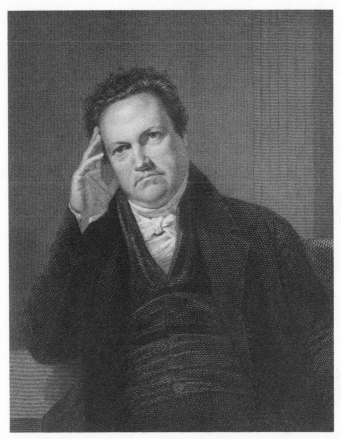

245 DEWITT CLINTON. Engraving by Asher Brown Durand after the painting by
Charles Cromwell Ingham. *Courtesy Dover Archives.*

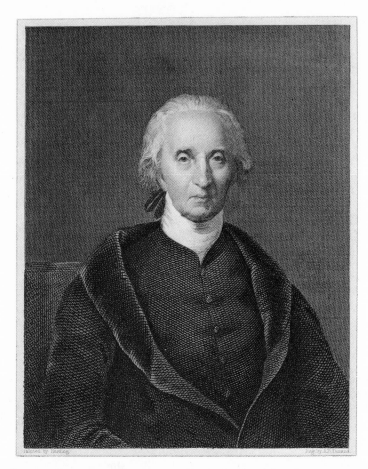

246 CHARLES CARROLL OF CARROLLTON. Engraving by Asher Brown Durand after the painting by Chester Harding. *Courtesy Dover Archives.*

is recorded as of the resignation of John Trumbull *deputy* adjutant-general, and is dated in March 1777. Mr. Herring's MS. proceeds thus: " A correspondence of some length ensued, which terminated, after some weeks, in the acceptance of the resignation, and thus his military career terminated." That is, in March 1777. In the MS. in his own hand writing, he states the resignation to be April 19th, 1777. " He then," continues his amanuensis, "returned to Lebanon, (to the object of *his first love, he said,*) and afterward went to Boston to profit by studying the works of Copley and others, where he remained until 1779." This statement is the same as that published in the National Portrait Gallery, under the patronage of the academy over which Mr. Trumbull presides—yet here, in 1834, we have it recorded in brass, that he took a sword "from a German soldier in a skirmish near Butt's Hill, Rhode Island, Aug. 29th, 1778." The reader will recollect that both statements are from Mr. Trumbull.

As an engraver of flesh Mr. Durand stands unrivalled in America, and by his truth of drawing he gives portrait engraving all the advantages of the likeness preserved in the original paintings placed before him. His heads in Herring and Longacre's National Portrait Gallery are perfect representations of the painters' copies from nature.

In a late letter from Horatio Greenough to Washington Allston, he says, that " Durand's engraving after Harding's portrait of Charles Carrol, which he showed in a coffee house at Florence, quite astonished the Italians; they would hardly believe that it was executed by an American."

Mr. Durand's character is that of the most perfect truth and simplicity. As a husband, a father, and a citizen, he is without blemish from evil report. He is an honour to those arts which delight to honour him.

CHESTER HARDING—1817.

Chester Harding, 1792–1866.

From himself.

" I was born in the town of Conway, Mass. Sept. 1st, 1792. My childhood and youth were spent in the way common to children of poor parentage, in this portion of the country; the winter months devoted to the acquisition of the rudiments of education, and the remainder of the time to agricultural pursuits.

" At the age of twenty-one I began the trade of chairmaking with my brother. This mode of life I followed for about two years; but as I did not entirely fancy the calling, I embraced

the first fair prospect that presented itself of my bettering my means of living. I tried various ways of accumulating property, amongst which was keeping a tavern in a country village in the western part of New-York. This and all others failing, I embarked at the head of the Aleghany river in a 'flat,' with my wife and one child, and floated down this beautiful stream in search of adventures.

"Pittsburgh was now to become the theatre for the new part I was to take in the great drama of life. I had no distinct notion of what I was to do for a living, and I felt for the first time in my life that I was a penniless stranger. After overcoming a great many difficulties, I opened a sign painter's shop, and continued in that branch of the useful arts until July 1817. During this period (a year and a half) I conceived the idea of painting portraits. I had become acquainted with a Mr. Nelson, 'an ornamental sign and portrait painter,' as his advertisement ran, and was much enamoured of his pictures. I sat to him for my own portrait, and also caused my wife to sit for hers, although I was by no means in a condition to afford the money they cost, which was ten dollars each. Mr. Nelson was one of that class of painters who have secret modes of painting faces, and would sell a 'receipt,' but saw no advantage that could possibly grow out of his *giving* his experience to another ; so that I never saw my own portrait in an unfinished state, nor would he let me be present at the painting of my wife's portrait. Here I must date the commencement of my present line of life. These pictures, although as bad as could well be produced in any new country, were, nevertheless, models for my study and objects of my admiration. Soon after I took these pictures home, I began to analyze them ; and it was not long before I set a palette, and then seating myself before my wife, made my first attempt. In this I was eminently successful ; and I question if I have ever felt more unalloyed pleasure in contemplating what I might consider at the time my pet-picture, than I did when I first discovered a likeness to my wife in my own work. This success led me to think much of portrait painting, and I began to grow disgusted with my vocation, neglected my customers, and thought seriously of following my newly discovered goddess, regardless of consequences. I now conceived the plan of going to Kentucky, which was almost as soon executed as formed. During my residence in Pittsburgh I painted a few portraits, perhaps ten or twelve, and in each I could always trace some remote resemblance to the originals. This gave me some confidence in myself, so much so that I ventured,

though with some misgivings, to announce myself as a *portrait painter* in the town of Paris, Kentucky.

" Here my mode of life underwent a great change. I was now pursuing a profession which had always been deemed honourable, though of that circumstance I had not the most remote idea. I regarded it in a more favourable light than I did the calling I had just abandoned, because it gave me more pleasure in the prosecution of it, not that it was more honourable. I took rooms and commenced business at once. My price was $25, which to the highminded Kentuckians was a trifle, though to me it seemed exorbitant ; but that price I was advised to charge, and at that price I opened my new shop.

" In this small town I painted near a hundred heads, and found that I was sufficiently in funds to enable me visit Philadelphia. I forthwith set off, and passed five or six weeks in looking at the portraits of Mr. Sully and others, and then returned to Kentucky to renew my labours with increased strength. I had now begun to think more favourably of my profession, and I determined to distinguish myself in it. I felt at the same time that there were more difficulties in the way than I had dreamed of before I went to Philadelphia. A knowledge of these difficulties I believe for a while impeded my progress. I thought that my pictures, after my return, were not as good as those I painted before I had thought so much of the art and its intricacies ; and I am now persuaded that the knowledge of the many obstacles that I must overcome before I could arrive at distinction in the art, had the effect of intimidating me, and it was a good while before I could get into my former free style of painting. About this time too, the currency of the state became sadly deranged, and all classes were obliged to curtail their expenses, so that my affairs did not prosper so well after I returned from Philadelphia as they did before I went.

"I shifted my place of residence several times, but failing to produce any very considerable interest in my favour, I made a grand move to St. Louis, Missouri.

" I had the good fortune to meet with constant occupation, and at the advanced price of forty dollars. I remained in this place until July, 1821. During my stay here, I greatly improved my pecuniary circumstances, and for the first time began to think of visiting Europe. In the autumn after I left St. Louis, I made my debut in the city of Washington. I painted a few heads for exhibition; so that by the time congress met, I made something of a display. I was successful beyond my most sanguine expectations. I painted some-

thing like forty heads, during this winter and spring. The autumn following I went to Boston, chiefly on a pilgrimage to Stuart. I saw him and many of his works, and felt, as every artist must feel, that he was without a rival in this country. I spent a week or so in Boston, and then went back to my native country, Massachusetts, with my mind filled with feelings very foreign to those I started into the world with, many years before. I had while at Washington become acquainted with Mr. E. H. Mills, our senator at that time in congress, who induced me to open rooms in Northampton. Here I painted a number of heads ; and while in that town I was employed by some gentlemen living in Boston, who thought so favourably of my pictures, that they urged me to go to that city and establish myself. I said no—not while Stuart was there. But they urged me so much, and at the same time offered to procure several sitters for me, that my reluctance was overcome, and I accordingly found myself in the same city with Stuart, seeking employment from amongst his admirers.

" The gentlemen who urged me to come to Boston, more than fulfilled their promises. They brought me many sitters, and in all respects were deserving of my highest gratitude. My room became a place of fashionable resort, and I painted the enormous number of eighty heads in six months ; and I verily believe, I had more than twice that number of applicants for portraits in that time. Mr. Stuart is too well known to allow of the supposition, that my portraits could bear any sort of comparison with his ; yet, such was the fact, that while I had a vast deal more offered than I could execute, Mr. *Stuart* was allowed to waste half his time in idleness, from want of sitters. Is not this a hard case? I can account for this public freak only in the circumstances of my being a back-woodsman, newly caught ; then the circumstance of my being self-taught was trumpeted about much to my advantage.

"Perhaps, to the superficial observer, there is no circumstance in the history of an artist, that carries such a charm with it, as that of being self-taught—while to those competent of judging, it conveys no other virtue with it, than that of perseverance. By self-taught, is here meant not having any particular instructor. It matters little how an artist arrives at a sort of midway elevation, at which all with common industry may arrive. But it is the man of genius, who soars above the common level, and leaves his less favoured brethern to follow in his track with mingled feelings of envy and admiration.

"I now found myself in funds sufficient for a trip across the

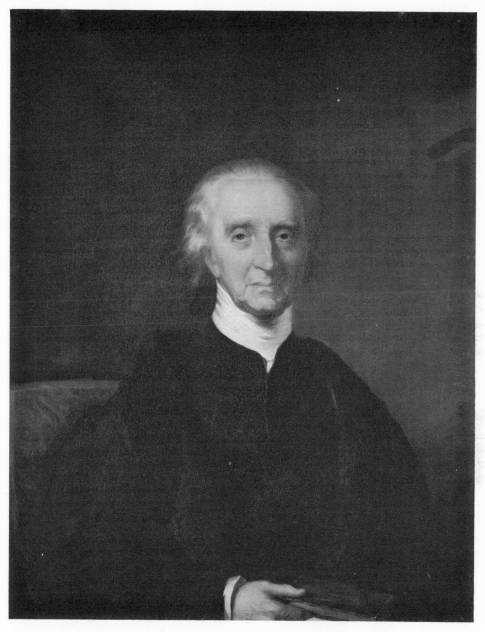

247 CHARLES CARROLL OF CARROLLTON. Painting by Chester Harding. *Courtesy Architect of the Capitol.*

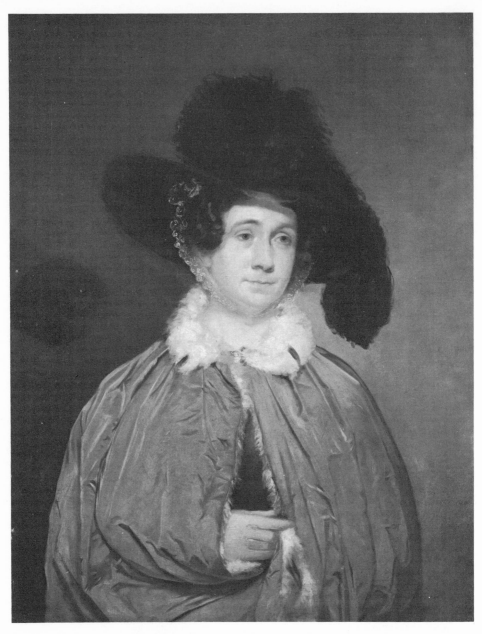

248 Mrs. Thomas Brewster Coolidge (Clarissa Baldwin), *c.* 1828–1830. Painting by Chester Harding. *Courtesy The Metropolitan Museum of Art, Rogers Fund.*

Atlantic, and notwithstanding the thousand times I had been told that I could learn nothing by going to London, and the pressing business I must give up, I set sail for Liverpool the first of August, 1823.

" On arriving in London, I found myself in a wilderness of art, and an equally dense wilderness of people. For a month or two my mind was in the greatest confusion. I was perfectly solitary; and from seeing so much of art, instead of being stimulated to exertion by it, became in a degree indifferent to all the sublime works that were within my reach. I felt that the old masters had been much over-rated, and that the greatest merit their works possessed was, that they bore the undoubted marks of antiquity. I don't know whether any other artist, on his first visiting the treasures of art in the old world, has been for a time satiated with them as I was. But my experience proves satisfactorily to me the truth of the hackneyed quotation of, " Drink deep, or taste not," &c. By degrees, however, as I became familiar with the works of Sir Thomas Lawrence, Sir Joshua and others, I began to perceive a change of feeling towards the old masters. I began to see new beauties every day in Raphael's cartoons, which at first struck me as little better than scene-painting at the theatre.

" If I was peculiar in my feelings of indifference, I cannot account for it to myself. I am willing to confess, however, that on my first arrival in London, my solitary life was made more so by the contrast that I was forced to draw between my lonely situation in London, and that I so lately left in Boston. I was now left to myself, and my thoughts naturally turned upon myself; and perhaps I felt more mortification than I was willing to admit, at discovering that I was not so rich in acquirements as my friends had very innocently led me to think. While in this state of mind, I did not derive all the advantage from my opportunities that I might have done, had my mind been bent on improvement alone.

" In a short time I began to get rid of this apathy, and it soon became my greatest pleasure to visit those very works, which had at first so disappointed my expectations. I soon found that my funds were insufficient to support me *one* year in London, though I thought them ample for two; and it became necessary that I should paint portraits, or shorten my contemplated visit. Amongst my first, was a head of Mr. Rush, our minister in London at that time.

" I was more than usually successful in the likeness. It had the effect of inducing others to sit, and it was the indirect

means of introducing me to the Duke of Sussex, whose patronage I subsequently enjoyed to a considerable extent. I was indebted to his royal highness for an introduction to the Duke of Hamilton, who was particularly kind to me during the whole of my stay in Great Britain. He sat to me for several portraits of himself, and invited me to stay with him at Hamilton Palace, which invitation I gladly accepted. I spent near three weeks at this splendid place. There are few richer galleries in Great Britain than that of Hamilton Palace; and amongst its rare gems is the original " Daniel in the Lions' Den," by Rubens, many splendid Vandyks, &c.

" During my stay in England I had the good fortune to spend a few weeks at Holkham, the seat of Mr. Coke. Here I saw a great deal of high life; and it requires but little imagination to see, that the transition from the back woods of Missouri to this seat of luxury and elegance, was most imposing, and, in some respects, embarrassing. My mornings were spent chiefly in looking at the " old masters," and the afternoons in shooting. In early life I had been in the frequent habit of shooting bears and other large game; but on this occasion I felt almost as ignorant of the fashions of the field as I was of those of the dinner-table and drawing-room. However, the sport of killing pheasants and partridges, that at first seemed to me so trifling, became, in a short time, very interesting. I met a good many noblemen of high rank during my visit here; and one of the most distinguished by the distinguished, was Mr. Chantry. I had the pleasure of shooting by his side by day, and sitting by his side at dinner.

" I was an exhibitor at Somerset House, every year while I was in England. I always profited by the comparison of my pictures with those about them, although it was always at the expense of my vanity. I invariably found that my pictures looked better to me, while in my own room, than they did by the side of the distinguished artists of the day. I used sometimes to indulge the feeling, that I had not justice done me in the hanging of my pictures at the Royal Academy: but I was compelled to admit, after due reflection, that the committee had done me more justice in placing me where they did, than if they had placed me more conspicuously in comparison with better painters. And I am led to believe, that the body of arttsts who have the management of this great institution are actuated by feelings entirely liberal, free from jealousy or envy. There is a charm in the bare walls even of Somerset House, that excites a student to emulation: but when those walls are filled with the works of cotemporary artists, one cannot but feel

proud of his profession, and disposed to give himself up to its study, caring for nothing else. Unfortunately for that state of mind, which is such perfect bliss, the worldly cares about house-rent, food, and clothing, for his wife and children, will break the spell. I am thoroughly convinced, that had I been a bachelor, when I was in London, I should have been there at this time. But I then had a wife and four children, which rendered it necessary that I should realize a certain amount of money every year. When an artist is harassed in his financial concerns, his mind is in no state to pursue the arts with pleasure or profit. In the course of the three years I was abroad I painted to the amount of 12,000 dollars; which sum was just sufficient for my expenses.

"I visited Paris; but my stay was so short, and my total ignorance of the language of the country so great, that I will make no comment upon the artists or the schools in that city. I returned to Boston in the autumn of 1826; since which I have made it my head quarters."

The frank and manly manner in which Mr. Harding answered my request to contribute a portion to my history of the arts of design, by giving me some notices of himself and his progress, has induced me to publish the above in his own words. I can add little to the information it contains.

My personal knowledge of this gentleman is slight, and made at intervals. When I was painting portraits in Utica he introduced himself to me in my painting room, and I was pleased with his appearance and manners. I noticed that he immediately selected the best head I had painted there—a proof of a true eye and taste. I again met him in Boston, and witnessed the impression his talents made in that city previous to his going to Europe.

Of late Messrs. Harding, Fisher, Doughty, and Alexander, have, in conjunction, exhibited their pictures in Boston with great effect; and as I am informed, with great profit, both in money and increased reputation.

Mr. Harding, I am told, has purchased a beautiful country seat in the neighbourhood of Northampton, in his native state, where he and his family will probably enjoy the fruits of his industry, perseverance, and talents. He is now acknowledged as standing in the foremost rank of portrait painters in the United States.

HUGH REINAGLE—1817.

Mr. Reinagle was born in Philadelphia. His father was a professor of music, and partner with Wignell in the Chesnut-street theatre. Hugh was a pupil of John J. Holland. He painted landscape both in water colour and oil. A panorama of New-York was painted by him, which was exhibited in Broadway. For many years he was principal scene painter at the New-York theatres ; and in 1830 went to New Orleans, in consequence of offers from Mr. Caldwell, manager of the American theatre at that place, and there died of Asiatic cholera in 1834. Mr. Reinagle was a man of amiable disposition, correct conduct, and unblemished reputation. He left a widow and large family, I fear slenderly provided for.

G. MARSIGLIA—1817.

Mr. Marsiglia, a native of Italy, arrived at New-York about the period above marked. He has painted many portraits, and exhibited several historical and other compositions of merit. He finishes with care, and colours with great clearness and brilliancy—not always with harmony. His productions of the complicated kind are remarkable for great beauties and obvious faults. He is an academician of the National Academy of Design, and is esteemed for his amiable manners and correct deportment.

JAMES HERRING—1817.

This intelligent and very enterprising gentleman is, like several other American painters, a native of England. The progress of the arts of design is at this time facilitated by the persevering enterprise of Mr. Herring as a publisher.

James Herring was born in London in the year 1796, and brought to this country by his father at the age of ten. The father was one of the many who sought in the United States of America the protection of a government more perfect, or less oppressive to the plebeian population, than that of Great Britain. Arriving at New-York, he established himself as a brewer and distiller in the neighbourhood of the Bowery ; but the business failed in 1812, in consequence of circumstances connected with our second war with England. Two years after, James was left, by the death of his father, without property or profession, and with a wife, at the age of eighteen. He had served his father in his brewhouse and distillery, but had no inclination to be the servant of a stranger. The spirit

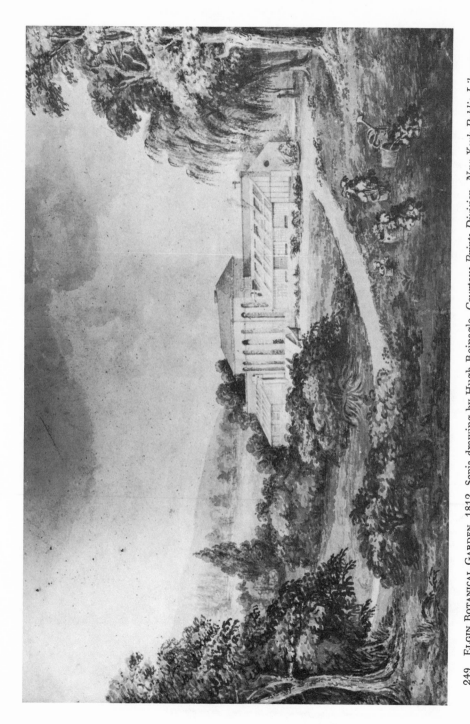

249 ELGIN BOTANICAL GARDEN, 1812. Sepia drawing by Hugh Reinagle. *Courtesy Prints Division, New York Public Library, Stokes Collection.*

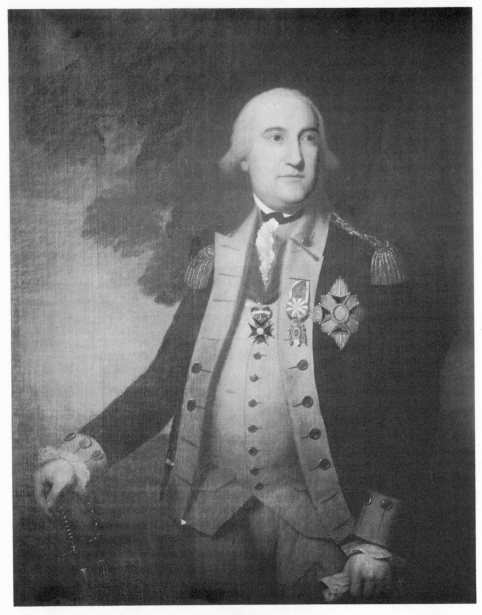

250 BARON WILLIAM AUGUSTUS VON STEUBEN. Painting by Gherlando Marsiglia after the painting by Ralph Earl. *Courtesy The Art Commission, City of New York.*

of the country was upon him, and he resolved to choose his own path in life. As a boy he had outdone his schoolmates in drawing, the desire to become a painter had grown with his growth, and he now thought of painting as the means of present subsistence and future prosperity. But the difficulties attending the commencement, and the struggles necessary for the present support of a family, required uncommon energy, and he possessed it.

He applied to a person of the name of Thatcher, who was then publishing prints manufactured by himself, and suited to the time; such as fights between our frigates and the English; and young Herring was employed by him to colour these triumphs of genius and patriotism. John Wesley Jarvis was engaged in scraping mezzotintos for the same market, and Herring got some employment in colouring from him. But a publisher of maps was his best patron; in colouring these his wife could assist him, and with her aid he earned a decent living. The patron, however, did not do so well, and found it necessary to make a precipitate retreat without notifying his creditors, among whom was Herring. Fortunately, the young man found that his debtor had stopped at Philadelphia, and he pursued him on foot, found him, and obtained part of the money due to him. But his employment in New-York had been diminished by the failure of the map-maker, and he looked about him for something in the city to which fortune had led him that might supply the deficiency; and he found it. Matthew Carey was a map publisher, and was willing to give him as much work as he could undertake. He removed his wife to Philadelphia, and they jointly carried on the business of colouring maps, until finally they employed girls to assist them, whom they taught. Carey paid three dollars a hundred, and Herring & Co. could make a clear $20 a week. Such particulars of the steps by which a youth makes his way up in the world, are very interesting to me—I hope my readers participate in my feelings.

His attention was called to drawing, at this time, by an application for a profile. This led to making profiles and colouring them. He then attempted a delineation of the whole face; and by a successful experiment made in New Jersey, he succeeded in gaining employment in that state as a portrait painter in water colours, and finally in oil. From New Brunswick to Easton he was the portrait painter. A citizen of New-York saw his work, and invited him thither to paint some members of his family. This succeeded, he had more applicants, removed his family to the great commercial metropolis,

and in a short time was an established portrait painter in the Bowery, near the spot at which he commenced life in the brewhouse and distillery of his father.

A fit of sickness caused him to reflect on the helpless situation of his wife and children if he should die, and he projected the establishment of a circulating library, which in such an event they could continue. When restored to health he, by the perseverance of several years, at times when not employed in painting, accomplished, and finally established one in Broadway, where it now yields him a handsome annual income of $1500. This success, and the intercourse with prints and books, suggested that scheme of publication to which I alluded in commencing this memoir—"The National Portrait Gallery," a work honourable to our country.

Mr. Longacre of Philadelphia having a project of the same nature in agitation, the two were united, and the work now gives employment to many of our engravers, and stimulates to that exertion on which the progress of the fine arts depends. I have seen twelve numbers of this elegant publication, and seen most of them with sincere admiration. Many of the engravings are from approved paintings, and answer public expectation both for likeness and execution. The 12th number is the most highly and expensively ornamented, but is not satisfactory to me, and I feel myself bound to notice the cause of my dissatisfaction. The greater part of the number is very properly devoted to George Washington, and instead of one portrait of him the editors have given two, besides a beautiful medallion. But unfortunately neither of the portraits have a semblance of George Washington. One is a very finely engraved plate by Durand, our first engraver, and one of our best draughtsmen, copied by him from Mr. Trumbull's full-length picture of Washington at Yale College, which has not a feature like the hero. It must be remembered that the painter is president of the institution under whose patronage the National Portrait Gallery is published; and the picture is said, in that work, to be "regarded by the artist as the finest portrait of General Washington in existence." Apparently as a contrast, another portrait follows in the same number, neatly engraved in an inferior style, from a copy, and apparently from a poor copy, of one of Stuart's Washingtons, with most of the deformities attending these copies; and it is given as being from a portrait *painted by G. Stuart.* I would ask why was not Mr. Durand engaged to engrave from Stuart's original picture in the athenæum at Boston, (or his own fine copy of it,) that a fair comparison might be made by those still re-

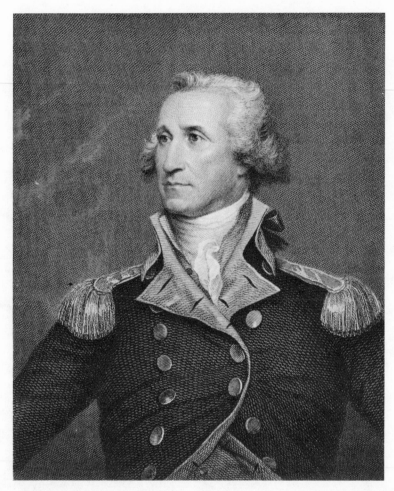

251 GEORGE WASHINGTON. Engraving by Asher Brown Durand after the painting
by John Trumbull for James Herring's "National Portrait Gallery." *Courtesy
Library of Congress.*

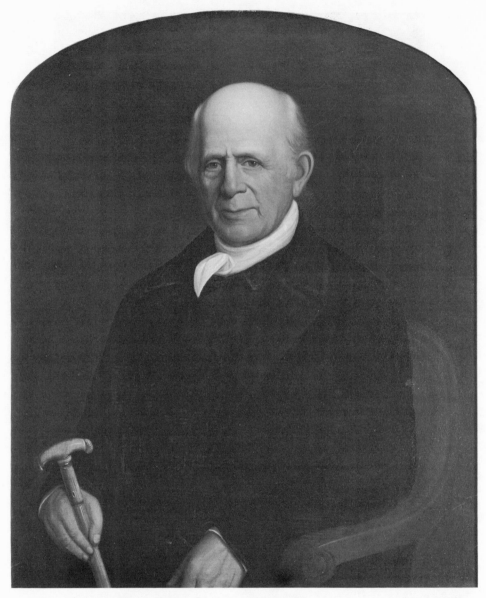

252 NAPHTALI PHILLIPS. Painting by James Herring. *Courtesy American Jewish Historical Society. Photograph Frick Art Reference Library.*

maining who knew the hero, and that in reality the world might see the intelligent and benevolent countenance of Washington.

I do not attribute this arrangement to Messrs. Herring and Longacre: the influence which produced it is manifest. It reminds me of the mode in which Mr. Rembrandt Peale exhibited his certificate-Washington, with a wretched copy of a copy, made by himself and placed on the floor without frame, beneath the portrait which he had the authority of Mr. Custis, Judge Marshall, and in fact all he asked for their signatures, for calling the *only* likeness of Washington. There appears to be a sinister intention in publishing the work of an inferior artist by the side of an engraving from the burin (in beautiful line style) of our best engraver. The very valuable work of Messrs. Herring and Longacre is increasing in popularity: the effect of this malign influence, called patronage, is, that in No. 12 they have given, at great expense, two portraits of Washington, and neither like. The medallion is more like than either.

GEORGE DIXEY AND JOHN V. DIXEY—1817.

George Dixey, ?–c. 1853.

John V. Dixey,
fl. c. 1819–c. 1863.

George is the son of John Dixey, an English sculptor heretofore mentioned. The subject of this notice was born in Philadelphia, and studied under the direction of his father. The only models of which I have any knowledge, executed by this gentleman, are Theseus finding his father's sword; Saint Paul in the island Malta, and Theseus and the Wild Boar.

John V. Dixey is the youngest son of John Dixey, and likewise instructed by his father. In 1819, he modelled St. John, writing the Revelations. I remember Mr. John V. Dixey well as a student of drawing with good promise and very prepossessing manners. He has painted several landscapes in oil, highly creditable to him, which have been exhibited at the gallery of the National Academy of Design.

ITHIEL TOWN—1817.

Ithiel Town, 1784–1844.

Of the time or place of this eminent architect's birth I am ignorant. He has long been prominent among the artists of New-York, and I believe is a native of New-England. Mr. Town travelled in Europe, and examined the works of art with a learned eye and judgment. His library of such works is truly magnificent, and unrivalled by any thing of the kind in America, perhaps no private library in Europe is its equal. He is connected with A. J. Davis, Esq., as an architect, and from him I have received a notice of some of the designs of Mr. Town for public buildings, as well as some of those de-

signed and executed in company. Under the head of **A. J. Davis**, this notice will be found.

It would give me pleasure to lay before the public a more full account of this scientific and liberal artist, whose splendid library is open to the inspection of the curious, and freely offered for the instruction of the student. I have been disappointed in not receiving promised information.

Gilbert Stuart Newton,
1794–1835.

GILBERT STUART NEWTON—1817.

This gentleman is the nephew of Gilbert Stuart, being his sister's son. He was born in Halifax, Nova Scotia, September 2, 1795, owing to the circumstance of his parents removing thither from Bostonwhen the British were driven from that town by Washington and his undisciplined, half-armed host. After his father's death, Newton, a child, was brought by his mother to her home in 1803, and resided in Charlestown near Boston. When his uncle took up his residence in Boston he received his instruction, and at that time I heard of him as a youth painting with great promise of excellence.

Colonel Sargent in a letter to me says, (when mentioning Gilbert Stuart,) "his nephew Stuart Newton was very displeasing to him, for he affected to know so much, and disputed with him so frequently, that Mr. Stuart finally became cool to him and cut his acquaintance. Newton now," that is, at the time of his late visit to the United States, "speaks of his uncle most disrespectfully, as I believe he does of most American painters." This agrees with the story of his provoking the old man by telling him that he would show him how to paint, and of the uncle turning him out of the room.

Newton was a short time in Italy, and as he proceeded through France to England he met Leslie in Paris, and they travelled to London together in 1817, through the Netherlands, and from that time these extraordinary men have been linked together in the strongest bonds of friendship.

Many Americans had their portraits painted by Stuart Newton in Paris and London. I have seen several that were brought to New-York, which were nowise extraordinary. He had not yet got into the path which was destined to lead him to fame. The first picture that I saw, indicative of his high talent, was the poet reading his verses to a gallant whose mistress was at the moment waiting for him by appointment. I saw this at my friend Doggett's frame-store in Boston, and while I was admiring it, the author's uncle came in. I expressed to him my pleasure, and was surprised at his coldness, not then knowing that the uncle and nephew had parted coolly.

253 YALE COLLEGE AND STATE HOUSE, NEW HAVEN, 1832. Architecture by Ithiel Town. Engraving by Alexander Jackson Davis. *Courtesy Library of Congress.*

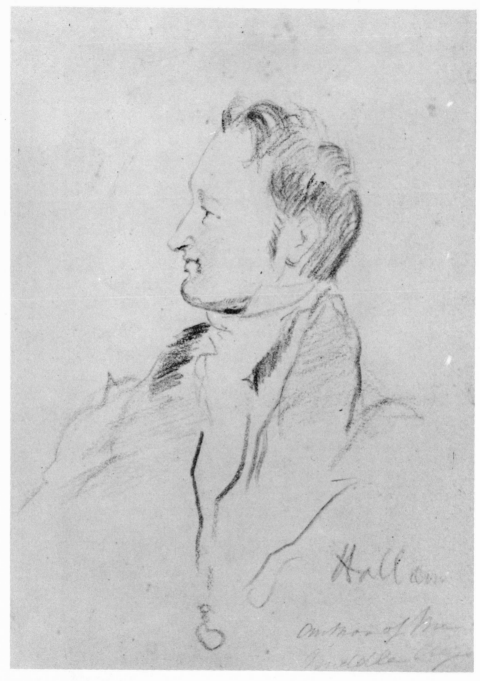

254 HENRY HALLAM. Drawing by Gilbert Stuart Newton. *Courtesy National Portrait Gallery, London.*

I afterwards saw in New-York the Sleeping Girl under the influence of an old man's lecture, in the possession of Philip Hone, Esq., but I saw at the same time, a picture which excelled it, notwithstanding its splendid colouring; that was Leslie's " Ann Page and Master Slender."

In a letter to me from West Point dated January 28, 1834, Mr. Leslie thus speaks of his friend : " You will no doubt like to have some accouut of my friend Newton. I met him for the first time in Paris in 1817. He was then on his way from Italy to England, and we travelled together through Brussels and Antwerp to London. Mr. Newton had gone from America to Italy for the purpose of pursuing his studies there. But he had the sagacity to discover soon after his arrival, that Italy with all its treasures of ancient art, is not at present the best place for a beginner. There is nothing more certain than that a young artist acquires his taste from the living artists that are about him much more than from the works of those who are gone. Mr. Newton painted a portrait or two in Italy, and some of the leading painters asked him what colours he used, and seemed desirous of receiving information from him.* When he arrived in London the artists were surprised to see a young man beginning so well; but none of them asked him what colours he used, and he now found he was among men from whom he could learn the art.

" Mr. Newton is blessed with an exquisite eye for colouring. He had also a great advantage in being from his childhood familiar with the works of his illustrious uncle Stuart. He very soon became known in England, and with less study than is usual, arrived at and maintains a very high rank among English artists. His comic pictures possess genuine humour; and as you have, no doubt, seen the engraving from his picture of the Vicar of Wakefield restoring Olivia to her mother, you can judge of his power in the pathetic—I know of nothing in the art more exquisitely conceived than the figure of Olivia.

" Mr. Newton was once asked if he was an historical painter. 'No,' said he, ' but I *shall be one next week.*' He, like all men who know what the art really is, estimated it by its intrinsic excellence much more than by the classifications of history, familiar life, portrait, landscape, &c. For my own part, I would much rather have been the painter of one of Sir Joshua Reynold's best portraits, or one of Claude's

* See hereafter R. W. Weir's remarks upon the present race of painters in Italy ; and those of T. Cole.

landscapes, than of any historical picture by Guido, Domine-
chino, or Annibal Carracci, I ever saw. If dramatic invention,
a true expression of the passions and feelings of human nature
and a perfect knowledge of physiognomy, are to be estimated
by their rarity, Hogarth was the greatest painter the world
ever saw. Yet, according to the received classification, his
art must take a lower rank than that of his father-in-law, Sir
James Thornhill, who decorated the dome of St. Paul's with
the history of the saint from which the church is named."

Notwithstanding my exalted opinion of Mr. Leslie, I must
here remark, that his love for the branch in which he excels
may mislead his judgment on this question. He appears to
confound the rank of the painters Hogarth and Thornhill,
with the rank of the branches of art they pursued. That
Hogarth was incomparably the best painter, is no argument
for the supremacy of familiar painting over historic. Sir
Joshua Reynolds' Infant Hercules places him higher, in my
opinion, than any portrait he ever painted; and if he could
have executed a great historical event or scriptural subject as
well, he would have been exalted still higher. My opinion of
the qualifications required for historical composition, and the
value to be placed on *choice of subject* are known, and as I
have no pretensions to eminence in any branch of the art, my
opinion must at least be received as impartial. Leslie says:
" I have here and there mixed up some of my own notions
with my accounts of other people. If you agree with me in
any opinion I have expressed and think it worth publishing,
I hope you will give it the advantage of your own language."
Although I may differ in opinion from this eminent artist, I
hold his opinions in too high estimation to keep them from the
public; and I should as soon attempt to mend his pictures as
his language.

To my inquiries respecting Newton, Washington Irving
has given the following answer:

New-York, March 9th, 1834.

" My dear sir,

" I know nothing clear and definite about Mr. Newton's
early life and his connexions. He was born in Halifax, Nova
Scotia, where his father held a post, I think in the commissa-
riat of the British army. I am not certain whether his father
was not a native of Boston, but feel sure that his mother was,
and that she was sister to Stuart the painter, after whom New-
ton is named. On the death of his father, which happened
when Newton was a boy, his mother returned to her relations
in Boston. Here Newton was reared; and being intended for

commercial life, was placed with a merchant. While yet a stripling, however, he showed a talent and inclination for drawing and painting, and used to take likenesses of his friends. These were shown about and applauded, sufficiently to gratify his pride and confirm his propensity: and in a little while it became apparent that he would never become a merchant. His friends were determined to indulge him in his taste and wishes, and hoped that he might one day rise to the eminence of his distinguished uncle. One of his elder brothers, who was engaged in commerce, being about to make a voyage to Italy, took Stuart Newton with him, and placed him at Florence, to improve himself in his art. Newton was never very assiduous in his academical studies, and could not be prevailed upon to devote himself to that close and patient drawing after the living models, so necessary to make an accomplished draughtsman; but he almost immediately attracted the attention of the oldest artists by his talent for colour. They saw, in his juvenile and unskilful sketchings, beautiful effects of colour, such as are to be met with in the works of the old masters, gifted in that respect. Several of the painters would notice with attention the way in which he prepared his palette and mixed his colours; and would seek, by inquiry of him, to discover the principles upon which he proceeded. He could give none.— It was his eye that governed him. An eye for colouring, in painting, is like an ear for harmony in music, and a feeling for style in writing—a natural gift, that produces its exquisite result almost without effort or design in the possessor.

" Newton remained but about a year in Italy, and then repaired to Paris, from whence he soon passed to England— arriving in London about the year 1817. Here he was fortunate enough to find his countrymen, Washington Allston and Charles R. Leslie, both sedulously devoted to the study and practice of the art, and both endowed with the highest qualifications. Allston soon returned to the United States, but Leslie remained: and from an intimate companionship for years with that exquisite artist and most estimable man, Newton derived more sound principles, elegant ideas, and pure excitement in his art, than ever he acquired at the Academy. —Indeed the fraternal career of these two young artists, and their advancement in skill and reputation, ever counselling, cheering, and honouring each other, until they rose to their present distinguished eminence, has something in it peculiarly generous and praiseworthy. Newton has, for some years past, been one of the most popular painters in England, in that branch of historical painting peculiarly devoted to scenes

in familiar life. His colouring is almost unrivalled, and he
has a liveliness of fancy, a quickness of conception, and a fa-
cility and grace of execution, that spread a magic charm over
his productions. His choice of subjects, inclining chiefly to
the elegant, the gay and piquante, scenes from Moliere, from
Gil Blas, &c. yet he has produced some compositions of touch-
ing pathos and simplicity: among which may be mentioned,
a scene from the Vicar of Wakefield, depicting the return of
Olivia to her family.

" Of Newton's visit to this country, his marriage, &c. you
have doubtless sufficient information. Should you desire any
additional information on any one point, a written question
will draw from me all that I possess. When I am well enough,
however, to bustle abroad I will call on you, and will be able,
in half an hour's chat, to give you more than I can write in a
day.

 " I am, my dear sir,
 " Very truly yours,
 "WASHINGTON IRVING."

Mr. Newton, it is said, congratulates himself upon being
born a subject to the king and aristocracy of Great Britain:
and on one occasion, in New-York, at a large dinner party,
got up and disclaimed being a citizen of the United States.—
He cannot, however, shake off the stigma of being an Ameri-
can painter. That he should prefer being thought a subject,
and a native of a province, which places him in a kind of
mongrel situation, neither Englishman nor American, though
it lowers him in my estimation as a man, cannot detract from
his great merit as an artist. Washington Irving, in con-
versation has represented Newton to me as a man of great
talent, quick to conceive and powerful to execute. He agrees
with Leslie in ascribing to him an extraordinary *eye for colour;*
and says, that the rapidity of his execution almost exceeds be-
lief. He has never applied himself with the necessary dili-
gence to the study of drawing; yet, with the want of accuracy
consequent to that neglect, his taste in composition and har-
mony of colouring, cover all defects, or cause them to be for-
gotten; while the eye is delighted and the imagination excited
by his treatment of familiar subjects of pathos or of humour.

If a friend, who sees the progress of a picture, objects to any
part, Newton defends it vehemently: perhaps, like Sir Fret-
ful, asserts, that it is the best portion of his work; but if the
friend returns the next day, he may find that part expunged
and repainted. So great is his facility, that he never hesitates
to dash out a figure, or a group: and, as Mr. Irving has said,

if one of his figures on the surface of his canvas could be scraped off, we should find half a dozen under it—or might detect six legs to one man—four painted and covered over, before the artist had adopted the last pair."

Mr. Newton's manners have been stigmatized as pert, and occasionally approaching to puppyism. He is said to delight in contradiction, especially of widely received opinions. But he must have a great and solid mass of good sense under this surface, as well as great and uncommon quickness, both of observation and repartee, and, at the bottom of all, an amiable disposition; or he would not, as he is, be the friend and favourite companion of Charles R. Leslie and Washington Irving. When he was in New York, the rector of Grace church at that time displayed his collection of paintings to Newton, saying, (no doubt expecting a compliment to his taste and judgment in selecting,) "I think you will say they are tolerable." "Tolerable!" said the painter; "tolerable! why yes; but would you eat a tolerable egg?"

When Mr. Irving returned to London, after a long absence on the continent, he anticipated great enjoyment from the society of Allston and Leslie; but he only arrived time enough to take leave of the great historical painter, who returned to the land he loved even better than England; his intimacy with Leslie he resumed, with renewed delight. On one occasion they had made an appointment to pass a day on Richmond Hill, and Leslie asked if he might take with them a young artist who had lately returned from Italy. It was agreed to: and on this occasion Irving first saw Stuart Newton.— They passed a day of frolic and fun, (such frolic and fun as became such men) and from that time Newton, Leslie, and Irving were inseparable while the latter remained in London.

Newton, as he disliked the labour of study, and found that historical or fancy composition required more exertion of mind than portrait painting, had determined to paint portraits, and not trouble himself with any other labour than that of copying his sitter. Irving, who had seen his talent for humorous and domestic scenes, (for he would dash off a sketch of an incident as rapidly as another could relate it, and then throw it away, as a thing of no value) remonstrated with him, and endeavoured to rouse his pride and ambition by depreciating portrait painting. But, as he defended a weak spot in his picture, so he defended the propriety of his choice—talked of Vandyke and Reynolds, and all the men famous for portraiture; and finally parted from his friend *in a huff,* saying, among other things, " that, knowing his predilection for por-

trait painting, it was improper," or perhaps using a harsher expression " in Mr. Irving to speak of that branch of art as he had done." Some days after, Irving called upon the offended painter, and found him engaged in painting " The Poet reading his Verses to the impatient Gallant." " Aha ! now you are in the right road !" exclaimed the friend. And from that time forth the artist devoted himself to that species of composition in which he has been so eminently successful.

It is well known that, on his visit to the United States, Mr. Newton married a young lady of Boston, and carried her to the land he loved best : but unhappily his domestic happiness has been clouded, if not destroyed, by a malady which has cut him off from his friends, and deprived the world of those exertions which added to the innocent pleasures of life, and promoted a taste on which no small portion of human happiness depends.

Mauro Gandolfi, 1764–1834.

MONRO GONDOLFI—1817,

The best foreign engraver that ever visited this country. He was a native of Bologna. In his youth he had studied and practised painting, and was noted for his skill as a draughtsman, and the beauty of his water-colour drawings. The art of engraving engaged his affections, and he soon made himself an engraver ; but, on visiting Paris, where his roving disposition led him, he became a pupil of the celebrated Bervic for a short time. In Paris he engraved several of the plates for the splendid edition of the pictures in the Louvre. Returning to Italy, he engraved and published several justly admired works, particularly a holy family after Guido, and a St. Cecilia, after a painting of his own. This last I have seen and admired. I know of but one copy in New-York, which is in possession of Doctor Hugh M'Lean.

However admirable Gondolfi's works render him as an artist, his conduct as a man has been that of a detestable profligate. He a second time left his native city for Paris, abandoned an amiable wife, and discarded his son, a sculptor of much promise. He carried with him to Paris a vulgar and ignorant peasant girl, with whom, as his wife, he came to New-York in 1817.

Trumbull engaged him for four thousand dollars to engrave his " Declaration of Independence." Heath had demanded eight thousand. Gondolfi made his bargain before he knew the value of money in America, and the cost of living ; he soon cancelled it, declaring that four thousand dollars would not support him and his madam, while he laboured at the

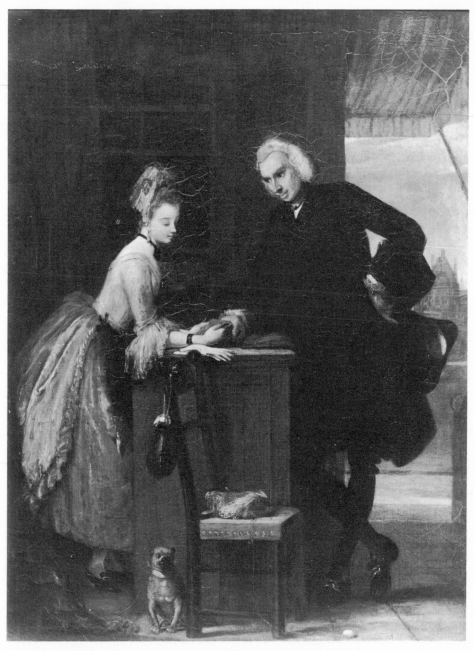

255 YORICK AND GRISETTE. Painting by Gilbert Stuart Newton. *Courtesy Tate Gallery, London.*

256 RUINS OF TRINITY CHURCH, c. 1780. Lithograph by John Evers after a sketch by Thomas Barrow, Esq. *Courtesy Prints Division, New York Public Library, Stokes Collection.*

plate, and supply him with claret. He showed me a water-coloured painting of his own designing, which he called his "Fantasie." It consisted of beautiful heads, and parts of figures floating in clouds, here and there grouped and drawn, coloured, and finished exquisitely. He visited Philadelphia, but soon returned to New-York, and then, as my informant who went to Europe with him shortly after, tells me, he formed a design of visiting the South Sea Islands, and passing the remainder of his days in the fancied simplicity of nature and innocence, to do which, he thought it necessary to shake off his nominal wife, the Italian peasant whom he had brought from home—but she chose to share his simplicity and innocence with him, and he gave up the scheme. He then suddenly set off for Italy, after attempting again to leave behind him the specimen of Bolognese rusticity he had brought with him and introduced as his wife. She was tenacious, and like the fruits of all evil doing, kept her hold—his torment and his shame.

As an artist, Gondolfi deservedly ranks high. His engravings are distinguished for boldness, and at the same time, faithfulness to the originals: and what is particularly to be remarked in his works, is the variety of his style, and its adaptation to that of the painter he copies.

Some of his works, which are spoken of as masterpieces in the art, have not been seen in this country. He showed a sensitiveness about his reputation well worthy of imitation, not allowing his plates to be used, the moment after they began to fail, but destroying them at once. For this reason the prints from his works are not so numerous, as those of others who have engraved less—and his prints are all in fact proof impressions. Most of his works have been subscribed for, before they were finished, and are therefore scarcely ever to be met with, but in private collections.

Is it not strange, that any one should be so sensitively careful of his reputation as an artist, and utterly regardless of his reputation as a man, and blind to the consequences that must follow his dereliction of the duties of a citizen, a husband, and a father?

JOHN EVERS—1817.

John Evers, 1797–1884.

This gentleman was born at New Town, Long Island, the 17th of April, 1797, and his inclinations leading him to landscape drawing, he chose as a profession scene-painting; in which branch of art he was instructed by J. J. Holland. Mr.

Evers has exhibited several landscapes in oil, of decided merit. He is a member of the National Academy of Design. In private life he is justly esteemed as an honourable and amiable man, and in his profession as a skillful artist.

Samuel Scarlett, *c.* 1775–?.

William J. Coffee, *c.* 1774–*c.* 1846.

John Quidor, 1801–1881.

SAMUEL SCARLETT—COFFEE—QUIDOR—1817.

Mr. Samuel Scarlett, a landscape painter, was born in Staffordshire, and came to America at the age of thirty-five. He went to London at twenty years of age, to study painting with Mr. N. Fielding, called the English Denner, from the high finish of his pictures. From London Mr. Scarlett removed to Bath, where he remained until he emigrated to Philadelphia. In 1829 he was appointed curator to the Pennsylvania Academy of the Fine Arts, and has of late painted but little. Mr. Scarlett is one of those, who, if not the most encouraged as artists, do honour to their profession by their conduct as men.

Mr. Coffee is an Englishman, and a modeller in clay. He has executed many small busts in this way, with decided merit. I believe he now resides in Charleston, South Carolina.

Mr. Quidor was a pupil of John Wesley Jarvis. He had painted several fancy subjects with cleverness. His picture of Rip Van Winkle has merit of no ordinary kind. His principal employment in New-York, has been painting devices for fire-engines, and work of that description.

CHAPTER XXIII.

Mr. Morse educated at Yale College—Goes to England as a pupil of Allston's—Friendship of West—Success in London—Returns and paints in Boston—Visits Charleston with great success—His picture of the house of representatives at Washington—Practises in New-York—Establishes the National Academy of Design—Returns to Europe—Picture of the Louvre—Returns home—His theory of colour—Earle the traveller—Aaron H. Corwaine and M. Jouett—Joshua Shaw—Wm. G. Wall—E. F. Petticolas—D. Dickenson—D. C. Johnson—Henry Inman—his introduction to Jarvis—Practises with him at New Orleans—Marriage and great success in every branch of the art.

Samuel Finley Breese Morse, 1791–1872.

SAMUEL FINLEY BREEZE MORSE—1817.

THIS gentleman, the eldest son of the Rev. Jedediah Morse, D. D. the first American geographer, was born in Charlestown, Mass., April 29th, 1791. His maternal great grandfather, from whom he derived his first name, was the Rev. Dr. Samuel Finley, a former president of Princeton college. From

257 HUGH WILLIAMSON, 1816. Sculpture by William J. Coffee. *Courtesy The New-York Historical Society*.

258 THE RETURN OF RIP VAN WINKLE. Painting by John Quidor. *Courtesy National Gallery of Art, Washington, D.C., Andrew Mellon Collection.*

his mother came the name of Breeze. Mr. Morse received his education at Yale college under Dr. Dwight, and was graduated in 1810. Washington Allston, Esq. a little previous to this time had returned from Europe. Morse had from a very early age resolved on the profession of a painter, and his acquaintance with Mr. Allston confirmed him more strongly in his resolution. The father of Mr. Morse, finding the passion for painting incorrigable in his son, determined to indulge him in his wishes to take advantage of the means of studying in Europe; and Mr. Allston being about to sail for England, young Morse was put under his charge, and in August, 1811, he arrived in London. A few weeks only had elapsed when Mr. C. R. Leslie also arrived in London, from Philadelphia, to pursue his studies in the same profession. Similarly situated in so many respects, an ardent friendship was formed between the two young painters, which has continued unbroken to the present hour. They took rooms together at No. 8, Buckingham Place, Fitzroy square, a house which has become somewhat celebrated as the residence of a succession of American artists for some thirty years.*

Mr. Morse had letters to *West* and to *Copley*, (the latter then quite infirm and fast failing,) and received from both every encouragement, but especially from the former. An anecdote is related of West in relation to the first drawing shown by Morse, which is worthy of recording for the useful lesson which it teaches to students.

Morse, anxious to appear in the most favourable light before West, had occupied himself for two weeks in making a finished drawing from a small cast of the Farnese Hercules. Mr. West, after strict scrutiny for some minutes, and giving the young artist many commendations, handed it again to him, saying, " Very well, sir, very well, go on and finish it." " It *is* finished," replied Morse. " Oh no," said Mr. West, " look here, and here, and here," pointing to many unfinished places which had escaped the untutored eye of the young student. No sooner were they pointed out, however, than they were felt, and a week longer was devoted to a more careful finishing of the drawing, until, full of confidence, he again presented it to the critical eyes of West. Still more encouraging and flattering expressions were lavished upon the drawing, but on returning it the advice was again given, " Very well indeed, sir, go on and finish it." " Is it not finished ?" asked Morse, almost discouraged. " Not yet,"

* It is now occupied by *Cheney*, a promising engraver from Boston.

replied West, " see, you have not marked that muscle, nor the articulations of the finger joints." Determined not to be answered by the constant " go on and finish it" of Mr. West, Morse again diligently spent three or four days retouching and reviewing his drawing, resolved if possible to elicit from his severe critic an acknowledgment that it was at length finished. He was not, however, more successful than before; the drawing was acknowledged to be exceedingly good, " very clever indeed ;" but all its praises were closed by the repetition of the advice, " Well, sir, go on and finish it." " I cannot finish it," said Morse, almost in despair. " Well," answered West, "I have tried you long enough ; now, sir, you have learned more by this drawing than you would have accomplished in double the time by a dozen half-finished beginnings. It is not numerous drawings, but the *character of one*, which makes a thorough draughtsman. Finish one picture, sir, and you are a painter."*

The first portraits painted in London, both by Morse and Leslie, were portraits of each other, in fancy costume. Morse was painted by Leslie in a Scotch costume, with black plumed bonnet and tartan plaid, and Leslie by Morse in a Spanish cavalier's dress, a Vandyke ruff, black cloak, and slashed sleeves ; both these portraits are at the house of their ancient hostess, who retains mementos of the like character—some product of the pencil of each of her American inmates.

It was about the year 1812, that Allston commenced his celebrated picture of the " *Dead Man restored to Life by touching the bones of Elijah,*" which is now in the Pennsylvania Academy of Arts ; in the study of this picture he made a model in clay of the head of the dead man, to assist him in painting the expression. This was the practice of the most eminent old masters. Morse had begun a large picture to come out before the British public at the Royal Academy exhibition ; the subject was the dying Hercules, and in order to paint it with the more effect, he followed the example of Allston, and determined to model the figure in clay. It was his first attempt at modelling. His original intention was simply to complete such parts of the figure as were useful in the single

* When Mr. West was painting his " Christ Rejected," Morse calling on him, the old gentleman began a critical examination of his hands, and at length said, " Let me tie you with this cord, and take that place, while I paint in the hands of the Saviour." Morse of course complied—West finished his work, and releasing him, said, " You may say now, if you please, that you had a hand in this picture."

259 EMBARKATION FROM COMMUNIPAW. Painting by John Quidor. *Courtesy The Detroit Institute of Arts.*

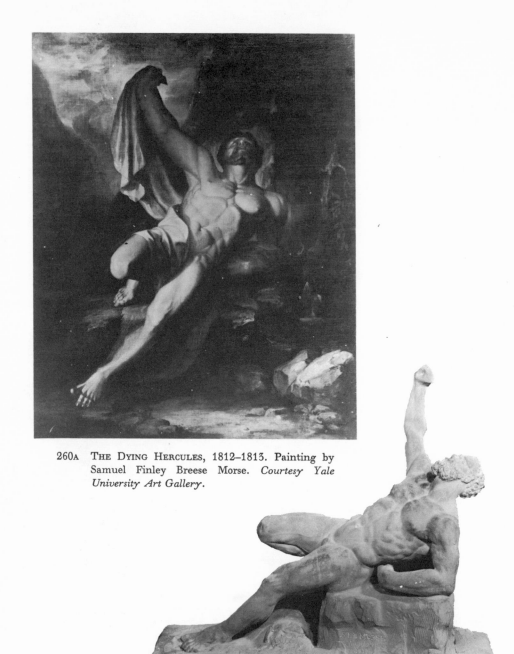

260A THE DYING HERCULES, 1812–1813. Painting by
Samuel Finley Breese Morse. *Courtesy Yale
University Art Gallery.*

260B THE DYING HERCULES, 1812. Sculpture by Samuel Finley Breese Morse.
Courtesy Yale University Art Gallery, gift of Rev. E. Goodrich Smith.

view necessary for the purpose of painting, but having done
this, he was encouraged, by the approbation of Allston and
other artists, to finish the entire figure. After completing it,
he had it cast in plaster of paris, and carried it to show to
West. West seemed more than pleased with it. After sur-
veying it all around critically, with many exclamations of sur-
prise, he sent his servant to call his son Raphael. As soon
as Raphael made his appearance, he pointed to the figure and
said, "Look there, sir, I have always told you any painter
can make a sculptor."

From this model Morse painted his picture of the dying
Hercules, of colossal size, and sent it, in May 1813, to the
Royal Academy exhibition at Somerset House. The picture
was well received. A critic of one of the journals of that day,
in speaking of the Royal Academy, thus notices Morse : "Of
the *academicians*, two or three have distinguished themselves
in a pre-eminent degree ; besides few have added much to
their fame, perhaps they have hardly sustained it ; but the
great feature in this exhibition is, that it presents several
works of very high merit by artists with whose performances,
and even with whose names we were hitherto unacquainted.
At the head of this class are Messrs. MONRO* and MORSE. The
prize of History may be contended for by *Mr. Northcote* and
Mr. Stothard. We should award it to the former. After these
gentlemen, Messrs. *Hilton, Turner, Lane, Monro,* and *Morse,*
follow in the same class." (London Globe, May 14th, 1813.)
In commemorating the "pre-eminent works of the exhibition,"
out of nearly two thousand pictures, this critic places the dy-
ing Hercules among the twelve first.

This success of his first picture was highly encouraging to
Morse, but it was not confined to the picture : upon showing
the plaster model to an artist of eminence, he was advised by
him to send it to the society of arts to take its chance for the
prize in sculpture, offered by that society for an *original cast
of a single figure*. Finding that the figure he had modelled
came within the rules of the society, he sent it to their rooms,
and was not a little astonished a few days after at receiving a
notice to appear on the 13th of May, in the great room at the
Adelphi, to receive in public the *gold medal*, which had been
adjudged to his model of the Hercules. On that day there

* This most promising young artist was the son of the celebrated physician
Dr. Munro, of London, famous for his treatment of insane patients. He died
but a few months after this notice of him.

were assembled the principal nobility of Britain, the foreign ambassadors, and distinguished strangers; among them but two Americans. The duke of Norfolk presided, and from his hands Morse received the gold medal, with many complimentary remarks. It is worthy of notice, that at this period Great Britain and the United States were at war.

We see in this another instance of the impartiality with which the English treated our artists. Allston and Leslie were treated in the same manner during this period of national hostility. Allston says England made no distinction between Americans and her own artists; yet Trumbull, as we have seen, attributes his failures at this time to the enmity of the English. We are glad to bear testimony to the good feeling of the enlightened public of Great Britain, which placed them above a mean jealousy or a barbaric warfare upon the arts.

Encouraged by this flattering reception of his first works in painting and in sculpture, the young artist redoubled his energies in his studies, and determined to contend for the highest premium in historical composition, offered by the royal academy the beginning of the year 1814. The subject was, " The Judgment of Jupiter in the case of Apollo, Marpessa, and Idas." The premium offered was *a gold medal and fifty guineas.* The decision was to take place in December of 1815. The composition, containing four figures, required much study; but by the exercise of great diligence, the picture was completed by the middle of July. Our young painter had now been in England four years, one year longer than the time allowed him by his parents, and he was obliged to return immediately home; but he had finished his picture under the conviction, strengthened by the opinion of West, that it would be allowed to remain and compete with those of the other candidates. To his regret, his petition to the council of the royal academy for this favour, handed in to them by *West,* and advocated strongly by him and Fuseli, was not granted; he was told that it was necessary, according to the rules of the academy, that the artist should be present to receive the premium—it could not be received by proxy. Fuseli expressed himself in very indignant terms at the narrowness of this decision. Thus disappointed, the artist had but one mode of consolation, he invited West to see his picture before he packed it up, at the same time requesting Mr. West to inform him, through Mr. Leslie, after the premiums should be adjudged in December, what chance he would have had, if he had remained. Mr. West, after sitting before the pic-

ture for a long time, promised to comply with the request, but added, " You had better remain, sir."*

Morse, however, was obliged to return, and in August 1815, he embarked for his native country. Early in the following year Mr. West, true to his promise, sent him word that from the moment he saw the picture he had not a doubt respecting its rank ; as president of the academy he could not prejudge the case at the time, but he regretted the necessity of Morse's return home, as the premium he said would certainly have been awarded to his picture had he remained in London till December. This picture was shown for sale in the artist's room, in Boston, for more than a year, but without a single inquiry from any one respecting the price. It was afterwards presented to the late John A. Allston, Esquire, of Georgetown, South Carolina, a gentleman who had employed the pencil of the artist in numerous and costly pictures.

Morse returned to his country flushed with high hopes of success in that department of painting in which he had gained laurels abroad. With the exception of two or three portraits, painted principally with a view to study the head, the whole time, a period of four years, was expended in the study of historical painting. He opened his rooms in Boston, and so far as social hospitality was concerned, his reception was most flattering ; all the attentions of polite society were lavished on him ; at dinner and evening parties he was a constant guest, and he was buoyed up with the hope that this attention would lead to professional orders, but he was disappointed. After remaining a year in that city without receiving a single order for an historical picture, or even an inquiry concerning the price of those already painted, his thoughts were for the first time seriously turned to consider the precarious prospects of a professed historical painter in the United States. His father had given him a liberal education, and had with limited means and other children to educate, supported him for four years in London, while acquiring the knowledge necessary for the highest branch of the art to which he had devoted himself; and finding no demand for his ability in that branch of the art, he determined that he would no longer call upon

* It is an interesting anecdote which I have from Mr. West's eldest son, that his father's mind was so vigorous during his last illness, (from which he expected to recover) that he contemplated painting another large picture on the scale of "Death on the pale Horse." The subject was "Christ looking at Peter after the apostle's denial." He was completing the sketch when taken ill. The subject is one of the finest, and justifies what I have said of West's judgment in selecting events suited to the high purposes of art.

his father for aid, but try what he could do in portraiture, although he had never made it his study. He prepared a few small pannels for painting on, packed up his painting materials and proceeded eastward, turning his back in sorrow and disappointment upon Boston. In New-Hampshire he found employment for small portraits at $15 each, and his hands so full, that in a few months he returned home with his pockets well lined. Two important events happened during this visit which affected his future life. He became acquainted with Miss Walker, and engaged to become her husband when fortune should be propitious; and he fell in with a southern gentleman who introduced himself, and gave Morse assurance of full employment at the south, at four times the price he was painting for in New-Hampshire. He immediately wrote to Dr. Finley, of Charleston, S. C., his uncle, for advice respecting a visit to that city, and received his warm invitation to come as his visiter and make a trial. Accordingly Mr. Morse proceeded to the hospitable city. Some weeks, however, passed on and no employer appeared. "This will not do, sir," he said to the Doctor, "I must ask you to permit me to paint your portrait as a remembrance, and I will go home again."

He painted Doctor Finley's portrait, which was seen by his friends, and before it was finished he had three engagements made. The names were put down on a sheet of paper, and he began to paint the portraits in rotation—more names were subscribed, more sheets of paper wanted, and his list in a few weeks amounted to 150 names, engaged at $60 each. His prospects were now bright, and he determined to work hard, and with money in his pocket and this list of subscribers, to return to New-Hampshire, marry, and return next winter to Charleston with a wife. Stimulated by such prospects, he did work hard, and for something more than three months, finished four portraits a week. He left Charleston with $3000 and engagements for a long time to come.

His marriage and return to Charleston took place of course, and he continued his visits every winter to Charleston until the close of the fourth.

This brings my memoir to the year 1819–20. At this period the rumour reached him of the great success of the Capuchin Chapel, as an exhibition picture, and his hopes of becoming an historical painter were revived by a plan he formed of painting an interior of the House of Representatives, at Washington, with portraits of the members. This, he thought, might be sent with an agent to various cities, and the

261 DEWITT CLINTON, 1826. Painting by Samuel Finley Breese Morse. *Courtesy The Metropolitan Museum of Art, Rogers Fund.*

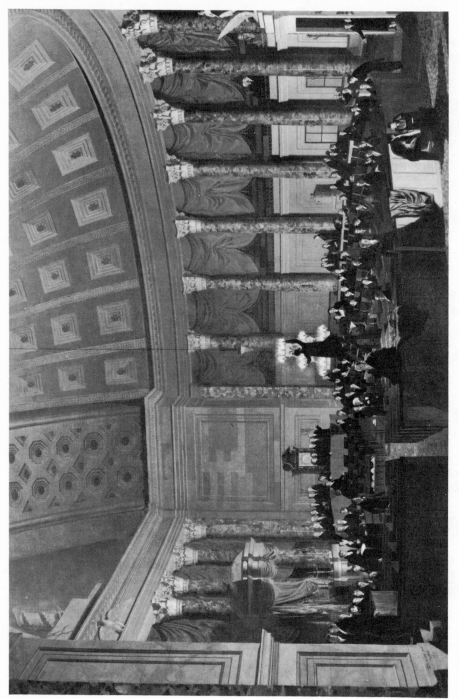

262 THE OLD HOUSE OF REPRESENTATIVES. Painting by Samuel Finley Breese Morse. *Courtesy The Corcoran Gallery of Art.*

revenue derived from its exhibition would enable him to employ himself in the branch of the art for which his studies in London had prepared him.

Having removed his family to New-Haven, he proceeded to Washington and made the necessary studies for this great subject. The picture he painted at home, and it cost him the labour of eighteen months. When finished, a most complicated work of beautiful architecture, with a multitude of figures, making a painting 8 feet by 9, it was exhibited to a loss of several hundred dollars, in addition to the cost of time lost in painting it.* Much of the little fortune accumulated by his labour in Charleston had been called for by a reverse in his father's situation, which he was not likely to spare his means in relieving. He was now again poor, and with a family to maintain.

At this period, 1822–3, he sought employment at New-York, and by the friendly aid of Mr. James Hilhouse, well known as a man of taste and a distinguished poet, he was introduced to the family of Isaac Lawrence, Esquire, where he found his works and talents justly appreciated, and his skill as an artist put in requisition. This led to an order from the corporation of New-York for a full-length portrait of General Lafayette, who being then at Washington, Morse went thither and painted the head of the venerable patriot, making the necessary drawings for the picture.

This was in the winter of 1824–5. I was at the time in Washington city, and embarking, in February, 1825, at Baltimore, on my return home, met Mr. Morse, likewise returning, and in deep affliction, having heard of the death of his wife. He had taken a house in New-York, and had the prospect, when he came to Washington, of returning to the enjoyment of domestic happiness as a man, and of prosperity as an artist.

His wife died at New Haven, and thither he proceeded, to his parents and his children. The full-length of La Fayette occupied his time for some months in New-York; but it was begun in misfortune and prosecuted in sorrow. A series of occurrences, all of the same funereal character, called him from his labours to his duties, as a son and a father, at New-Haven. One of his children lay at the point of death —his aged and venerable father, the first who taught us the geogra-

* This picture was rolled up and packed away for some years. Finally, a gentleman offered $1000 for it, which was accepted, and our House of Representatives in a body removed to Great Britain.

phy of our country, died—his beloved mother died—and he
felt himself a desolate being, with only the ties of parental af-
fection to hold him to this earth.

It was amidst these afflictions that his love for his art in-
duced him to form that association of artists for mutual im-
provement which resulted in the establishment of the only
academy for teaching the fine arts that has existed in America,
The National Academy of Design. A school for students,
with competent teachers, professors, and lecturers. A notice
of this institution, and the causes which led to its establish-
ment, will be found under the head of Academies.

Mr. Morse's exertions and success drew upon him the bitter
enmity and malignant vituperation of the dictator and leaders
of the nominal American Academy of the Fine Arts; and of
course, in consequence of sneers and misrepresentations, the
ill-will of the friends of these gentlemen. Morse being elected
president, and having been the original mover in the forma-
tion of the association for mutual improvement, had to bear
the greater share of the calumny which was propagated against
all the artists concerned in this establishment. He has borne
it, or repelled it, until, as is the course ordained, the shafts
have rebounded, and are fixed as thorns in the flesh of those
who aimed them at the reputation (the heart of hearts) of men
who were serving their country, by devoting their time and
talents to the progress of those arts which are the pride of
civilized society, and the source of all the elegant comforts of
domestic life.

Mr. Morse delivered a course of lectures on the fine arts,
before the New-York Athenæum, which was received by
crowded audiences with delight. This was the first course of
lectures on the subject read in America. These lectures were
repeated to the students and academicians of the National
Academy of Design.

In 1829 Mr. Morse found himself in circumstances to visit,
not only England again, but to reside, for a sufficient time in
Italy to study the works of art, copy many of the best pictures,
and to improve in every branch of painting, to a degree which
has surprised me as much as it has given me pleasure. On
his arrival from America, he found his friends, Newton and
Leslie, in London, and with them attended two lectures at the
Royal Academy, both remarkable for circumstances of very
different natures. Leslie introduced Morse to the academi-
cians, who received the president of the National Academy of
Design with peculiar honour. The first of these lectures was
remarkable, as being the last time Sir Thomas Lawrence was
out of his house. The second, for a compliment paid by the

lecturer to Washington Allston. Martin Archer Shee, the successor of Lawrence, was, on this occasion, requested to take the presidential chair: Morse, Leslie, and Newton, sat at his right hand. Mr. Greene, the lecturer, remarked, that he was glad Mr. Morse was present, as he had had occasion to mention an American gentleman who was an honour to the Royal Academy, Mr. Allston: and in the course of his lecture he quoted two of Allston's sonnets.

Returning homeward he made a stop in Paris, and pursued his studies in the Louvre. He there made a picture of that celebrated gallery, copying in miniature the most valuable paintings as hanging on the walls.* Of this splendid work my friend James Fennimore Cooper speaks thus, in a letter to me dated Paris, March 16th 1832: "Morse is painting an exhibition picture that I feel certain must take. He copies admirably, and this is a drawing of the Louvre, with copies of some fifty of its best pictures."

The picture of the gallery of the Louvre was not finished until Morse returned to New-York; but when nearly finished and removed from the gallery, the Chevalier Alexander Le Noir, conservateur of the Museum of France, (a celebrated antiquary, who is now engaged in arranging the papers on the ruins of Pelenque in Mexico, mentioned at page 11, vol. i, of this work,) wished to see the painting, and made an appointment for the purpose. He sat long before it, and complimented the artist highly, who received the praise as the effusion of politeness; but the next day he had a proof of the learned critic's good opinion, for he received from him two folios and a quarto, published by him, containing several hundred plates, descriptive of the ancient monuments of France and their history.

On leaving Paris he returned to London, and had the satisfaction of renewing former recollections and acquaintances, and particularly of enjoying the society of his friend Leslie. His good old friend and master, West, was no more, and his younger friend and instructer, Allston, was in America; but he had recollections of the latter brought to his mind very unexpectedly. Morse had brought a letter to a gentleman from Italy, whose direction was No. 11 Tinny-street, London. After an absence of sixteen or seventeen years, he had no

* This picture was finished in New-York, and exhibited in that city and in New-Haven. Every artist and connoisseur was charmed with it, but it was "caviare to the multitude." Those who had flocked to see the nudity of Adam and Eve, had no curiosity to see this beautiful and curious specimen of art. It has been purchased by George Clarke, Esq., of Otsego, and removed to Hyde Hall, on Otsego Lake.

remembrance of the street, or thought that it was connected with any transactions of interest to him. He sought the street, and on entering it he saw objects which appeared familiar to him; but which might only have reminded him of those dreamy sensations we experience throughout life, when entering a strange place we feel as if all the scene was merely a renewal of former impressions, made we know not how or when. He inquired for No. 11 of a gentleman passing, who exclaimed, " Surely I know you, sir." " My name is Morse." " And have you forgotten that house," pointing to it, " that is No. 11, my name is Collard, and there, with you and your friend Allston, and his friends Coleridge and Lonsdale, I have passed many happy hours in times past." The reality now flashed upon Morse—he entered the house, and found himself in the apartment where he had witnessed such poignant scenes of distress in former days—the chamber in which his dear friend and mentor's wife had expired, and where he had seen that friend deprived of reason in consequence of the sudden bereavement.

On the 16th of November, 1832, Mr. Morse arrived in New-York, and relieved me from the charge I had sustained as vice-president of the National Academy of Design, to the presidency of which institution he had been re-elected annually. I have mentioned his great improvement in his profession. I have a letter from Mr. Allston of late date, (1834,) in which he says to me, " I rejoice to hear your report of Morse's advance in his art. *I* know what *is in him*, perhaps, better than any one else. If he will only bring out all that is *there*, he will show powers that many now do not dream of."*

* Mr. Morse has told me that he formed a theory for the distribution of colours in a picture many years since, when standing before a picture of Paul Veronese, which has been confirmed by all his subsequent studies of the works of the great masters. This picture is now in the National Gallery, London. He saw in it that the *highest* light was cold; the *mass of light* warm; the *middle tint* cool; the *shadow* negative; and the *reflections* hot. He says he has tried this theory by placing a white ball in a box lined with white, and convinced himself that the system of Paul Veronese is the order of nature. Balls of orange or of blue so placed, give the same relative result. The high light of the ball is uniformly cold, in comparison with the local colour of the ball. "I have observed in a picture by Rubens that it had a *foxy* tone, and on examination I found that the shadow (which according to my theory ought to be negative,) was *hot*. Whenever I found this to be the case, I found the pictures foxy." On one occasion, his friend Allston said to him while standing before an unfinished painting, "I have painted that piece of drapery of every colour, and it will not harmonize with the rest of the picture." Morse found that the drapery belonged to the *mass* of light, and said "according to my theory it must be warm; paint it flesh colour." "What do you mean by your theory?" Morse explained as above. Allston immediately said, "It is so. It is in nature," and has since said, "Your theory has saved me many an hour's labour."

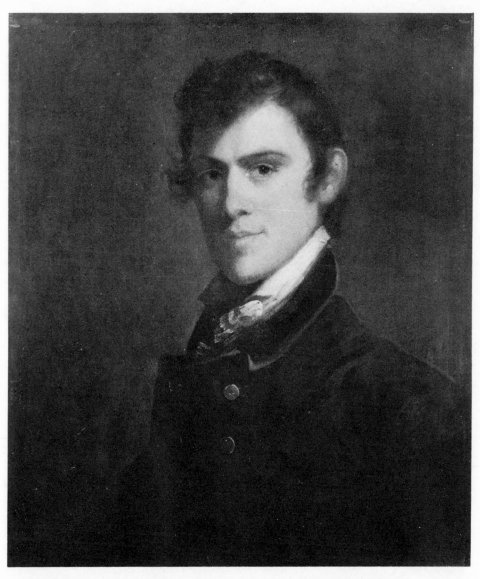

263 JOHN GRIMES, *c.* 1812. Painting by Matthew Harris Jouett. *Courtesy The Metropolitan Museum of Art, gift of Mrs. Sarah Bell Menefee.*

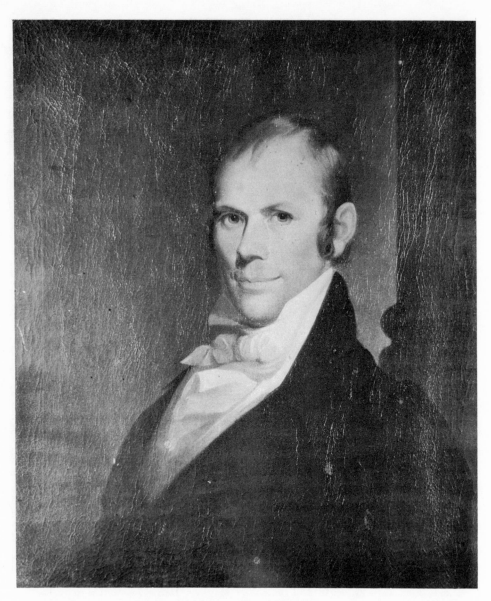

264 HENRY CLAY. Painting by Matthew Harris Jouett. *Courtesy Transylvania College.*

Mr. Morse has been appointed, by the university of New-York, professor of the literature of the fine arts.

MATTHEW JOUETT—1817.

Matthew Harris Jouett,
1787/88–1827.

My wish to gain accurate information of this gentleman and other painters of the west, induced me to write to the Hon. Henry Clay, as a known friend to the fine arts. He referred me to his son Henry Clay, jr. Esq., of Maplewood near Lexington, from whom I received a very friendly letter, of which the following is an extract: "Jouett, as you perhaps know, was a man of taste and possessed a vein of humour copious and rich, but unaffected and innocent in its tendency, which made him a charming companion, and which will perhaps greatly add to the interest of his biography. Of him I can send you a very accurate notice. Of Harding, the account will not be so full. He has removed from this state, but I can send you some particulars connected with his early career while a resident and painter in Kentucky. I will endeavour also to send you a similar account of West." This promise was made last January, and I have reminded Mr. Clay of it, but imperious circumstances, no doubt, have prevented the fulfillment. My correspondent John Neagle, Esq. of Philadelphia, says, "I saw Jouett in Lexington, Kentucky, in the year 1819. He was the best portrait painter west of the mountains. He studied with G. Stuart, and painted somewhat in his manner. I saw in his room a head of Henry Clay, much in general arrangement like Stuart. He was a tall, thin man. I know he admired Stuart much, and desired me by letter to send him a copy of my portrait of Mr. Stuart." From this circumstance, I judge that the death of Mr. Jouett did not take place until about the year 1826. J. R. Lambdin, Esq., writes to me thus of Jouett: "Matthew Jouett was born in Fayette county, Kentucky, and educated for the bar. He entered the army during the last war, and was one of those brave sons of Kentucky, who distinguished themselves on our western frontier. At the close of the war he practised painting for a short time as an amusement, but being dissatisfied with the life of a lawyer, determined on adopting the profession, and accordingly visited Boston in 1817, and was for several months, as is well known, a favourite pupil of Stuart's. No man ever made better use of the time than did Jouett. His pictures, though executed with an appearance of carelessness, possess much of the character of his master. He upheld the argument of Reynolds regarding vermilion and lake, and as he seldom varnished his pictures, the consequence is, that more than one fifth of them have so much faded in their car-

nations, as to be little more than a chalk-board. I have some of his portraits executed at the south, which would have done credit to Stuart in his best days. Having married early in life, he settled his family on a farm in the vicinity of Lexington, from whence during the winter, he migrated to the south, and practised successfully in New Orleans and at Natchez. His well stored mind—his astonishing powers of conversation and companionable disposition, caused his society to be constantly courted, and gave him an amount of employment never enjoyed by any other artist in the west. He died at Lexington, in 1826, shortly after his return from a visit to the south, in the forty-third year of his age." Of course this extraordinary man, gentleman and artist, was born in 1783.

Joshua Shaw, c. 1777–1860.

JOSHUA SHAW—1817.

A landscape-painter of eminence, was born in the memorable year 1776, in Bellingborough, Lincoln county, England. Left an orphan at a very early age, he had to pass through the hardships which genius so often encounters in its way to the level it ultimately attains. A farmer's boy—a mender of broken windows—a post-boy carrying the mail—apprentice to a country sign painter, and at the age of manhood, a sign-painter himself, and a married man in Manchester. Through these various stages young Shaw had practised drawing and latterly esel painting, with a view to casting off the mechanic and becoming an artist. With a strong constitution and stronger determination, he persevered in improving himself in flower-painting, still life, portraiture and landscape, and finally succeeded in attracting public attention, had orders for pictures and dropped the business of sign painting for ever.

The exact time of Mr. Shaw's coming to this country I do not know; but he had long contemplated America as the land of promise. I first met him in Norfolk, returning from a visit to South Carolina. He practised his profession in Philadelphia many years with deserved applause. Of late years he has turned his attention to mechanics, and invented improvements in gun-locks with eminent success. This pursuit has led him to Europe, and he has revisited his native country. I see by the public prints that he has obtained a premium from the emperor of Russia, for improvements in naval warfare. He is again in Philadelphia and actively engaged in establishing an exhibition of the works of living artists, preparatory to schools in which the arts of design may be taught. I remember a stag-hunt by Mr. Shaw with great pleasure, seen some years back.

265 SCENES FROM THE ROAD WEST. Drawings by Joshua Shaw. *Courtesy Chicago Museum of Science and Industry.*

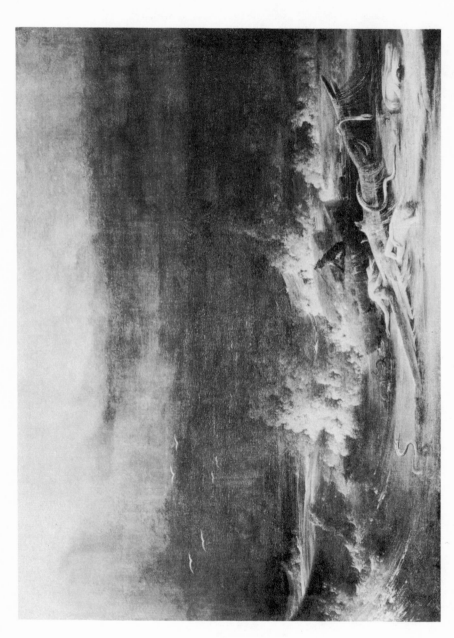

266 THE DELUGE, c. 1813. Painting by Joshua Shaw. *Courtesy The Metropolitan Museum of Art, gift of William Merritt Chase.*

EDWARD F. PETTICOLAS—1817.

Edward F. Peticolas, 1793–c. 1853.

Of this gentleman, my correspondent T. Sully says, " I think Petticolas must have been born in Philadelphia. His family settled in Richmond about 1805. I painted in miniature then, and gave some instruction to Petticolas; the father instructed my wife in music as an equivalent. Petticolas afterwards took to oil painting—visited England and France—returned and married a lady of Richmond, and again visited Europe and returned ; after a short residence in Richmond he visited Europe for the third time, and is now (1833) in Richmond."

In 1821, I visited Mr. Petticolas in Richmond, and saw the portraits he had in his painting room. His style was chaste, his colouring clear, and I felt that he deserved all the employment of that city. Mr. George Cooke however found employers in Richmond, and probably Petticolas was neglected. There was a modest manner in the artist, and rather a want of boldness in his work.

Sully in another letter, speaking of this gentleman, says, " he would have made an able and excellent portrait painter had he kept to London. He has knowledge, elementary, especially ; but is timid and cramped. Correct and gentlemanly in deportment; much beloved in Richmond, but is too fond of seclusion to get on." When Mr. Petticolas returned from his second visit to England in 1826, he told Mr. Sully that Mrs. Dunlop (herself a painter,) had been a sitter to Lawrence, and said that he made use of carefully finished studies made from his sitters, for painting from in their absence ; and these studies were the chief means of completing the portrait.

WILLIAM G. WALL—1818.

William Guy Wall, 1792–after 1864.

This gentleman was born in Dublin, 1792, and landed in New-York the first of September, 1818, where he commenced his career as an artist. The first views he made for publishing were scenery of the Hudson, and he has continued a successful application of his talents to landscapes in oil and water colours ever since. His pictures were a great attraction at the early exhibitions of the National Academy of Design in 1826-7 and 8. Mr. Wall has of late resided at Newport, Rhode Island, but has removed to New Haven, where he is pursuing his profession with great success. He has sold many of his late pictures at from three to four hundred dollars each. This gentleman has been indefatigable in studying American landscape, and his reputation stands deservedly high. A short time before the death of Thomas Jef-

ferson, he wrote to Mr. Wall, offering him in the most friendly manner, the situation of teacher of drawing and painting at his college of Charlotteville; but as it was not made a professorship, Mr. Wall declined. Mr. Wall's practice of late is to colour all his drawings from nature on the spot, " the only way," as he says, " to copy nature truly."

Augustus Earl, 1793–c. 1833.

AUGUSTUS EARLE—1818.

The reader will find in the first volume of this work a notice of Mr. Earle of Connecticut, at page 223; and at page 427, a Mr. Earle is mentioned who died at Charleston, and who I supposed was an Englishman, principally from the circumstance that Mr. Sully told me he had seen his widow in London, and communicated to her circumstances connected with his death. I have from recent information reason to believe that the person who died in Charleston, was the same mentioned in the previous page, as I now know that Earle of Connecticut married when studying in London, and left his wife and children there when he returned home; and that he was the father of Augustus Earle, known as the wandering artist. Augustus was the intimate friend and fellow-student of C. R. Leslie and S. F. B. Morse.

The latter gentleman has related to me some particulars of a ramble he took in company with Earle, when they both were students of the Royal Academy in 1813. With their sketchbooks and drawing apparatus, they visited the sea-shore and the towns adjacent, making pedestrian excursions into the country in search of scenery, and sometimes meeting an adventure. On one occasion, their aim after a days ramble was to reach Deal, and there put up for the night, but they found when about five miles from the town, that they had to cross a dreary moor, and the sun was about to withdraw his light from them. As they mounted a style they were met by a farmer, who accosted them with, "Gentlemen, are you going to cross the moor so late?" "Yes. We can't lose our way, can we?" "No. But you may lose your lives." "How so?" "Why there be always a power of shipping at Deal, and the sailors be sad chaps; they come ashore and rob and murder on the moor, without your leave or by your leave." " Has there any thing of the kind taken place lately?" " Why yes, a young woman was murdered not long ago by two sailors. You will see the spot on your way, *if you will go*: there is a pile of stones where she was killed. The fellows were taken, and I saw them hanged." " So, there is no danger from them, then." " About a mile further on, you will see bushes on your left hand—there a

267 HUDSON RIVER FROM WEST POINT, LOOKING TOWARD MOUNT TAURUS. Painting by William Guy Wall. *Courtesy Lyman Allyn Museum, gift of Mrs. Edward S. Harkness.*

268 BARCLAY'S IRON WORKS, SAUGERTIES, c. 1828. Watercolor by William Guy Wall. *Courtesy The New-York Historical Society.*

man was murdered not long ago—but the worst place is further on—you will come to a narrow lane with a high hedge on each side—it will be dark before you get there, and in that lane you will come to a style, and just beyond you will see a white stone set up, and on it is written all the circumstances of the murder of a young woman, a neighbour of mine, who was coming home from town all dressed in white, with a bundle in her hand tied in a dark red handkerchief—but, gentlemen, you had better turn back and stop the night at my house, and you shall be heartily welcome." They thanked him, but saying they were two, and a match for two, they full of confidence pursued their route. It soon became twilight. They found the heap of stones, and a slight shudder occurred when looking on the dreary scene, and the mark by which murder was designated. They passed on rather tired, and striving to keep up each other's courage until they came to the bushes. Here was another spot where foul murder had been committed. They quickened their pace as they found darkness increase, and now they came to the lane with the high hedge row on each side, which rendered their way almost a path of utter darkness. They became silent, and with no pleasant feelings expected to see the style, and if not too dark, the stone erected to commemorate the murder of the young girl in white, with the dark red handkerchief. "What's that?" said Earle stopping. "I see nothing," said Morse—"yes—now that I stoop down I see the style." "Don't you see something white beyond the style?" "That, I suppose is the white stone." "Stones do not move," said Earle. Morse stooped again, so as to bring the style against the sky as a background and whispered, "I see some one on the style—hush." A figure now approached, and as they stood aside to give ample room for it to pass, they perceived a tall female dressed in white, with a dark red bundle in her hand. On came the figure, and the lads gazed with a full recollection of the farmer's story of murder, and some feelings allied to awe. On she came, and without noticing them passed to go over the moor. "It will not do to let it go without speaking to it," thought Morse, and he called out, "Young woman! are you not afraid to pass over the moor so late?" "Oh no, sir," said the ghost, "I live hard by, and when I've done work, I am used to crossing the moor in the eve—good night," and on she tripped.

The young painters laughed at each other, and pursued their way without further thought of ghosts or murderers. They saw indeed the murder-marking monument, but it was

too dark to read the tale, and they soon found themselves in comfortable quarters after their long day's ramble, and forgot their fears and their fatigues together.

Eighteen years, or more after, Mr. Morse inquired of Leslie for their old companion Earle, and learned that he had been rambling far beyond Deal. " He had visited every part of the Mediterranean," said Leslie—" roamed in Africa—rambled in the United States—sketched in South America—attempted to go to the Cape of Good Hope in a worn out Margate hoy, and was shipwrecked on Tristan d'Acunha, where he passed six months with some old tars who hutted there—at length a vessel touched the desolate place and released him. He then visited Van Dieman's Land, New South Wales, and New Zealand, where he drew from the naked figure, and saw the finest forms in the world addicted to cannibalism. Returning to Sydney, he, by way of variety proceeded to the Caroline Islands—stopped at the Ladrones—looked in upon Manilla and finally settled himself at Madras, and made money as a portrait painter. Not content he went to Pondicherry, and there embarked for France, but stopped at the Mauritius, and after some few more calls at various places, found his way home. Here his sister had married a Mr. Murray, a relative of the Duke of Athol, and being left a widow, found a home as *chargé des affaires* for his grace, who you know is a harmless madman, thinks himself overwhelmed with business, and shuts himself up with books and papers, which he cannot understand, and then calls for his coach and rides out on some important errand, which forgotten, he returns again. Earle wrote and published his travels, and attracted some attention. One day he came to me with delight painted on his face,—' I am anchored for life—I have an offer of £200 a year, and every thing found me, only to reside under the roof of the Duke of Athol, and ride out with him when he takes it in his head to call his coach—I am settled at last!' I congratulated him—'You can write and draw at your leisure, and give us all your adventures.' ' Yes—nothing could be happier.' A few weeks after Earle came again.— ' Congratulate me, Leslie.' ' What has happened ?' ' I have been offered a berth in a ship bound to the South Pole! I have accepted it—it is just what I wish.' And he is now in his element again; for rove he must as long as he lives."

It may be asked, how is Augustus a subject for this work? Independent of being the son of a Yankee, he when in America exercised his profession in New-York, living in the house with Mr. Cummings, the father of the well known miniature painter. This was in 1818. Thomas S. Cummings, then a boy, was

encouraged in his attempts at art by Earle, and possesses many of his sketches which are replete with character. Mr. Cummings describes Earle as being at that time a fair complexioned, flaxen-haired young man. He is probably now as black as his favourites of the South Sea Islands.

AARON H. CORWAINE—1818.

Aaron H. Corwine, 1802–1830.

This unfortunate child of genius was born in Kentucky, and as my correspondent T. Sully, Esq. thinks, near Maysville. In 1818 he studied with Mr. Sully, who says, " His first attempts, when with me, evinced *remarkable* tact. He was, however, indolent, and this might in a measure have been caused by his infirm health." He had a painting room in Chesnut-street, Philadelphia, in the house of Mr. Earle, the frame-maker; and Sully says, " he might be seen at almost any hour lounging at Earle's shop door."

This shop of Earle's, it must be remarked, contained all the best engravings, and paintings were brought thither to be framed. Corwaine would stretch himself on the floor by a picture, and appear to devour it with his eyes. " His figure, manners, and kind mode of expression," continues Sully, " put me in mind of the mild and bland appearance of Leslie. He was gentle and full of kind sympathy and delicate taste—he was candid and guileless. After a short residence in Philadelphia he returned to the western country, I think Maysville. I heard of him from time to time, of his increasing industry and consequent improvement. Three or four years ago he wrote to ask my advice in visiting Europe for improvement, and according to what I said on the subject, he repaired to London. I have been often requested to advise in the like case, and have always recommended the English school as the best for portrait painting; but Corwaine is one of the *few* who have followed my counsel. Of all those who have studied on the continent, I have not found one whose style, as a portrait painter, has not been rendered unfit for the taste of this country.

" Corwaine left Philadelphia, when he embarked for London, in a bad state of health, but with some hope that the sea voyage would restore it, and an ardent desire to redeem lost time. Misfortune attended his steps from this time to the day of his death. The funds he had provided to defray his charges in London were all lost by the failure of the merchant in whose hands he had placed them shortly after his arrival: meanwhile his disease was aggravated by close application to his studies. He has since told me that the overstrained

effort to continue the work in hand, which engaged his attention, has caused him to faint.　He returned to Philadelphia pennyless, with a ruined constitution and depressed spirits, to die in the arms of his kind and faithful cousins, two maiden ladies, the Miss Cones, in whose house he resided until death relieved him from his pains at the early age of twenty-eight.

" The few studies and copies made by Corwaine when in London show what high ground he would eventually have taken, had life been continued."

Extracts from an Obituary Notice.

" Cincinnati, July 17th, 1830.

" Died,—In Philadelphia on the 4th instant, Mr. A. H. Corwaine, portrait painter, in the 28th year of his age.

" The subject of this notice was a native of Kentucky, and like many of the legitimate children of genius, he struggled in the commencement of life with every obstacle that want of family influence and of wealth could present.　In early youth he wandered to Maysville, and making himself master of the rudest materials of his art, he commenced his rough attempts at sketching portraits.　These, coarse as they were, were distinguished by that quality which marked his productions at a maturer period ; that of catching some powerful point of feature and expression, which gave peculiar force to his likenesses. On his coming to Cincinnati, some years ago, and while yet a boy, several gentlemen of this city, struck with his wonderful powers, induced him to place himself under the direction of Mr. Sully, and furnished him with the means of remaining in Philadelphia for two or three years.　On quitting Philadelphia he established himself in Cincinnati, where he remained in the prosecution of his art until the spring of 1829.

" Ardently devoted to his art, he resolved to connect his improvement in it with the pursuit of health.　With this view he selected England as the place of his European visit.　In London his health seemed at first to be improved, but in the beginning of the past winter, symptoms of returning disease became alarming, and he came to Philadelphia, where, after lingering some months, he bowed to the decrees of Providence, and was called to a better world, while yet in the morn of life."

Nathaniel Jocelyn, 1796–1881.

N. JOSCELYN—1818.

This gentleman, who, like A. B. Durand, is both engraver and painter, was born in New Haven, Connecticut, in the year 1796.　Mr. Joscelyn has passed through many scenes of life with honour, and is an independent man : but of the particu-

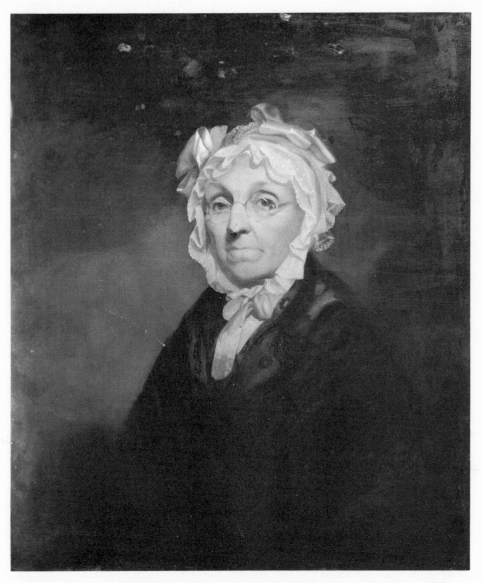

269 MEHITABEL CURTISS DE FOREST. Painting by Nathaniel Jocelyn. *Courtesy Yale University Art Gallery, gift of Mrs. P. J. Griffin.*

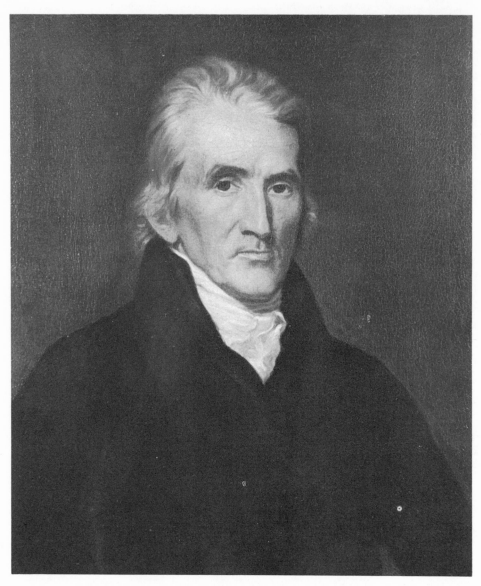

270 JAMES HILLHOUSE. Painting by Nathaniel Jocelyn after the painting by John Vanderlyn. *Courtesy Yale University Art Gallery*.

lars of those events or exertions which have led to his present
eligible situation in his native city, I am ignorant; although
I had been promised ample information on the subject, which
I was anxious to obtain, as I know that Mr. Joscelyn's con-
nexions with distinguished men, both at home and abroad,
and his talent for observation, would have made my memoir
of him interesting and instructive.

I know that, in 1815, he was a student of drawing and en-
graving; and engaged in the latter, as a profession, at Hart-
ford, in Connecticut, in 1818. Although he has studied and
practised oil painting, he has continued his professional exer-
tions as an engraver. In 1820 he professed himself a portrait
painter; and visiting Savannah, Georgia, he practised with
success and improvement.

Mr. Joscelyn was a member of the graphic company at Hart-
ford, whose principal business was bank-note engraving. The
bank-note system has been friendly to the arts of design, and
stimulated as well as employed very many artists.

In 1826, when the National Academy of Design opened
their first exhibition, at the corner of Reade-street and Broad-
way, Mr. Joscelyn exhibited several portraits of merit. In
1829, he visited London, as I believe, on business connected
with mechanical inventions : but whatever it was, he observed
with the eye of a shrewd and talented man, the works of art
around him. With the skillful and amiable Danforth, whose en-
graving from Leslie's Uncle Toby and the Widow has made
him universally known among his countrymen, Mr. Joscelyn
had always been in strict friendship; and when in London
they lived together, together enjoying the society of their cele-
brated countrymen, Leslie and Newton.

Mr. Joscelyn is established at New Haven; and has, in
1834, the most eligible suite of rooms for his painting and ex-
hibition of any artist I know of. I saw specimens of his head
portraiture in August, 1834, which placed him, in my opinion,
in the rank of our best portrait painters, though not foremost
of the rank.

Long married, this gentleman fulfils the duties of a good
citizen, and enjoys the esteem of all around him.

D. C. JOHNSTON—1819.

HIS ANSWER TO MY INQUIRIES.

David Claypoole Johnston,
1799–1865.

Sir—By particular desire I have placed myself, as Coleman
says, " bolt upright on my head's antipodes," to detail to you
the most remarkable incidents of my *interesting* life and ad-
ventures from infancy, up to the present time—and to convince
you that of all opiates, there is none so powerful—when ad-

ministered by so skillful a hand as myself—as a certain quantity of ink and paper.—To begin at the beginning, and preserve future ages from such uncertainty as at present exists, concerning the nativity of Homer—and other celebrated characters, I hereby declare, that in the drab-coloured city of brotherly-love I first saw the light of day, under what particular planet I am unable to say; but of this you may learn something, if you can lay your hand on an almanac for 1799, under the head of March.

Had my parents adopted for me a profession which my earliest propensities seemed to recommend, I might at this time have been " a rude and boisterous captain of the sea ;" for according to all authentic information, I neglected no opportunity to indulge in a hearty squall; by some, however, the propensity was attributed to an unusual development of the organ of tune, which, at the time was no doubt supposed to be a species of hand-organ, situated not far from *honour*, as set by Swift; for I seldom was allowed to complete more than half a dozen bars in a vocal solo, without a smart accompaniment by somebody, on this supposed organ. At the same time, my parents might have been suspected of having adopted this opinion ; but my opinion now is that that conduct was entirely devoid of phrenological prejudices ; it was necessary for my own happiness, that my particular propensity should be overcome, to effect which, it was deemed necessary whenever I chose to indulge in so selfish a gratification, as a squall, not to seek for bumps on my head, but to turn me bottom up, and apply a wholesome quantity of bumps to the opposite part of the anatomical structure. This capsizing system, though particularly disagreeable to a structure not copper-bottomed, had the desired effect; my penchant for squalls gradually subsided, and calms became more frequent, till at length I thought the latter decidedly preferable to the former, attended with the inevitable organ accompaniment.

My school-boy days were remarkable only for backwardness of study, and forwardness of petty mischief; in reading, between mouthing, mumbling, and skipping hard words, I got on indifferently well. In penmanship, judging from a few early specimens which occasionally meet my eye, I evinced more than ordinary taste, and generally managed to destroy the cold and monotonous appearance of the white paper, by passing my little-finger, or perhaps the cuff of my coat, over the undried ink, or by an accidental blot licked up with the tongue, thereby producing a pleasing effect, chiaro scuro, which the tasteless Domine was unable to appreciate ; insensible to the

harmony of light and shade, he universally denounced my best *effects* as vile, every page of my copybook he no doubt conceived to be a rivulet of pot-hooks and hangers, meandering through a meadow of smut; and as many pages as my book contained, so many thwacks did I receive on my palm, by way of improving my hand. In figures, (that is, caricature figures) I was more successful; these I usually exchanged with some of my fellow scholars, for a slate full of such figures as suited the preceptor, who not unfrequently approved of *my calculations*, without calculating himself, that they were received as a quid pro quo, for a wretched attempt at a likeness of himself or his assistant. Having completed my schooling, (with the exception of the last eighteen months, or two years) after the above fashion, a choice of profession became the next subject of consideration with my parents. My graphic efforts, though wretched in the extreme, had acquired for me a certain degree of reputation among my friends and relatives; and as I unquestionably was fond of *picture making*, it was decreed that I should become an artist. Painting at this time would have been my choice, but this branch not being so lucrative and generally useful as engraving, I was placed some time in 1815, under the tuition of Mr. Francis Kearny, a gentleman of established reputation, both as an engraver and draughtsman; in this situation I remained four years, during which time I acquitted myself to the satisfaction of my worthy tutor. At the termination of my pupilage, there was but little business doing in book and print publishing, which necessarily produced a general state of idleness among artists of the burin, particularly among the junior class, who, like myself, had just acquired the enviable distinction of *artist* of *my own book*. Under these circumstances, I added publisher to my newly acquired title, and occasionally put forth a caricature of dandies, militia trainings, etc. In these efforts I succeeded so far, that sundry well-known characters in each department were readily recognised, the prints met with ready sale, and I began to aspire to something above *dog-collars* and *door-plates*; the engraving of which constituted an important branch of my business.

In the plenitude of my vanity, I began to think that I had assuredly taken a certain " tide in the affairs of men," and was flowing on to fortune, at the rate of ten knots an hour; but dandies and exquisites held it not honest, to have their follies thus set down and exposed at the shop windows; and valiant militia colonels and majors, in overhanging epaulets, breathed nought but slaughter, blood, and thunder; my cus-

tomers, the print and booksellers, being threatened with libel suits one on hand, and extermination on the other, chose rather to avoid such difficulties, than to continue the sale of my productions.

This unexpected turn of tide rendered it necessary for me to look about for employment in some way, that would enable me to provide food and clothing, (for I could not consent to remain dependent on my parents,) and at the same time, allow me a portion of leisure to devote to my pencil. I was at this time fond of the theatre, and had acquired no inconsiderable reputation among my acquaintance, as a mimic not only of actors, but of many individuals in private life, and was reckoned good at a comic song, and altogether a nice man for a small party. These *wonderful accomplishments* induced me to try my fortune on the boards. The theatre was then open but four nights per week, and I calculated on having many hours per day for my more agreeable avocations. Without delay therefore, I made application to the manager, Mr. Wood ; who selected for me the part of Henry, in Speed the Plough, in which character I in a few days made my debut, as the saying is, before a splendid and *enraptured* audience.

The first appearance of a novice has been compared to the state of a person that has just been shot at and missed ; I know not what my appearance was, but judging from my feelings, I must have looked more like a person hit than missed ; the shot having carried away the words of my author, my head seemed pirouetting on its vertebra, the foot-lights danced like wills o' the wisp ; the audience appeared to be seated in an immense rocking-chair in full se-saw ; to my eye every thing was topsy turvy, and to my ear, every thing was buz. Fortunately this sensation was but of short duration, the plaudits of the good-natured audience were soon recognised by my tympanum, the lights ceased to dance, the rocking-chair became stationary, the lost words of my author returned, and Henry was himself again, and commenced walking *into the audience* without material deviation from the usual mode of representing the character. There might have been a few accidental new-readings, which at present I do not recollect, I but remember one point, though not a new one, was made *sharper* than usual, and proved to be a decided hit ; to explain which, it becomes necessary to inform you that in consequence of a primitive misunderstanding between my knees, they never failed to come to blows, as soon as my legs were put in motion ; I was, therefore, at a very early age sent to dancing school, as the most effective means to correct this joint animosity. The experiment was

not only attended with success, but resulted in so great a fondness for " tripping it on the light fantastic toe," that I soon became the most indefatigable *toe-shaker* or *artiste* (to use the more fashionable term,) of my age. This brings me to the *point* alluded to, which occurred in the dance with Miss Bland-ford; my terpsichorean powers would have excited the envy of the muse herself. Poor Robert Handy, who scarcely knew a pirouette from a double shuffle, was, "in amazement lost;" the electrified audience for a while kept their approving hands moving in time to my heels, until I commenced cutting three and four, and pigeonwinging backward and forward; this was " going the whole swine;" the audience were obliged to yield the *palm*, and I was acknowledged the most dancing Henry that had appeared for years. Instead of asking myself, like a silly fool, where could Henry have learned to dance? I merely asked, like a sensible actor, what can I do to get ap-plause?

A few evenings previous to my appearance, I witnessed the opera of the Devil's Bridge, and heard the *poor peasant* Florian introduce a song with considerable applause, be-ginning—

I have health, I have grounds,
I have wealth, I have hounds, &c.

Being acquainted with the representative of Florian, I took the liberty to hint to him, that according to my notion, his song was by no means suited to the part. " Not suited to the part!" he exclaimed, " what the devil have I to do with what suits the part? my object is to suit the audience, and if you expect to succeed in this profession, you must put such ridicu-lous notions out of your head, young man."

My second character was Master Slender, whether my per-formance of this part was an improvement on my first ap-pearance, I will not pretend to say. I but know that I felt much more at ease than in the sentimental Henry. My appearance as a young gentleman, was succeeded by an offer of an engagement from the manager, to fill the situation of what is technically called, the *walking gentleman*, in which capacity I remained during the first season.

The second season was commenced by an advance of salary and a slight addition of business ; that is, a minor comic cha-racter was now and then trusted to me, and occasionally, a second or third-rate *scoundrel;* so that by the time I began the third season, I was a sort of actor of all work.

I had run through an extensive range of characters from first and second robber, to the man of wax in Romeo and Ju-

liet—from the grave-digger to Laertes—from Sheepface to
Sir Benjamin Backbite—from African Sal and Dusty Bob to
the Duke of Venice. During my actorship I occasionally put
forth something in the *print way*, sometimes a political cari-
cature, and now and then a theatrical star ; so that between
my salary, my pencil and my graver, I lived rather comforta-
bly ; but as I never was positively stage-struck, I kept a sharp
look out for an opportunity to bid adieu to the shield and
truncheon ; to carotty wigs and poisoned goblets. To facili-
tate this object I engaged with the Boston managers for the
season of 1825. My motive for making this move was owing
to a more extensive sale of my graphic productions in that
city than in my native place. A short residence in Boston
convinced me that by applying myself to cut copper, I should
soon be enabled to cut the boards. I gradually became known
to the book-publishers, who being in want occasionally of de-
signs both for wood and copper, my humble abilities were in a
short time more than appreciated and so liberally rewarded,
that at the close of the season I thanked the ladies *Thalia* and
Melpomene, particularly the former, who to my taste is the
more agreeable of the two ; and in the language of a moving
shop-keeper, begged a continuance of former favours in my
new or rather old stand, which I still occupy, designing
prints for booksellers and publishers. Most of my time, how-
ever, is taken up in drawing on blocks for wood engravers. I
manage occasionally as opportunity offers, to execute a politi-
cal caricature, and steal time enough to make something for
the annual exhibition of the National Academy of New-York,
and ditto for the Boston Athenæum ; the few odds and ends of
time that remain I work up into *scraps*, which brings me to the
end of the year and to the end of my epistle, for which you
are no doubt very thankful.

 You are perhaps not a little surprised at the length of this
epistle, knowing as I do, that in your notice of me you can
come to Hecuba in half a dozen lines, but as I generally have
at this season of the year a week or two of leisure time, I thought
I could not do better than employ part of it in bestowing my
tediousness upon you and giving you the *whole life*, that you
may choose your lines where you please.

<div style="text-align:center">I remain Sir,

Your most obt. serv't.

D. C. JOHNSTON.</div>

To William Dunlap, Esq.

271 Cᴜᴘɪᴅ. Engraving by David Claypoole Johnston after his own drawing. *Courtesy Dover Archives.*

272 MRS. JOSEPH ANDREWS (Sally Salomon). Miniature attributed to Daniel Dickinson. *Courtesy Museum of the City of New York.*

DANIEL DICKINSON—1819.

Daniel Dickinson
(or Dickerson), 1795–?.

The good sense of the following letter in answer to my inquiries, induces me to publish it entire. Mr. Dickinson is in many respects a contrast to his brother Anson Dickinson, before mentioned ; though not a better artist.

" I was born in Litchfield, Connecticut, in 1795 ; was never under any master ; Nathaniel and Smith Joscelyn and myself, were brother tyros in the art at New-Haven, where we studied drawing all at the same time, principally from drawing and other books. I adopted a style between my brother Anson's, Malbone's and J. Wood's, fifteen years after my brother commenced ; being that number of years younger. Being led to miniature painting on ivory, I have employed my leisure time in fancy subjects, such as might best illustrate female beauty and grace. In 1830, I began to study oil painting, and have lately finished my first original in that style, and if successful shall pursue this branch, as it will afford a greater field particularly in works of fancy. The encouragement I receive enables me to remain in the same city in which I first commenced, Philadelphia, without ever painting in any other ; I have been stationary upwards of fourteen years ; the latter part of which time my yearly income is about sixteen hundred dollars."

CHAPTER XXIV.

Doctor Hosack saves the American Academy of Fine Arts from extinction—Its state—Progress of the National Academy of Design—Question of union and answer—Attempt at union at the request of the old academy—Committees—Agreement—Rejected by Mr. Trumbull—Report or project of the committees—Address of Mr. Trumbull—Examination of it—Present prosperous state of the National Academy—Schools for drawing from the antique—Modelling, and the school of ornament—List of donations to the National Academy—Alonzo Hartwell—Michael Pekemino—George Cooke.

ACADEMIES—1820.

I CANNOT admit into this work the paltry attacks made by the enemies of the National Academy of Design, when they found that artists could establish a real academy, governed by artists with artists for teachers, having an exhibition which supported their school and other expenses, and becoming properly appre-

ciated by the public. It is true that the exhibition annually
of the works of living artists destroyed the exhibition of the
old academy, called annual, but only *so* as open *all the year.*
It is true that the old institution sunk into insignificance and
contempt; but it was the natural consequence of that dictation
by which it was governed, which had told the patrons that artists
could not govern an academy, and were not to be entrusted with
its interests or its property.

The corporation of New-York at length gave notice to the old
academy that they must remove. Destruction seemed now to
stare the institution in the face; but Doctor Hosack saved
them by offering to appropriate ground and erect a build-
ing to receive the casts, and open exhibitions, for the ad-
vancements of the arts. He demanded merely interest for the
money. Mr. Trumbull gave an excellent plan; an architect
was employed, and the academy, as it is called, was erected in
Barclay-street. It was opened and an exhibition made. The
public went to see the building; and finding the same casts and
pictures which had been seen for years, they were satisfied and
went no more. The rent of the building and perhaps a sur-
plus is obtained by letting out the rooms to adventurers and
picture dealers; but for all the purposes of an academy, it
remains to this day dead. The directors, with Mr. Trum-
bull at their head, are an institution to let out rooms for the
exhibition of pictures or statuary.

There have been isolated portions of time when the statuary
has been opened to students, particularly soon after the estab-
lishment of the National Academy of Design; so far the lat-
ter institution has additional credit for opening to artists the
treasures originally intended for their use.

The National Academy of Design had been in successful
operation for years, with schools, gratuitous teaching, profes-
sors and lectures, and still the calumny that artists could not
govern an academy, and were prone more than any other men
to quarelling, first propagated under sanction of Mr. Trum-
bull's name as above stated, was repeated. Well meaning
friends of the arts, ignorant of the circumstances which led to
the formation of the National Academy of Design, and of the
benefits it is diffusing by its schools, not only among profes-
sors of the fine arts, but among professors of those arts which
contribute to the comforts, as well as elegancies of domestic
life, were led to believe that the artists were injuring the cause
most dear to them. Every academician has in turn been ac-
costed with " Why do you not join the old academy ?" And
as it is impossible to enter on a history of the fine arts, and

explain the nature of an academy for teaching them when thus
questioned in the street or the drawing-room, I have sometimes
briefly said, " Union with an institution composed of perhaps
two hundred men of all professions, governed by a majority,
must place a few artists in a minority, and of coarse we must put
ourselves and our flourishing academy under the direction of
men who are necessarily ignorant of the arts we profess and
wish to teach. These men have said we are unfit to govern
ourselves, or to be entrusted with their property ; property in-
tended for the use of artists. By an union we must place our-
selves under the direction of men who assume a tone of supe-
riority to professors of the fine arts. The poor slave is only
rescued from contempt by the knowledge that he is compelled
to be such. The slave by choice, must be the most contempti-
ble of all human beings. We are now *free :* we direct our
own work, and the time and manner of it, and we direct it,
like working bees in the hive of society to the general good of
the hive."

During these years of prosperity to the National Academy,
my friend Doctor Hosack, *but for whom* the old institution
would perhaps have been altogether extinct, had repeatedly
urged me to devise some plan by which the National Acade-
my and the friends of the arts should all be united. He had
repeatedly said with his characteristic liberality, that he wished
every thing to be directed by, and opened to the use of artists.
There appeared to be only the selfish ambition of one man in
the way.

On the return of S. F. B. Morse, Esq., the president of
the National Academy of Design, from a three years visit to
Europe, Doctor Hosack renewed his conversations on this
subject both with the writer and Mr. Morse, and by appoint-
ment the Doctor and the president had a meeting expressly
to discuss the subject. On this occasion, Dr. Hosack showed
himself particularly anxious that the artists should have the
benefit of the building he had erected, and the accumulated
property of the old institution. Some time after this meeting,
a notification was received from the directors of the old acade-
my, or American Academy of the Fine Arts, by the council
of the National Academy, saying that they had appointed
three gentlemen as a committee, to confer with three of the
council. Immediately, Messrs. Morse, Dunlap and Durand,
were appointed by the council, and met Messrs. Hosack, Ro-
gers and Glover, three directors of the old academy. Henry
F. Rogers, Esq., frankly said that he did not know what pro-
position was to be made, or how to open the business. Mr.

Dunlap suggested as a first step, to sink both academies and establish a new one, by a new title. This was a rash suggestion and happily did not take effect, though at the time it met with the approbation of all present. Mr. Rogers said that he now for the first time saw a probability of union. The committee of the National Academy said they would not agree to any other mode of government than that they had adopted, and found successful : a council of artists chosen by artists. The other gentlemen, particularly Messrs. Hosack and Rogers, avowed their wish to have no share in the direction of an Academy of Arts. Mr. Glover assented. A general plan of union was agreed on : the committee of the National Academy agreeing for the sake of very inadequate advantage, to encumber the institution (if their constituents consented,) with the stockholders and honorary members of the old institution. The committees adjourned to meet again. They did so ; the delegates from the American Academy being changed to Messrs. Hosack, Flandin and Herring. After several meetings, and after every point had apparently been settled, Messrs. Morse and Herring were appointed to draw up the *projet* of agreement. It was done and presented to the council of the National Academy and agreed to ; the ratification to depend upon a meeting of Academicians.

Messrs. Hosack, Flandin and Herring, were by agreement to call a meeting of the directors of their institution, and lay the report before them, and the two committees agreed to meet at Doctor Hosack's to know the result. Dr. Hosack and Mr. Flandin came directly from the meeting of the directors, and finding the committee of the National Academy in waiting, reported : not that the *projet* agreed upon had been laid before the directors—not that they had discussed and adopted or rejected it—but that Mr. Trumbull had taken a paper from his pocket, which he brought to the meeting and read, and that they all agreed to it and ordered it to be printed. How these gentlemen answer to themselves the presenting to any person the *projet* or report of their proceedings before the meeting took place, I cannot divine. Mr. Trumbull rejected the whole, and the whole was rejected. It had been repeatedly asked at the meetings of the committees, if in case there was an union, Mr. Trumbull would be elected president : and always answered that it must depend solely on the artists, none others by agreement being electors. It was known that he would not be elected, as it was known that the artists thought him incompetent or worse.

This abortive labour was reported to a meeting of the mem-

bers of the National Academy, and a resolution was unanimously adopted, that the agreement of the committees of the two institutions should be published together with Mr. Trumbull's rejection.

I print here the joint report of the committees; Mr. Trumbull's address prepared before the directory had seen or heard the report; and extracts from an examination of that address, by S. F. B. Morse.

"JOINT REPORT *of the Committees of Conference appointed by the American Academy of Fine Arts, and the National Academy of Design, to arrange the terms of a union of the two institutions.*

The artists and friends of the fine arts, at present embodied in the city of New-York, in the two academies, called the *American Academy of Fine Arts*, and the *National Academy of Design*, mutually impressed with a conviction, that the great object for which they have associated, viz. the *promotion of the fine arts*, can be better accomplished by a union of the means, for that purpose collected in each institution, have entered into negotiations through a committee, of conference, appointed by each of the academies, which committee, having given the whole subject a deliberate examination, beg leave respectfully to report to the stockholders of the American Academy of Fine Arts, and the academicians of the National Academy of Design, the result of their labours.

It was represented on the part of the *American Academy*, that this academy was possessed of property, (of indefinite value,) such as casts from the antique, pictures, prints, &c. highly useful to an academy, in the instruction of artists; that this property was held by stockholders, who had purchased shares, by the payment of twenty-five dollars each share. That the object of such purchase was not to obtain any dividend in money, but was intended for the encouragement of the arts, by furnishing means of study to artists particularly, and the public generally; and that for such payment they are entitled to certain privileges in the institution, viz. free admission for each of the stockholders and his immediate family, to the exhibitions of the academy; liberty to transfer his right by sale of his stock, to perpetuate it to his heirs, and to vote for directors and other officers of the academy at the annual elections. It was further represented that debts (to a certain amount) were contracted in the necessary operations of the academy, and that the means to pay these debts, and the current expenses of the institution, were, in the last resort, the sale of the property of the academy; or, ordinarily, the receipts of the exhibitions, and the rental of rooms, not immediately used by the academy.

It was represented on the part of the *National Academy of Design*, that this academy was also possessed of property, (of indefinite value,) of a nature similar to that possessed by the American academy, and intended for the same general and particular purposes; that the academic body consisted of artists exclusively, and that attached to the institution were a body of honorary members, having privileges of a nature, in some respects, similar to those of the stockholders of the American academy. They (the honorary members) have free admission, not only to the exhibitions and library, but also to the lectures; they are not responsible in any way, for the expenses, the debts, or management of the institution. It was further represented, that debts (to a certain amount) were contracted, in the necessary operations of the academy, and that the means to pay these debts, and the current expenses of the institution, were, in the last resort, the sale of the property of the academy; or, ordinarily, the receipts of the exhibition and the rental of rooms, not immediately used by the academy.

In the view of these two representations, it appeared to the united committee, that there were here two institutions, agreeing—

1st. In professing the same general object, viz. the promotion of the fine arts.

2d. In possessing property of similar character to promote this end.

3d. In having debts to a small amount, to be liquidated by the same means, and in depending, also, on similar means for replenishing the treasury.

It further appeared, that the differences to be accommodated, consist principally in reconciling the privilege of voting transferrable and inheritable—possessed by the stockholders of the American academy, with the exclusive right possessed by the academicians of the national academy, (they being all professional artists,) of electing their own members. This point was considered vital, and as presenting the most serious obstacle in the way of uniting the two academies. It was contended on the part of the American academy, that each stockholder possessed certain privileges of property to the amount of his share of stock ; that the privilege of voting was designed solely to secure to him the proper application of his property and no more. It was urged on the other hand, by the National Aacdemy, that such power operated more than was intended, by controlling the opinions and plans relating to the management of an institution designed for instruction in the arts, and which management, they, as artists, thought they might, without presumption, claim best to know, as being within the province of their own profession, and in which they felt the deepest interest. They urged, that the power to control by vote the elections into the body of artists, or the election of officers to manage the concerns of the academy, was a power inconsistent with the judicious management of an academy of arts, and unauthorized by any precedent in any known academy ; all such institutions in the world having artists exclusive in its academic body. They further contended, that to the exertions and professional labours of the artists, was naturally owing the principal interest of the exhibitions, and as these were the chief source of income, and as they were responsible for the debts of the academy they ought of right be uncontrolled in measures which they might deem best adapted to promote these ends.

It appeared, therefore, to the committee, after long and serious attention, that this point might be adjusted in the following way :

A new academy, to be called the New-York Academy of the Fine Arts, shall be formed, embodying the members of the two academies, viz. the American Academy of the Fine Arts, and the National Academy of Design, on the following general plan in reference to this point and others of minor importance :

There shall be four classes of membership, viz. academicians, associates, lay members, and honorary members.

The academicians of the American Academy of Fine Arts, and the academicians of the National Academy of Design being academicians of each body on the 8th of January 1833, and whose names are hereunto annexed, shall constitute the primitive body of academicians in the New-York Academy of Fine Arts.

The associates of the American Academy of Fine Arts, and the associates of the National Academy of Design, being associates of each body on the 8th of January 1833, and whose names are hereunto annexed, shall constitute the body of associates in the New-York Academy of Fine Arts.

The stockholders of the American Academy of Fine Arts shall constitute the body of lay members in the New-York Academy of Fine Arts.

The honorary members of the American Academy of Fine Arts, and the honorary members of the National Academy of Design, shall constitute the body of honorary members in the New-York Academy of Fine Arts.

The property of the American Academy of Fine Arts, and the property of the National Academy of Design, shall be the property of the New-York Academy of Fine Arts, subject to conditions hereinafter named.

For the debts of the American Academy of Fine Arts, and for the debts of the National Academy of Design, the New-York Academy shall become responsible.

The property of the American Academy of Fine Arts shall be held in trust by five trustees, representatives of the stockholders, or lay members, and chosen annually by them, in such manner as they may think proper. The property aforesaid shall be held liable for the debts of the American Academy of Fine Arts only.

The property of the National Academy of Design shall be held in trust by five trustees, chosen annually by the academicians, in such manner as they may

think proper. The property aforesaid shall be held liable for the debts of the National Academy of Design only. Said property, or any part thereof, shall, in no case, be sold or alienated by the New-York Academy, without the consent of the trustees of each property respectively; but in its use for the instruction and benefit of the institution, shall be under the sole management of the Academy.

Each member of the academy, viz. academicians, associate, lay member and honorary member, with his own immediate family, shall have access to all the exhibitions of the academy, to the lectures, to the schools, and to the library, free of expense during his life.

It appeared to the committees, that by the adoption of this plan by the two academies, and embodying these principles in the constitution of a new academy, the principal difficulties, if not all, that exist will be removed. There will be a mutual abandonment of the name of the two academies in adopting the name of New-York Academy of Fine Arts. The artists in both academies will be united on the same equal terms. The honorary members of each will also be on equal terms, and the present stockholders of the American Academy of Fine Arts, as lay members, will have the same security as at present, through their trustees, for the faithful application of their property, while for the use of said property they have the same real advantages that they now enjoy, with the additional prospect of seeing improved and larger exhibitions, annually increasing, under the management of a united body of artists.

[That the reader may have the whole subject on both sides before him, the Address of Col. Trumbull, which made the examination necessary, is appended.]

At a meeting of the Directors of the American Academy of the Fine Arts, held at their building in Barclay-street, on the 28th day of January, 1833, the following paper was read by the President, a copy ordered to be entered on the minutes, and 300 copies to be printed.

GENTLEMEN,

We have heard the Report of the Committee which was appointed to confer with the Committee of the National Academy of Design, on the subject of a proposed union of the two Academies; and you will permit me to leave the chair a few moments, for the purpose of offering my opinion upon the subject.

It appears to me that the Academy of Design require the abolition of the stockholders of this academy, as the basis of the negotiation, the *sine qua non*, on their part, of a union; you will permit me to state at large the reasons why I regard this basis as utterly inadmissible.

It has been proved by all experience, and, indeed, it is a truism, that the arts cannot flourish without patronage in some form; it is manifest that artists cannot interchangeably purchase the works of each other and prosper; they are necessarily dependent upon the protection of the rich and the great. In this country there is no sovereign who can establish and endow academies, as Louis XIV., did in Paris, and at Rome; or as the late George III., did in London; and, in case of want of success in their early efforts, to aid them, as the latter monarch did aid the Royal Academy of London, by a gift from the privy purse, to the amount of £5000, or $25,000.

The governments, that is, the legislative assemblies of our nation, or of the separate states, cannot be looked up to by the arts, with any hope of protection like this; the church offers us as little hope as the state; and the fine arts, those arts which polish and adorn society, are, in this country, thrown for protection and support upon the bounty of individuals, and the liberality of the public.

The foundation of this institution was laid by a few individuals, not artists; at the head of whom stood the late Chancellor Robert R. Livingston, and his brother, Edward Livingston, now Secretary of State of the United States; these gentlemen raised a subscription, in shares of $50, which amounted to nearly $3000, and this sum, under the direction of the same Robert R. Livingston, when minister of the United States at the court of France, purchased the fine collection of casts from the antique statues, &c., which constitute the pride

of this institution. And the influence of the same Robert R. Livingston, obtained from Napoleon Buonaparte a gift of the magnificent collection of engravings and works on the arts, which will be the boast of your future library. Thus, these gentlemen, the original subscribers, became holders of a joint stock, composed of $50 shares. And the distinguished individual, Robert R. Livingston, who was the author of the plan—our first president—and, in the fullest sense, the founder of this academy, was not an artist; he was nothing more than a *stockholder.*

Again, gentlemen, John R. Murray and Charles Wilkes, Esq., to whom, next after Chancellor Livingston, we are indebted for our existence through the struggles of a feeble infancy, were not artists; but merely *stockholders.*

Again, gentlemen, when, in the year 1815 or 16, the bounty of the corporation offered to us the shelter of a roof, and money was wanted to new model the interior of the alms-house, and to convert the small rooms which had been built for the convenience and comfort of the poor, into large and lofty apartments suited to the purposes of the arts, have we forgotten how that money was obtained? Did not a gentleman, now present with us as a director, borrow the sum required, from a bank in this city, upon his own private note? And was that gentleman an artist? No. Dr. Hosack was but a *stockholder.*

Again, when, by a contract with the gentleman last named, this building was furnished and prepared for use, have we forgotten that a distinguished artist, now one of our academicians, hired our room for the exhibition of a splendid and pathetic picture, at a handsome rent for three months? Have we forgotten that, by some strange fatality, that fine picture failed to obtain popular approbation? Do we not know that, under these circumstances, it would have been ruinous to the artist to be compelled to pay $300, and very discouraging to the academy to lose it? And have we forgotten that an end was put to this embarrassment, and both parties relieved by the munificent interposition of a gentlemen here present; a director, but not an artist? No, he is but a *stockholder.*

Again, gentlemen, how did we obtain the glorious portrait of Mr. West, the master-piece of Sir Thomas Lawrence? Was it purchased by our own funds? No. Twenty gentlemen gave the necessary sum by subscription, in shares of $100 each. And were these subscribers artists? No; with the exception of a very few, they too, were *stockholders.*

And, recently, gentlemen, have we not received an unrivalled present from John Jacob Astor, Esq., in two marble busts of the late emperor and empress of the French, executed by command of the emperor, by the late celebrated Canova, in his finest manner? And is Mr. Astor an artist? No; he too, is only a *stockholder.*

With such an enumeration of munificent acts of stockholders before us, can there be one among us who can be persuaded to consent to the monstrous act of ingratitude proposed, of violating, or attempting to violate the right of suffrage and of property which, by our charter, are vested in those gentlemen? I trust, there is not one who can deliberately consent to it.

At least, gentlemen, I, whose name stands in your first charter, granted in 1808, as one of the original grantees, and first vice-president of the institution, and who have had the honour during many successive years to be elected your president, feel myself bound by the most imperious duty to guard vigilantly your interests and your honour. And I do here most deliberately and most solemnly repeat what I have before said informally : that never, while I live and have my reason, will I, a stockholder, consent to such a violation of their rights, and of our own duties, as is proposed ; and no motive, not even the union of the two academies, will ever weigh with me to change this solemn resolution.

Gentlemen, I beg leave to call to your recollection that, on the 16th of February, 1830, I asked the attention of this board to the draught of two by-laws, which I then offered, and which, after lying upon your table for consideration, an unusual length of time, were, on the 4th of March, 1831, called up on the motion of Dr. Hosack, seconded by Mr. Robertson, and unanimously adopted. They are entered on the 24th page of your book of minutes, from which, with your permission, I will read them.

These ordinances were proposed by me for the purpose of removing those objections, which, so far as I could understand them, had induced artists to withdraw themselves from this, and to form a new academy ; by the first, artists are no longer required to pay twenty-five dollars, in order to become stockholders and members with us ; the exhibition of a work of art in our rooms, approved of course by us, as being entitled by its merits to be exhibited, admits every one who may wish it, to a free participation with us in all our rights as stockholders. And by the second, which requires that at all future times, a majority of the directors shall be artists by profession, in the actual exercise " of their several pursuits, whether of painting, sculpture, architecture, or engraving," it was intended to guard the interests of the arts, in the most effectual manner, without violating the rights of the stockholders.

It appears to me, that by these two ordinances, the doors of this institution are thrown open for the admission of all who choose to enter. While the preliminary demand of the National Academy of Design requires nothing less than the unconditional surrender of all the chartered rights of all the parties in this institution.

If, then, the proposed union cannot be effected upon some other basis, I presume the negotiation is at an end ; and the two academies must remain as they are, separate and rival institutions.

And, however this may be lamented, we of the American Academy of the fine arts, have the satisfaction of knowing that the separation did not originate with us. We did not secede ; we were seceded from. And I confess that, at the time, I felt most severely, not only the act, but the manner of the secession ; but time and reflection have dissipated entirely those gloomy anticipations of ruin which I felt at first. We have survived the first fury of the tempest, and I am confident that we shall safely ride out the gale.

The separation took place in 1825, and was soon followed by an apprehension that the corporation was about to withdraw from us their protection, and to leave us without a roof under which to shelter our heads ; and soon this fear was realized—and we received *formal notice to quit.*

Thank God, we did not sink under this accumulation of evils : on the contrary, our energy was roused to greater exertions ; and now we find ourselves, still, by the favour of a *stockholder*, under an excellent roof, at a moderate rent, with fine apartments, a respectable property, and few debts. And what I regard as the surest, happiest omen of future prosperity, the members who left us are already replaced by young men of eminent talents and unwearied industry. While others are rapidly coming forward, like the young leaves of spring, to replace with renovated beauty and vigour, what may have been desolated by the tempests of winter.

Gentlemen, let us not forget that since the separation in 1825, this city is immensely increased in numbers and in opulence. When I see entire streets of new and magnificent houses, which have been built in the upper part of the city since that period, I almost imagine myself to be carried back to Paris or to London. All these houses are elegantly furnished, and inhabited by families who manifestly must have some taste for the arts. There was a time when I felt a wish that we had not two hundred stockholders, who, with their families are free to visit our exhibitions : I did consider this as an unfortunate deduction from our probable receipts ; but now my fears on that head have vanished ; for what are two hundred to the multitude of opulent families who may, and will, and do, visit the various exhibitions. It does now appear to me that there is a fair prospect in future of ample patronage for both academies, and that we have only to persist in an honourable and amicable emulation : the very spirit of fair emulation will probably elevate the arts to a higher degree of excellence than could reasonably be expected if either of the academies stood alone, possessing a monopoly of the rewards and honours of our pursuits.

Gentlemen, there can be no doubt, but that the united efforts of the artists of both academies, would form one splendid exhibition : and as the payment of one rent is easier than of two, no one can doubt, that a union of all the artists on proper terms, would be advantageous to all. But, gentlemen, even gold may be pur-

chased at too high a price; and it does appear to me, that the price demanded by the National Academy of Design, as the condition of union, is altogether extravagant, and utterly inadmissible.

May I beg, gentlemen, that this paper may be copied into your minutes.

<div style="text-align: right">JOHN TRUMBULL.</div>

January, 28, 1833.

The committee from the National Academy reported that the council had unanimously accepted it. The committee from the American Academy reported that "Colonel Trumbull left the chair, and made an address against accepting it; and that after the address, the majority seemed so manifestly opposed to the report, that it was deemed unnecessary to put it to vote, and it was ordered to be placed on file. Colonell Trumbull's address was ordered to be entered on the minutes and three hundred copies to be printed!" The address is accordingly published, and it contains sentiments so disparaging to the arts, and representations to the recent negotiations, and of the origin of the National Academy, so erroneous and so injurious, that we cannot, in justice to ourselves and our profession, permit it to pass without examination.

The first pages of the address are principally occupied in enumerating various munificent acts of the stockholders of the American Academy. There can be no difference of opinion on the character of acts like these. I therefore, need not dwell on this part, further than to ask, for what purpose is all this parade of names and rich gifts? Is it to inform us that the stockholders of the American Academy are liberal? Who denies it? Surely not the National Academy. We have uniformly, in public and private, done ample justice to the generosity and good intentions of the founders of the American Academy. How is this "enumeration of munificent acts" made to bear against the report? Colonel Trumbull says, "with such an enumeration of munificent acts of stockholders before us, can there be one among us who can be persuaded to consent to the monstrous act of ingratitude proposed, of violating, or attempting to violate the rights of suffrage and of property, which, by our charter, are vested in those gentlemen? I trust there is not one who can deliberately consent to it. At least gentlemen, I, whose name stands in your first charter, granted in 1808, as one of the original grantees, and first vice-president of the institution, and who have had the honour, during many years to be elected your president, feel myself bound by the most imperious duty to guard vigilantly your interests and your honour. And I do here most deliberately and most solemnly repeat, what I have before said informally, that never, while I live and have my reason, will I, a stockholder, consent to such a violation of their rights, and of our own duties, as is proposed; and no motive, not even the union of the two academies, will ever weigh with me to change this solemn resolution." And what is this monstrous act of ingratitude which has been proposed, and has caused all this vehemence of protestation? Examine the report, is there in it any proposition for "violating or attempting to violate the rights of suffrage and of property" of any individual? That instrument contains the terms on which there is to be a mutual surrender of rights, for a great and important object to both parties. Cannot one propose to another an equivalent for his property without being liable to a charge of "attempting to violate his rights!" Have we asked on our part for a surrender of any property or privilege without offering an equivalent, ay, more than an equivalent? Let us look at this point.

What gives the right to vote in the American Academy? Is it not a share of stock? And is not the value calculable in dollars and cents? The price of a share is twenty-five dollars. Each stockholder's vote then is worth twenty-five dollars. The interest of twenty-five dollars is one dollar and fifty cents per annum, which sum would anually purchase three season tickets for the annual exhibition in the proposed new academy. Each stockholder's family will contain on an average five persons; consequently, merely by free admission to the annual exhibition, he would receive nearly double the interest of his money; and when in addition we offer free attendance upon all the lectures, the schools and the library, for which others must pay annually at least twelve dollars, do we offer nothing for a twenty-five dollar share? *Fifty* per cent., one would think, is

good interest. But this is not all. We make ourselves reponsible for the debts of the American Academy. We free the stockholders from this burden, and take it upon ourselves to pay them from our own labours, from the profits of our own exhibitions; (our own property being liable for our debts in the last resort and the property of the American Academy for their debts in the last resort;) further, we ask only for the *use* of their property. We propose a board of trustees who are to hold the property of the American Academy, and without whose consent that property can never be alienated; and these trustees are to be elected annually, not by the artists, but by the present stockholders. A strange "violation of property" truly, when it is left so under the control of its owners that it cannot be alienated without their consent. Yet, says Colonel Trumbull, we have a "violation of the rights of suffrage and of property" of the academy. Have we offered no equivalent for a twenty-five dollar share?

The National Academy agree to grant to the body of academicians, one of "the parties" of the American Academy, the same privileges with their own academicians; they agree to grant to the body of associates, another of "the parties" of the American Academy, the same privileges with their own associates; they agree to grant to the honorary members, the only remaining "party" of the American Academy, the same privileges with their honorary members. With all this in the report lying before him, the author of the address has the boldness to say, "the preliminary demand of the National Academy of Design, requires nothing less than the UNCONDITIONAL surrender of all the chartered rights of ALL THE PARTIES in this institution."

Let it be remembered, that it was only on the ground that the American Academy desired to make such a change in its constitution *as would give the control to artists*, that the National Academy consented to any negotiation whatever. The language of all the stockholders, with whom some of the members of the National Academy conversed previous to the negotiations, was, "it is the desire of the great mass of the stockholders *to give up the institution into the hands of the artists*;" these were the very words, often repeated, in and out of the committee. The answer was, "well, gentlemen, if this be the disposition, then all can easily be arranged; we have only to settle the manner and the terms." The result of the arrangement is in the report, which speaks for itself.

As the National Academy did not seek this negotiation, so they are not dissatisfied at its termination. They regret, however, that occasion has been taken from it to fill the public ear with renewed disparaging representations of themselves and their profession. The author of the address goes out of his way, (for it belongs to no part of his argument against the report,) to revive some hard names, with which, in the early stages of the existence of the National Academy, it was attempted to make us obnoxious. He says, "we of the American Academy of Fine Arts, have the satisfaction of knowing that the *separation* did not originate with us. We did not *secede*, we were *seceded* from, &c." Here, and in several other parts of the same page, are the epithets reiterated of *secession* and *separation*. The impression left upon the public mind is, that we were formerly artists of the American Academy, and that, having deserted that institution, we had set up another in *opposition*. It is time the public should be undeceived, if it be deceived on this point. The gentlemen who formed the National Academy of Design, were a class of *thirty* independent artists, who, having the interests of their own profession to consult, combined together, eight years ago, for mutual benefit, in a society called the *Drawing Association*, which afterwards resolved itself into the National Academy. They were not *united* and *never had been united* to the American Academy, neither were they *opposed* to it. But were not those that formed the National Academy, stockholders in the American Academy? No, *four* only out of the *thirty* artists were stockholders in the American Academy; where then is the ground for the epithets, *secession, separation,* &c.? It is true the artists established an academy, but not by *secession*, as I have shown, nor in *opposition*, as I shall show, before I close.

On the first page of the address appears the following paragraph: "It has been proved by all experience, and, indeed, it is a truism, that the *arts* cannot flourish, without patronage in some form; it is manifest, that *artists* cannot interchangeably purchase the works of each other and prosper; they are necessa-

rily dependent upon the protection of the rich and the great. In this country there is no sovereign who can establish and endow academies, &c."

Let us see how this paragraph will read by substituting *literature* for the *arts ;* for it is as applicable to the one as the other. It is a truism, that *literature* cannot flourish without patronage in some form ; it is manifest, that *authors* cannot interchangeably purchase the works of each other and prosper ; they are necessarily dependent on the protection of the rich and the great, &c. All this is as true of *authors* as of *artists :* now let me ask of any author, what kind of *patronage* he seeks from the *rich* and the *great ?* What sort of *dependence* he has on them for *protection* in this country, since there is no *sovereign* to whom he can look for *protection,* no aristocracy on which he can depend for *patronage ?* Is there a man of independent feelings, of whatever profession he may be, who does not feel disgust at language like this ? And is it to be supposed that the artists of the country are so behind the sentiments of their countrymen, as not to spurn any *patronage* or *protection* that takes such a shape as this ?—The artist, poor, helpless thing, must learn to *boo* and *boo* in the halls and antechambers of my lord, implore his lordship's protection, advertise himself painter to his majesty or his royal highness, boast over his fellows, because he has his grace for a patron, and think himself well off if he may be permitted* to come in at the back-door of his patron's gallery.

If there are any who desire to have such a patronizing institution as this—if there are artists who desire to be thus *protected* and thus *dependent,* it is a free country, and there is room for all ; every man to his taste ;—but the artists of the National Academy have some sense of character to be deadened, some pride of profession to be humbled, some aspirings after excellence in art to be brought down, some of the independent spirit of their country to lose, before they can be bent to the purposes of such an anti-republican institution. In making these remarks on the language and sentiments of the address, I disclaim identifying them with those of the stockholders of the American Academy. I knew not that there are any who have imbibed such degrading notions of the arts, or such contemptuous opinions of artists; if there are, we wish them to rally round just such a tree as the sentiments of the address would nurture. We believe that our climate is uncongenial to the growth of such an aristocratic plant ; and that the public will not be long in deciding whether such an institution, or the National Academy, is most in harmony with the independent character of the country.

I come now to speak of the *fundamental cause* of the collisions between the two academies ; collisions which, it is to be feared, will often recur, until this *cause* shall be removed. It lies in the *name* of *Academy of Arts,* given at its formation to the American Academy of Fine Arts. It was not an Academy of Arts, and could not be, for it wanted the *essential quality* of an Academy of Arts, viz., *a body of artists to control its concerns ;* and no provision is made in its constitution, to give it into the hands of artists at a future period. Every Academy of Arts in the world is exclusively under the control of artists, who elect into their own body, choose their own officers, and manage the entire concerns of the academy ; subject only, in aristocratic and despotic countries, to the approval or disapproval of the king or emperor, and even in England the monarch, the *patron,* has yielded to the will of the artist.†

* "All artists *shall be permitted* to exhibit their works. Amateurs *shall be invitde* to expose their performances."

[*Laws of the American Academy of Fine Arts*

† An anecdote of an occurrence, not long ago, in the Royal Academy of London, will well illustrate the kind of control in that monarchical country, which the king exercises over the artists. Sir Thomas Lawrence's death occasioned the vacancy of the presidential chair of the Royal Academy.—The king, (George IV.,) desirous of seeing the celebrated Wilkie elevated to the vacant seat, hinted his wishes, in a tone a little too dictatorial to the academicians. The academicians, feeling that their independence was attacked, and although Wilkie was a deserved favourite with them all, and but for the officiousness of the king would have been their choice, immediately elected Sir M. A. Shee their president, who still fills the chair with honour to himself and to the academy. So strong was public opinion in favour of this of act of independence, that the king ratified their choice.

I have thought it my duty to place before the public these transactions and documents; indeed in this work it was unavoidable. Let the general reader pass over the chapters on academies, but let the lover of the arts peruse them carefully, and he will never again ask the question, " Why does not the two institutions unite?" or listen to assertions, that the artists who form and govern the National Academy of Design are " *disorganizers*," or "*seceders*," from an academy of which they were members, or dissatisfied persons who desired to possess property belonging to others.

The National Academy of Design is rich in beautiful casts from the antique, and splendid models for the student of ornament in architecture and the mechanic arts. The school is opened three evenings in the week, the teachers being artists of the first class, and the teaching gratuitous. Never having had any encouragement from government, either of the United States, the state of New-York, or the city of New-York, the institution has incurred a debt in establishing its schools for the public benefit, otherwise students would not incur any expense. They now pay for light and fire. There are three distinct schools now open : one for drawing from the antique, one for modelling, and one for the study of ornament, or the ornamental school.*

List of donations from friends of the arts to the National Academy of Design, New-York.

A bust, being his first attempt in sculpture—presented by J. S. Cogdell, Esq.
Two pictures, one " Presenting flowers to the Pope," the other a battle piece—presented by Louis Mark, Esq., consul at Bavaria.
A cast of Milo—presented by Mr. Dixey.
A cast of a dog from the antique—presented by Michael Paff, Esq.
A number of casts of various descriptions—presented by Messrs. Archibald and Alexander Robertson.
Statue of Mercury and a bronze Midas—presented by Cav. Alberto Thorwaldsen.
Venus of Thorwaldsen, and Venus and Cupid by Gibson—presented by Daniel Coit, Esq.
Statue of Venus entering the bath—presented by Richard Wyatt, Esq.
Cupid and bust of Columbus—presented by Signore Trentenova.
Farnese Hercules, a splendid colossal cast, being the only one on this side of the Atlantic—presented by G. W. Lee, Esq.
Augustus (bust,) Torso, and Antinoüs, of the Braschi palace (colossal)—presented by Mendes J. Cohen, Esq.
A number of Bronze medals—presented by Signore Girometti.

* I am informed that the artists of Philadelphia have organized an Academy of Design, to be directed by artists, and composed of artists only, with an annual exhibition of the works of living artists, to support these schools, and form a fund for the unfortunate professors of art. They have called it " The Artist's Fund Academy."

A bust of Americus Vespucius—presented by J. J. Browere.

Vase of the Villa Albani, Genie suppliant, Houdon's anatomical figure, Legs of Germanicus, and a variety of parts of the human body in plaster, from nature and the antique, also the arabesque ornaments of the Loggie of Raffaelle and rare works on the arts—presented by J. Fennimore Cooper, Esq.

A valuable collection of impressions from antique and modern gems—presented by Lieut. G. W. Williams, of the engineer corps.

Several volumes to the library—presented by Thomas Dixon, Esq.

Planches anatomiques, a l'usage des jeunes gens—presented by F. G. King, M. D.

Several engravings by himself—presented by M. E. Corr, engraver and professor at Antwerp.

A medallion—presented by Count Hawkes le Grice.

A copy of Ruben's picture of the fates, weaving the web of life of Mary de Medicis—presented by C. M. Patterson, Esq.

A donation of fifty dollars—presented by Miss Glover.

Alonzo Hartwell, 1805–1873.

Michele Pekenino, *fl. c.* 1820–*c.* 1822.

George Cooke (Cook), 1793–1849.

ALONZO HARTWELL—MICHAEL PEKEMINO— GEORGE COOKE—1820.

Mr. Hartwell now distinguished among our engravers on wood, was born in Littleton, Mass., February 19, 1805, and at the age of seventeen, placed with a merchant in Boston, but preferring the fine arts, particularly engraving, he transferred himself to the work shop of Mr. Throop, and practised with the burin until his master removed from Boston. Hartwell then engaged with Mr. Abel Bowen, a wood engraver, and with him has acquired the beautiful art he professes.

Pekemino was a Piedmontese architect and draftsman, who on arriving, exhibited very clever specimens of drawing with the pen, shaded by stippling with that instrument. He applied to Mr. Durand for instruction in engraving, and was received as a pupil. He soon succeeded in engraving several heads, among which was one of his instructor, from a portrait by Waldo and Jewett. He removed to Philadelphia and worked for a time ; but wishing to return to Europe, by way of raising the wind for the voyage, he erased the name of Durand from the plate he had engraved, representing his teacher in honest art, and substituted that of Bolivar, then high in popular favour, and making our peaceful fellow-citizen pass for the fire-eating liberator, he sold the counterfeit readily, and got off with the spoil.

Mr. Cooke was born in St. Mary's county, Maryland, the 11th of March, 1793. He had the usual desire in childhood to represent forms in the shape of pictures, and with about the usual success of those who are tempted in after life to pursue the arts of design. His father was a lawyer, and gave George a good education. In his fourteenth year (1807) he first saw

273 GEORGE WASHINGTON. Engraving by Michele Pekenino after the painting by Gilbert Stuart. *Courtesy Dover Archives.*

Barralet del. From a sketch by A.Wilson.

General view of the Falls of Niagara.

274 GENERAL VIEW OF THE FALLS OF NIAGARA. Engraving by George Cooke after a painting by John James Barralet from a sketch by Alexander Wilson. *Courtesy Dover Archives.*

a portrait in oil, it was by Stuart: this he attempted to copy in water colours, and his attempt encouraged General Mason to write for the terms on which C. W. Peale would receive him as a pupil. He was referred to Rembrandt, just then returned from Europe, who was willing to receive him, says my informant "for something like 2000 dollars." This put a damper for a time to young Cooke's hopes, as his father did not encourage them. In the year 1817, Mr. Cooke married Miss Heath of Virginia, and in some measure guided by Charles B. King, he again after the death of his father attempted painting.

In the 27th year of his age, Mr. Cooke commenced painting professionally, and says that, "from that day to this he has never been without a subject engaged," if the time engaged in travelling be excepted. This I believe is more than any other painter can say with truth. In Alexandria and in Richmond Mr. Cooke found constant employment, but his labours affected his health, and he determined to visit Europe. Accompanied by his wife, he sailed from New-York for Havre the 26th of July, 1826. In the Louvre he studied the works of olden time. After a month in Paris, Mr. Cooke hastened to Italy. His first permanent residence was in Florence, where he entered as a student of the casts and statues of the academy. He studied anatomy. But his principal devotion was to copying from the old masters in the galleries. From October 1827 to June 1829, he studied in Rome, as he has said, " day and night." Naples he merely visited. Returning to Paris, he stopped in the cities in his route, and on his arrival at the capital of France found his health so much impaired, that he was obliged to place himself under the care of a celebrated surgeon, and undergo an operation which happily restored him.

After an absence of five years Mr. Cooke returned to New-York, 1830, in which city he has exhibited his works with success, and, as he has said, found constant employment.

Mr. Cooke is an intelligent man, and communicates his ideas by words with great fluency and propriety. In the course of his European studies he has been harassed by ill health ; but judging from the number of copies made by him, and brought home, his industry has been very great, and he has employed himself assiduously. Perhaps copying a less number might have been equally advantageous to his style and general improvement.

CHAPTER XXV.

Inman born at Utica—his choice of books—pupil of J. W. Jarvis—great success—
T. Cole—birth—removal to the west—early struggles to become a painter—ad-
ventures in the western states—arrival in Philadelphia—New-York—friendship
of G. W. Bru en, Esq.—Studies on the banks of the Hudson—his pictures com-
mand a sale, and he has many orders—Visit to England and Italy—return and
mmense improvement—Luman Reed, Esq.

Henry Inman, 1801-1846. HENRY INMAN—1820.

THIS eminent artist was born at Utica, in the state of New-
York, on the 20th of October, 1801. His infancy and that
of this great and flourishing place are coeval. His parents
were English, and among the first settlers of Utica. Like most
who are prominent as painters, his early delights were con-
nected with pictures, and his first aspirations to be enrolled
among famous artists. He read, as soon as he could read, a
translation from Madame de Genlis' "Tales of the Castle,"
and here he found food to nourish and strengthen his love.
Among the notes to one of the stories contained in that work,
are to be found brief biographies of celebrated painters and
sculptors. He never wearied of poring over their histories;
and the name of Raphael embodied in his young mind all that
could be conceived of greatness. It is a proof of an extraor-
dinary intellect, when the love of facts supersedes the universal
appetite for fiction.

The father of Mr. Inman perceiving the bent of his son's
mind, thus early disclosed, kindly encouraged his inclinations.
An itinerant drawing master was engaged to give him lessons :
but the poor man and poorer artist, soon found it necessary to
decamp from Utica, leaving his pupil and his creditors to
mourn his absence.

About the year 1812 the parents of Mr. Inman removed to
the city of New-York, and there the study of drawing was re-
commenced under a competent teacher, who was engaged at
the day school which Henry attended. About the year 1814,
Wertmüller's celebrated picture of Danæ was exhibited at
Mr. Jarvis's rooms in Murray-street, and thither, as to other
exhibitions, the father of the young aspirant took him. Henry
was not satisfied with one visit to the rooms of such a painter
as Jarvis, and the result of his second visit is so well told by
himself, in a letter from which I am permitted to make the ex-
tract, that I give it in his own words :

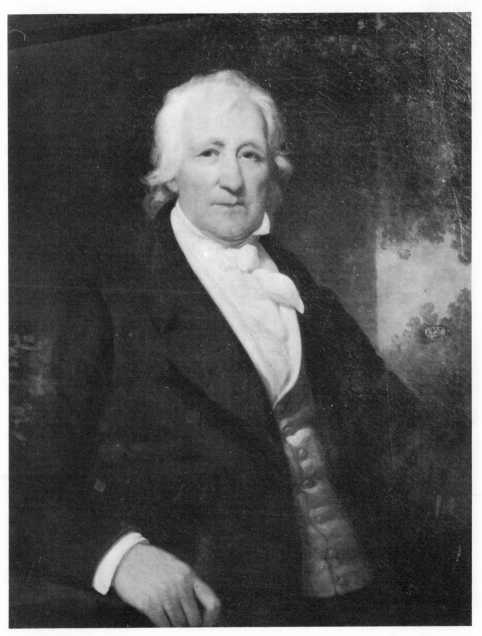

275 HENRY PRATT. Painting by Henry Inman. *Courtesy The Pennsylvania Academy of the Fine Arts.*

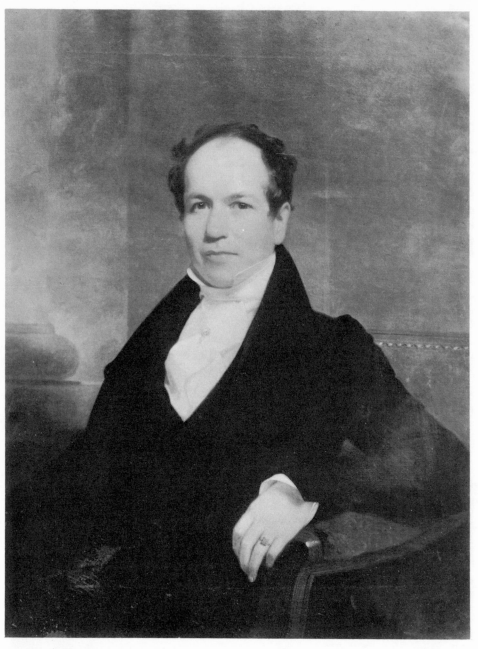

276 DAVID PAUL BROWN. Painting by Henry Inman. *Courtesy The Pennsylvania Academy of the Fine Arts.*

" On a second visit when I went alone, I saw Mr. Jarvis himself, who came up from his painting room into the apart- ment in which the Danæ with other works of art, was placed. On observing his entrance with maul stick in his hand, and palette on his arm, I removed my hat and bowed, presuming that he was the proprietor of the establishment. At that time I regarded an artist with peculiar reverence. Without notic- ing my salutation he walked rapidly towards me, and with his singular look of scrutiny, peered into my face. Suddenly he exclaimed, " By heavens, the very head for a painter !" He then put some questions to me, invited me below stairs, and permitted me to examine his portfolios. He shortly after called upon my father and proposed to take me as a pupil. I was at this time preparing for my entrance to the West Point Institution as a cadet, for which I had already obtained a war- rant. My father left the matter to myself, and I gladly acceded to Mr. Jarvis's proposal. I accordingly entered upon a seven years' apprenticeship with him. Notwithstanding his phreno- logical observations upon my cranium, a circumstance con- nected with my first effort in oil colours would seem to contra- dict the favourable inference it contained. Another of his stu- dents and myself were set down before a small tinted land- scape, with instructions to copy it. Palettes and brushes were put into our hands, and to work we went. After much anxious looking and laborious daubing, Mr. Jarvis came up to see what progress we had made. After regarding our work for some moments in silence, he astounded us with these words, ' Get up ! Get up ! These are the damn'dest attempts I ever saw ! Here ! Philip ! (turning to a mulatto boy who was grinding paints in another part of the room,) take the brushes and finish what these gentlemen have begun so bravely !' All this took place in the presence of several strangers who had come to look at the gallery. You can imagine what a shock our self-love received. Such mortifications are the most en- during of all remembrances. Notwithstanding this rebuff, I managed to make other and more successful efforts."

Well might he say so. A short time after he worked upon the same canvases with his teacher. Mr. Inman remained with Mr. Jarvis during the whole time of his engagement, and with him visited New-Orleans and other cities.

Immediately upon his emancipation he commenced portrait and miniature painter, well qualified for both branches. He must have entered into another engagement as soon as the first was ended, for I remember meeting him, and congratulating him upon his freedom and success, adding, " Now as soon as

you can visit Europe," and being told the next day that he
was married to Miss O'Brian. To judge by his success, a
visit to Europe would have been superfluous. In miniatures
Mr. Inman is second only to the works of Malbone, but the
demand for oil portraits in large has induced him to relinquish
that branch of art to his friend and former pupil Thomas S.
Cummings.

In 1824–5, Mr. Inman joined the association of artists for
drawing, and on the establishment of the National Academy
of Design, was elected vice-president, which office he filled
until his removal to Philadelphia, within a short distance of
which city, at Mount Holly, he had purchased an estate, or
farm and cottage, where he can paint surrounded by his family
with the delights of rural scenes in summer, and the comforts
of his own fireside in winter.

The versatility as well as excellence of Mr. Inman as an
artist, was once expressed to me by Mr. Sully in nearly these
words, " I remember going round your exhibition of the
National Academy at Clinton-hall in New York, and seeing a
fine landscape, I asked, ' Who painted this ?' The answer was,
' Inman.' Then I came to a beautiful group of figures—' Ah,
this is very clever—let us see whose this is,' I looked at my
catalogue,—' Inman.'· Then some Indians caught my eye—
catalogue again—' Inman.' A little further on, and I ex-
claimed, ' By George, here is the finest miniature I have seen
for many a day !' it was a lady in black, ' Who is this minia-
ture painter?' ' Inman.' His large portraits I was acquainted
with, but this variety of style took me altogether by surprise."

To Mr. ·Inman the Arts of Design owe, in addition to his
many pictures and their influence, two excellent painters, one
in oil and the other in miniature, in the latter Mr. Thomas S.
Cummings, in the former Mr. G. W. Twibill.

Since writing the above, Mr. Inman has removed with his
family to New-York, having, as I understand, engagements
which would render his country residence inconvenient.

Thomas Cole, 1801–1848. **THOMAS COLE—1820.**

It appears to me that few pictures can be more touching
than that of an amiable, virtuous, well educated, and tenderly
nurtured family, expatriated by reverse of fortune, and strug-
gling among strangers for a subsistence. The parents obliged
to have recourse, not only to temporary expedients, to prolong
their own existence for the sake of their children, but to try
avocations, of which their only knowledge is derived from the

reading of days when books were the elegant employment of leisure hours, and the study of science the favourite pursuit of life.

Let us suppose such a family composed of females, with the exception of the father and the youngest child, transported from England, and all its ever ready facilities for pleasure and comfort, to the western wilds of America.

The father of such a family applies the knowledge he had gained from books, to the establishment of a manufactory on a puny scale, of some articles which begin to be wanted in the newly risen towns of the west ; and which requires little capital or credit. He hopes that, by saving the cost of transportation which a bulky article incurs in proportion to its value, he may with profit supply his neighbours at a rate lower than the trader. The mother and the daughters cheerfully assist—renounce all former elegancies—attend to the domestic economy with scrupulous frugality, and aid in such part of the creative process as comes within their sphere.

For a time, industry and ingenuity appear to succeed ; but the sale of the wares is tardy ; the term of credit expires ; the effort fails, and poverty is rendered more poor—perhaps is aggravated by want of power to fulfil engagements made in perfect good faith.

This is in part an imaginary, and in part a picture from real life. Mr. Cole, now one of the first painters in landscape, as I believe, that the world possesses, and one of its most amiable of men, was born in England, and brought to America in childhood; and although by birth English, his relatives both by the male and female side, resided in this country previous to his birth. His grandfather was a farmer, that is, what all American farmers are, a yeoman cultivating his own soil, near Baltimore, in the latter part of the last century. His family, like that of C. R. Leslie, is Anglo-American, some born on one side the ocean and some on the other. Himself, like Leslie, born in England, yet bred in America ; and so strong is his desire to have a right to call that country his, which he feels *to be his*, that I have heard it said he has exclaimed, " I would give my left hand to identify myself with this country, by being able to say I was born here."

This is strong language, yet it agrees with that enthusiasm, which marks his character—an enthusiasm generally suppressed by modesty, but apparent in the works of his pencil.

His family, consisting of his parents, three sisters, and himself the youngest child, and only son, resided at one time in

Philadelphia, afterwards in Pittsburg, and then in Steubenville, Ohio. In this last place, in 1818, his father established
a paper-hanging manufactory, and Thomas was early engaged
in drawing patterns and combining pigments for colours.
This was his first step on that ladder, whose summit he has attained.

From his infancy he was fond of drawing, and passionately
devoted to the contemplation of the scenery of nature. An
excessive bashfulness joined to this love of the combination of
land, water, and sky, which the ordinary eye may be said not
to see, caused him to avoid the society not only of adults,
but of children of his own age—he sought and found in nature
the pleasure which seemed denied to him elsewhere.

To ramble through the woods, or on the beautiful banks of
the Ohio, indulging in day-dreams, was the apparently idle
occupation of a most active mind—of one who has proved
a most persevering and industrious practitioner and student of
nature's lessons.

I am permitted to copy a part of a letter, in which the painter speaks of this period of his life. " My school opportunities
were very small ; reading and music were among my recreations, but drawing occupied most of my leisure hours. My
first attempts were made from cups and saucers, from them, I
rose to copying prints, from copying prints to making originals.
My employment in my father's business was somewhat to
my mind, but there was too little art and too much manual
labour for one of an imaginative mind.

" About the year 1820, Mr. Stein, a portrait painter, came
to Steubenville. I became acquainted with him—saw him
paint, and considered his works wonderful—I believe they
were respectable. He lent me an English work on painting,
(I have forgotten its title,) it was illustrated with engravings,
and treated of design, composition, and colour. This book
was my companion day and night, nothing could separate us—
my usual avocations were neglected—painting was all in all to
me. I had made some proficiency in drawing, and had engraved a little both in wood and copper, but not until now had
my passion for painting been thoroughly roused—my love for
the art exceeded all love—my ambition grew, and in my imagination I pictured the glory of being a great painter. The
names of Stuart and Sully came to my ears like the titles of
great conquerors, and the great masters were hallowed above
all earthly things."

About this period, his father's affairs were unprosperous, and
the youth felt himself called upon for exertion in some new

field, for his own support, and the assistance of his beloved family. He determined to be a painter. In the letter above quoted from, is a passage which marks his character, and could only come from himself. He says:

" I had painted several landscapes, but had never drawn from nature, although I had looked at her ' with a loving eye.' One of these landscapes Judge Tappan, of Steubenville, happened to see, and being pleased with it, invited me to look at a copy he had made from Stuart. He lent me a palette, and gave me some excellent advice. This kindness I repaid ungratefully, for I unfortunately broke the palette; and although I often met him in the street, my excessive bashfulness prevented me from making any explanation or apology for keeping it so long. This circumstance gave me much pain, and although it may appear trivial, it marks my common conduct in those days, and is one of a thousand follies of that nature committed through diffidence. Indeed it is only of late years that I have surmounted this weakness. I long endeavoured to conquer it, and often when I knew my folly, and struggled with it, I have heard my heart beat, and felt myself incapable of utterance, in the presence of persons neither distinguished or talented. This weakness perhaps might be dignified with the title of nervousness; be that as it may, I have in a great measure conquered it, or it has cured itself."

Up to this time young Cole had only made drawings of heads with the black lead pencil, but now, 1820, he took up the palette to paint portraits. His father first submitted to the operation. It was pronounced like. Another and another succeeded; and the three, although painted unskilfully and without proper materials, gave satisfaction and encouraged the would-be painter to proceed in a path that he hoped would lead to the object of his wishes, the power to assist his beloved parents and sisters. From this affectionate group he parted for St. Clairsville, thirty miles from home. On a clear, keen morning in February, the young adventurer climbed the hills that surround Steubenville; the glittering frost-crystals dancing in the air; and although on foot and heavily laden, his spirits were light, and hope and youthful confidence added the wings of Mercury to his feet. Over his shoulder was slung a green baize bag, containing a scanty stock of wearing apparel, his German flute, his paints, a cumbrous stone *muller*, and brushes of various kinds, many of them his own manufacture. His equipments for entering the world were all heavy except his purse, which contained but one solitary dollar.

The morning, like the morning of life, was bright, the earth

was firm under his feet ; but as the day advanced a thaw came
on, the walking became laborious and his limbs weary, and
about twenty miles on his way he encountered a rivulet with-
out bridge and but slightly frozen. He sought a crossing
place ; and at length, enticed by the appearance of horses'
tracks on the ice, he ventured and reached the middle of the
stream in safety, but his frail bridge broke and he was plunged
to the bottom. Happily the water reached no higher than his
breast, and lifting the green bag with all his treasure over his
head, he walked to the opposite shore, breaking the ice for a
passage, and not knowing but every step would plunge him
deeper in the cold element, or subject him to being carried
under the ice—we may be thankful that neither happened—
and glowing with the exertion, he reached the shore in safety.
The evening was now coming on, and with it the freezing
state of the atmosphere—our pedestrian had two miles to go
in his dripping clothes, the road was up hill, but he ran all
the way, and thus probably prevented the inconveniences
which might be anticipated from his adventure. At the vil-
lage of Mount Pleasant he found the hospitality of an inn and
a kind landlord, who lent him dry clothes ; there, seated by a
blazing fire with a good supper before him, he felt like one
who had overcome all difficulties, and was about to enjoy the
fruits of his victory. So terminated the first day of a journey,
in search of fame and fortune, as a portrait painter.

Early the next day our adventurer arrived at St. Clairsville,
and his first inquiries of the landlord were to ascertain what
hopes he might indulge of success as a painter. The answers
were most discouraging. A German painter had been some
time in the village, and had painted all the paintable faces.
Cole felt his hopes at once blighted, but he was too proud to
recede and return to Steubenville without further effort, and
the first was to visit the German and look at his works. One
glance revived his hopes ; and though conscious of his own
deficiencies, when he saw the abortive attempts of his rival, he
might have exclaimed with the Italian, " auch io sono pittore."
He determined to wrestle with this German Hercules, and was
fortunate enough to find a saddler willing to sit for his por-
trait in exchange for a saddle,—Hope whispering, " perhaps
some one else will give you a horse for a portrait," but the
horse never came to be saddled. The saddler's picture was
thought like, and one *who had been in Philadelphia* pro-
nounced the handling excellent. Poor Cole, struggling for
life, little thought of handling, and scarcely knew the meaning
of the word. His next employer was an officer of militia, who

paid him with a silver watch. Another sitter, a store-keeper, furnished the watch with a gold chain, which proved like the gold chains of Michael Perez, the "Copper Captain."

Mr. Cole has said to a friend that nothing delighted him so much as that his sitters should fall asleep, (which was not unfrequent) he then felt that he had them in his power. Poor as were both his pictures and the payment, Cole advanced his reputation, and was pronounced better than *Des Combes*, the German, who left the field to him, and his triumph was complete when he was required " to doctor" the German's pictures—for the cure he received a pair of shoes and a dollar—the first and last he received in St. Clairsville. The saddle, watch and watch-chain were not found sufficient at the end of three months to satisfy the landlord of his inn, who would not be painted in payment; however, he took the chattels, in addition to a drinking scene for his bar-room, and suffered his boarder to depart with *the* dollar in his pocket. He had been advised by a gentleman of Zanesville, one hundred miles off, to visit that place, with assurance of his influence in his favour: he further promised to sit for his portrait and " did not doubt but Duncan, the tavern-keeper of Zanesville, would agree to have himself painted in payment of board."

Here were bright prospects! and in three days the pedestrian painter reached Zanesville, with his green baize bag on his back. During this time he walked incessantly from morn till night, except that in the middle of the day he sat down by a spring, pulled out the crust he had saved from his breakfast, and after his frugal meal made the woods ring with the notes of his flute. His flute was not only the solace of his solitude, but procured him, like that of Goldsmith, at night a lodging and kind treatment, without the usual disbursement for such favours at an inn. Notwithstanding this cheap travelling, he arrived with empty pockets at Zanesville. His prospects on entering the town did not appear so brilliant as when he was one hundred miles off, and when he entered " Duncan the tavern-keeper's" inn, he found his German evil genius, who had been a week before him, and painted the landlord and his family. The person who invited the visit, did not desert him, he sat for his portrait, and the unconquerable spirit of youth buoyed the young painter and carried him through. He took a room, offered himself as a teacher of drawing—he had no sitters, and but two scholars. At length he was *patronized* by a tailor and a barber; but when the time of settlement with his landlord came, the scoundrel who had tempted him to stay by engaging an *historical picture*, would only be

satisfied by cash. In vain the young man stated that he had
only stayed at his house in consequence of his promise
to employ him—that he was destitute and could not pay.
The reasonings of poverty are always poor; he was answered
by a threat of the jail, and was only relieved by several
gentlemen combining and paying the debt, trusting, as well
they might, to his countenance, manners, and assurances of
reimbursement.

He had been two months in Zanesville, and had concluded
a treaty of peace with Des Combes, the German. It was
based upon this condition from the Dutchman: "If you will
say notink apout ma bigtures, I will say notink apout yours."

Chilicothe now was the land of promise, and another hun-
dred miles was to be trudged on foot with the green baize bag
and its luggage, strapped over the pedestrian's shoulder. It
was now the burning heat of summer, and health as well as
hope began to fail. But on—on the wanderer must go, and
in two days and a half he came in sight of Chilicothe, on the
noon of an excessively hot day. To walk forty miles a day
was no difficult task to this apparently delicate young man.
Happily he had always accustomed himself to the exercise
which has enabled him, in the days which succeeded *these of
necessity*, to walk for pleasure or to explore the beauties of
nature for his incomparable landscapes, over distances that
would, in naming, appal most athletic men. To mount the
hills, to climb the precipice, which promised a picturesque
view, and to overcome difficulties in the pursuit of his studies
which opened subjects that otherwise were closed to him, has
been the practice of his happier days, and has added both to
his strength of body and power of pencil.

Fatigued and heated as he was when he gained the first
view of Chilicothe, he found himself near the banks of the
Sciota, he sought the shade of the trees which bordered the
river, bathed himself, washed a shirt, and sat down to rumi-
nate while it dried. He took courage. Chilicothe, a new
field of action, was before him—the German was behind him,
and happily again never haunted him. He had stopped at a
village called Lancaster, (through which Cole passed and
heard the blessed news) and finding an opening in a new line,
threw away palette and brushes, and commenced preaching.

Encouraged by these considerations, the young itinerant
entered Chilicothe, and at first fortune seemed to smile. The
landlord of the inn and his wife consented to take their por-
traits for his board; but no more sitters came. He obtained
some pupils in drawing, but the hope of accumulating some-

thing to carry to those for whose welfare he wished to labour, became fainter and fainter—all that he had yet done was done in vain. He received information that the family intended to remove to Pittsburg—he abandoned his plan of pursuing his journey to Tennessee, and determined to return. At Chilicothe, notwithstanding his strict economy, his expenses exceeded his means, and some small debts were due. On a picture of Washington, painted from the print, he relied for relief, and sent it to auction. It sold for five dollars ; but a friend rescued the picture and obtained twenty-five for him, by a raffle. He now turned his face towards home, and after five days and a few hours' walking entered Steubenville, and found himself in the arms of those who rejoiced to receive the wanderer, whether rich or poor.

The family removed to Pittsburg, but he unexpectedly found himself in request at Steubenville, and remained during the winter employed in painting portraits. He was called upon to exercise his skill as a scene painter likewise, by an association of those who play for their own amusement.

His father, on arriving at Pittsburg, endeavoured to establish a floor-cloth manufactory, and Thomas repaired thither to assist. He applied himself assiduously to designing patterns, preparing colours, and all the labour that might aid the project, but all failed, doubtless through want of capital. The spring had arrived, and the young painter seemed to awake to the beauties of nature in landscape, and to feel not only his love for, but his power in that branch of art. Heretofore, in his pursuit of art, he had been straying in a wrong path. He now began in 1823, to make studies from nature. Every morning before it was light, he was on his way to the banks of the beautiful Monongahela, with his paper and pencils. He made small, but accurate studies of single objects ; a tree, a leafless bough—every ramification and twig was studied, and as the season advanced he studied the foliage, clothed his naked trees, and by degrees attempted extensive scenes. He had now found the right path, and what is most extraordinary, he had found the true mode of pursuing it. Thus in those studies whose results we now see, he passed the early morning, and by nine o'clock returned to the labour of the day as a manufacturer.

To me the struggles of a virtuous man endeavouring to buffet fortune, steeped to the very lips in poverty, yet never despairing, or a moment ceasing his exertions, and finally overcoming every obstacle, is one of the most sublime objects of contemplation, as well as the most instructive and encouraging.

that can be presented to the mind. Such a man is truly a hero, whether he sink or swim.

But the struggles of young Cole were not yet over. Besides his studies and his labour in the manufactory, Thomas engraved in mezzotinto a head of Jackson, and painted several portraits and landscapes. So passed the summer, and the winter brought colder and more blighting prospects to the manufacturers. The young man saw that he must be a painter or starve, and determined to go to Philadelphia and seek his fortune. With means altogether inadequate, but looking only to the end, he obtained the consent of his parents once more to venture from home. His fond mother was always confident of his success, and would have sacrificed every thing to aid him in his favourite pursuit.

Early one dark morning in November, there was a sprinkling of snow on the ground, he took leave of his parents and sisters, rich in good wishes and blessings, but poor in pocket : a few dollars were all that could be spared to aid his long journey and adventurous purpose. His trunk was placed in a carrier's wagon, and he promised his mother to travel with it. This arrangement impeded the traveller, besides subjecting him to the necessity of hearing, especially at night, the blasphemy and obscene language of his conductor, and those who put up at the carriers' inns by the way. During the day he escaped from this moral pestilence by walking ahead, but then he had the trouble of retracing his steps to learn what had become of his trunk, and the drunkard who had charge of it. He generally found his guide engaged in a drunken quarrel. Thus sleeping at night on straw and walking by day exposed to the sleet and rain, which at this season usually enshroud the Alleghanies, he at length entered the great city of Philadelphia. He had before only seen it as a child, and now the lofty buildings, wide streets and busy multitude, struck him with admiration and awe. Accustomed to the lowly structures of the west and the solitude of the wilderness, he felt oppressed, and in the midst of a crowd of strangers his spirits sunk under a sense of solitude greater far than that of the forest.

He was now to seek instruction and employment. His plan for living, as he could not pay for board, was to take an empty room, sleep in the blanket he had brought from home, and live upon bread and water. And he commenced this mode of life. But the hardships he had previously undergone from cold and poor fare, brought on a serious illness. One morning after a night in December passed in misery from cold, he found himself scarcely able to rise, and in excruciating pain.

277 THE OXBOW (THE CONNECTICUT RIVER NEAR NORTHAMPTON), 1836. Painting by Thomas Cole. *Courtesy The Metropolitan Museum of Art, gift of Mrs. Russell Sage.*

278 VIEW ON THE CATSKILL, EARLY AUTUMN, 1837. Painting by Thomas Cole. *Courtesy The Metropolitan Museum of Art, gift in memory of Jonathan Sturges by his children.*

He made his way down stairs, and told the people of the house that he was very ill. They were strangers to him and far from rich; but the woman was rich in that which characterizes the sex, and during an illness of several weeks, he received her kind attentions, although no good Samaritan appeared to pay the cost. The young adventurer's funds were soon exhausted. By selling a camera obscura and some other articles, he procured a stove and fuel, and as soon as he was able commenced painting.

He obtained through the kindness of Mr. Thackara the keeper, permission to draw at the Pennsylvania Academy of Fine Arts, but was so overwhelmed by the specimens of art, that he used to go day after day and gaze on the casts and pictures, until the keeper aroused him, saying, " Young man, this is no place to lounge in; your permission is for you to draw here." This was a hard cut to the sensitive youth; but the old gentleman meant well, and was afterwards kind to him.

The pictures he painted were sent to auction and sold for a mere trifle. He has said " this was indeed ' the winter of my discontent.' " His heart sunk as he felt his deficiencies in art, when standing before the landscapes of Birch and Doughty; but it was only by feeling the deficiency, that it could be remedied. But the incipient artist could not devote his time to study—he must work for bread, and gladly he undertook to paint on the backs of bellows for a japanner, the most lucrative employment that had offered; but in this japanner he found a friend, and he gave him a commission to paint a large picture—a copy from the print of Louis XVIth., and his family; though the price was small, it enabled him to live and work. He painted some portraits, and received his first commission for a landscape—price seven dollars. Summer came and La Fayette, the nation's guest, came. Transparencies were wanted, and Cole got some of this work to do, by an introduction to Bass Otis.

His father and family passed through Philadelphia to take up their residence in New-York, and after passing another winter in the capital of Pennsylvania, still unknown as a painter, he followed. In New-York he set up his esel in his father's garret, and painted some landscapes which were placed in the store of Mr. Dixey, who was friendly, and here Mr. G. W. Bruen saw and purchased one of his pictures for $10. Mr. Bruen sought the young artist's acquaintance, and as he wished to visit the banks of the Hudson for the purpose of study and sketching, the same gentleman encouraged him, and furnished him a small sum for that purpose. The result of this excur-

sion was three pictures, which Mr. Bruen's interest placed at Coleman's for sale at $25 each. Trumbull saw them and purchased one, and the same day called on me, and expressed his admiration of the unknown young man's talent. Durand accidentally came in, and we all immediately went to see the landscapes.

I remember the sensitive and amiable painter, then seen by me for the first time, standing in presence of the three above-mentioned, like a school-boy in presence of the trustees, and looking an image of diffidence before men, neither of whom could produce a rival to the works he offered for the paltry price of $25 each. Trumbull had had the first choice—I had the second, and Durand took the third. Trumbull had previously said to me, " this youth has done what I have all my life attempted in vain." When I saw the pictures, I found them to exceed all that this praise had made me expect. P. Hone, Esq., soon offered me $50 for my purchase, which I accepted, and my necessities prevented me from giving the profit, as I ought to have done, to the painter. One thing I did, which was my duty. I published in the journals of the day, an account of the young artist and his pictures ; it was no puff, but an honest declaration of my opinion, and I believe it served merit by attracting attention to it.

From that time forward, Mr. Cole received commissions to paint landscapes from all quarters ; was enabled to increase his prices, and his facility of handling, as well as his truth of drawing and power of colouring.

The judicious reader will perceive while perusing the foregoing, that some of the facts I have related, in my own way, must have come from the subject of my memoir. They were drawn from him by my solicitation ; and he proceeded no further in his narrative than his arrival at New-York, and the friendship of Mr. Bruen. I wrote to him for notices of his visit to Europe—his opinion of artists there, and the state of the arts—in short, I pressed him to bring down the biographical sketch to the present time. He has complied with my urgent request, and I feel that I should do injustice to my reader and my subject if I did not give his communication as received. It is evidently an honest exhibition of truth, both as to facts, feelings and opinions ; and although some of the opinions, particularly those respecting Turner, may be found in opposition to high authority, already stated in this book, they are not to be overlooked. The opinions of Mr. Cole on the subject of landscape, I look upon as the highest authority : as I consider his mind of the first order, and his works in that

department of art, superior to those of any painter of the present day, that has come under my inspection. His words are :

"A great deal might be said on the subjects of England and Italy ; but to say that which will be most available to you may be difficult. I did not find England so delightful as I anticipated. The gloom of the climate, the coldness of the artists, together with the kind of art in fashion, threw a tone of melancholy over my mind, that lasted for months, even after I had arrived in sunny Italy. Perhaps my vanity suffered. I found myself a nameless, noteless individual, in the midst of an immense selfish multitude. I did not expect much, scarcely any thing more than to have an opportunity of studying, and showing some of my pictures in the public exhibitions, and to a few individuals of taste in my own room. I did study ; but the pictures I sent two seasons, both to the Royal Academy and the British Gallery, were, without exception, hung in the worst places ; so that my acquaintance had difficulty in knowing them. I was mortified ; not that they had been so disposed, but because the vilest daubs, caricatures, and washy imitations, were placed in excellent situations.

" The last time I exhibited, (or sent pictures to be exhibited) I had expected a little different treatment, for one of the hanging committee of the Royal Academy had led me to expect something better—I was disappointed. At the British Gallery I had hopes also : Mr. Samuel Rogers had promised to intercede for me ; but unfortunately he was called out of town at the very moment he could have aided me ; and my pictures had to stand on their own merits, which, in the eyes of the hangsmen, amounted to nothing. On the varnishing day I found them in the most *exalted* situations.

" At the Gallery of the British Artists I exhibited once, and was better treated. My picture of a " Tornado in an American Forest" was placed in a good situation, and was praised exceedingly in several of the most fashionable papers.

" The Society of British Artists is governed by artists themselves, which may account for the favourable manner in which I was treated in their exhibition.

" I have said, that I found the artists in London cold and selfish : there might be exceptions, but I found few. My own works, and myself most likely, had nothing to interest them sufficiently to excite attention : the subjects of my pictures were generally American—the very worst that could be chosen in London. I passed weeks in my room without a single artist entering, except Americans. Leslie was friendly, although he never appeared to think there was any merit in my

works; and Newton called on me twice in two years. I saw him often; for although none would trouble themselves to call on me, a wish to acquire information in my art induced me to visit them.

"To Sir T. Lawrence I was introduced by a letter from Mr. Gilmor, of Baltimore: he treated me in a very friendly manner, was pleased with my pictures, and sent his carriage for me to come and breakfast with him. We breakfasted at eight in a spacious apartment, filled with works of art—we conversed on the fine arts and America—he said he was much indebted to America, for he had some highly-esteemed acquaintances Americans. After breakfast he took me into his painting room, which was a picture wilderness. A short time afterwards I met him at the British Gallery, and he invited me to go with him to Sir R. Peel's, in a few days, to see his collection; but death, whose hand was already upon him, deprived me of that pleasure; I lost a valuable acquaintance, and the world, a distinguished man.

"Mr. Joshua Bates, a partner of Baring, Brothers & Co. formerly of Boston, was one of my best friends, and purchased several pictures from me. Mr. Rogers, the poet, also took an interest in me; and the friendship of his family, and particularly of Mr. Henry Rogers, served in some measure to lighten many hours that would otherwise have been spent in my solitary room. Both the Rogers's had choice collections of pictures; that of Samuel was the most valuable, but Henry's had been selected with great care. To Mr. S. Rogers I was introduced through means of Mr. Fennimore Cooper, and I found him a valuable acquaintance.

"Although, in many respects, I was delighted with the English school of painting, yet, on the whole, I was disappointed: my *natural* eye was disgusted with its gaud and ostentation: to colour and chiaro-scuro all else is sacrificed—design is forgotten; to catch the eye by some dazzling display, seems to be the grand aim. The English have a mania for what *they* call generalizing; which is nothing more nor less than the idle art of making a little study go a great way, and their pictures are generally things "full of sound and fury, signifying nothing." The mechanical genius of the people exhibits itself in the mechanism of the art—their dextrous management of glazing, scumbling, &c. Frequent and crowded exhibitions of recently painted pictures, and the gloom of the climate, account for the gaudy and glaring style in fashion. There are few exceptions among the artists of England to this meretricious style; even Wilkie and Leslie, in their late pictures, have become more washy and vapid than in their former productions.

" Turner is the prince of the evil spirits. With imagination and a deep knowledge of the machinery of his art, he has produced some surprising specimens of effect. His earlier pictures are really beautiful and true, though rather misty ; but in his late works you see the most splendid combinations of colour and chiaro-scuro—gorgeous but altogether false—there is a visionary, unsubstantial look about them that, for some subjects, is admirably appropriate ; but in pictures, representing scenes in this world, rocks should not look like sugar-candy, nor the ground like jelly.

" These opinions of existing English art, I know, may be considered heterodox ; but I will venture them, because I believe them correct. The standard by which I form my judgment is—beautiful nature ; and if I am astray, it is on a path which I have taken for that of truth.

" In May, 1831, I left England for the continent. When I arrived in Paris I found, to my great disappointment, that the works of the old masters in the Louvre were covered by an exhibition of modern French works, and there was no expectation of a removal of them for some time. I left Paris on my way to Italy.

" Modern French painting pleased me even less than English. In landscape they are poor—in portrait, much inferior to the English ; and in history, cold and affected. In design they are much superior to the English ; but in expression, false.— Their subjects are often horrid : and in the exhibition at the Louvre I saw more murderous and bloody scenes than I had ever seen before.

" The melancholy which I experienced in England continued with me for several months after I had arrived in Italy. I looked upon the beautiful scenery, and knew it to be beautiful, but did not feel it so. Previous to going to Rome I passed nine months in Florence ; which I spent in studying the magnificent collections there, and in painting several pictures ; among which was a small " Sunset on the Arno," and a wild scene, for Mr. Gilmor, of Baltimore. The " Arno" was exhibited in the Academy of St. Luke, and seemed to attract attention. The Grand Duke is said to have been much pleased with it, but he did not buy it. I studied the figure, part of my time, and drew from the life, at the Academy ; and painted my Dead Abel, which was intended as a study for a large picture, to represent Adam and Eve finding the body of Abel.

" Florence to me was a delightful residence. The magnificent works of art, the quietness and seclusion in which a man can live, make it a painter's paradise. Indeed, to speak of

Italy is to recall the desire to return to it. And what I believe
contributes to the enjoyment of being there, is the delighful
freedom from the common cares and business of life—the vor-
tex of politics and utilitarianism, that is for ever whirling at
home.

"In Rome I was about three months, where I had a studio in
the very house in which Claude lived. The Roman heads
that you have seen I painted there. I made several excursions
into the Campagna. I went to Tivoli, Aricia, and Nemi; and
obtained sketches, from which I painted on my return to Flo-
rence. The large view of the Aqueducts, the Cascatelles of
Tivoli, and several other pictures, which you have seen. Mr.
C. Lyman and Mr. Hoyt gave me commissions for those two
paintings in Rome ; as did Mr. Field, for that of the Fountain
of Egeria and another.

" From Rome I went to Naples, where I spent several weeks
pleasantly. I visited Pompeii, Vesuvius, and Pestum ; and at
the last place made sketches, from which I have painted, since
my return, a view of those magnificent temples, for Miss Dou-
glas. The commission was given in Rome.

" Returned to Florence, I painted more pictures in three
months than I have ever done in twice the time before or since.
I was in the spirit of it : and I now grieve that information of
the sickness of my parents, with their desire for my return,
should have broken in upon me. I packed up and sailed from
Leghorn in October, 1832, without seeing Switzerland, which
I had so longed to see (for I left France by way of Marseilles)
and without seeing Venice. In that three months I painted
the Aqueduct picture, the view of the Cascatelles of Tivoli,
Mr. Lord's pictures of Italian Scenery, four small pictures for
Mr. Tappan, a small view near Tivoli, and several others.—
O that I was there again, and in the same spirit !

"What shall I say of modern Italian art? I am afraid you will
think I looked at all with a jaundiced eye. I have been told that
I did so at the ancient also : if so, I have lost much enjoyment.
I can only speak as I have felt. Italian painting is perhaps
worse than the French, which it resembles in its frigidity. In
landscape it is dry, and, in fact, wretched. There are a few
German and English artists in Rome, who paint with more
soul than the Italians. It would scarcely be credited, that,
surrounded by the richest works of the old schools, there should
be a total ignorance of the means of producing brilliance and
transparency ; and that, among the greater part of the Itali-
ans, glazing is unknown : and the few who, from seeing the
English at work, have acquired some knowledge of it, use

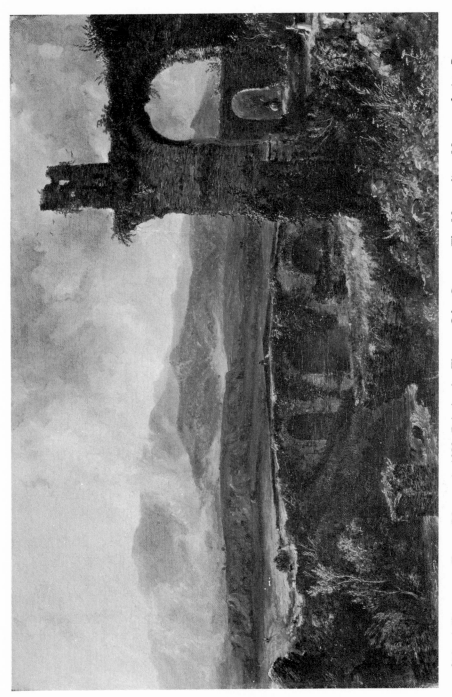

279 A View near Tivoli (Morning), 1832. Painting by Thomas Cole. *Courtesy The Metropolitan Museum of Art, Rogers Fund.*

280 TORNADO. Painting by Thomas Cole, Courtesy The Corcoran Gallery of Art.

magilps and varnishes as though they were deadly poisons.—
Indeed, of all meagre, starved things, an Italian's palette is
the perfection. The pictures of the great Italian masters gave
me the greatest delight, and I laboured to make their princi-
ples my own; for these, which have stood best the criticism
of ages, are produced on principles of truth, and on no ab-
stract notion of the sublime or beautiful. The artists were
gifted with a keen perception of the beautiful of nature, and
imitated it in simplicity and single-heartedness. They did not
sit down, as the modern artist too often does, with a precon-
ceived notion of what *is* or *ought* to be beautiful: but their
beau ideal was the choicest of nature—they often introduced
absurdities and things of bad taste in their pictures; but they
were honest—there was no affectation. I do not believe that
they theorized, as we do; they loved the beauty that they saw
around them, and painted.

"Many of the old masters have been praised for their defects,
and the blackness of age has been called tone; and there are
some whose merits appear to me to be but small. Salvator
Rosa's is a great name—his pictures disappointed me—he is
peculiar, energetic, but of limited capacity, comparatively.—
Claude, to me, is the greatest of all landscape painters, and
indeed I should rank him with Raphael or Michael Angelo.
Poussin I delighted in; and Ruysdael, for his truth, which is
equal to Claude, but not so choice.

" Will you allow me here to say a word or two on landscape?
It is usual to rank it as a lower branch of the art, below the
historical. Why so? Is there a better reason, than that the
vanity of man makes him delight most in his own image? In
its difficulty (though perhaps it may come ill from me, al-
though I have dabbled a little in history) it is equal at least to
the historical. There are certainly fewer good landscape pic-
tures in the world, in proportion to their number, than of his-
torical. In landscapes there is a greater variety of objects, tex-
tures, and phenomena to imitate. It has expression also; not
of passion, to be sure, but of sentiment—whether it shall be
tranquil or spirit-stirring. Its seasons—sun-rise, sun-set, the
storm, the calm—various kinds of trees, herbage, waters,
mountains, skies. And whatever scene is chosen, one spirit
pervades the whole—light and darkness tremble in the atmos-
phere, and each change transmutes.

" This is perhaps all unnecessary to you; but I have so often
been surprised at the almost universal ignorance of the subjects
that I am induced to speak. I mean to say, that if the talent
of Raphael had been applied to landscape, his productions
would have been as great as those he really did produce.

" I should like to say something of Mr. Reed, and the liberal commissions he has given me; but I feel rather delicate on the subject, on account of his having expressed a desire that I should not say much about the matter. I am not sure whether you saw the large composition, Italian Scenery, that I painted for him, and which was in the exhibition last season.

" I have, since I came into the country,* been engaged on a series, the subject of which I will trouble you with: it is to be the History of a Scene, as well as an Epitome of Man.— There will be five pictures: the same location will be preserved in each. The first will be the Savage state; the second, the Simple, when cultivation has commenced; the third, the state of Refinement and highest civilization; the fourth, the Vicious, or state of destruction; the fifth, the state of Desolation, when the works of art are again resolving into elemental nature.

" I would give you, (but that I am afraid I have tired you already) a fuller description of what I did intend to do, but unfortunately my intentions cannot be fulfilled. I have advanced far with the two first pictures, and find all my gold is turning to clay. I know my subject is a grand one, and I am disappointed at finding that my execution is not worthy of it. In the first picture I feel that I have entirely failed: in the second I am rather better pleased; but perhaps it is because there is so much unfinished. I have no doubt but they will please some of my indulgent friends, but they are not what I want.

" I am afraid I have trespassed on your time, if I have, it is because I scarcely knew what would be useful to you, and when I am talking about pictures, I " take no note of time." A word about my picture of the Angel, and as it was painted last winter, in about two months—I could not afford more—it has been a losing concern to me; its exhibition in New York cost me ninety dollars more than receipts; I hope it will do better in Boston. I had forgot to say that I made but one copy during my sojourn in Europe, and that was from a small Wilson of H. Rogers. Since writing the previous remarks on Turner, I have happened to find in an English magazine, 'The Metropolitan,' a critique on him that will serve to corroborate what I have said; as you may not have an opportunity of seeing that periodical, I will copy the part relating to this painter.

" ' Putting aside all the jargon of criticism, stand by and. hear what the multitude say to his conglomerations of yellow, white, and red: the surprise, the ridicule, the contempt that

* This was written at Catskill in September, 1834.

they excite. Painting may be an abstruse art in its practice, but in its effect, it ought to be on a level with the meanest capacity. It is a problem, the solution of which lies, as to its truth, in the mere act of turning from the picture made by the hand of man, circumscribed by a gilt frame, to that made by the hand of God, belted in by the horizon. The mere spectator may not feel the poetry, the exquisite taste of the arrangement, the classical grouping, but he can feel, and he does understand the truth or falsehood of the representation. Turner's pictures may be fine, but they are not true.' "

The pictures mentioned by Mr. Cole painted by him in Italy and immediately after his return, I have seen and admired : indeed it is upon their merits that I ground my opinion as above expressed. As to the rank in which he places his favourite branch of the art, I differ from him. The reader may remember, (or may see) that Leslie places his particular branch (as Cole does his) on a level with history painting. It is very natural that it should be so ; but until I am convinced that it requires as great variety and amount of knowledge to represent a landscape, or a scene of familiar life, as it does a great historic event ; or that a landscape, or domestic scene, can fill the mind, like the contemplation of a picture, representing an event on which the destinies of mankind depended,— an event which will influence those destinies to all eternity— I must continue to differ from my two amiable and enlightened friends.

I have, in another page, spoken of the munificent patronage Mr. Luman Reed, of New-York, has bestowed on the fine arts, and his friendship for our distinguished artists. Mr. Cole has felt as if he was prohibited from speaking of this gentleman's liberality. I am free to say, that I consider him as standing among the greatest benefactors to the fine arts, and the most purely disinterested that our country can boast.

I visited Mr. Reed's gallery some months ago, and saw the picture of Italian scenery which Mr. Cole painted for him. When it was finished, Mr. Reed asked the painter what price he put upon it. " I shall be satisfied," said Cole, " if I receive $300 ; but I should be gratified if the price is fixed at $500."—" You shall be gratified," said the liberal encourager of art. And he commissioned him to paint five more pictures of the same size at the same price, for his gallery.

CHAPTER XXVI.

Miss Hall; early disposition to the imitative arts; first teacher; comes to New-York; instructed by Alex. Robertson; makes herself mistress of a rich style of colouring by studying pictures of the old Italian masters; notice of some of her works—De Rose—Danforth—John Neagle; his high standing as a portrait painter; born in Boston; apprenticed to a coach painter in Philadelphia; adventures in the west; establishment in Philadelphia—Pat Lyon—Neagle's full success in his profession—Henry C. Pratt—George Catlin—Binon—Yenni—J. Parker—Robinson—The two Stricklands—Godefroy—Prudhomme—Dorsey—Steel—C. V. Ward—I. C. Ward.

Ann Hall, 1792–1863.

ANNE HALL—1820.

" Miss Anne Hall is a native of Pomfret, in Connecticut, and the third daughter of Dr. John Hall; who was a physician of eminence in that vicinity, and whose excellence will be long remembered and related in the place where he resided.

" It has been said, that our propensities are hereditary; and the truth of this remark may be exemplified in the instance of Miss Hall, whose grandfather, David Hall, D. D. of Sutton, Massachusetts, possessed uncommon talents, both for painting and music, though the duties of his profession gave him little leisure for their cultivation. Her father also had great taste in every thing connected with the fine arts, and by judicious criticism, and well-timed encouragement, fostered the genius of his daughter, which began to be developed at a very early age. When only five or six years old, she gave indications of talent in the imitative arts, and used to cut out figures with the scissors, and model little images in wax, which were surprisingly beautiful, as the work of a child. These elicited the admiration of the visiters of her parents, one of whom, presented her with some water-colours and pencils, the first paints she ever used. Her father being pleased with her attempts, gave her a box of colours from China: and afterwards, her brother C. H. Hall, Esq., who resided in New-York, and who was delighted with the specimens of taste and skill which she sent him, supplied her from time to time with such materials for painting and drawing as might most facilitate her progress. With these she used to imitate nature; and few of the beautiful flowers, birds, fishes, or insects, which inhabited the neighbouring woods and streams, escaped the eye or the pencil of the young artist. The seclusion of her situation in the country, prevented her from seeing what had been done

by others, but nature being her only model, was perhaps the source of her originality. Soon the " human face divine," became the favourite object of her contemplation, and was preferred to all others.

In this state of progress, she accompanied her oldest sister in a visit to some friends in Newport, R. I. where at her father's request, she took some lessons in the art of applying colours to ivory, instead of paper, from Mr. S. King, an artist of respectability, who had previously had the honour of giving lessons in oil painting, to our distinguished countryman Mr. Allston. Her stay in Newport was very short, and at her early age, of little value to her subsequent progress in miniature painting.

Her brother, who afterward resided for some years in Europe, was enabled to procure some fine pictures both in oil and water-colours, which he sent to his sister, and she was encouraged to copy them, until she could in some manner approach to their excellence. By comparing these with nature, she was enabled to avoid the formality of a mere copyist, and justly to delineate the forms and colours with which her fancy was imbued, when she again attempted original compositions.

Being in New-York some time after this, she received instruction in oil painting from Mr. Alexander Robertson, at that time, and still an excellent teacher of painting. She painted some pleasing pictures in oil, but eventually relinquished it to devote herself more exclusively to miniature painting. In this style her pencil has not only been a source of pleasure, but has enable her to enjoy " the glorious privilege" of being independent. She has been favourably distinguished by the artists in New-York and elsewhere, and has received much kind attention from those whose praise is honour. To conclude with the words of Solomon, " *give her the fruits of her hands,* and let her own works praise her in the gates."

The above is from a friend, who, at my request, has given me this brief, but elegant notice. My attention to Miss Hall, was attracted by seeing several miniature copies from oil pictures by old masters, particularly two from Guido, executed with a force and glow of colouring that surprised and delighted me. Her late portraits in miniature are of the first order. I have seen groups of children composed with the taste and skill of a master, and the delicacy which the female character can infuse into works of beauty beyond the reach of man—except it might be such a man as Malbone, who delighted in

female society, and caught its purity. I have lately seen a full length of the oldest child of Dr. John W. Francis, (and called John from his father,) which is composed with the beautiful simplicity of some of Reynolds' or Lawrence's portraits of children, and is in colouring glowing, and masterly in the touch.

This lady has occasionally exhibited with the National Academy of Design, and was elected unanimously an academician. Her portrait of a Greek girl attracted much attention. It has been engraved. Of the few pictures of Miss Hall which I have had the pleasure of seeing, a portrait of Samuel Ward, jun., and a group of two girls and a boy, the children of Samuel Ward, Esq. are particularly deserving of praise. The group is, in composition, colouring, and expression, beyond any thing I have seen for a long time. It reminds me of Malbone. The flowers, and the children combine in an elegant and well arranged *bouquet*. The same high praise belongs to a group of two ladies and a boy, combined with flowers—still her management of infantile beauty, when the difficulties attendant upon such studies are considered, makes me place the full length of Master Francis among the chef d'œuvres of Miss Hall; but perhaps the best original picture she has executed, is a group of a mother and child, the latter almost naked, and clasped to the mother's bosom. The mother is Madonna like, and the child perfect in attitude and expression. This group represents Mrs. Jay, the wife of Dr. Jay, and her infant.

Anthony Lewis De Rose,
1803–1836.

ANTHONY LEWIS DE ROSE—1820.

I give the brief notice which Mr. De Rose has favoured me with, as I think it honourable to him, and more satisfactory than I could present in my own words:

" I was born in the city of New-York, on the 17th of August 1803, and began my professional career in the winter of 1821, by setting out upon the world as a professed artist, after studying scarcely a year and a half; so eager was I to claim the distinction which I fancied belonged to an artist. I was designed for a mechanical employment, by my only surviving parent; but such was my repugnance to being forced to learn the secrets and mysteries of a trade, whether I would or no, that my scruples and the melancholy it caused, finally prevailed, and I was suffered to follow my inclinations and desires, in the pursuit of art. I commenced the rudiments of drawing with a young artist in New-York; after studying six

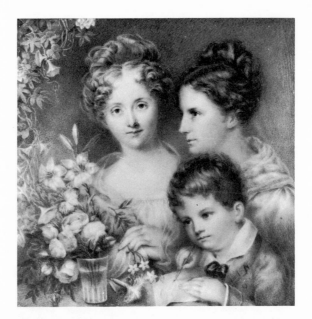

281 PORTRAIT OF THE ARTIST WITH HER SISTER, ELIZA HALL WARD AND MASTER HENRY HALL WARD. Miniature by Ann Hall. *Courtesy The New-York Historical Society*.

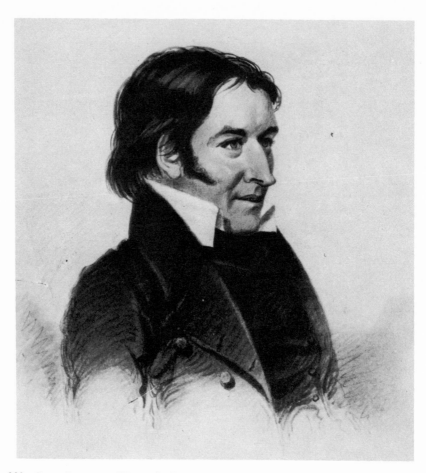

282 DAVY CROCKETT. Watercolor by Anthony Lewis De Rose. *Courtesy The New-York Historical Society.*

months with him, I was placed under the instructions of J. R. Smith, an excellent teacher of drawing, and I think I owe much of my subsequent success to his admirable system of instruction ; occasionally I drew at the academy in Chambers-street under your directions, during the brief hours allowed for that purpose by the board of directors.

" You may remember too, that I have been a constant attendant upon your course of lectures in *our academy*, and undoubtedly owe much to them, as having given a proper direction to my course of study. I have copied but few pictures, preferring nature—her charms have won and claimed my entire admiration. Pleased with my first success in portrait painting, I wandered over many parts of our widely extended country in search of employment, and from a restless desire to see its varied beauty. Since the foundation of our *excellent academy* (the National Academy of Design,) my professional views have taken a higher aim ; I have occasionally employed my pencil in historical composition, with what success you shall witness at our next annual exhibition."

M. J. DANFORTH—1820.

This gentleman, one of the best engravers in London, was born in Hartford, Connecticut. He began to engrave in 1818 as a pupil of the Hartford graphic company, mentioned above, in the notice of E. Tisdale. He moved to New Haven and engraved professionally in 1821. For a publisher of Hartford he copied one of Raphael Morghen's fine prints ; and so well, that my informant says, the proprietor has not yet published it, and keeps it to palm off hereafter as a genuine Morghen. I hope the trick will be exposed and result in disgrace, as all falsehood ought.

In 1826 Mr. Danforth joined the National Academy of Design in New-York, and studied in the school. In 1827 he went to London with the intention of engraving there a portrait of De Witt Clinton, painted by S. F. B. Morse, president of the National Academy, for which a subscription was attempted, but the project failed.

In London Mr. Danforth pursued his studies assiduously at the Royal Academy, and drew industriously from the Elgin marbles, his drawings from which attracted much attention and admiration : he likewise painted in water-colours, copying some of the oil pictures of the old masters, with great effect and perfect truth.

Mr. N. Jocelyn arrived in London in 1829, and renewing his intimacy with Danforth, they resided together. Newton,

Moseley (or Mosely) Isaac Danforth, 1800–1862.

Leslie; and Sir T. Lawrence, were the intimate friends and admirers of Mr. Danforth. He formed himself as an artist, by his independent study in London, and did not put himself under the direction of any engraver. He has engraved Leslie's portraits of Scott and Washington Irving, and a daughter of Lord Holland, for an annual. The beautiful picture by Leslie of Uncle Toby and the Widow, is before me, as engraved by Danforth in very fine style. This print was Leslie's gift to me on his leaving America in 1834.

Mr. Danforth is a moral and religious man ; of a retiring disposition ; an honour to art and a blessing to society, as every such man must be.

John Neagle, 1796–1865.

JOHN NEAGLE—1820.

The following words have already been inserted in this work : " It too often happens that the biographer, after dilating with enthusiasm on the merits of the artist, is obliged, with shame and mortification, to confess or to palliate the vices or grossness of the man." In very few instances has this "shame and mortification" fallen to my lot. The artists of the present day in our country, among whom Mr. Neagle holds a distinguished place, have emulated in their conduct the best men, as they have rivalled in their works the best professors of the fine arts.

Mr. Neagle was born in Marlborough-street, Boston, the capital of Massachusetts, on the 4th day of November, 1799. His parents were residents of Philadelphia, and on a visit to Boston at the time of his birth. The father of this gentleman was a native of Doneraile in the county of Cork, Ireland, and his mother, whose name was Taylor, was the daughter of a New Jersey yeoman, and born near Bordentown. John lost his father when he was but four years of age. His mother still lives. With the usual desire to draw figures of things earthly and unearthly, the boy's efforts were directed to something like systematic drawing by a school-fellow. This was Petticolas, afterwards and now the well known artist of Richmond. Neagle looked up to him as a master, and imitated his attempts, until he became a wonder himself to his schoolmates. His mother married a second husband, who was no friend to John or to the arts, and he passed through the evils of a stepfather's ill will. After the education of a common English school, the boy was sent to the drawing school of Signor Pietro Ancora for one quarter, and then placed by his stepfather in his grocery store. By his own choice young Neagle was apprenticed to Mr. Thomas Wilson, a coach and

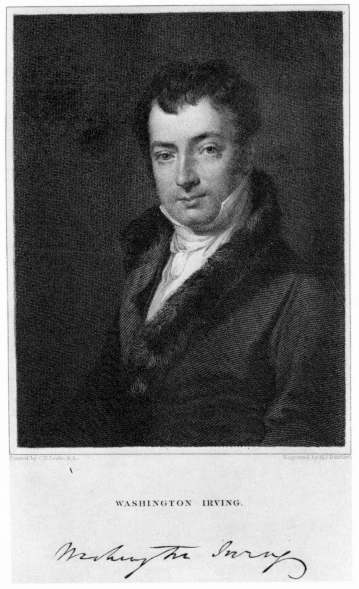

Painted by C.R.Leslie R.A. Engraved by M.J.Danforth

WASHINGTON IRVING.

283 WASHINGTON IRVING. Engraving by Moseley Isaac Danforth after the painting by Charles Robert Leslie. *Courtesy Dover Archives.*

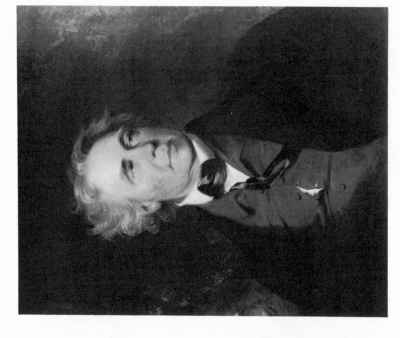

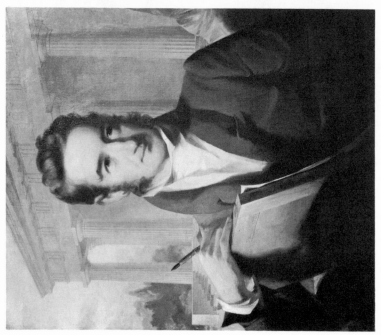

284A WILLIAM STRICKLAND. Painting by John Neagle.
*Courtesy Yale University Art Gallery, Mabel
Brady Garvan Collection.*

284B COLONEL RICHARD M. JOHNSON. Painting by John
Neagle. *Courtesy The Corcoran Gallery of Art,
gift of Mrs. Benjamin Ogle Tayloe.*

ornamental painter, but had his ambition aroused by the ambition of his master, who became a pupil of Mr. Bass Otis the portrait painter. John had to carry palettes and brushes to and fro, which introduced him to Otis's painting room, and created the determination to become as great a painter as the man whose works he admired above all things. Having access to materials, he applied himself day and night to drawing and painting, "in his own way," and when not employed by his master. The skill acquired by his own exertions rendered him the most profitable to Wilson of all the apprentices in ornamental work. By his indentures, John was bound to serve five years and five months, which left him a period of eighteen months freedom before he was of age, which was in 1820.

During his apprenticeship he had some lessons, by an arrangement with Wilson, from Mr. Otis, for about two months, which is all the instruction he ever had as a pupil to a professional painter. The attempts of the apprentice were encouraged and praised by Krimmel, C. W. Peale, Otis, Sully, and others, and he was a favourite with Wilson, who appreciated his usefulness and his talents. The first portraits the young painter attempted were during his apprenticeship, and the truth of likeness even from the commencement gained him applause and encouraged his efforts. Mr. Neagle has said, that in after years, however much he may have otherwise improved, he could not have improved the *likeness* in his first subjects.

I will copy from a letter before me Mr. Neagle's account of his first interview with Mr. Sully: "Mr. Sully then lived where the Athenæum now is, in Fifth-street, and he had on his *eazle* a study for the *pro*-scenium, or *part over the stage*, for the Chesnut-street theatre. I was at that time an apprentice, and went with Mr. Otis to Mr. Sully's painting room, where he left me alone with him. The very polite but formal manner in which he received me I shall never forget, particularly when he assured me, that ' the arts did not point the way to fortune, and that had he been a merchant, with the same perseverance which had characterized his efforts in art, he might have realized a fortune.' " I have shown the vicissitudes which attended Sully's professional career, and probably this conversation occurred at a time when fortune frowned and the public forgot him. Neagle continues: " On my departure he invited me to visit his exhibition room, whenever I felt a desire —which I often did—but never paid him a personal visit until 1822, after he had called upon me to congratulate me, as he

said on my great success in the exhibition, presenting me at the same time with a card of invitation in his own hand writing, to Earle and Sully's gallery." It was some years before Neagle became intimate in Sully's family; but the intimacy, when it took place, led to the marriage with one of the painter's daughters.

It was in 1818, and before he began to practise his profession in Philadelphia, thinking he might better compete with painters beyond the mountains, he travelled to Lexington, Kentucky, with a view to establish himself in that growing place. His first inquiry was, " Is there any portrait painter in Lexington?" and to his amazement he was told there were two. He went in search of them, and chance directed him first to Mr. Jouett's painting room. On looking at this gentleman's works he saw at once that he had no prospect of being the leading painter in Lexington. In fact he found in Jouett a good and well instructed artist. There was no hope of employment, and the young adventurer's money was expended. He determined to go on to New Orleans, and if no good fortune occurred, to find his way home by sea. To pay his passage down the great river of the west, was out of the question, he therefore offered himself to the captain of a boat to work his way. His dress not comporting with his purse or his offer, the rough boatmen thought he was a dandy who jeered them, and soon gave him such indications of their dislike to quizzing, except among themselves, that he was glad to retreat without giving hopeless battle to a half horse half alligator.

Happily for Neagle, the flow of population from the Atlantic states to the west is so great, that an inhabitant of any of the cities of the old states can hardly fail to meet some one with whom he is acquainted. The young painter in this dilemma was accosted by one who had known him in Philadelphia, and finding that he was awkwardly situated, frankly offered him assistance. The offer of the loan of a few dollars* was accepted, and the youth once more afloat, was wafted with the current towards the great commercial emporium of the west. As they approached New Orleans he felt the necessity of raising a further supply, and opening his trunk to consult its contents on the means of raising the wind, he was fortunate enough to get up a gentle breeze by a sale of part of his wardrobe to the skipper. He was now landed at New Or-

* The name of this friend was Burn, and the painter afterward presented him with his portrait, probably of $100 price, for the three dollars then lent him.

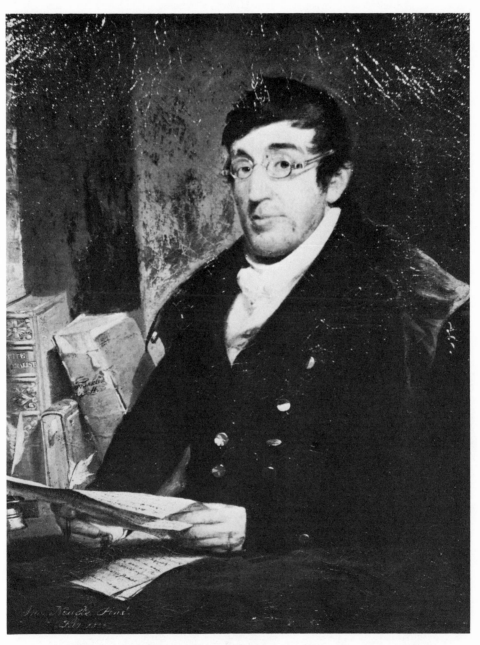

285 ROBERT WALSH, 1822. Painting by John Neagle. *Courtesy Georgetown University News Service.*

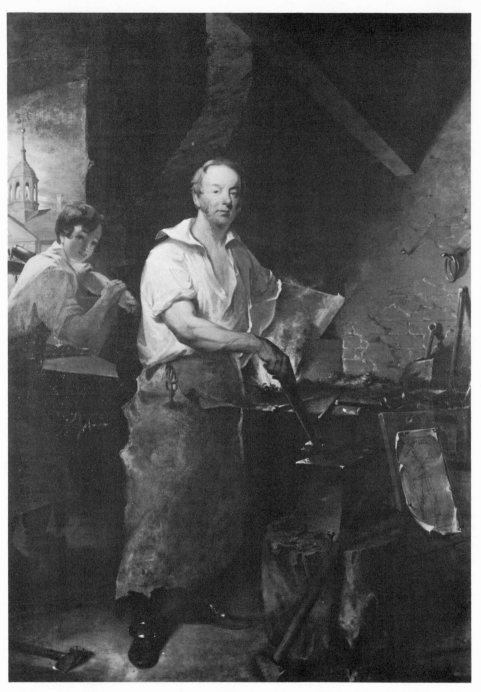

286 PAT LYON AT THE FORGE, c. 1826. Painting by John Neagle. *Courtesy The Pennsylvania Academy of the Fine Arts.*

leans, one of the most extravagant places for board and lodging in the United States, and he would have found himself most awkwardly situated again, but that here he met another acquaintance from the east. This gentleman had been a sitter to him for his portrait, and now bought a Washington's head of him, which he had brought from Philadelphia rolled up in his trunk : this enabled him to take passage for the city of Penn, where in due time he safely arrived. Neagle is not the only American who has been extricated from difficulty by that same head.

Neagle's business improved after his travels, and he became an established portrait painter in the metropolis of Pennsylvania, although Kentucky had rejected him. In May 1820, he married Miss Mary Chester Sully, a daughter of Thomas Sully, Esq., and continued to improve by his unwearied study and application to his art. A full-length picture of a blacksmith, painted in 1826, size of life, at his forge, excited very general attention, and as general applause. This was the portrait of Patrick Lyon, who having made a fortune by his industry as a blacksmith, and ingenuity as a locksmith, chose to have his portrait painted in the costume of Vulcan, with all the paraphernalia attendant upon his fiery occupation.

" Do it at full length," said Lyon, " do it your own way— take your own time, and charge your own price—paint me as a blacksmith—I don't wish to be represented as what I am not—*a gentleman.*" Mr. Neagle had an order for a second picture of Lyon. One of them was purchased for the Athenæum, Boston.

After being exhibited in Philadelphia, much to the artist's credit, Lyon's portrait was loaned to the National Academy of Design, for one of their annual exhibitions of the works of living artists, and I published the following notice of the picture into the " American."

Patrick Lyon the Blacksmith.—One of the best, and most interesting pictures in the present exhibition of the National Academy at the Arcade Baths, is a blacksmith standing by his anvil, resting his brawny arm and blackened hand upon his hammer, while a youth at the bellows, renews the red heat of the iron his master has been labouring upon.

This picture is remarkable, both for its execution and subject. Mr. Neagle of Philadelphia, the painter, has established his claim to a high rank in his profession, by the skill and knowledge he has displayed in composing and completing so complicated and difficult a work. The figure stands admirably ; the dress is truly appropriate ; the expression of the head equal-

ly so; and the arm is a masterly performance. The light and indications of heat, are managed with perfect skill. In the back ground at a distance, is seen the Philadelphia prison, and thereby " hangs a tale," whether true in all particulars, is perhaps of little moment; I give it as I took it.

Pat. Lyon, as he is familiarly called in the city of Penn, was the blacksmith and locksmith of the Bank of —, and the vaults having been entered and a large amount of money carried off, suspicion fell upon the man of locks, bolts, and bars. So strong were the suspicions of the directors, that Pat was arrested, and imprisoned for a long time in the castle, which, by his desire, the painter has introduced into this historical portrait.

In process of time, however, the real culprits were found to be the watchmen employed to guard the bank, and not the blacksmith who had fashioned its iron securities. Pat, who probably manufactured the locks and bars which held him in the city prison, was released, and made his old employers and recent persecutors pay handsome damages. He became rich, and with a liberal spirit engaged Mr. Neagle, a young artist struggling for fame and fortune, to paint his portrait, not as Patrick Lyon, Esq. but as *Pat the blacksmith*, supported by that hammer and anvil, with which and on which he forged his own wealth, and hammered iron bars into bank notes and eagles.

Another story is told of the blacksmith, which displays some humour, and if known to the visitors of the exhibition, where Mr. Neagle's picture is displayed, may enable them to see more in the face of Pat, than they otherwise might do without. Being sent for to open an iron chest made by himself, lock and all, whose owner had lost the key, Pat dexterously performed the operation, and holding the lid with one hand, presented the other, with a demand for ten dollars. It was refused. Pat let fall the lid, the spring lock took its former hold, and the blacksmith walked off, leaving the treasure as fast sealed as before. There was no remedy, and reluctantly the owner of the strong box, again sent for Pat. He promptly appeared, and the box was as quickly opened. The first demand of ten dollars was instantly offered; but no, " I must have twenty now," says the operator: and twenty was paid without demur, for the lid and the lock were still in the iron grasp of the maker.

Mr. Neagle has contributed much to the information contained in this work. His anecdotes of Stuart have, I hope, amused every reader, and his account of Stuart's advice to him, when the veteran was sitting to the young painter, will instruct the student. I have seen many excellent portraits from the esel of Mr. Neagle, some of which have been engraved,

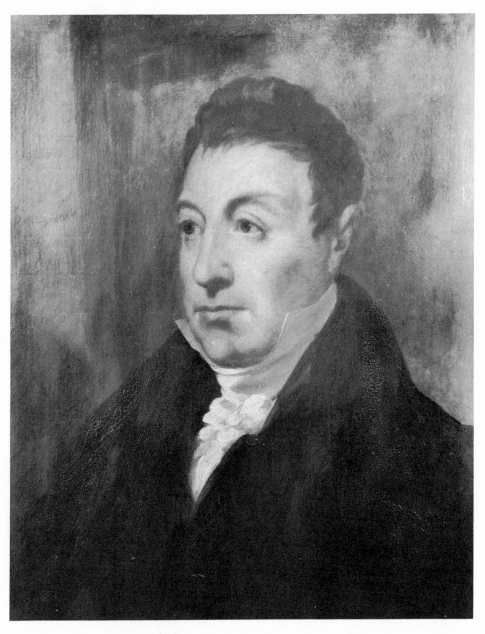

287 MARQUIS DE LAFAYETTE. Painting by Henry Cheever Pratt. *Courtesy The Massachusetts Historical Society.*

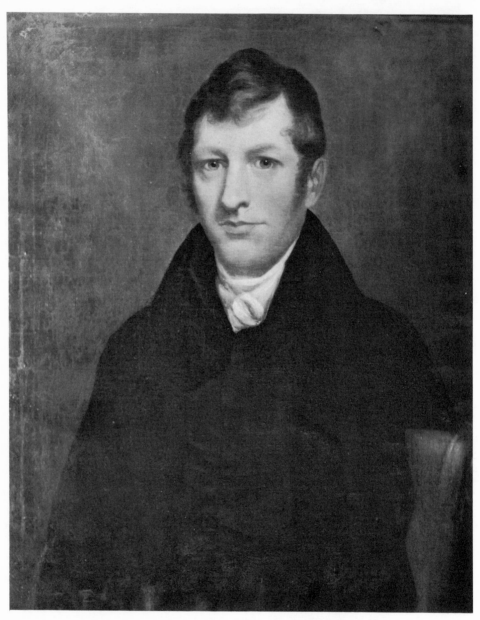

288 FRANCIS BROWN. Painting by Henry Cheever Pratt after the painting by Samuel
F. B. Morse. *Courtesy Dartmouth College.*

and are more generally known than others; I will only men-
tion those of Dr. Chapman, Commodore Barron, and the
Rev. Mr. Pilmore.

My previous pages have given particulars of Mr. Neagle's
visit to the place of his birth, (from which he was removed an
infant) and to the great portrait painter Stuart, of whom he
has said, "he treated me like a child."

Of his first interview with Allston, I have a memorandum
before me—"Mr. Allston, with whom I dined thrice at his own
house, was also kind; he took the pains to go to Mr. Stuart's
painting room to see my picture of him, compared it with the
life, and complimented me by his favourable opinion."

After the journey to the west, Mr. Neagle set up his esel in
Southwark, and worked, first at fifteen, then twenty, then twen-
ty-five and thirty dollars a head. His employment increased,
and he painted a half length of Robert Walsh, and other dis-
tinguished men sought him, though out of the city. In 1822,
he removed into town, and soon after raised his price to fifty
dollars a head. From this he has advanced to eighty, ninety,
and finally to a hundred dollars. Mr. Neagle is full of the love
of his art, ardent, industrious, and justly impressed with a sense
of the high and honourable stand his profession is entitled to,
and the conduct necessary in its professors.

HENRY C. PRATT—GEORGE CATLIN—1820.

This amiable and intelligent gentleman, *Henry Cheeves
Pratt*, was born at Oxford, New-Hampshire, on the 13th of June
1803. His instructor in painting was Samuel F. B. Morse,
(afterwards president of the National Academy of Design)
when that gentleman was practising in Boston, on his arrival
from his visit to and studies in London. In a letter which I
have seen, he says, speaking of Mr. Morse, "It is to the
liberality and kindness of that gentleman, that I am indebted
for the knowledge I have of the art." Mr. Pratt commenced
painting landscapes and portraits at New Haven, in 1823, and
continues the practice of both branches at this time in Boston.

Mr. Cole, our great landscape painter, travelled on foot
with Pratt over the White Mountains, both sedulously studying
the sublime of nature in those regions above the clouds. His
friend Cole speaks in glowing terms of his pure love of nature,
excellent good sense, and kindness of disposition. His por-
traits are well drawn, and possess much that is most valued
in that branch of art. His landscapes are uncommonly well
composed and executed, but somewhat deficient in colouring.

Henry Cheever Pratt,
1803–1880.

George Catlin, 1796–1872.

George Catlin, Esq., is a native, as I am told, of one of the eastern states, and was educated for the bar. What induced him to prefer painting I do not know: he probably, with Ranger, thought that law was "a damned dry study." I first became acquainted with him at Albany, when as a miniature painter he had gained the good will of De Witt Clinton, and was making an attempt in small oil painting of the governor. This was certainly very poor, but it led to greater things, for when the corporation of New-York city wanted to have a full-length picture of Clinton, as governor, he chose Catlin as the painter. His motive was undoubtedly praise worthy, as it must have been to aid the young artist, but he was wrong: the city of New-York was entitled to a portrait from a man of established reputation, if not from the best painter in the state, and Catlin was utterly incompetent. He has the distinguished notoriety of having produced the worst full-length which the city of New-York possesses.

Mr. Catlin is since better known as a traveller among the western Indians, and by letters published in the Commercial Advertiser. He has had an opportunity of studying the sons of the forest, and I doubt not that he has improved both as a colourist and a draughtsman. He has no competitor among the Black Hawks and the White Eagles, and nothing to ruffle his mind in the shape of criticism.

BINON—YENNI—J. PARKER—ROBINSON—1820.

J. B. Binon, *fl. c.* 1820.

Johann Heinrich Jenny (or Yenni), *fl. c.* 1820.

J. Parker. Cannot be positively identified.

John Robinson, ?–1829.

Mr. Binon was a French sculptor, who exercised his art in Boston in the year 1820. He executed a bust of John Adams of considerable merit, and was an early instructor of Horatio Greenough. *Mr. Yenni* was a Swiss artist, who painted street views in New-York. He went with Commodore Stewart as draughtsman to the Pacific Ocean.

J. Parker. A sufficient notice of Mr. Parker will be found in Stuart's biography. I remember him in New-York painting poor portraits.

Mr. Robinson was a miniature painter of some skill, who came from London and resided in Philadelphia for some years. He showed me a miniature of Mr. West, for which he said the old gentleman sat, and in the back-ground he represented a part of West's great picture of "Christ rejected." He came to America after 1817. He was then a man advanced in life, and he died about 1829.

WILLIAM STRICKLAND—GEORGE STRICKLAND—1820

William Strickland, 1788–1854.

George Strickland, 1797–1881.

I think I remember Mr. *William Strickland* when in the scene shop of the Park Theatre, a companion of Hugh

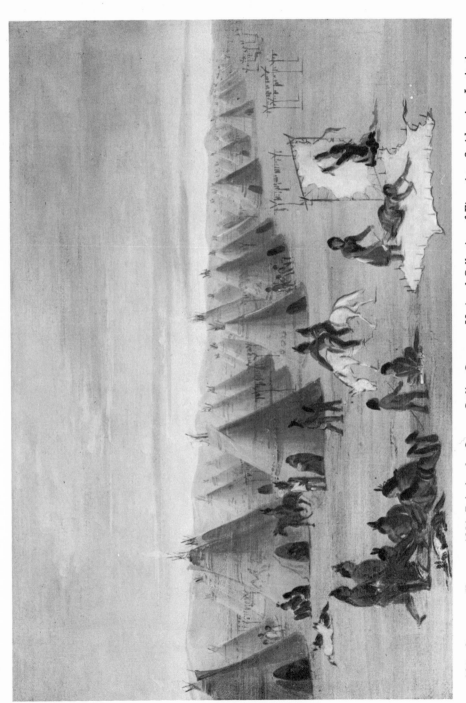

289 COMANCHE VILLAGE, 1834. Painting by George Catlin. *Courtesy National Collection of Fine Arts, Smithsonian Institution.*

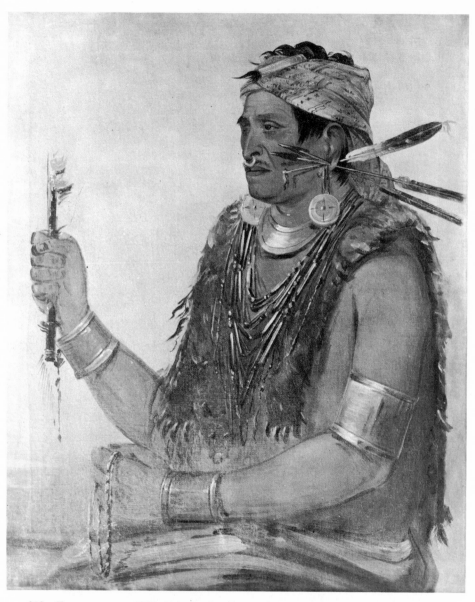

290 TENSKWATAWA, 1832. Painting by George Catlin. *Courtesy Smithsonian Institution, bureau of American Ethnology.*

Reinagle and a pupil of John Joseph Holland. When Holland rebuilt that theatre, Strickland's father was the carpenter. If I err, it is because Mr. Strickland is among the very modest artists, who do not choose to answer my inquiries, or assist my efforts to be accurate in the history of the Arts of Design. He has studied diligently—been to Europe to see the work of art, and stands high as an architect. He built the Bank of the United States, Philadelphia, after the model of the antique, the only model we have.

George is his brother, and also designs in architecture; he has taught architectural drawings in the Franklin Institute. Both reside in Philadelphia, and I believe are Americans by birth.

MAXIMILIAN GODEFROI—JOHN DORSEY—1820.

Maximilian Godefroy, c. 1770–c. 1837.

John Dorsey, *fl. c.* 1820.

Mr. Godefroi was a French gentleman and architect, who was driven to this country by the events of the French revolution, and married in Baltimore, where he resided many years. He finally returned to France, and is supposed to have been restored to his estates. Mr. Godefroi built the beautiful gothic chapel, at St. Mary's College, and the Unitarian Church, Baltimore. He designed and erected the Battle Monument, and in conjunction with B. H. Latrobe he built the Exchange of Baltimore. The design was Latrobe's. M. Godefroi was a candidate for building the United States Bank, Philadelphia; and in 1811 and 1813 he exhibited in that city many original drawings.

Mr. Dorsey is an architect of Philadelphia. He designed the gothic building in Chesnut-street and other conspicuous edifices.

E. PRUDHOMME—JAMES W. STEELE—1820.

John Francis Eugene Prud'homme, 1800–1892.

James W. Steele, 1799–1879.

Mr. Prudhomme was born in the Island of St. Thomas, and brought by his parents to New-York, at the age of eight years. He is a good draughtsman and engraver. He commenced working on his own account at the age of seventeen, and is now engaged in engraving for the National Portrait Gallery of Herring and Longacre, and has distinguished himself.

Mr. Steele is an Irishman, and engraves well in the line manner. I have seen an excellent print of his, from Mr. John Neagle's portrait of the Rev. G. T. Bedell, published in 1831.

C. V. WARD AND J. C. WARD.

Charles V. Ward, *fl. c.* 1829–1848.

Jacob C. Ward, 1809–1891.

These artists are, I believe, natives of New-York, and brothers. They both have painted landscapes for many years.

Both have merit. Their pictures have clearness, and many other requisites, but appear to me rather the imitations of art than nature.

CHAPTER XXVII.

T. Doughty, one of our most distinguished landscape painters—R. W. Weir—early life and various employments—Determination to make painting his profession—attempts a large picture—Voyage to Europe and studies at Florence and Rome—Horatio Greenough and Weir—return home—decided success in composition and landscape—marriage—removal to West Point—Robert M. Sully—studies with his uncle—visits Europe—return and establishment at Petersburgh—Miss Leslie—John Durand—Bowen—Bushe—T. S. Cummings—encouraged by Augustus Earle—pupil of Henry Inman and afterwards his partner—devotion to miniature—success—marriage—notice of a few of his pictures.

Thomas Doughty, 1793–1856.

THOMAS DOUGHTY—1820.

THIS gentleman was born in the year 1793, on the 19th of July, in Philadelphia.

Mr. Doughty says,—" At the age of fifteen or sixteen, I was put out with a younger brother to learn the " leather business," at which I served a regular apprenticeship, and pursued the business a few years afterwards. I attempted three or four paintings in oil during the latter part of my apprenship, but they were mere daubs, inasmuch as I had never received any instruction in oils, and I may as well add here perhaps, that the only instructions I ever received, were, I may say almost in my childhood at a most excellent school: our master used to allow those boys who evinced any talents for drawing, one afternoon in each week to practise, but without the aid of a master; he would inspect the drawings himself—but the time is so far back that I have no recollection as to the result of my studies; I merely remember the fact—that I did draw some at that time.

The other and only opportunity that ever occurred, was in the latter part of my apprenticeship, when I received one quarter's tuition at a night school in drawing in "Indian ink." The opportunities above mentioned no doubt implanted within my bosom a love for painting which only strengthened with my dislike for the trade I had learned; and contrary to the wishes of all my friends, I resolved to pursue painting as a profession, which, in their opinion, was a rash and uncertain step! my mind, however, was firmly fixed, I had acquired a love for the art which no circumstance could unsettle. I was then, I believe, in my 27th or 28th year, with a wife and child

291 MRS. PIERRE HURTEL (Felicia Victoria Dutustu). Miniature attributed to John
Robinson. *Courtesy Carolina Art Association. Photograph Frick Art Reference
Library.*

292 BANK OF THE UNITED STATES, PHILADELPHIA. Architecture by William Strickland. Engraved after a drawing by George Strickland. *Courtesy Dover Archives.*

to support; and I must confess, a dull and gloomy prospect as regarded pecuniary remuneration; but then I was consoled with the reflection, that in all probability my condition in life would be bettered. I knew also that I should be improving from year to year. Consequently my embarrassments would lessen as I acquired knowledge and practice."

Mr. Doughty has long stood in the first rank as a landscape painter—he was at one time the first and best in the country. He now resides in Boston, and has this year, (1834) in conjunction with Harding, Alvan Fisher and Alexander, got up a splendid and popular exhibition of the works of the four, much to the benefit of the company.

ROBERT W. WEIR—1821.

Robert Walter Weir, 1803–1889.

This gentleman has the high merit of making his way through difficulties which might have appalled a mind of less firmness, and likewise that of having, in the very hey-day of youth, resisted the allurements of pleasure in the witching land of Italy, allurements which, if yielded to, would have marred that fame and fortune to which he is destined.

In prosecuting this undertaking I have applied very generally to artists for information respecting themselves and others. I have found them ready to assist me, in giving accuracy and value to my work, very much in proportion to their standing as men and professors of the ennobling arts which have occupied their thoughts through life. The most worthy have been most frank, and among them is Mr. Weir. I shall make use of his letters by sometimes quoting his words, and sometimes mingling the knowledge communicated by him, with that appertaining to myself.

Mr. Weir says, " The lights and shadows of my early days, to use technical phraseology, were not well balanced, leaving little that I can now turn to with recollections of pleasure."

Robert W. Weir was born on the 18th of June 1803, at New Rochelle, in the state of New-York. His parents were in good circumstances, and the first ten years of his existence were passed without his experiencing any other sorrows than those which seem to be affixed to the period of childhood, by way of preparing us for the struggles of after life. Residing with his parents at his father's country seat, in New Rochelle, the period of infancy passed smoothly; but in the year 1813, a ruthless storm of misfortune came which blasted all his pleasant prospects. His father's mercantile business

failed, and in one year all his property went to satisfy creditors. " I was taken from the academy," Mr. Weir writes, " and placed in a cotton factory, where my thoughts were turned from books and play, to be chained to the steady and almost ceaseless motions of a spinning-jenny. I gained little credit, however, from my application, as I was never considered a good workman or very attentive to the duties required in waiting upon the machinery, and in eighteen months lost my employment by caricaturing one of the dignitaries of the establishment."

About the end of the year 1815, my father endeavoured to re-establish himself in business in the city of New-York, but his health had been undermined by misfortune, and he never recovered from the blow which deprived him of his wealth ; so that after some fruitless attempts, he gave it up in despair. He then offered his services to an extensive mercantile house, who appreciated his worth, and whose confidence he enjoyed until the time of his death. During the period of his hardest struggles, my father's anxiety respecting my education appeared to be one of his greatest troubles. The expense that he could so ill bear and yet incurred on my account, and the many inconveniences he was content to suffer for my future good, still harrow my soul when I think how little I have been able to give back in return."

If it were possible in youth to realize how delightful the remembrance of faithfully performed duties towards our parents would be to mature years, and how sharp the pangs of remorse, if conscious of a contrary course of conduct, how many youthful follies would be checked, and in how many instances would man be saved from ruin ! But not only ignorance of the future, but of the probable result of our actions seems to be the lot of youth. Many, and the writer is one, look back in old age, and feel as if in scarcely one occurrence of a long life they have done their duty—and more especially to parents. The words of Mr. Weir, still in the prime of life, are to me a proof that he has " given back in return" all that the exertions of a virtuous course of life has enabled him to pay to the authors of his existence.

Let him again speak for himself. " About this time a relative from Albany made us a visit, and observing my father's uneasiness on my account, offered, on condition that I should accompany him home, to complete my education at his own expense, provided nevertheless, that I should devote such portion of my time to his business as was not actually taken up by my studies, and this assistance was to be considered as

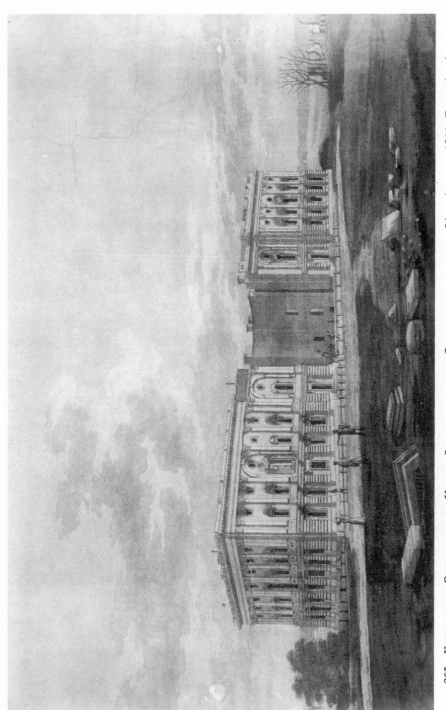

293 View of the Capitol of the United States after the Conflagration of the 24th August, 1814. Engraving by William Strickland after George Munger. *Courtesy Library of Congress.*

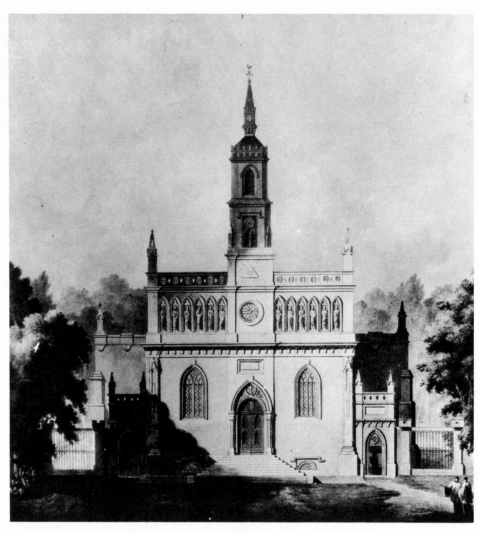

294 ST. MARY'S SEMINARY CHAPEL, BALTIMORE. Architecture by Maximilian Gode-
froy. Drawing by the architect. *Courtesy Library of Congress.*

an equivalent for my expenses. These preliminaries being agreed upon, we set out late in the fall of 1816, in a sloop bound for Albany; but on account of the ice could not proceed farther than Athens, where we arrived wearied with the tediousness of the passage, and determined to land and proceed to the first inn, where we might procure some mode of conveyance to our place of destination.

" Beside my uncle and myself there were three other passengers, who agreed to accompany us, and as the night was fine and clear and frosty, and the ground rang like mettle beneath our tread, we promised ourselves a pleasant exhilarating walk. With these feelings and under these agreeable auspices, we pursued our way for about two miles, occasionally hearing an anecdote, or a story of some bold deed of manly prowess, or tale of true love crossed, when we were suddenly and unexpectedly met by two heavy looking square-built pedestrians, dressed in sailor's attire, and accosted in the rough language of that peculiar class, with ' shipmates, how late is it ?' Immediately three watches were displayed, and the time given in answer. With an ' Umph' and thanks which sounded like curses, our ' shipmates' left us and proceeded towards the point from which we had started ; but it was not many minutes before we heard approaching footsteps in our rear, and upon turning discovered two figures on the summit of the hill we had just descended, darkly contrasted with the sky, which was lighted by the moon. The effect was instantaneous upon all—we started off like frighted deer at the utmost speed we could make, but finding myself left behind by the fleetness of my chivalric companions, (who had all been heroes in the stories they had told) and being incumbered with a bundle, upon which I placed too great value to part with, I determined to turn from the road at the first favourable place and conceal myself among the bushes until the rogues should pass. My retreat was scarcely made and my concealment effected before they came up, and stopping near the place, they struck their clubs upon the ground in great dudgeon, and with a few hearty curses upon the long legs of my uncle and his companions, they gave up the chase and returned leisurely back.

" It may be supposed that my mind was not inactive during the few moments of suspense after secreting myself. My thoughts turned to my uncle, who had left me without any apparent concern, to manage for myself; and when I had crept from my place of concealment and followed on to overtake my courageous companions, I could not help weighing the value my

uncle set upon the person and welfare of his nephew, and finding it light in the balance. I joined my fellow pedestrians, and without further danger or adventure arrived at the place of our destination, my affections a little cooler than when we started, and my uncle somewhat shy of the anecdote—which, by the way, I took much pleasure in telling, and not unfrequently made it the subject of a sketch, generally scratched on the blank leaf of some favourite book of my kind relative, not much to his delight or the increase of his affection to his nephew.

" My stay with my uncle was little short of a year, and the misery I suffered is indescribable; yet I endured it all rather than afflict my father with a knowledge of my unhappiness, which, in the end, was quick enough in finding its way to his ear, and my recall was then immediate. My father examined me as to my attainments, and I was found wanting, and again sent to school.

" It so happened that opposite the school-house, Mr. Jarvis had his painting room, and I frequently lingered about the door in order to get a glimpse at the mystery of his art; but after many fruitless attempts, I at length summoned courage enough to enter the precincts of his studio, and gratify my curiosity, while I asked his terms as if I wanted my portrait painted; but this was not in presence of the great man himself; Mr. Jarvis was not at home, and my inquiries were politely answered by his pupil, who kindly stated the different prices of the various sizes, and offered to sketch my head on Bristolboard for five dollars. This was my first interview with my friend Inman; and we little thought at that time that we should be better acquainted.*

" My father at length procured a situation for me in a respectable French mercantile house at the south, and in the fall of 1817 I bade farewell to my friends, and for the first time beheld my father's tears, as he placed me in charge of the captain of the vessel, which was to bear me from my native state. The influence of those tears was lasting, and I can safely say they saved me from many an error.

" I remained in this situation about eighteen months, when it was thought advisable to remove this branch of the concern and unite it to the main house at New-York. My services

* Mr. Weir says, " the first book on painting that fell in my way was Dryden's translation of Du Fresnoy, with notes by De Piles. I read it with enthusiastic delight; every word sank deep within me, and caused tears of joy, and shouts of ecstacy to escape at every page; my soul swelled with pure zeal for the art, and when I finished, I felt better and happier, and resolved to be a painter."

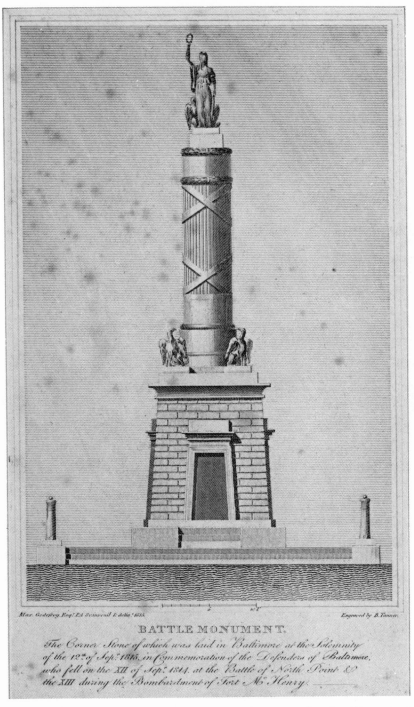

BATTLE MONUMENT.

The Corner Stone of which was laid in Baltimore at the Solemnity
of the 12.th of Sep.r 1815, in Commemoration of the Defenders of Baltimore,
who fell on the XII of Sep.r 1814, at the Battle of North Point &
the XIII during the Bombardment of Fort Mc.Henry.

295 BATTLE MONUMENT. Designed and built by Maximilian Godefroy. Engraving by
Benjamin Tanner after the designer's drawing. *Courtesy Dover Archives.*

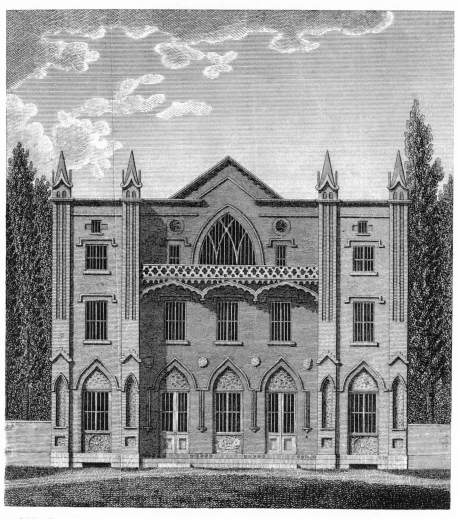

296 GOTHIC MANSION. Architecture by John Dorsey. Engraving by Benjamin Tanner after a drawing by Robert Mills. *Courtesy Dover Archives.*

were duly appreciated, and I had advantageous offers from two of the principal houses in the place, with one of which I closed, and after making a short visit home, was to return and take my place as head clerk.

" On my arrival at New-York, I found my father well, and my mother absent on a visit in the country. She was soon to return, and I went to the wharf hoping to meet her, having intimation of the time she was expected. I waited at the boat to receive her, and after all the passengers but one had gone ashore, was beginning to think of returning home disappointed; but not liking to leave the spot, without making some inquiry, I addressed myself to a lady who sat opposite, with a hat and veil which concealed her face, and who was apparently waiting for some one whom she expected. I had scarcely opened my lips, when she exclaimed, " My son ! is it indeed you ?" and burst into tears.

" My appearance must have been much altered, for I had suffered severely from a fever, previous to my embarking for home, and the disease still lingered on me. My mother could not think of again parting with me, and in her solicitude for my health, discovered a cancerous pimple on my face, which gave her much uneasiness. To quiet her fears, I submitted to a most painful operation, which confined me to a dark room and low diet for near two months, at the end of which time I felt as little inclined to leave home as my mother could wish.

"I now entered as head clerk in a mercantile establishment at New-York, and after three years had an offer of coming in as a partner. My father, however, dissuaded me from the terms; and, as I thought I never should amass property sufficient to commence on my own footing, I determined to turn my attention to something that did not require lucre for its capital. My fondness for sketching had often been displayed on sundry books and bits of paper in the vicinity of the desk and counting-room, and had rather been encouraged by my father, who, I must confess, heard my determination with surprise. At first he endeavoured to dissuade me from my scheme, but finding me resolved, he changed his views, and promised to help me as far as he was able.*

* " My first, and only instruction in the art, was received from Robert Cook, an English painter in heraldry, who sought employment in this country as a teacher of painting. He was a worthy man, and had seen something of art in his own country, but had not devoted much time to study; he consumed his precious hours in making fruitless experiments in search of some other and better vehicle than oil to paint with. I devoted from six to eight o'clock in the morning to study with Mr. Cook, three times a week, for three months, and the rest of the

" In the fall of 1821, I set myself seriously to work, and after several fruitless attempts, succeeded in making a tolerable copy of a portrait. At this time I became acquainted with Mr. Paff, who kindly lent me several pictures, which I took great pains, as well as pleasure in copying, and succeeded so well as to attract the attention of many connoisseurs of high standing.

" My fame as a copyist had reached Philadelphia, and during the fever of 1822, I received a commission from that city to copy a famous picture then exhibiting there, for which I received $200. This was my first commission. The copy afterwards went to New Orleans and sold for $1100, and subsequently was brought to New-York for exhibition, but being damaged on the passage, was withheld from the public, who may congratulate themselves on being spared their patience and twenty-five cents each.

" On my return to New-York, I made a small sketch of Paul preaching at Athens, which I offered to a gentleman of taste and apparent love for the arts, for the small sum of eight dollars, but he declined it, and Mr. Paff became the purchaser at five dollars, and the payment made in old prints. I was now solicited by the person to whom I had first offered it, to purchase the sketch back from Mr. Paff, as he was willing to give any sum under fifty dollars, and think himself happy in the possession of it; but its owner declined selling it on any terms, saying it was the best thing I had ever painted, or ever would paint.*

" After the praise which had been bestowed on the sketch of Paul preaching at Athens, I was induced to attempt the same

day attended to my business as clerk. I learned one salutary lesson from him which has been repeatedly confirmed by others—that time is too valuable to be consumed in making experiments, and I have contented myself with the knowledge of others, or have stated my views to some scientific friend, whose leisure enabled him to investigate the question, and waited patiently the result."

* "About three years ago, i. e. in 1830, and after my return from Italy," says Mr. Weir, " Mr. P. sold this sketch for fifty dollars, and the purchaser called upon me and wished to have a companion, repeating what Mr. P. had said respecting my ability to paint another as good. At the end of three days the second sketch was finished, (the subject of which was Peter and John curing the lame,) and was so much superior to the first, that Mr. P. contrived to purchase them back for a very high price, and still keeps them in his possession." The young painter called upon Mr. Trumbull after his long absence in Europe, and Trumbull showing Weir one of his early compositions, asked him if he remembered it. " Yes sir," said Weir, " and I remember that you bought it of Mr. Paff, and when I waited upon you, delighted to be noticed by the president of the American Academy, you told me I had better turn my attention to making shoes." This Weir has said made him sick for a week after; but the reception Morse received from the same person, when in London he waited upon him, a youth full of hope and encouraged by Allston and West, is still more characteristic: " You had better go home again."

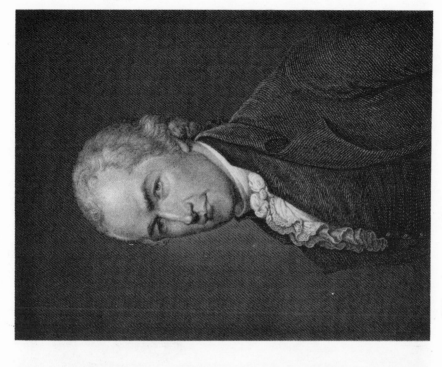

297B ALEXANDER HAMILTON. Engraving by John Francis Eugene Prud'homme after the painting by Archibald Robertson. *Courtesy Dover Archives.*

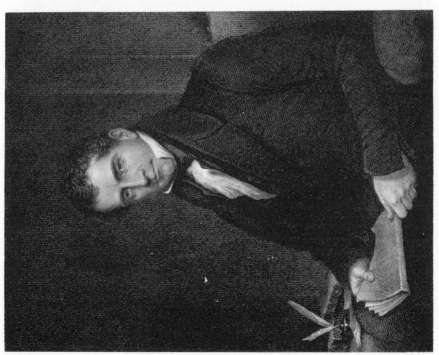

297A THEODRIC ROMEYN BECK, M.D. Engraving by John Francis Eugene Prud'homme after the painting by Robert Walter Weir. *Courtesy Dover Archives.*

298 BATTLE OF NEW ORLEANS. Engraving by James W. Steele after the painting by Samuel Seymour. *Courtesy Library of Congress.*

subject as large as life. This laborious undertaking occupied me about nine months, during most of which I was beating about through a sea of trouble, sometimes rubbing out whole platoons of figures, and at others, labouring hard to raise recruits for another obliterating sweep. Thus I worked on, occasionally dunned for rent of an attic in that part of the old alms-house, granted to the American Academy of Fine Arts, rent free by the corporation, for the purpose of encouraging the arts, and occasionally receiving a visit from some friend whose anxiety for my failure or success had induced him to climb ladders, ascending through trap-doors and working a dusty way through the rubbish which was stowed away in this garret, to the place in which I pursued my studies, in silence and solitude.

" At last this work was completed and publicly exhibited at Washington Hall. It attracted some little attention; but I believe chiefly because it was the work of a New-Yorker, and one who had never received any regular instruction in the art. I was however encouraged by compliments, to apply myself with redoubled ardour to the study of the art I had determined to pursue.

" I was convinced of the necessity of obtaining a knowledge of anatomy.* For this purpose I commenced a course under Doctor Post, and greatly injured my health by application to that branch of my profession. My next step was to learn Italian, for my hopes and desires now rested on and centered in Italy. I had determined to go, and, if by no other means, to work my passage over before the mast. I had now made some valuable friends, and among others, Henry Carey, by whose kindness and assistance I was enabled to realize the hopes I had entertained, and visit in comparative ease the land of art—the theatre where Michael Angelo, Raphael and Titian,

* "My first essay in the study of anatomy was rather ludicrous. I had been presented with the half of a barber's head, who had been executed about a week before for murder. It had been divided through the middle, and the tongue remained in my part. I wrapped it up in my handkerchief, and late at night walked home with it under my arm. The novelty of carrying such a commodity set my imagination to work, and thoughts arose on the way, respecting that unruly member, which had so often wagged fluent with lies, to please its owner's customers; and before reaching my father's house, my feverish fancy was so much excited, that I began to think it might wag again. Having reached my bed-chamber, I deposited the troublesome burthen in my trunk, and crept to bed; not to sleep—for the thoughts which had possession of my brain, and certain disagreeble odours emitted from the trunk pursued me, and after tossing about until two o'clock in the morning, I determined to get up and carry my treasure back. In my anxiety I had forgotten that every house must be shut at that time, and I wandered the silent and deserted streets until daylight enabled me to find my friend, who relieved me from my disgusting load."

and the host of other artists had figured, and left behind a school unsurpassed for simplicity and greatness of design.

" It had been an amusement for me occasionally to paint a picture, and, nearly obliterating it with dirt, to put it in the way of some would-be connoisseur, who, after examining it attentively, would pronounce it an undoubted work of some one of the old masters. I have several libels upon antiquity of this kind to answer for, and one in particular which had nearly lost me the friendship of a brother artist. I had called one morning, and found him delightfully employed in copying one of my antiques. 'What are you about, Tom?' I exclaimed. 'Ah!' was his reply, 'there's a jewel for you!—that's an undoubted original of Annibal Caracci.' 'An undoubted humbug,' was my rejoinder. Tom turned his dark eyes fiercely on me, repeating 'Do you doubt it?—do you doubt it?—why Mr. P. lent it to me yesterday, and at the same time told me it cost him $300.' 'Well Tom, I can only say, if you take that picture out of the frame, you will find on the lower edge of the panel, the initials of my name.' To satisfy himself he took it out, and there the little tell-tales were. The next day, Tom sent the picture home, with many thanks to the owner, and at the same time threw his copy into the fire. In the same manner I had copied some of Rembrandt's etchings so close as to be with difficulty detected, and was on the eve of turning my attention seriously to the publication of etchings from various old pictures in the possession of different gentlemen in New-York, but, like many other things of the kind, it fell through, after the first or second plate was finished.

" On the 15th of December, 1824, I bade adieu to friends and country, and after a tedious passage of sixty days, I found myself in Leghorn. It was my custom while at sea to sketch, and during the passage I had illustrated great part of Dante's Inferno. These sketches were not without merit, though some of them were rough enough, to be sure. After remaining a short time at Leghorn, during which I visited Pisa, and examined the works of art contained in the cathedral, and the curious frescos of the Campo Sante, I prepared for my departure to Florence.

" When I waited upon our consul for the necessary document to safe travelling, he said with apparent sincerity, ' Mr. Weir, I have a picture in the next room, and I should like to have your candid opinion of its merits. I have been offered $5000 for it, which I refused.' With some little ceremony I was ushered in, and after a nice adjustment of light, during which the pedigree of the picture was detailed—its loss—its

299 ENCAMPMENT ON THE SACRAMENTO. Engraving by James W. Steele after the painting by Alfred T. Agate. *Courtesy Library of Congress.*

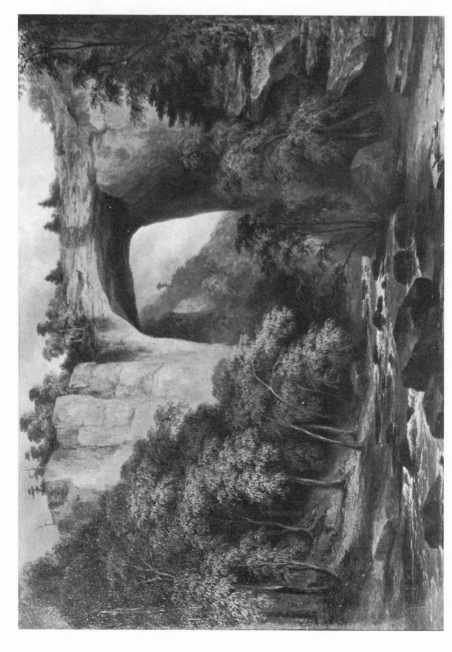

300 Natural Bridge, Virginia. Painting by Jacob C. Ward. Courtesy William Rockhill Nelson Gallery of Art, Atkins Museum; Nelson Fund.

miraculous discovery, which was effected simply by a small piece of blue drapery in one corner, the only part visible—and then the green silk curtain which hung before it was withdrawn, and a Venus of undue proportions was displayed. I was candid enough to say what I thought; but had no sooner expressed my opinion, than with a low growl the curtain passed before the picture, and my astonished ears were saluted with ' Sir, your passport is ready.' "

Artists are of course desirous to see good pictures, and are pleased to be invited by the owners, who thereby pay a compliment to the artist's judgment—but he frequently has to pay a cruel tax for the gratification he experiences. An anecdote told of Fuseli, shows how an older artist than Mr. Weir was, in 1824, managed in similar circumstances. A noble lord invited the painter to see a jewel of a painting, of which he was the happy possessor, and lauded it to the skies. Fuseli felt bound to go to the nobleman's house, and took a pupil with him. After the usual ceremony, the painting was displayed and the artist examined it, and ejaculated, " Extraordinary !" The owner reiterated its praises—pointed out its beauties— and still Fuseli cried " Extraordinary ?" After a decent length of time the painter and his pupil departed. On their way home, the pupil finding his master silent, said, " Mr. Fuseli, I don't think much of that picture—what did you mean by " extraordinary ?" " Extraordinary bad," was the reply.

I return to Mr. Weir's narrative. " At Florence, my first thoughts were to settle a plan of study. It had been my practice to affect a bold, dashing, apparently off-hand execution ; and the masters I most admired were those who excelled in embodying their ideas with the fewest touches, and those so nicely laid on as to express all that labour and high finish could accomplish. But after observing the early works of those very men so celebrated for their execution, I was surprised to find them in every instance, most minutely, even laboriously finished. It then struck me, that I had commenced where I should have left off, and with difficulty compelled myself to go through the drudgery of studying with the greatest care and precision ; that by doing so I might get the habit of expressing things with care, and at the same time with truth. It was no easy matter to throw off my loose habits, and it cost me some trouble to accomplish it; but when done, I took delight in studying nature in every detail, and the very dryness that I before despised, now pleased me as correctness and truth.

" The Chevalier Pietro Benvenuti was at this time occupied in painting the life of Hercules in fresco for the grand duke,

and as my ambition propelled to history, I contrived to become his pupil. The scene of study was in the Pitti Palace; but the slow process of plastering and tracing, staining, hatching and stippling was too tedious for me, and I conceived my time misspent in acquiring, what at home would perhaps never be required of me; I therefore left my witty master, and the society of gods and centaurs, and went to the fields to study nature as she is, content to take her with all her faults, and leave to others the colder and more circuitous route of approaching her shrine through halls of Grecian art.

" Among the acquaintance I made at the palace, was Madam D—, a lady of distinction, whose influence gained me several commissions, and among others one from the Princess Pauline. The subject was of a fanciful nature, and I was to have introduced her likeness, but illness deprived me of her sittings, and after several different appointments, she sent me her miniature as a substitute; but before I had time to use it, her death deprived me of the opportunity of fulfilling the commission. Another of my acquaintance, who appeared to take a great interest in my welfare, was a Mr. O—, a most rare specimen of Italian character: he was fawning, subtle, and vindictive, and took umbrage at my leaving Signor Benvenuti. Several little circumstances took place which sometimes irritated and sometimes soothed him, but at length he let me know that unless I left Florence, my life was in danger.

" On visiting different galleries with Italian artists, I was not a little surprised to hear them burst out in raptures when viewing the colouring of Titian and Paul Veronese. With unaffected delight they appeared to feel and enjoy the effect of good colour; but when they returned to their own studies, their cold leaden hues were but a sad apology for flesh, and contradicted the enthusiasm exhibited before the great masters of old. I was confident it was not because they did not feel what they talked so feelingly about, but suspected that their bad colouring was owing to their manner of study—to their continuing so long to work with chalk, and accustoming the eye to see nothing but light and shade. This rendered the eye unfit, or deceptive, when they took the brush in hand, and attempted to give colour at the same time with form. I have even gone home with some and endeavoured to show them what little I knew; and with one, who was painting a Narcissus, I painted the right arm with the reflection in the water for him; but with what success he finished the picture I cannot say—the last time I saw it he had not matched a single tint.

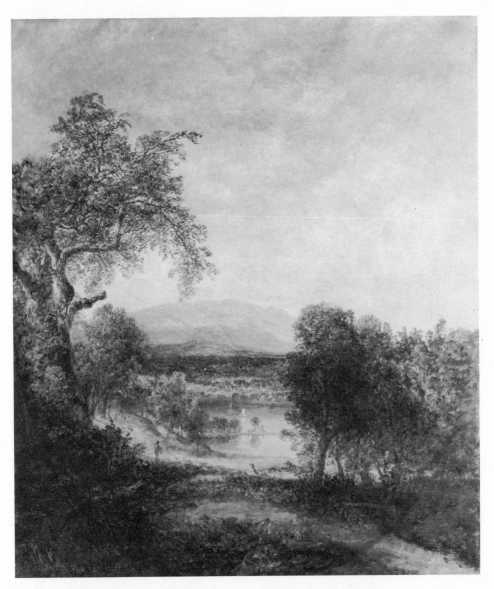

301 A RIVER GLIMPSE. Painting by Thomas Doughty. *Courtesy The Metropolitan Museum of Art, gift of Samuel P. Avery.*

302 ON THE SUSQUEHANNA. Painting by Thomas Doughty. *Courtesy The Pennsylvania Academy of the Fine Arts.*

His lights were too pink, his middle tint was warm, and his shadows too cold.

" It is the same with all of them from Camucini down, with the exception of Bozzioli, whose works have great brilliancy as well as depth and transparency; and may entitle him to the reputation of being the best colourist of the present Italian school. As for Camucini, who is certainly one of the finest draughtsman living, his colouring is deplorable—his flesh is cold and leaden, as well as his skies and back-grounds; and his draperies are nearly all positive colours, either scarlet, blue, or bright yellow; and composed in such a way as to offend the eye; their violent contrast destroying even that which we know to be good. His cartoons, however, are beautiful. They are finished compositions, as large as life, drawn with black and white chalk on a tinted ground. You do not feel the want of colour when looking at them—they are every thing you could wish—but when in the next room the finished picture is shown, you scarcely recognize the composition, so forcibly are some parts obtruded by strong and violent colour, while others, that in the cartoon appear as foreground objects, are weakened by cold and retiring tints. The habit too of working with small pencils is injurious to good colouring; and the charm of fine broad execution is seldom seen in the works of modern Italian artists. There is a lion hunt by Camucini from a picture of Rubens, painted entirely with quill brushes, and the same texture pervades the whole surface—hair, fur, flesh, are all alike.

I painted in Florence "Christ and Nicodemus," and the " Angel releasing Peter."

" I believe it was about the beginning of December, 1825, when I left Florence, and stopped a day at Sienna to examine the celebrated outlines in the pavement of the cathedral, and the works of Pinturichio in the sacristy, which by the way are very exquisite, and in a better state of preservation than anything of their time that I recollect to have seen; but as my face was set towards Rome, and my heart many leagues in advance, it constrained me to be satisfied with merely looking, when perhaps if I had made even the slightest sketch, it would have enabled me at this time to draw conclusions with nearly the same correctness as if I had the picture before me.—It is perhaps an error which young artists too frequently make of trusting their memory with too much, and paper with too little—even though the sketch be rough and hurried, it is better than none.

" A few days brought me to the gates of the great city of

art, where I entered most unpropitiously amidst hail and rain, but it did not prevent me from seeing the Colosseum, and some works of art before I retired for the night. Here I found our friend Greenough, who had lately arrived; and we soon agreed to take rooms together, which we happily procured on the Pincian-hill. Our home was situated opposite to that which had been occupied by Claude Lorraine, and between those known as Salvator Rosa's and Nicolo Poussin's. You may imagine that in the midst of such, to us "holy ground," our enthusiasm was not a little excited. There we set ourselves most industriously to work, and as you wished me to detail to you our mode of study, I will attempt it:

"We rose tolerably early, and either pursued some study in our own room, or went to the French academy and drew from the antique until breakfast time, after which we separated, Greenough to his studio, whilst I either went to the Vatican, or the Sistine Chapel, or some of the private galleries, that are liberally thrown open for the purpose of study. There I worked away until three o'clock, at which hour they closed. I then took a lunch, and either a stroll through St. Peter's, or the antique galleries of the Vatican, or went to the French academy and drew from casts, or to my own room, or in the fields, and drew from nature until six, which was our dinner hour. We then assembled at the Bacco di Lione, a famous eating-house, the dining-hall of which had been the painting-room of Pompio Battoni. It was in this room where he received Reynolds with the pompous salutation of "Well, young man, walk in, walk in, you shall see Pompio Battoni paint." The art had been long declining in Italy, and poor Battoni was the mere smoke after the last flame had flickered out. It served our imagination, however, and formed a part of that atmosphere of art which surrounds the student in Rome, that makes his lamp burn bright, and his enthusiasm strong.

"After dinner, or rather, after supper, all the artists met at a place called the Greek Coffee-house, where we had our coffee, and chatted until seven; at which hour the life-schools opened, and we separated, some to the French or Italian, and Greenough and myself to the English; where we studied from the life until nine o'clock, and then, if the night proved fine and the moon shone bright, we formed small parties, to go and dream among the ruins of imperial Rome. This formed our round of daily occupation; we lived and moved in art: it was our food, ready at all times, we had but to stretch out our hands and pluck what we wanted.

" The studies that I made from the old masters were chiefly from Raphael's frescos in the Vatican, the Prophets and Sybils of Michael Angelo in the Sistine Chapel, and Titian and the great colourists that were to be found in the minor collections ; the drawings from Raphael were made the size of the original ; those from Michael Angelo were reduced. My studies in colour were nearly all finished copies ; which I now regret, as I think too much time was consumed in making them, when sketches of the compositions of one colour merely, without entering into the minutiæ of tints, would have answered all the purposes as well, and perhaps better.

" There was much need of system in all this. I saw artists fly from one thing to another, without any apparent fixed principle. At one time they pursued a train of studies that appeared to lead them on, when they would stop short in the midst of apparent success and pursue an opposite course, in search of Flemish detail and finish ; which led them down to littleness, and consumed their time in learning the mere tricks of art. With much skill in drawing, among the Italian artists, there is a great deal that retards their progress as painters ; they continue too long with the port-crayon, and lose their eye for colour ; and when they take their palette in hand, and with the living model before them, they find it too much to embody both colour and drawing at once. Their productions are cold and heavy, and the beauty of the drawing lost, in a measure, under the leaden hues which a constant habit of seeing things only in black and white gives them.

" I recollect an observation that Etty made ; it struck me as being correct, and I have tried to adopt it. He said, ' as he intended to be a painter, and acquire some fame with the point of his brush, he thought it best to begin at once, and use it at all times and upon all occasions, in preference to any thing else.' Thus you would then get colour, drawing, and mechanical dexterity, which those who work with a hard point, such as lead or chalk, seldom or never attain, as painters.

" Another, and perhaps better reason, why the modern Italians do not excel in painting flesh, or giving a true texture to the different substances they wish to express. is, that they do not paint portraits, or copy individual nature, as they see it, but try to make all their figures Apollos or Herculeses, by bending nature to their preconceived notions of what she ought to be, as derived from casts and stone. It is this introduction of *art* that makes them reject nature as they find it, and substitute in the place of an easy development of her parts, the squared and flattened lines which they say constitutes *style*,

and makes their copy resemble the model in nothing but its latitude. There is one thing that has often surprised me ; it is, that those who set out in life with the purpose of acquiring an art to represent nature, after being but a short time in the presence of the works of the old masters, change their veneration for the mother of all good, to the works of the geniuses that have been, and thus copy nature at two or three removes; and which, if pursued, would, in a short time, reduce art to the lowest degradation and servility.

" I cannot help thinking, that those ' mighty Dutchmen,' as our friend Greenough used to call them, have done the art a great and lasting good : their simple imitations speak with the voice of nature, and teach us how to represent her.

" I made several compositions during my stay in Rome, with separate studies for each part ; but as my business was rather to collect materials, I contented myself with gathering into my portfolio such hints and studies as I thought would enable me to pursue my profession with advantage after my return. There was one study from the life, representing the back of a female, which I believe you have seen, but which unluckily got me into rather an awkward situation ; and to prevent the like from occurring again, I painted it out.

" My purse was barely sufficient for my support ; and once, when I indulged myself with the purchase of a suit of armour, I was obliged to retrench, and live upon ten cents a day, for near a month, before I relieved myself from the embarrassment it caused.

" After living near two years in Rome, I paid a visit to Naples, where Mr. Greenough had gone but a short time previous. Here I was joined by an English architect, with whom I made an extensive excursion to Pæstum, where we measured the temples, and made such notes as we thought would be of use : and on our return were joined by Mr. Greenough, who accompanied us to Rome. My intentions were, to have walked to Venice and returned home by way of France ; but the illness of a friend made me relinquish the idea, and embark with him from the nearest port. I had secret hopes of returning ; but my father had died during my absence, and circumstances of a domestic nature obliged me to remain.

" I have, however, until lately, cherished the thought of again seeing Europe ; but I am now married, and feel myself anchored for life, especially as I have some little kedges out, that have moored me to the soil."

Mr. Weir has been appointed to the situation Charles R. Leslie occupied at West Point, as teacher of drawing, in its

303 RED JACKET. Painting by Robert Walter Weir. *Courtesy New York State Historical Association, Cooperstown, New York.*

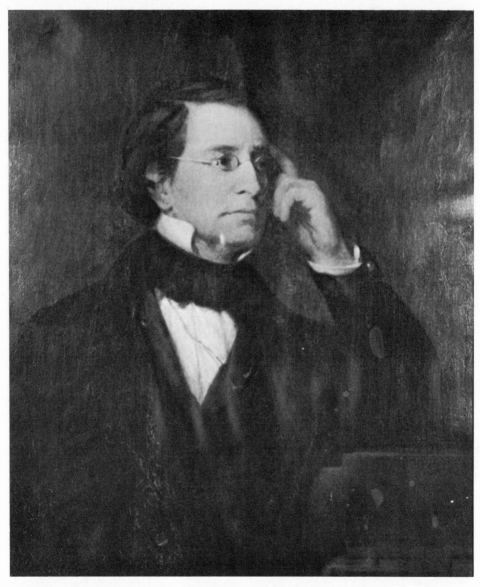

304 JACOB WHITMAN BAILEY. Painting by Robert Walter Weir. *Courtesy United States Military Academy. U.S. Army Photograph.*

various departments, to the cadets. This honourable station will not deprive us of his talents as a painter, the duties of the office leaving time for executing those compositions in which he delights.

Mr. Weir has produced a great many finished pictures since his return from Italy, several of which have been engraved. His "Red Jacket" is well known. This chief of the Senecas exhibited a fine specimen of savage manners when he came with his attendants, or companions of the forest, to the painter's room. He seated himself down on an ample arm-chair with the nonchalance of a superior, and his wild tribes-men surrounded him. A scene only to be found occasionally in our country—once their country. This picture is in the collection of Samuel Ward, Esq. and is too well known to need my eulogium.* Some scenes from Scott and Fennimore Cooper have employed Mr. Weir's pencil; but his last

* I have received a communication from Dr. J. W. Francis, on the subject of Red Jacket's interview with the painter Weir: I have room only for the following paragraph. " It becomes not me," says Dr. Francis, " to speak of the peculiar merits of the painting of Red Jacket, (Saguoaha, or Keeper-awake) by Weir.--- It is admitted, by the competent, to eclipse all other delineations of our Indian chiefs, and demands, as a work of art, no less regard than the subject himself, as one of pre-eminent consideration among our aborigines. The circumstances, however, which gave the artist the opportunity of portraying the distinguished warrior and great orator of the Seneca nation, deserve at least a short notice.--- An acquaintance of some years with Red Jacket, which was rendered, perhaps, more impressive in his recollection by occasional supplies of tobacco, led him to make an appointment with me to sit for his picture upon his arrival in the city. When he came to New York, in 1828, with his interpreter, Jamieson, he very promptly repaired to the painting-room of Mr. Weir. For this purpose he dressed himself in the costume which he deemed most appropriate to his character, decorated with his brilliant overcovering and belt, his tomahawk and Washington medal. For the whole period of nearly two hours, on four or five successive days, he was as punctual to the arrangements of the artist as any individual could be. He chose a large arm-chair for his convenience ; while his interpreter, as well as himself, was occupied, for the most part, in surveying the various objects which decorated the artist's room. His several confederates, adopting the horizontal posture, in different parts of the room, regaled themselves with the fumes of tobacco to their utmost gratification. Red Jacket occasionally united in this relaxation ; but was so deeply absorbed in attention to the work of the painter, as to think perhaps of no other subject. At times he manifested extreme pleasure, as the outlines of the picture were filled up. The drawing of his costume, which he seemed to prize, as peculiarly appropriate, and the distant view of the Falls of Niagara, (scenery nigh his residence at the Reservation) forced him to an indistinct utterance of satisfaction. When his medal appeared complete, he addressed his interpreter, accompanied by striking gestures ; and when his noble front was finished, he sprang from his seat with great alacrity, and seizing the artist by the hand, exclaimed, with great energy, 'Good ! good !' The painting being finished, he parted with Mr. Weir with a satisfaction apparently equal to that which he doubtless, on some occasions, had felt, in effecting an Indian treaty. Red Jacket must have been beyond his seventieth year when the painting was made : he exhibited in his countenance somewhat of the traces of time and trial upon his constitution; he was, nevertheless, of a tall and erect form, and walked with a firm gait. His characteristics are preserved

and best familiar subject is, his " Boat Club." Landscape
has occupied his attention much of late, and his improvement
in that branch 'of art is striking. His friend Gulian C. Ver-
planck has written some scenes, in a dramatic form, to accom-
pany one of the painter's landscapes, with figures representing
the march of the Constable Bourbon to Rome.

Robert Matthew Sully,
1803–1855.

ROBERT M. SULLY—1821.

This gentleman has frankly communicated the incidents of
his life, and in language I do not wish to alter. In answer to
my inquiries he says :—

" I was born in Petersburgh, Virginia, July 17, 1803. My
father you may probably remember as an actor, for many
years attached to the Charleston theatre. Between my ninth
and tenth year, not long after my father's death, I evinced
extreme fondness for drawing, which was increased if not ex-
cited by the sight of some of his drawings. When a youth
he received some instruction from Nasmyth, the celebrated
landscape painter of Edinburgh. I am certain that his talent
for that branch of the art (landscape) was very great. I have
sketches of his in my possession fully justifying my assertion.

" About sixteen or seventeen, I determined to become a
painter, in spite of the many difficulties and deprivations at-
tending the profession; all of which were prudently pointed
out by my friends. I was in my eighteenth year when I
visited Philadelphia for the purpose of obtaining instructions
from my uncle, T. Sully. Here my zeal, hitherto wasted in
ill-directed efforts, was for the first time applied to a proper
course of study. I was enthusiastic and worked hard, and I
think my progress was rapid. My obligations to my uncle I
shall ever remember with gratitude.

" I remained with him eight or nine months, and on my re-
turn to Virginia commenced professionally. ' A prophet hath
no honour in his own country.' I soon found that a painter
is generally equally unfortunate in the city of his residence.
I must not, however, omit the name of one of my earliest
patrons, Mr. J. H. Strobia of Richmond. I can apply the
term *patron* to him, as his kindness proceeded, I am convinced,

by the artist to admiration; and his majestic front exhibits an altitude surpass-
ing every other that I have seen of the human skull. As a specimen for the cra-
niologist, Red Jacket need not yield his pretensions to those of the most astute
philosopher. He affirmed of himself, that he was *born an orator*. He will long
live by the painting of Weir, in the poetry of Halleck, and by the fame of his own
deeds."

far more from the desire to encourage and assist me than from any wish to possess my works. I despise the canting term of patron as it is generally used, as much as I should the artist who could descend to apply it to those who, after all, give him merely the value of his services.

" My uncle's letters about this time were very encouraging, and strongly advised me to visit London as soon as possible. I felt a strong desire to follow his advice, and to assist my purpose, I visited several towns in N. Carolina, where I was successful.

" I determined to sail for England the following summer, and took passage from Virginia to London August 1st, 1824, and arrived September 23d.

" Hurled into this vortex of art, it was some little time before I could sufficiently recover from the excitement produced by the change, to commence a regular course of study.

" Of the living artists Lawrence became my first idol; but having remained some time in London, and carefully studied the works of Reynolds, my admiration for the former somewhat lessened. Nothing so delighted me as the pictures of Reynolds; and frequently (as some fine engraving from his works would catch my eye) have I reconciled myself to the loss of my dinner, and spent my last shilling to possess it.

" Jackson, the second portrait painter, I think surpassed Lawrence in *colour.* There is a fine rich tone in his pictures very like Reynolds; but he wanted the grace and elegance of Lawrence. I found none equal to Leslie and Newton in their peculiar walk. In the higher ranks of history, Haydon, Gitty and Hilton, I certainly thought inferior to Allston. A picture of the last mentioned artist was exhibited at the British gallery. (Jacob's dream.) My opinion originated from a sight of that exquisite production.

" In the course of my second year in London I painted a portrait of C. Beloe, the secretary of the British Institution. It was shown to the veteran in art, Northcote; it gained his approbation, although qualified by a very judicious criticism, which ended with his sending me an excellent picture by Sir J. Reynolds to copy; from which I derived much improvement. About this time I also painted a portrait of Mr. Northcote. The portrait of Mr. Beloe was exhibited the same year at Somerset House; that of Northcote, some little time after, at the Suffolk-street exhibition. My acquaintance with Northcote furnished me with much useful information respecting Reynolds, (his master) Opie, Gainsborough, and others.

It is to be regretted that young artists are not permitted to

copy in the different collections. In the Angerstein and Dulwich galleries, they are allowed to make sketches in water colours; but little improvement can be derived from that system of study.

" The older artists I found little disposed to aid their younger brethren in art, either by advice or the loan of their pictures. I must make one exception; Mr. Leslie was not only very kind in directing my studies and criticising my work, but in lending me many of his own studies. I sailed from Liverpool July 15th, 1828, and arrived in America in September, after an absence of four years."

Mr. Sully has performed the promise made by his early works. I have never seen either him or his paintings; but I have the testimony of those I confide in as to the merit of both.

Mr. Sully's portrait of Northcote gained him great credit in London, and was praised by artists and connoisseurs. I find in the " Inquirer" a notice of some copies made by Mr. Sully, which I copy on account of the subjects: " The painting of Pocahontas was brought from Warwickshire, England, about the year 1772, by Ryland Randolph of Turkey Island, in the county of Henrico, Virginia; and sold in 1784 by the administrator of the estate to Thomas Bolling of Cobbs, one of the descendants of the Indian princess." (So says a certificate, but certificates are very deceitful things.) " The original is crumbling so rapidly that it may be considered as having already passed out of existence." So much for immortality by the pencil! But, like men, one picture generates another in its likeness, and the graver and the press continue the existence of the artist and his work.

Anne Leslie (or Ann M. L.),
1792–after 1860.

MISS LESLIE—1822.

This lady's merit, as a painter, would have distinguished the name of Leslie in the fine arts, if her brother had not already placed it among the *most* distinguished of the present age. She was born in Philadelphia, a short time before her father and mother made that visit to England which has occasioned the claim made by that country upon Charles Robert. The father and mother of this highly-talented family of children, (for another sister has displayed graphic powers as a writer) were Robert Leslie and Lydia Baker; who visited London in 1793, taking with them the subject of this portion of our work, an infant, and returning to America with their children in 1799.

Miss Leslie, as well as her brother, showed her taste for

305 PORTRAIT OF POCAHONTAS, 1832. Painting by Robert Matthew Sully. *Courtesy State Historical Society of Wisconsin.*

306 Zachary Taylor. Painting by Joseph Henry Bush. *Courtesy The White House Collection.*

drawing when a child, but never painted, as a regular employment, until 1822, when on a visit to her brother in London. She then copied a number of his pictures, and two or three pictures by Sir Joshua Reynolds. She also painted occasionally portraits of her friends. Her first attempt in oil was a portrait from nature as large as life.

She returned to Philadelphia in 1825, with Mr. and Mrs. Henry Carey, her sister and brother-in-law ; and again visited her brother, in London, in 1829. Several of the copies she made after that time were engraved in this country for the Atlantic Souvenir. Her brother-in-law, Mr. Carey, possesses an admirable copy, which she made from one of Mr. Newton's best pictures ; the subject is from the Sentimental Journey.

We have seen, among other things, from the pencil of this lady, her copy from the " Sancho and Duchess" of her brother ; which is so admirably executed, that I should have pronounced it the original of Charles Robert.

ROBT. C. BRUEN—JOHN DURAND—BUSHE—1823.

Robert C. Bruen, *fl. c.* 1820.

John Durand, *fl. c.* 1820–*c.* 1822.

Joseph Henry Bush, *c.* 1794–1865.

Mr. Bruen was an apprentice to P. Maverick, with A. B. Durand, and afterwards practised engraving with great success, but became deranged ; and in the winter walked upon the ice of the river into the water and was drowned.

Mr. John Durand, a brother of A. B. Durand, was a most promising engraver. Originally a jeweller ; but, on taking up engraving, he appeared to make progress as by inspiration, under his brother's tuition : but death put a period to a progress which his brother thinks would have placed him at the head of the profession. He invented a machine for bordering bank-notes, which was used by Maverick, Durand, & Co. He died at the age of twenty-eight, after two years' application to engraving.

Of *Mr. Bushe* all I can say is, that finding there was an artist of this name, I wrote to my never-failing source of information, Thomas Sully, requesting some account of him.— His answer, dated 1833, is—" Bushe was befriended (I had almost said patronised, a word I hate as much as you do) by Clay—studied a short time in Philadelphia, and now pursues his vocation in the western country."

THOMAS S. CUMMINGS—1824.

Thomas Seir Cummings, 1804–1894.

Mr. Cummings was born in England, and brought to New-York an infant. He is the only child of Charles and Rebecca Cummings. The place of this gentleman's birth was Bath :

the time August 26th, 1804. Shortly after Thomas' birth his
father removed to Bristol, and from thence came to America,
when our subject was yet in early childhood. All Mr. Cum-
mings' ideas, except some very faint traces of Bristol, are
American. When he was about fourteen years of age, Au-
gustus Earle, the traveller and painter, came to New-York,
and took part of the house (as an office) occupied by the
father of Mr. Cummings. Earle saw the boy's drawings and
encouraged him to proceed. His father placed him at the
drawing-school of J. R. Smith, and in 1821 he was received
as a pupil by Henry Inman, who had but recently left the
guidance (as an artist) of Jarvis. During three years' study
with so excellent a master as Inman, Mr. Cummings became
a painter in oil and water colours, (or miniature) but prefer-
red, and of course succeeded best in the latter, which he had
made peculiarly his study. At the end of three years the
teacher and pupil entered into a partnership, which continued
three years, and a friendship was founded which is unbroken.
Inman devoted himself almost exclusively to oil painting,
leaving Cummings, in the year 1827, the best instructed
miniature painter then in the United States, by withdrawing
from that branch of the art altogether.

It will be remarked by any reader of this work, that a great
many of our eminent artists were born in Europe, brought to
this country in infancy, or when boys, and became artists as
well as Americans. We will here mention some, who, as well
as Mr. Cummings, are in this predicament. Charles R. Les-
lie, John Wesley Jarvis, Thomas Cole, Thomas Sully; and
even Charles Ingham was but a youth when he arrived in
America; and although well taught in the rudiments of the
art, has become the excellent painter he is since his arrival.

It is a most happy circumstance for a country so liable to
be flooded by emigrants, who are strangers to its constitution,
laws, manners, and customs, that the children of these stran-
gers, whose fathers are so apt to misunderstand us, all become
Americans, even though they first drew breath in Europe.
There may be some who imbibe prejudices from their parents,
and are but pseudo republicans, and "not to the manner" re-
conciled; but generally every man bred in America is a
democrat; learns to estimate worth by talent and virtue alone,
and not by fortune or descent; and to see that the democratic
system is not that which European sophists represent, a level-
ling by bringing down the few, but an equalizing, by lifting
up the many.

We do not know one artist (born in Europe, and educated
in America,) who is not an American democrat.

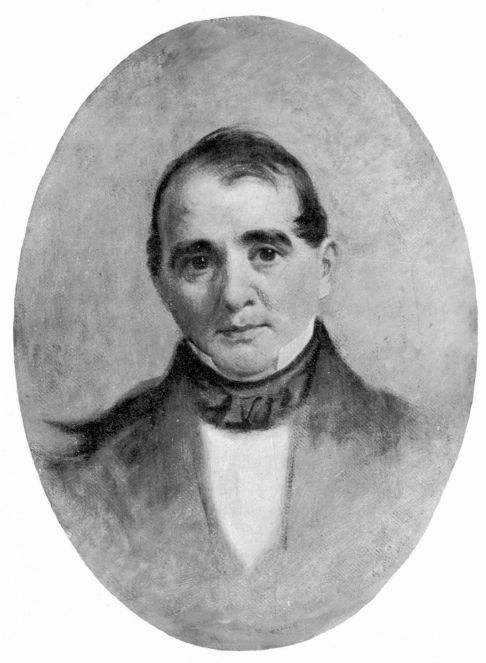

307 SELF-PORTRAIT. Painting by Joseph Henry Bush. *Courtesy The Filson Club.*
Photograph Frick Art Reference Library.

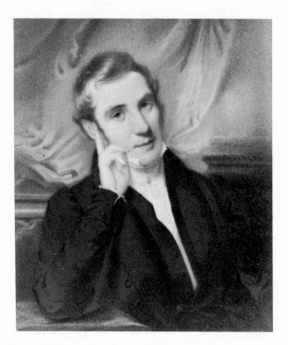

308 THOMAS COLE. Miniature by Thomas Seir Cummings. *Courtesy Yale University Art Gallery, Mabel Brady Garvan Collection.*

Portrait painting is vulgarly stigmatized as a branch of the art devoted to the gratification of vanity. I can say most conscientiously, that far the greater number of applicants for portraits are those who submit to the ceremony of sitting for the gratification of others; and the portrait painter has generally the satisfaction of knowing that he exerts his skill in behalf of the best feelings of our nature. The painter of miniatures has, perhaps, even more than the painter in large, this satisfaction; and although the painter in oil, and on a large scale, not unfrequently feels as if he stood higher than his brother, whose delicate and exquisitely touched work is dependent on more seemingly fragile materials, yet we know that the works of Trott and Malbone, Brown and Rogers, Shumway, Inman, Ingham, and Cummings, and the delicate productions of Miss Hall on ivory, have, and will for years to come, raise sensations in the bosoms of those who gaze on them, which may rival any excited by the works of their brethren, that are displayed in gallery and hall. The contemptuous expression of " a faded miniature," will often meet the eye; but I know that a miniature painted by an artist like Mr. Cummings, and treated as miniatures ought to be—that is, kept as we keep jewels, only for occasional gratification—will lose neither force nor freshness for centuries. The best portrait we have of one of England's greatest men, once a republican and always a friend to the most precious of liberty—' liberty of conscience,' Oliver Cromwell, is the miniature by Cooper.

Mr. Cummings stands, if not the first in his branch of portrait painting, certainly among the first, and by his liberality to younger artists, and his exemplary conduct as a man and a gentleman, must be looked to as one of those who are raising the Arts of Design to that station in public estimation which they claim as their right. He has long been one of the council and the treasurer of the National Academy of Design, and has delivered lectures on his art to the students.

Mr. Cummings is altogether an American artist: his success in his profession, and his early marriage, which has placed him in youth at the head of a large family, have prevented even the desire to visit Europe, except as every lover of art feels at times a wish to see the wonders of ancient masters. Mr. Cummings married in 1822, a young lady, born like himself, in England, and brought in childhood to our hemisphere, Miss Jane Cook. The marriage is happy, for the parties are virtuous. I have witnessed the correctness of Mr. Cummings' conduct as a man of business, and his filial piety to his parents. He is one of the few who may reflect through life

that he has fully repaid the trouble and anxiety which every good father experiences in his endeavours to forward the welfare of his children.

The reader must have noticed the essay on the theory and practice of miniature painting, which enriches this work ; that, and the sketch of the history of the art, are from the pen of Mr. Cummings. Among the many beautiful portraits which Mr. Cummings' constant practice produces, I will only mention those of Miss O'Bryan, Mrs. Cummings, Mr. H. Inman, and Mr. Hatch. These, and many others, will bear comparison with any works in that branch of the art.

────

CHAPTER XXVIII.

Lawson and Audubon—Audubon's autobiography—H. J. Mount—J. A. Mount A. J. Davis—study of architecture—partnership with Ithiel Town—buildings erected by them—J. B. Longacre—Horatio Greenough—Henry Greenough's letter—J. Fennimore Cooper's letter—chanting cherubs—statue of Washington—bust of La Fayette, and J. Fennimore Cooper's letter repecting it.

John James Audubon, 1785–1851.

JOHN JAMES AUDUBON—1824.

THIS very enterprising ornithologist and artist has attracted great attention by undertaking to publish from drawings and writings of his own on American ornithology, the figures in which are the size of life. How much science gains by increasing the picture of a bird beyond that size necessary to display all the parts distinctly, is with me questionable ; but the work of Mr. Audubon, as far as I have seen it, is honourable to his skill, perseverance and energy. It is gratifying to see the arts of design enlisted in the cause of science, and it is one of the many proofs of man's progress towards the goal intended for him. It has been observed that superstition, always the enemy of reason, is often the parent and the nurse of the fine arts. It would be more just to say that in the progress of man from barbarism to civilization, ignorance engenders superstition, and artful men enlist in her cause for a time those arts, which by diffusing knowledge will ultimately overthrow her. Science and literature become the allies of the fine arts, and in the ages to come, even more than in the present, art will be the friend and coadjutor of reason, the propagator of truth, and the support of religion. Public and private buildings will employ the architect, the sculptor, and the painter ; while the volumes which increasing knowledge produces will require decorations and illustration from the design-

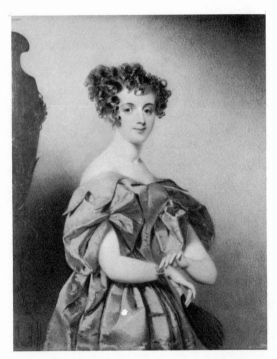

309 THE BRACELET: PORTRAIT OF THE ARTIST'S WIFE, JANE COOK. Miniature by
Thomas Seir Cummings. *Courtesy The Metropolitan Museum of Art, gift of
Mrs. Richard B. Hartshone.*

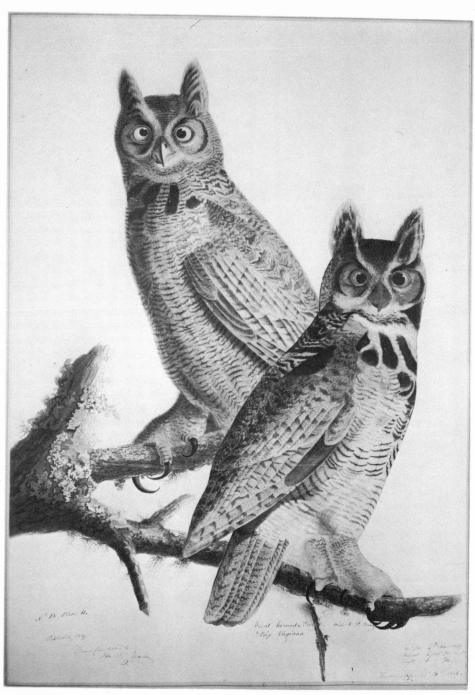

310 HORNED OWL. Watercolor by John James Audubon. *Courtesy The New-York Historical Society.*

er and engraver. In works on natural history we see the incalculable advantage of the arts of design to convey those images which words cannot present to the mind. For this reason I view the works of Mr. Audubon with a partial eye ; but my feelings in his favour have been damped by the exaggerated praises inserted in our public journals, and by the style of his biography, published and written by himself. However, it is my duty from such sources as are presented to me, to give a memoir of the artist ; and those sources are verbal communications with Alexander Lawson, the friend of Wilson, and jealous of, perhaps, even inimical to, Audubon, and Mr. Audubon's own account of himself, which may be considered as that of a friend.

I will first give the testimony and narrative of Lawson, who is undoubtedly biassed against the rival of his friend Wilson, but whose character places him above doubt as to the facts he states.

Lawson's account of his first knowledge of Audubon is as follows :　On a certain occasion, a well known quaker gentleman of Philadelphia, told his friend Lawson that a wonderful man had arrived in the city, from the back woods, (all the wonders come from the back woods) bringing paintings of birds, beautiful beyond all praise, coloured with pigments, found out and prepared by himself, of course a self-taught original genius. Lawson was at this time engraving for Charles Bonaparte's ornithology. One morning, very early, Bonaparte rouzed him from bed—he was accompanied by a rough fellow, bearing a port-folio. They were admitted and the port-folio opened, in which was a number of paintings of birds, executed with crayons, or pastils, which were displayed as the work of an untaught wild man from the woods, by Bonaparte, and as such, the engraver thought them very extraordinary. Bonaparte admired them exceedingly, and expatiated upon their merit as originals from nature, painted by a self-taught genius.

Audubon—for the " rough fellow" who had borne the portfolio, was the ornithologist and artist—sat by in silence. At length, in the course of this examination, they came to the picture of the " Horned Owl." Bonaparte, who had been liberal in admiration and commendation throughout the exhibition, now declared this portrait to be superior to Wilson's of the same grave personage. " It is twice as big," said the engraver. On examining it closely he thought, notwithstanding its size, that it had a remarkable resemblance to his friend Wilson's original picture of the same bird. " Come here, my

dear," said he to his daughter, "bring down the Horned Owl." It was brought, and Audubon's proved to be a copy from Wilson's, reversed and magnified.

Lawson told me that he spoke freely of the pictures, and said that they were ill drawn, not true to nature, and anatomically incorrect. Audubon said nothing. Bonaparte defended them, and said he would buy them, and Lawson should engrave them. "You may buy them," said the Scotchman, "but I will not engrave them." "Why not?" "Because ornithology requires truth in forms, and correctness in the lines. Here are neither." In short, he refused to be employed as the engraver, and Audubon departed with the admirer who had brought him. During this visit Lawson said that Audubon did not once speak to him. It appears that at this time Mr. Audubon's only plan was to sell the paintings.

After a time Charles Bonaparte came again to the engraver, bringing with him one of the pictures, which he said he had bought, and requested to have it engraved for his work. Lawson consented, but it was found too large for the book. Bonaparte wanted him to reduce it. "No. I will engrave it line for line, but I will not reduce it, or correct it in any part." He then pointed out the defects, showing that this and that part were untrue; concluding, "Let him reduce it, and I will engrave it." Soon after, Audubon came to the engraver with the same picture, and said, "I understand that you object to engraving this." "Yes, it is too large for the book." "And you object to my drawing?" "Yes." "Why so?" "This leg does not join the body as in nature. This bill is, in the crow, straight, sharp, wedge-like. You have made it crooked and waving. These feathers are too large." "I have seen them twice as large." "Then it is a species of crow I have never seen. I think your painting very extraordinary for one who is self-taught—but we in Philadelphia are accustomed to seeing very correct drawing." "Sir, I have been instructed seven years by the greatest masters in France." "Then you made dom bad use of your time," said the Scotchman.

"Sir," said Lawson, to the writer, "he measured me with his eye, and but that he found me a big fellow, I thought he might have knocked me down."

In the picture of the turkey, the engraver says that Audubon has given the bird a flat foot—the thumb or hinder claw flat—whereas in nature it is not and cannot so be used. "But that I am the engraver of Wilson's work," he continued, "I would expose this man."

In opposition to this, we know from Mr. Audubon that he was born in Louisiana ; we know that he has been well received and complimented in Europe ; and is well spoken of by many in this country. It is now some years since his visit to Mr. Lawson, and although his drawing might then be incorrect, his persevering and energetic character would surmount the deficiency. His knowledge and his skill would be constantly increasing.

Mr. Sully told me that Audubon, on his first coming to Philadelphia visited him, and expressed his desire to acquire the art of portrait painting, and become a portrait painter. That he took rooms near him and received his instructions, but was soon discouraged and gave up the pursuit. Sully considered him as a man of talents. This was in 1824. He offered remuneration for the instruction he had received, which was declined. Of his birds Mr. Sully spoke highly, saying they were very fine, particularly the red-bird and the " wren and her young." The date of the attempt to become a portrait painter agrees with Lawson's account of his arrival in Philadelphia, and with the date, the 5th of April, 1824, which Audubon, in his autobiography, gives as the time of his arrival in that city ; but he says nothing of his attempt at portrait painting, or Mr. Sully's instructions. He mentions M'Murtrie and Sully as friendly to him.

We will now refer to Mr. Audubon's published account of himself, which I could wish had less mystification about it. This autobiography is dated " Edinburgh, March 1831." The title page of the book gives us his name and titles, "John James Audubon, F. R. S. S. L. & E., &c. &c." He tells us, in the introduction to his ornithological biography, that he " received life and light in the new world ;" but this is little more definite than saying that he was born on the globe ; he leaves us to fix the spot between the north and south poles ; but I understand he gives New Orleans, or at least Louisiana as the place of his birth, and the United States of America as his country.

Mr. Audubon tells us that " the productions of nature" became his playmates, and he soon felt that intimacy with them, " not consisting of friendship merely, but bordering on frenzy, must accompany" his " steps through life." His father encouraged and instructed him in his study of nature—when or where we are not told. When a child he " gazed with ecstasy upon the pearly and shining eggs as they lay imbedded in the softest down." His wishes were, in childhood, all frenzy and ecstacy, and he says as he grew up " they grew with my form."

His father showed him pictures of birds, and he tried to copy them—"to have been torn from the study would have been death to me." "I produced hundreds of these rude sketches annually."

Notwithstanding this frenzy and ecstacy growing with his growth, we are told that he "applied patiently and with industry" to the study of drawing; and at the age of seventeen, after "many masters" had "guided his hand," he says he "returned from France, whither I had gone to receive the rudiments of my education." And then, at the age of seventeen, "my drawings had assumed some form. David had guided my hand in tracing objects of a large size."

"I returned," he proceeds, "to the woods of the new world with fresh ardour, and commenced a collection of drawings, which I henceforth continued, and which is now publishing under the title of ʻThe Birds of America.'" Thus it must appear that the collection of drawings publishing in 1831, was begun when he was seventeen years of age.

"In Pennsylvania," he says, "a beautiful state, almost central on the line of our Atlantic states, my father, in his desire of proving my friend, gave me what Americans call a beautiful plantation;" and here he "commenced his simple and agreeable studies." We next understand, from him, that he became a husband. That he tried various branches of commerce, and failed in them all. Twenty years passed in these commercial experiments, one of which, as I understand, was keeping a shop in Broadway, New-York, where he failed as in the others. His failures in commerce he attributes to his "passion for rambling and admiring those objects in nature from which alone," he says, "I received the purest gratification. I had to struggle against the will of all who called themselves my friends. I might here, however, except my wife and children. The remarks of my other friends irritated me beyond endurance, and breaking through all bonds, I gave myself up to my pursuits. I undertook long and tedious journies: ransacked the woods, the lakes, the prairies, and the shores of the Atlantic. Years were spent away from my family." And during all this time, he says, "Never, for a moment, did I conceive the hope of becoming in any degree useful to my kind." It appears, from this statement, that he had no object in view but self-gratification. To the importance of his studies, to the happiness of mankind, his mind was awakened by accidentally becoming acquainted with a prince, the *prince of Musignano.* On the 5th of April, 1824, Mr. Audubon arrived at Philadelphia. Dr. Mease was his

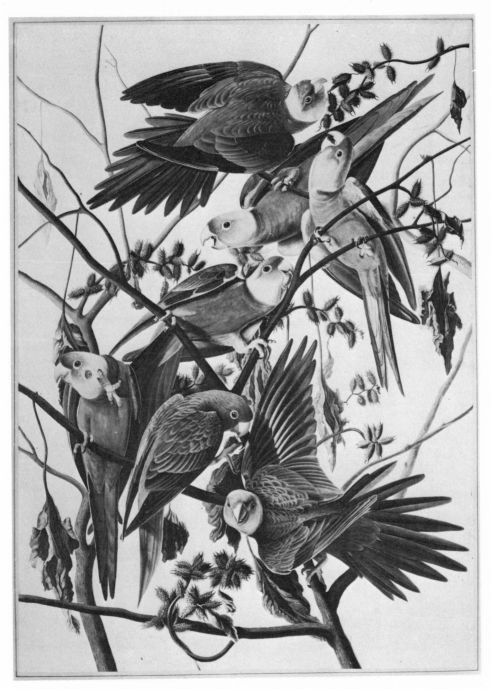

311 CAROLINA PAROQUET. Watercolor by John James Audubon. *Courtesy The New-York Historical Society.*

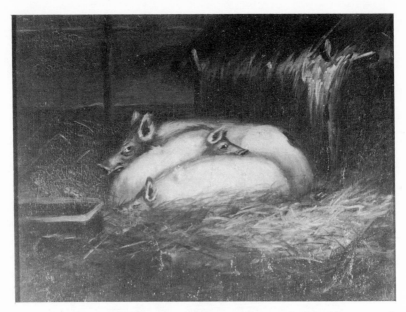

312A PIGS. Painting by Henry Smith Mount. *Courtesy Suffolk Museum at Stony Brook, Long Island, Melville Collection.*

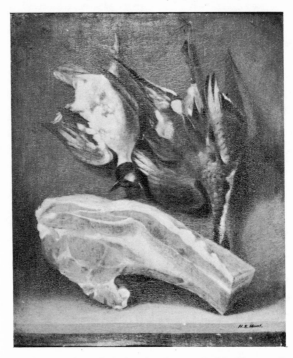

312B BEEF AND GAME, 1831. Painting by Henry Smith Mount. *Courtesy Suffolk Museum at Stony Brook, Long Island, Melville Collection.*

only acquaintance ; on him he waited and produced his draw-ings ; he introduced him to Charles Lucien Bonaparte, who introduced him to the Natural Society of Philadelphia. " The patronage I so much wanted," he says, " I soon found myself compelled to seek elsewhere." New-York receives him more kindly, and he glides " over our broad lakes to seek the wild-est solitudes of the pathless and gloomy forests." No notice of his attempt to become a portrait painter in Philadelphia. In the forests beyond the lakes he determines on visiting Eu-rope again. " Eighteen months elapsed. I returned to my family then in Louisiana, explored every portion of the vast woods around, and at last sailed towards the old world." It appears that he landed in England about the year 1826–7.

The autobiographer now digresses, and tells us his mode of drawing by the compass : and he tells us that he resided several years at the village of Henderson in Kentucky ; but at what period he does not inform us. He tells us, that leav-ing Henderson he absented himself from his family for several months, but had sent to them a box containing representations of " nearly a thousand inhabitants of the air." On his return he found that the rats had invaded the box and eaten all the paper birds. This produced insanity—positive madness for several days, " until the animal powers being recalled into action," he says, " through the strength of my constitution, I took up my gun, my note book, and my pencil, and went forth as gaily as if nothing had happened." In " a period not exceeding three years" he had " his portfolio filled again." This was, of course, if I can understand Mr. Audubon, before he conceived the design of being the benefactor of the human race by publishing his drawings.

We have seen that Mr. Audubon went to England in 1826, or 7. He tells us that America being his native country, he left it with regret, after in vain trying to publish his " illustra-tions" in the United States. " In Philadelphia, Wilson's princi-pal engraver, amongst others, gave it, as his opinion to my friends, that my drawings could never be engraved." We have seen what Lawson says on this subject.

Mr. Audubon landed at Liverpool, and the Rathbones, the Roscoes &c. took him by the hand—the drawings rejected in America, were received with praises at Liverpool ; and after-ward visiting " fair Edina," he met with equal success. Of England, he says, " I found all her churches hung with her glories, and her people all alive to the kindest hospitality." In Scotland, he was equally caressed, and he there commenced publishing his " illustrations." He acknowledges with great

propriety that to Britain he owes his success. " She furnished the artists through whom my labours were presented to the world. She has granted me the highest patronage and honours."

We have seen what Wilson, a modest unpretending man did for the science of Ornithology, and the skill he acquired as a draughtsman, without having his hand guided by *David* and many masters. We have seen that his merits were appreciated in America, although he did not call himself an American.

Before concluding the auto-biography, the author enters into a defence of the size of his plates. He praises his own candour as a writer—surely whether intended or not, he has exhibited a strange picture of himself—I may admire, but I cannot esteem such a man.

It was after his visit to Britain, and before his return to that country and the publication of his biography, that I had a few interviews with him, in the Lyceum of Natural History of New-York, and in my own painting room. If I did not become attached to him, it was not because he failed in compliments to my work. I saw the plates he then had with him, and admired them generally—some of them much—and I admired the energy he had shown, in so far accomplishing his purpose.

Henry Smith Mount, 1802–1841.

Shepard Alonzo Mount, 1804–1868.

H. S. MOUNT—SHEPARD A. MOUNT—1824.

These gentlemen are brothers, and brothers to Wm. Sidney Mount, hereafter mentioned. H. S. Mount, the elder, was devoted to sign painting, but distinguished himself by pictures of still life of great merit. He became a student of the National Academy of Design, and exhibited frequently in the gallery of Clinton Hall. Born at Setauket, on Long-Island, the son of a substantial yeoman. His early years were those of a " farmer's boy." He continues the business of sign-painting, with talents for a higher grade of art.

Shepard A. Mount has devoted himself to portrait painting, likewise a student of the National Academy, his efforts in the branch he has chosen promise success.

Alexander Jackson Davis, 1803–1892.

ALEXANDER JACKSON DAVIS—1825.

Is the son of Cornelius Davis, and was born in the city of New-York, July 24th, 1803.

Leaving school, at the age of sixteen, he accompanied an elder brother to one of the southern cities of the Union, where he became actively engaged at a printing-office, in composing types for the Daily Paper, of which his brother was

313 Found the Cow. Painting by Shepard Alonzo Mount. *Courtesy Suffolk Museum at Stony Brook, Long Island.*

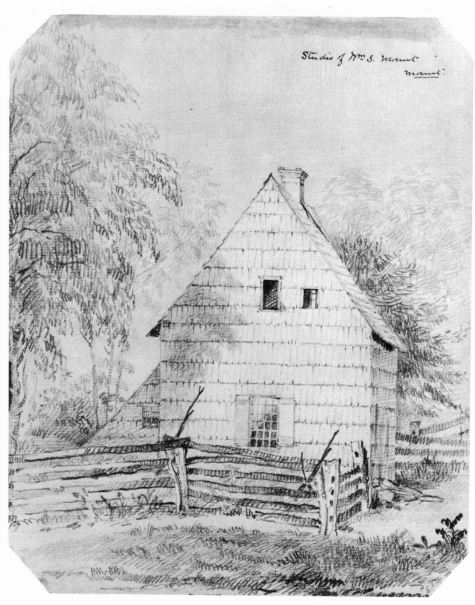

Studio of Wm. S. Mount
Mount:

314　STUDIO OF WILLIAM SIDNEY MOUNT. Pencil drawing by Shepard Alonzo Mount.
Courtesy The Metropolitan Museum of Art, gift of James C. McGuire.

the ostensible editor. Like another Franklin, strongly addicted to reading, he limited himself to the accomplishment of a fixed task, and being a quick compositor, he would soon complete it, and fly to his books, but not like Franklin, to books of science and useful learning, but to works of imagination, poetry, and the drama; whence, however, he imbibed a portion of that high imaginative spirit so necessary to constitute an artist destined to practise in the field of invention.

I have known him, says my informant, pass hours in puzzling over the plan of some ancient castle of romance, arranging the trap doors, subterraneous passages, and drawbridges, as pictorial embellishment was the least of his care, invention all his aim. His brother would often condemn such studies, and profiting by the salutary admonition of his fraternal counsellor, he occasionally directed his reading to history, biography and antiquities, to language, and the first principles of the mathematics.

At the age of twenty he left the printing-office, and returning to New York, a friend advised him to devote himself to architecture, as a branch of art most likely to meet with encouragement, and one for which, by the particular bent of his mind, he appeared to be well fitted. About this time, the *Antique School* was opened in the apartments of the Philosophical Society, where artists met to draw from the model. The National Academy of Design grew out of this association, and Mr. Davis was one of the earliest members. He now applied himself to perspective, the grammar of his art, made drawings of the public buildings of the city, for Mr. A. T. Goodrich the bookseller and publisher, and plans for Mr. Brady, architect, two of his earliest employers, and thus became gradually initiated into some of the first principles of his art. With Mr. Brady, at that time, says my informant, the only architect in New York he passed some time in the study of practical architecture, and classical antiquities. In the spring of 1826, he opened an office in Wall-street, as an architectural draughtsman, and furnished proprietors and builders with plans, elevations, and perspective views for public and private edifices both in town and country. Some of the first embellishments of the New York Mirror, also proceeded from his pencil.

Yet a tyro in his profession, in the winter of 1827 he went to Boston, and made many views of the principal edifices in that city for publication. A large view of the Boston state house, (a building by no means remarkable for its beauty, but distinguished by its character and location)

was the first to engage his attention. This view was drawn from actual admeasurement, and is to this day, says my informant, the finest specimen of lithography, in the class of architecture, yet produced on this side the Atlantic. Harvard University, the Market houses, and the Bunker-hill Monument also furnished subjects, and he made of each an excellent view.

Mr. Davis had not been long in Boston, before he attracted the attention of Dr. Parkman, and of Dr. Bigalow, whose beautiful models in architecture, and private collections were opened to him, and who invited him to study at the library and galleries of the Athæneum. Availing himself of the advantages so liberally afforded him at this noble library, then the only respectable one on the fine arts, in the western hemisphere, he continued in reading, extracting and study for two winters, when he returned to New York. In New York he published a large folio on the architecture of that city, a work already scarce, and lauded in Europe.

In February 1829, proposals were made to him by Ithiel Town, Esq., architect and bridge engineer, then recently from the east, and an association was formed under the firm of Ithiel Town and A. J. Davis, architects, and an office opened in the merchants' exchange for the transaction of business. In the immense library which Mr. Town had then ac-cumulated, and which has since increased so as to include every work on architecture, sculpture and painting, which Europe has produced, together with a great collection of engravings, Mr. Davis continues to enjoy a wide field for study, and the attainment of eminence. The many noble edifices of which he is the joint architect with Mr. Town, are now in the course of publication in the first volume of the " American Architect," a work of imperial quarto, edited by the artists themselves, and useful alike to the amateur and practitioner, exhibiting a series of sound precepts and perfect design. We may enumerate some of the most important of their works.

The state capitol* and episcopal church at New Haven, with the residences of James Hillhouse, jun.†, and A. N. Skinner, Esq.† in the outskirts of the same city.

A presbyterian church and the Town Hall at Middletown-street, with the residence of Mr. Russel.‡

* This capitol is in the form of the ancient Greek temple, and is of the Doric amphiprostyle species. The columns are between seven and eight feet in diameter. The material is brick, but this matters not, "form alone fastens on the mind in works of art, the rest is meretricious, if used as a substitute to supersede this grand desideratum."

† Ionic prostyle from the temple on the Ilissus.

‡ Corinthian amphiprostyle, from the monument of Lysicrates.

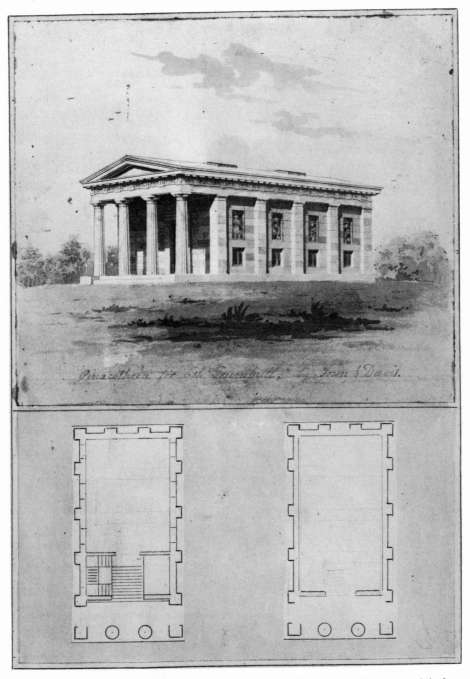

315 PINACOTHECA FOR COLONEL TRUMBULL, 1830. Watercolor drawing (original perspective view and plans) by Alexander Jackson Davis. Architecture by Town and Davis. *Courtesy Prints Division, New York Public Library, Stokes Collection.*

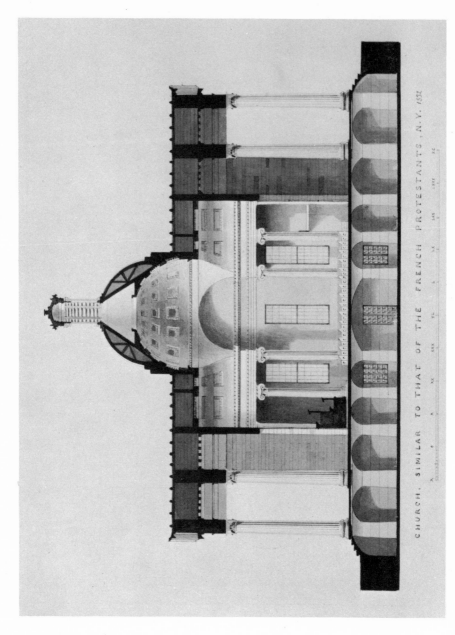

CHURCH, SIMILAR TO THAT OF THE FRENCH PROTESTANTS, N.Y. 1832

316 CHURCH SIMILAR TO THAT OF THE FRENCH PROTESTANTS, NEW YORK, 1832. Architectural watercolor by Alexander Jackson Davis. Architecture by Town and Davis. Courtesy The Metropolitan Museum of Art, Harris Brisbane Dick Fund.

The residences of Mr. Bowers,* and Saml. Whitmarsh, at Northampton, Mass.

The City-hall† at Hartford, Connecticut.

The church of the French Protestants‡ in the city of New York.—The West Presbyterian church.— Mr. Arthur Tappan's store, Pearl-street, in which granite piers were first introduced in New-York ; and Jones's-court, Wall-street, with the new Custom House,§ now in progress.

The capitol of Indiana, and the capitol of North Carolina, both of the Doric order ; and designs have been given for building to accommodate the several departments at Washington. — For a new patent office, and for improvements in and around the capitol of the United States.—Two or three designs for the University, one for the Merchants' Exchange, the Clinton Hall, Astor's Hotel, and very many residences. My informant thinks that many of these designs have suffered in execution by the hands of blundering workmen; and others have been tortured by the ignorance and self-sufficiency of proprietors or commissioners ; but all tended to advance the progress of legitimate art and taste in the land.||

J. B. LONGACRE—1825.

James Barton Longacre, 1794–1869.

This accomplished artist, who is not only a good engraver, but an excellent draftsman and portrait painter, was born in Chester county, near the birth place of Benj. West. At what time, Mr. Longacre, although he promised that and other

* Ionic amphiprostyle, from the temple of Erectheus.

† Doric amphiprostyle pseudoperipteral.

‡ Tetrastyle Ionic prostyle, with dipteral portico. This edifice is of marble, and the columns are four feet four inches in diameter, and thirty-eight feet high. The interior is in the form of a Latin cross, with a dome over the intersection, and the ceiling is supported by eight Ionic columns of the Erecthonian example, three feet in diameter.

§ Octastyle Doric, pseudoperipteral, with dipteral porticos, twenty-nine columns, five feet six inches in diameter, and thirty-one high.

|| Although omitted in chronological order, I take this opportunity of connecting the name of JOHN KEARSELEY with the subject of architecture, of which art he was one of the early practitioners in this country. He was a physician, and an amateur architect ; and gave the plan of the State-house in Philadelphia, which was begun in 1729, and finished in 1734. This building is endeared to Americans, as under its roof the independence of the country was resolved upon and declared, I saw it nearly in its pristine state in 1783, on the day of the seventh anniversary of the patriotic and heroic act. The bell which was heard in its steeple by the colonists, was inscribed with these words : " proclaim liberty throughout the land, and to all the people thereof ;" and it fulfilled its prophetic bidding, being the first to give tongue to the proclamation of July 4th 1776. The words are to be found in Leviticus, xxv. 10. Dr. Kearseley also gave the plan of Christ Church, Philadelphia.

information, has neglected to inform me. John F. Watson, Esq. author of the Annals of Pennsylvania and other works, saw his genius, and placed him with George Murray the engraver. Watson in a letter to me says, "I found him a country boy in West's neighbourhood, took him into my family and book store, and afterwards procured him a place as an artist with Murray the engraver in Philadelphia."

Some of the most faithful likenesses in the National Portrait Gallery, conducted by Longacre in Philadelphia, and Herring in New-York, are from the pencil of J. B. Longacre, and many of them engraved by himself. As an artist and a man, Mr. Longacre is among the most estimable.

Horatio Greenough, 1805–1852.

HORATIO GREENOUGH—1825.

I cannot do justice to the biographical sketch of this accomplished gentleman, and eminent sculptor, unless I publish without alteration the materials that have been put in my hands. And first the letter from the sculptor's brother, Henry Greenough, Esq., of Boston :

"Dear sir—In answer to your inquiries respecting my brother Horatio Greenough, although I shall confine myself to the points you mention, particularly, I shall endeavour to be communicative, so as to give you some choice of matter ; whatever I write, is with this view, hoping you will *prune with an unsparing hand,* as my brother, having learned from some source that the honour of a notice in your much desired work, was intended him, expressed a hope in a late letter to me that it might be confined, as far as possible, to a few facts and dates, "*A note to Allston's life,*" says he, "*might tell all of me which is essential. What is the use of blowing up bladders, for posterity to jump upon, for the mere pleasure of hearing them crack ?*"

"This passage I quote merely to apologize for the poverty of my communication, which, for your sake and the usefulness of your works, I could wish more valuable.

"He was born in Green-street, Boston, on the sixth of September, 1805. At an early age he was placed at school, to be instructed in the course of his studies in the branches necessary to fit him for a collegiate education. His instructors were changed from time to time as he advanced, or as more eligible situations presented themselves. Most of these were masters of country academies, at some distance from Boston. I myself recollect twelve different persons, under most of whom we studied together.

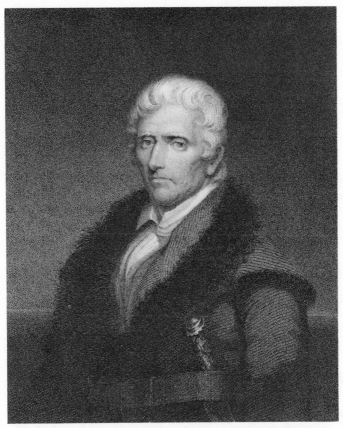

317　DANIEL BOONE. Engraving by James Barton Longacre after the painting by Chester Harding. *Courtesy Dover Archives.*

318 JOHN PAUL JONES. Engraving by James Barton Longacre after the painting by Charles Willson Peale. *Courtesy Dover Archives.*

" He was distinguisned for his proficiency in the classics, and especially for his excellent memory ; having once obtained a prize for having committed in a given time, more lines of English poetry, than any of his competitors by a thousand and odd. To mathematics he had always a repugnance, and made little show ; though the taste, I suspect, rather than the talent, was wanting.

" Being generally robust, and of an active and sanguine temperament, he usually entered with great ardour into all the games and amusements at school. In the athletic exercises, as running, jumping, and swimming, he excelled most of his age. But many of his amusements were of a nature to show a decided propensity for the profession which he finally chose.

" Although seeing an elder brother constantly engaged in drawing and painting, might have induced him to do the same, from mere imitation ; yet in the manufacture of his playthings, a love of the beauty of form early manifested itself. His schoolfellows often begged of him to carve them wood cimeters and daggers, as every one he made surpassed the last in beauty. I recollect in particular, a small pocket pistol of his manufacture, which was cast of lead, aud mounted on a very graceful formed stock, inlaid with flowers and ornamental work, of thin strips of lead, which had when new, the appearance of silver. On several occasions when detected in manufacturing playthings in school hours, his performances procured him praise for their ingenuity and beauty, instead of the intended reprimand.

" I might mention numerous instances of this kind, but will merely speak of one more favourite amusement. This was the manufacture of little carriages, horses, and drivers of bees-wax of different colours, which being very small, (the wheels of the circumference of a cent) were the admiration of all our visitors, from their beauty and delicacy. The carriages were formed on exceedingly graceful models, trimmed and lined with bits of silk and gold cord, and with the horses, which were very well modelled, had quite the air of the equipages of some lilliputian noble.

" A small room was, by the consent of our parents, appropriated for the manufacture and preservation of these articles, and invention soon suggested the idea of laying out, on long pine tables, estates for the supposed proprietors of these equipages. The houses and stables were laid out, as it were, on a ground plan merely, the apartments being divided, like pews in a church, by partitions, made of drawing paper, and

furnished with miniature articles of similar manufacture; and in this room, and with these puppets, adventures were dramatically gone through, with great enthusiasm, in play hours, for nearly two years, when the system having arrived at what seemed the " ne plus ultra," was abandoned for some new project.

" I have often heard him attribute his first wish to attempt something like sculpture to having constantly before his eyes a marble statue of Phocion, a copy of the antique, which my father caused to be placed, with its pedestal, as an ornament to a mound in the garden. His first attempts were made in chalk, on account of its whiteness and softness. He soon attempted alabaster, or rather rock plaster of paris (unburnt) with equal success; and within a few weeks of his first attempt he had been so assiduous as to transform his chamber to a regular museum, where rows of miniature busts, carved from engravings, were ranged on little pine shelves. I recollect, in particular, a little chalk statue of William Penn, which he copied from an engraving in the ' *Portfolio*,' from the bronze statue in Philadelphia. A gentleman who saw him copying, in chalk, the bust of John Adams by Binon, was so pleased with his success, that he carried him to the Athenæum and presented him to Mr. Shaw, I believe the first founder of the institution, and at that time the sole director. My brother was then about twelve years old, and of course was much edified by Mr. Shaw's conversation, who assured him, as he held the chalk in his hand, that there were the germs of a great and noble art. He then showed him the casts there, and promising him he should always find a bit of carpet, to cut his chalk upon, whenever he wished to copy any thing, gave him a carte blanche to the ' *fine arts*' *room*, with its valuable collection of engravings, &c. He may be considered from this time as studying with something like a definite purpose and with some system. The friendship of Mr. Solomon Willard, of Boston, soon initiated him into the mysteries of modelling in clay, which he had unsuccessfully endeavoured to acquire from directions in the Edinburgh Cyclopedia; and Mr. Alpheus Cary, a stone cutter of Boston, gave him a similar insight into the manner of carving marble, so as soon to enable him to realize his wishes in the shape of a bust of Bacchus. He profited much also by the friendship of Mr. Binon, a French artist then in Boston, going daily to his rooms and modelling in his company.

" His progress was so rapid, that his father no longer opposed his devoting most of his time to these pursuits; insisting

only on his graduating at Harvard University, Cambridge, on the ground that if he continued in his determination, a college education would only the better fit him for an artist's life. He accordingly entered college at the age of sixteen, A. D. 1821. His time was now almost exclusively devoted to reading works of art, and in drawing and modelling, and the study of anatomy—Professor Cogswell, the librarian of the university, assisted him in the former by a loan of a valuable collection of original drawings, as well as by his counsel and criticisms: and to Dr. George Parkman, of Boston, he was indebted for most of his anatomical knowledge, learned from *his* books, skeletons, and preparations. These are, however, not the only gentlemen to whom he was indebted for such real services, and of whom he always speaks with affection and gratitude: but as the object of the present communication is merely to trace the order of his studies and works as *an artist*, I have avoided mentioning any names excepting as tending to show how any main object of study had been effected.

" Notwithstanding the benefit he must be sensible of having derived from his studies at Cambridge, I have heard him say he estimated them little in comparison to what he obtained from the friendship of Mr. W. Allston, whose acquaintance he made at the house of Mr. Edmund Dana, the brother of Mr. R. Dana the poet. With Mr. Allston much of his time, during his junior and senior years, was spent. By him his ideas of his art were elevated, and his endeavours directed to a proper path.

" Towards the close of the senior year, a vessel being about to sail for Marseilles, he obtained permission from the government of the college to leave before the usual time, and his diploma was forwarded to him afterwards. He arrived at Marseilles in the first of the autumn, and proceeded directly by land to Rome. This was in 1825.

" The unbounded facilities afforded by Rome to a young artist, enabled him to carry into effect the plans of study he had formed under Mr. Allston's advice. His mornings were devoted to making careful drawings of the antique; his afternoons to modelling from the life some subject of his own composition, which enabled him to exert his invention, and bring into play the practice of the morning; and his evenings to drawing from the Nudo at the academy. Having letters to Thorwaldsen, he was enabled to profit by the visits which he so readily pays to young artists, to improve them by his criticism, or encourage by approbation. My brother often says,

however, that in the mechanical part of the art he learnt most from young fellow students.

"A young friend once complained to him, that for himself he could get no instruction from his master—' *When I ask him any thing about the management of my clay,*' says he, ' *he begins to talk about what a great man was Phidias.*' My brother advised him to be more frank in his communications with his fellow students, as they usually *take a pleasure in explaining how they overcame a late difficulty and communicating any mechanical expedient*—while the master, to keep up his dignity partly, and partly as being the subject of real interest to him, loves to discourse on general principles, and laud the powers of genius, to which it is natural he should wish his own success attributed.

"He had made many studies in chalks, *i. e.* crayons, and clays, and besides several busts of the size of life, had finished a model of a statue of Abel in Rome, (1825–6) when his studies were unfortunately suspended for a year or more, by his taking the malaria a little before the the termination of his first year. (1826.)

"The effects of this illness were so severe as to oblige him to return to America, after having made an excursion to Naples in company with some friends, who had kindly taken charge of him, but without any benefit to his health. He accordingly sailed from Leghorn for Boston, where he arrived in perfect health. His sea-sickness and consequent benefit of the sea air, having done for him what medicine had been unable to effect.

"About a year was now passed by him in America, the first five or six months at home with his father's family, where his time was spent in drawing and modelling. At the beginning of the winter he left home for the purpose of modelling the bust of President J. Q. Adams, at Washington ; besides the bust of Adams, he also modelled a likeness of Chief Justice Marshal, and on his way home modelled one or two busts in Baltimore.

"Soon after returning from Washington, he made arrangements for returning to Italy, for the purpose of executing in marble the several models for which he had commissions, and accordingly left us in the month of March, 1827.

"From Gibraltar and Marseilles he proceeded directly to Carraca, where he remained three months or more, during which time he finished two busts and saw others prepared. His design in thus settling for a time at Carraca, was, I believe, for the purpose of making himself thoroughly acquainted with all the details of preparing and finishing works of sculp-

ture, for which, Carraca, being the grand workshop of the Italian sculptors, gave him every opportunity.

" His next remove was to Florence, which he had fixed upon as his head quarters, on account of the advantages in the study of his art and its healthiness. During his first year there, he became in a manner the pupil of Bartolini, whom he still considers the first portrait sculptor in existence. A marble Venus, in the possession of Lord Londonderry has made the name of Bartolini deservedly honoured in England. His time, since then, has been fully occupied in the execution of commissions from his countrymen. These works are nearly all in America, and two of them are more generally known, having been exhibited, namely, the groupe of the *Chanting Cherubs*, belonging to J. Fenimore Cooper, and the *Medora*, belonging to Mr. R. Gilmor, of Baltimore. With the exception of one winter, spent in Paris, where he modelled busts of General Lafayette, Mr. Cooper and one or two other individuals, his time has been spent altogether in Florence.

" He is now almost exclusively occupied in the execution of the statue of Washington for Congress, only recreating himself occasionally by attending to smaller works.

" In giving you these facts I have endeavoured to be rather particular, as one is less likely to come to any false conclusions, when thoroughly possessed of any matter. It is scarcely necessary to add, that they are intended merely as memoranda, which I hope will be generalized as much as possible. If I have omitted any thing important, by your informing me of it, I can now answer you readily, and will do all in my power with great pleasure.

<div align="center">"I remain, sir, your obedient servant,</div>

<div align="right">" HENRY GREENOUGH."</div>

By the preceding letter the reader has seen that the studies of the young artist were interrupted by illness, before he had been quite a year in Rome. Robert W. Weir, Esq. of New-York, was his fellow student, though in different branches of the arts of design. To Mr. Weir I am indebted for some particulars relative to his interesting friend at this period. They occupied apartments and studios under the same roof, and the one modelled his clay and chiselled his marble in one apartment, while the other copied or composed with the crayon, or the treasures of the palette. All around was classic ground— they studied where Poussin and Claude, and other immortal names had studied before them. But they were too ardent and indefatigable in their studies, and Greenough's health was sink-

ing. The season of malaria approached, and the sculptor re-
tired from Rome and labour for a short time. His more fortu-
nate companion remained with unimpaired strength, partly ow-
ing to a greater diversity in his various occupations, more exer-
cise and air as he visited and studied in the various galleries
of paintings, while Greenough exhausted himself by incessant
study at home, from hired models either in drawing or model-
ing through the day, beside visiting the academies for drawing
in the evening, and often rising in the night to resume his la-
bours.

Weir, left sole possessor of these ample apartments, and
knowing that ten dollars the month was an expense too great
for his funds, removed to a less fashionable quarter of the im-
mortal city, and took apartments at four dollars the month.
When Greenough returned, not finding accommodations under
the same roof, he established his studio and apartments in ano-
ther quarter, and the friends were thus separated. This sepa-
ration operated with his incessant application to produce an
alarming state of body and mind in the sculptor. His strength
declined, and he became melancholy.

One day, the woman who had charge of Greenough's
apartments came to Weir, saying, "I wish, sir, you would come
to Signor Horatio, for he is very miserable. I wish you had
not been separated from him." The painter found his friend
declining fast, and very much dejected. He removed to his
apartments, and undertook the office of nurse. Medical ad-
vice recommended change of air, and Mr. Weir abandoned his
studies, and accompanied his friend to Naples. His complaint,
originating in indigestion, caused by his sedentary employ-
ment and anxious exertions, did not yield to change of place,
and it was determined that he should return home. Weir de-
termined to accompany him, and gave notice to the sufferer's
family of the weak and alarming state in which he would be
presented to them. They embarked at Leghorn, the young
painter taking sole charge of his friend, a year younger than
himself, and provided with medicine and medical advice. The
voyage had a happy effect, and Mr. Weir had the pleasure of
restoring his friend to his family in Boston, in a condition very
different from that his letter had led them to expect. As we
have seen by the letter of the sculptor's brother, he remained a
year in America, and when passing through New-York to
Washington, he was introduced to me.

On his return to Italy he made Florence his head quarters,
and when my friend James Fenimore Cooper and his family
visited that city, he was introduced to his young countryman

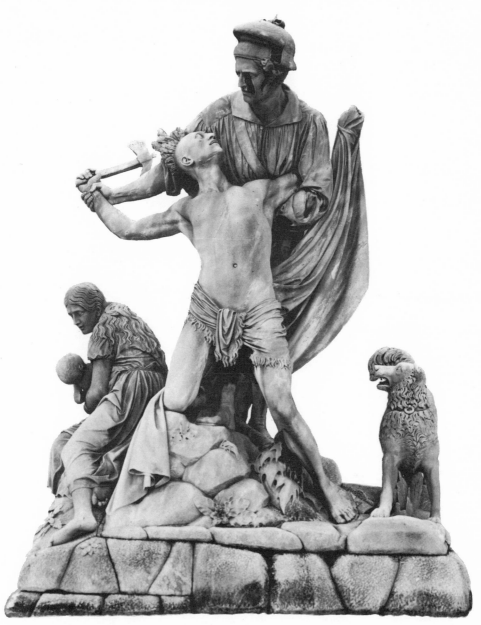

319 THE RESCUE GROUP. Sculpture by Horatio Greenough. *Courtesy Architect of the Capitol.*

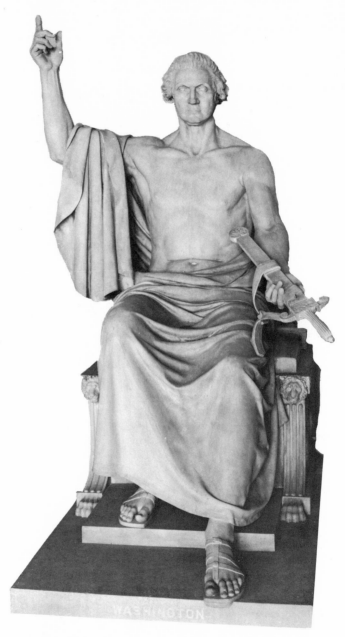

320 GEORGE WASHINGTON. Sculpture by Horatio Greenough. *Courtesy National Collection of Fine Arts, Smithsonian Institution.*

Greenough, and necessarily was pleased with his appearance, manners and conversation. He had then executed only busts in marble, and had few or no orders. He was pursuing his studies diligently, designing and modelling—executing some heroic fancy by moulding it in clay, and dismissing it again by dashing the fabric to pieces. The English and American travellers passed him by, to employ Italians—orders came from America to inferior artists—but Greenough was an American.

Some of the young ladies of Mr. Cooper's family in the course of their studies were copying a print from a picture of Raphael, in which were two cherubs singing. Fenimore saw with regret the neglect Greenough experienced, and was convinced that if he had an opportunity of executing a figure, or, still more to show his powers, a group, it would bring him into notice; and the thought of the chanting cherubs struck him, as a group of great beauty, and suited to Greenough's taste. He gave him the order, and the young sculptor, only having the print before him, which the young ladies had been copying, produced the lovely group which we have seen. The effect of raising a name for Horatio Greenough was produced; and to produce a greater effect, by convincing Americans that they had a countryman superior in talent and skill to the Italians they were employing, Cooper sent the group home to be exhibited. This is the first group from the chisel of an American artist.*

When this beautiful group had been a sufficient time in America to become known, Mr. Cooper conceived the hope of influencing the government to employ Greenough on a statue of Washington for the capitol. He accordingly wrote to the

* *Extract from a letter from Mr. Cooper, published in the New-York American of the 30th of April,* 1831.

Most of our people who come to Italy employ the artists of the country to make copies, under the impression that they will be both cheaper and better, than those done by Americans studying there. My own observation has led me to adopt a different course. I am well assured that few things are done for us by Europeans, under the same sense of responsibility, as when they work for customers nearer home. The very occupation of the copyist infers some want of that original capacity, without which no man can impart to a work, however exact it may be in its mechanical details, the charm of expression. In the case of Mr. Greenough, I was led even to try the experiment of an original. The difference in value between an original and a copy, is so greatly in favour of the former, with any thing like an approach to success, that I am surprised more of our amateurs are not induced to command them. The little group I have sent home, will always have an interest, that can belong to no other work of the same character. It is the first effort of a young artist, who bids fair to build for himself a name, and wh... e life will be connected with the history of the art in that

president, and to Mr. McLane, the secretary of the treasury, strongly urging the honourable plan of a statue of the American hero, by the first American sculptor who had shown himself competent to so great a task. Fenimore Cooper's wishes were realized, and a law passed, by which Greenough is commissioned to execute a statue of Washington for the capitol.

In a letter to Mr. Greenough I asked for information relative to himself for this work, and this is his answer:—

" Florence, Dec. 1st, 1833.

" Dear sir—Your letter, introducing Mr. Fay, was presented to me by that gentleman, in person, the day before

country, which is so soon to occupy such a place in the world. It is more; it is probably the first group ever completed by an American sculptor.

The subject is taken from a picture in the Pitti Palace at Florence, and which is well known as La Madonna del Trono. The picture is said to be by Raphael, though some pretend to see the work of one of his scholars in the principal figure. The Virgin is seated on a throne, and the principal subject is relieved, according to the fashion of that day, by cherubim and angels, represented as singing or sounding the praise of the infant. We selected two little cherubs, or rather two infant angels, who are standing at the foot of the throne, singing from a scroll, to be transferred to the marble. They are as large as life, if one may use the term on such an occasion, and are beautifully expressive of that infantine grace and innocence, which painters love to embody in those imaginary beings.

I left Florence for Naples before the work had commenced in marble, and I can only speak of it, as I saw it in the plaster. In that state it was beautiful, and I can safely say, that all the time I was in Italy, I saw no modern work of the same character that gave me so much pleasure on account of the effect. It was universally admired, and really I think it deserved to be so.

In the picture, these angels were accessories, and when they came to be principals, it was necessary to alter their attitudes. Then the painter could give but half the subject, whereas the sculptor was obliged to give all. Again, the former artist was enabled to produce his effect by the use of colours; while the latter, as you well know, is limited to lights and shades. Owing to these differences between the means and the effects of the two arts, Mr. Greenough had little more aid from the original than he derived from the idea. Perhaps the authority of Raphael was necessary to render such a representation of the subject palatable in our day.

I think you will be delighted with the expression of the youngest of these two imaginary beings. It is that of innocence itself, while it is an innocence superior to the feebleness of childhood. It represents rather the want of the inclination than of the ability to err, a poetical delineation of his subjects in which Raphael greatly excelled, and which, in this instance, has been certainly transferred to the marble with singular fidelity and talent.

Agreeably to the conditions of our bargain, Mr. Greenough has the right to exhibit this little group for his own benefit. I hope that the peculiarity of its being the first work of the kind which has come from an American chisel, as well as the rare merit of the artist, will be found to interest the public at home.

 * * * * * * *

Yours, truly,

J. FENIMORE COOPER.

Dresden, July 29, 1830.

yesterday. You will be happy to learn that he has entirely
recovered his health. He has taken a comfortable and plea-
sant apartment for the month. I look forward to the winter
with less dread, in hopes of enjoying his society. I beg you
will rest assured, that my best services, in behalf of any friend
of yours, are at your command. The nature of my occupa-
tions prevents me from personally assisting strangers here so
far as I could wish ; but I can always command a few mo-
ments, to attend to the necessary, the indispensable.

" I thank you for the opinion you express of what little I
have done in the art of sculpture : I have not yet had the time
to do much. I fear that the circumstances under which I be-
gan my career will ever prevent me realizing my idea of what
sculpture should be. Still the effort may be useful to future
artists, and yield some works of a relative and special value.
I cannot pretend to occupy any space in a work consecrated
to American art. Sculpture, when I left home, was practised
no where, to my knowledge, in the United States. I learned
the first rudiments of modelling from a Frenchman, named
Binon, who resided long in Boston. My friends opposed my
studying the art ; but gently, reasonably, and kindly. It
would require more time than you would find it profitable to
spend, to listen to the thousand accidents that shaped my in-
clination to the study of this art. I might perhaps interest
you more by mentioning the many instances in which I have
been comforted, assisted, advised, induced, in short, to per-
severe in it, by acquaintance and friends. I could tell you
of the most generous efforts to assist me, on the part of men
who scarcely knew me—of the most flattering and encourag-
ing notice by elegant and accomplished women—but I might
hurt or offend those who have so kindly helped me ; and (what
I shrink from also for myself,) I fear there would be a fearful
disproportion between the seed and the fruit.

" Mr. Cogswell, who now keeps an academy at Northamp-
ton, contributed perhaps more than any one to fix my purpose,
and supplied me with casts, &c. to nurse my fondness of sta-
tuary. Allston, in the sequel, was to me a father, in what
concerned my progress of every kind. He taught me first
how to discriminate—how to think—how to feel. Before I
knew him I felt strongly but blindly, as it were ; and if I
should never pass mediocrity, I should attribute it to my ab-
sence from him. ` So adapted did he seem to kindle and en-
lighten me, making me no longer myself, but, as it were, an
emanation of his own soul.

" Dr. J. Parkman, during my sophomore year, proposed to assist me in obtaining some knowledge of anatomy. He supplied me with bones, preparations, &c. every week; as also with such books as I could not get from the college library. He not only continued this kindness during the three years of my remaining college life, but lent me generous assistance in forwarding my studies by travel. I began to *study* art in Rome, in 1826. Until then I had rather amused myself with clay and marble than studied. When I say, that those materials were familiar to my touch, I say all that I profited by my boyish efforts. They were rude. I lived with poets and poetry, and could not then see that my art was to be studied from folk who eat their three meals every day. I *gazed* at the Apollo and the Venus, and *learned* very little by it. It was not till I ran through all the galleries and studio of Rome, and had had under my eye the genial forms of Italy that I began to feel nature's value. I had before adored her, but as a Persian does the sun, with my face to the earth. I then began to examine her—and entered on that course of study in which I am still toiling.

" Fenimore Cooper saved me from despair, after my second return to Italy. He employed me as I wished to be employed; and has, up to this moment, been a father to me in kindness. That I ever shall answer all the expectations of my friends is impossible; but no duty, thank God! extends beyond his means.

" I sigh for a little intercourse with you, gentlemen, at home: I long to be among you; but I am anchored here for the next four years. I will not risk a voyage before my statue is done. I think it my duty not to run away at the first sight of the enemy.

" When I went, the other morning, into the huge room in which I propose to execute my statue, I felt like a spoilt boy, who, after insisting upon riding on horseback, bawls aloud with fright at finding himself in the saddle, so far from the ground! I hope, however, that this will wear off. Begging you will remember me kindly to our common friends, and particularly to wicked Morse,

" I am, dear sir,

" Yours, truly,

" HORATIO GREENOUGH."

Another statue ought to proceed from the same hand. America must have a statue of Lafayette, the companion, the friend of Washington—the American republican Lafayette. Greenough has a claim to the execution of this statue, independent of his talents and skill. When in Paris, Fenimore Cooper urged Lafayette to sit to the young American sculptor. But one likeness in marble had been made of the republican hero. David had executed a likeness—but it was ideal, and it was French. Lafayette had determined that this should be the only one, and the last of his sittings, but Cooper wished to see an American Lafayette, and a fac-simile of the man America loves. The old man at length consented, and Greenough executed his task at La Grange, and according to his friend Cooper's wish, made a fac simile. That this is so literally, I wished to be assured, and wrote to Mr. Cooper—I give his answer below, in the following extract of a letter:

" Dear sir—You are very right in supposing that I have some knowledge of Greenough's bust of General Lafayette. The circumstances connected with its being modelled, are all known to me, and as they are also connected with its authenticity, the late melancholy event may give them value.

"Mr. Greenough came up to Paris from Florence, in the autumn of 1831, with a desire to obtain sittings for this very bust. It happened that General Lafayette manifested a good deal of reluctance, and I was employed as a mediator. David had made a bust of him not long before, and I found our venerable friend had entered into some sort of an understanding, that this was to be the one to transmit to posterity. —Singular as it may appear in this age of sculptors, when works of this nature are so very abundant, I do not remember ever to have seen any thing of General Lafayette that had the least pretension to be the production of an artist of any eminence but these heads of David and Greenough. There are a great many plaster casts, it is true, but they all seem to have been made at random, and to be of the class of conjectural resemblances. Let this be as it may, David was deservedly a favourite with General Lafayette, and the latter seemed indisposed to do any thing which might invade his interests. My own office was consequently a little delicate, for I was on very friendly terms with Mr. David also, and should certainly have declined interfering for any other than Greenough. But it was so flattering to ourselves, and so desirable in every point of view to get a likeness by a native artist, that the mat-

ter was pushed a little perhaps beyond the strict rules of propriety. General Lafayette yielded at last to my importunities, saying in his pleasant way, " Well, we will have this bust too, and it shall be the American bust; while David's shall be the French bust; and if I have made any promise to David, it could not have included America." He attached to this concession the condition that I should meet him at Greenough's rooms, and be present at the sittings, most, if not all of which I attended.

"I am thus particular, for the point at issue is the future historical representation of the head of one of the most illustrious men of our time.

"The bust of David is like, it cannot be mistaken, but it is in his ordinary manner heroic, or poetical. The artist has aimed more at a sentiment, than at fidelity of portraiture or nature. On the other hand, the bust of Greenough is the very man, and should be dear to us in proportion as it is faithful. As Lafayette himself expressed it, one is a French bust, the other an American. Each possesses the characteristics of its proper people. There appears to me to be just the difference between these two busts, that there is between the well known picture of the " Oath of the Jeu de Paume," and that of Trumbull's Declaration of Independence. Each is faithful to the character of its country. As Lafayette had two countries, so, in some respects, he may be said to have had two characters. His air, though always calm and dignified, was not always the same when addressing French and American audiences. With the former, he sometimes assumed the more artificial tone, that is better suited to the genius of their language; while with us, he submitted more to nature. The two busts in question, one might almost think, had been intended to perpetuate these peculiarities. Chateaubriand describes Washington as having an air that was calm, rather than noble; and, if I understand his meaning, he had found in him the quiet and simplicity of the American Lafayette, rather than the *manner* of the French Lafayette. All this, however, must be taken with great allowance, for Lafayette was at all times, and at all places, more than usually simple and natural for a Frenchman. He was of the ancient race of gentlemen, a class that, as you well know, let them be of what people they might, were always to be distinguished for these qualities.

" The fidelity of Greenough's bust may be proved by a single fact, to which I can personally testify. The head of Lafayette was very remarkable. The forward part of it, or the brows, the face, jaws, cheeks, and indeed all the features were mas-

sive and noble ; while the portions behind seemed to be formed on an entirely different scale. His ears were the largest I remember ever to have seen, but they lay so flat to the head, and the portion of the head where these organs are placed, was so contracted in comparison with the face, that when one stood directly before the latter, at the distance of three or four feet, no part of them was to be seen. Greenough pointed out to me this peculiarity, in which I cannot be mistaken, for I took great care to assure myself of it ; and, unless deceived, I think Mr. Morse can testify to the same thing. I caused the latter, who was often with us at the sittings, to observe it also. The bust of Greenough is true in this particular, which I think is the fact with no other, and you will readily understand how much such a distinguishing mark would effect the faithfulness of a resemblance. I cannot recall another head formed in this manner.

"I do not know what Mr. Greenough has done with his bust, but I should think it would now become an object of great value, for to those who knew and loved General Lafayette, it must be very desirable to possess so faithful a copy of his head.

"You have the history of the cherubs almost as well as myself. They were made at Florence by Mr. Greenough, chiefly in the year 1829 ; and I believe them to the the first group ever designed and executed by an American sculptor ; if, indeed, they are not the first figures. In this sense, they must become historical, to say nothing of their intrinsic merit, or of the growing reputation of the artist. Greenough had great difficulty in making them, for it is not an easy matter to find in Italy children well formed and of the proper age, to serve as models, on account of a vicious practice which prevails of swaddling the infants in a way to affect their limbs. I chose the subject for two reasons, one of which was natural enough, while the other is one you may possibly think a little impertinent. The first was a due regard to my purse, which would scarcely bear the drain of a heavier work, and the second was a notion I had imbibed that the bias of Greenough's mind just then, was adverse to success in his art. I found him bent altogether on the Michael Angelo or the heroic school ; certainly a noble and commendable disposition in a sculptor, but one that was not so well suited to the popular taste, as that which is connected with the more graceful forms of children and females. It was my wish, that he should do something to win favour from those who are accustomed to admire Venuses and Cupids, more than the Laocoon and the Dying Gladiator.

Thousands would be sensible of the beauty of a cherub who would have no feeling for the sublimity and mystery of the Moses of Buonarotti. With this view the subject was selected. There certainly was an innocent little conspiracy between us that this group should pave the way to a Washington for the capitol, and glad am I to say that the plot, (I believe the only one of the kind of which I have to accuse myself,) has completely succeeded. Its benefits, I firmly believe, will be as great to the nation as to the artist.

"I do not know that I can communicate any other facts that will be of use to the work you have in hand, for the success of which you have my best wishes.

"I am, dear sir, ever your friend,

"J. FENIMORE COOPER."

It will be to me a most gratifying circumstance, if my country should owe a perfect resemblance in marble of the country's friend—the country's honoured guest—the unbending man of truth, who resisted tyranny in every shape, either in threats, or tortures, or seductive smiles—to the suggestions of a pure patriot, and great writer, and the skill of an accomplished artist and gentleman, both natives of the soil.*

———

CHAPTER XXIX.

Francis Alexander—his autobiography—James Whitehorn—J. A. Adams—William Allen Wall—J. F. Hanks—G. W. Tyler—Frederick S. Agate—Alfred Agate—Frederick R. Spencer—John G. Chapman—H. Augur—C. C. Wright—J. R. Lambdin—W. M. Oddie—Wm. Maine—G. W. Newcombe—John W. Dodge—Jane Stuart—Abraham John Mason—John Ludlow Morton—W. J. Hubard—Samuel Seymour—George W. Hatch.

Francis Alexander, 1800–1880.

FRANCIS ALEXANDER—1825.

THIS gentleman, now (1834,) one of our most successful portrait painters, has answered my inquiries with so much *naiveté*, such good feeling and good sense, that I should do injustice to him and my work, if I attempted to give his very interesting story in any words but his own. His early efforts, his success, his gratitude to those who noticed him, are all honourable, and show that he is still the child of nature.

" Since you pay me the compliment to number me among those whose names shall appear in your proposed work, and since you ask of me some of the events of my life, I shall

———

* Greenough's *Medora*, sculptured for R. Gilmor, of Baltimore is spoken of as a work of great perfection.

321 PRUDENCE CRANDALL. Painting by Francis Alexander. *Courtesy Cornell University Library*.

322 JAMES GATES PERCIVAL, *c.* 1825. Painting by Francis Alexander. *Courtesy Yale University Art Gallery, gift of Harvard University.*

no longer hesitate to comply, at least in part. Well then, to begin at the beginning, I was born at Killingsby, Windham county, Connecticut, on the 3d of February, 1800. My father being a farmer of moderate circumstances, of course *my course* in early life was none of the smoothest ; it being 'midst rocks and stumps, briers and thistles, and finally, through all the perplexities and privations incident to the life of a poor farmer's son. I might tell you of going barefooted to church, hundreds of times in warm weather, three miles distant, and of a thousand similar incidents, such as would only convince you of early poverty after all; the relation of such facts might not interest your readers so much, perhaps, as it might injure the feelings of my very aged and very respectable parents. (Their ages are 76 and 77, and they are living in much comfort and quiet, in a beautiful white cottage which I erected two years ago, expressly for their benefit.) From the age of eight up to twenty, I laboured almost incessantly, the eight warm months of the year, upon my father's farm. The other four months in the year I went to a country district school, till I was seventeen. My eighteenth and nineteenth winters I kept school (in the same district where I had been one of the scholars previously,) and taught the small fry under my charge, the bad pronunciation and bad reading which I had imbibed from my old schoolmasters, and which I have found it so difficult to *unlearn* since. I had never received any pay whatever for services upon the farm, except food, clothing and schooling, so you may well *guess* that the forty dollars which I received for school-keeping, formed a pile, in *my eye*, more majestic than an Egyptian pyramid. The next winter I received forty-four dollars for the same time, in the same district. The summer intervening, I laboured upon the farm, and the summer following till August ; during that month loss of bodily strength, owing to the severe labour in *haying* and *reaping*, obliged me to hang up my scythe and sickle, and take to the house. I was only *comfortably* ill however, and for diversion I went out in the boat fishing upon the pond, the *beautiful* pond, which helps to make the scenery about my father's house so very picturesque. Well, I caught a pickerel, some perch and roach; while I was idly gazing upon their beautiful tints and fine forms, it occurred to me that they would look very pretty painted, and thought of a box of water-colours which had been left me by a boy, (which cost a shilling ; it was such as children use,) and I went immediately home with the determination of painting the fish. I laid them on the table, hunted up one solitary camel's hair pencil which had been given me

years before, and went to copying *nature* for the first time. (I
must digress to say that I had in boyhood a taste for sketch-
ing birds and other objects with my pen and slate-pencil, from
fancy. At school, they called me a 'curious boy;' and would
bring all their white scraps of paper for me to illustrate with
pen and ink; and I remember to have tarried many a 'noon-
tide' in the school-house to sketch for the little girls, while all
of my own sex were playing ball in the field.) But to return,
I painted the fish—I was delighted with the pictures—I thought
then, and know *now*, that they were more like *real* objects
than any paintings I had *then* seen. The family praised them;
and an old fisherman, who happened to see them, said, if the
painted fish were cut out of the paper and laid upon the floor with
real fish, that he should mistake the shadow for the reality!
I, who had never received so much praise before, attempted
other objects from nature, such as real flowers, dead birds, &c.,
with about the same success as before. I then made up my
mind to become an ornamental or sign painter, merely be-
cause I thought I could make more money than by farming.
My ambition rose no higher. Indeed, my reading had been
so limited, and my birth so obscure, that I thought sign paint-
ing the highest branch of painting in the world. I had been
at Providence—had seen the signs there, and those were the
only marvels in painting that I saw till I was twenty, except-
ing two very ordinary portraits that I had seen at some coun-
try inn.

"I made up my mind to go to New-York to learn to paint:
I hardly knew what. My partiality to New-York I believe,
arose from the following trifling circumstance: an old pedler,
who frequented my father's house with picture-books, took
great pleasure in showing me the pictures or cuts of all the
books in his budget—because, I evinced so much interest. He
dwelt on the comparative excellences of Boston and New-
York cuts. Those books published by Samuel Wood and sons,
New-York, pleased me most. I thought the cuts much the
finest. The crazy pedler acknowledged the justness of my
criticism. He was a model for Michael Angelo in his propor-
tions; height six and a half feet, with the head of Jupiter To-
nans; he had graduated from one of the colleges, I believe,
and seen better days. If he were alive now, I would make a
pilgrimage to paint him. Well, the old pedler's influence upon
my youthful taste was so lasting, that at the age of twenty, I
did not think of visiting any other city for instruction. I re-
membered the old man's words, that 'they do these things
better in New-York than in any city in the country.' I talk-

323 SILAS WRIGHT. Painting by James A. Whitehorne. *Courtesy The Art Commission, City of New York.*

THE NEW-YORK MIRROR.

EDITED BY GEORGE P. MORRIS, THEODORE S. FAY AND NATHANIEL P. WILLIS.

SATURDAY, FEBRUARY 21, 1835.

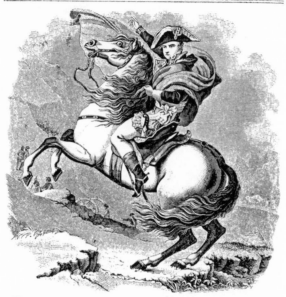

Napoleon crossing the Alps.—Another beautiful specimen of engraving in wood, by Adams. It was made as an appropriate embellishment for the certificates of membership in Captain Van Buren's company of Napoleon Cadets, belonging to the regiment of infantry commanded by Colonel Nathan B. Graham. This is a volunteer corps, the exceeding good taste and beauty of whose uniform and equipments, as well as the precision of their movements and their high state of discipline, has been frequently noticed and spoken of in very complimentary terms. We take pleasure in acknowledging our obligation to this gallant band of citizen soldiers for the use of the engraving. The subject is altogether too well known to require description ; prints of David's celebrated picture, from which it is taken, have been seen by everybody, and who is not acquainted with the famous incident in the life of Napoleon—" the greatest captain of the age"—which that painting was intended to illustrate ?

324 Napoleon Crossing the Alps. Wood engraving by Joseph Alexander Adams after Jacques Louis David. *Courtesy Dover Archives.*

ed of visiting New-York immediately; my friends all remonstrated with one accord and one voice; my brothers said I had better go into the field to work; and they all talked of laziness, and a thousand other things in order to laugh me out of it. They called it a wild project; a last resort of idleness to get rid of work, &c. But still I persisted, and went, against the advice of all my friends and acquaintance. I started without letters or without an acquaintance in New-York; but when I got as far as Pomfret, Mr. Prescott Hall, learning the object of my visit to the city, gave me a letter of introduction to his brother Charles H. Hall, then and still a resident there. Charles was very polite to me; accompanied me to see the various exhibitions of painting in the city. He exerted himself also, to get me a place for instruction. He recommended me to J. R. Smith as a pupil, and him to me as a good instructor. Mr. Smith said he should form a class in the course of fifteen days, and would then *take me in.* I awaited with little patience for the fifteen days to expire, and then he *did take me in* to his drawing room, just long enough to tell me that his pupils had not returned from the country, and that he should not open his school, or give instruction for the present. My little stock of money was going, and time flying. While kept in suspense by Mr. Smith, I met a townsman of mine, who introduced me to an elderly gentleman in Warren-street, a Mr. McKoy; a gentleman of some taste and skill in painting ornamental work. He was very kind to me and gave me much good advice, and an introduction to Alexander Robertson, then secretary to the Academy of Fine Arts. Mr. Robertson received me in his school, gave me a few little things to copy in lead-pencil and India-ink, and finally, at my particular request, he let me paint in oils, or rather copy two or three first lessons for girls, such as a mountain or lake, very simple. I wanted to be put forward to something more difficult, but he said 'No;' that I could not be allowed to copy heads or figures till I had been with him a number of months; so, of necessity I left, after staying five or six weeks with him, for my money was all gone but barely enough to carry me home.

"To make another attempt, I again went to New-York, by way of Norwich and New-London. I wished to go *rapidly,* owing to my natural impatience, yet I felt obliged to go as *cheap* as possible. I took a deck passage on board the Fulton, Capt. Law, who told me that I should be set down in New-York, for four dollars. I lodged on the cold deck, (in September,) without blanket or cloak. The Fulton in those days exchanged passengers at New-Haven with the Connecti-

cut, Capt. Bunker. It so happened that between the two captains or their two secretaries, they took seven dollars from me before I got to New-York which was too decided a removal of my ' deposites' to be forgotten even at this late period. The sum was more important to me than three hundred *now.* Those that slept in the cabin and fared sumptuously, paid only nine dollars. I was not allowed to look below. As the captains of the boat may be both alive, *perhaps*, were it worth the notice, you would be obliged to omit the mention of the circumstances, though *I* should admire to have them read it.

While at Robertson's school I had free access to the academy over the school room. That was a field of wonder to me, and what I saw there induced me afterwards to try my hand at painting heads or portraits. However, as I knew nothing of flesh-colouring (and hardly *any thing of the tints of landscape, or of mixing them)* I began, after my return home, to ornament the plaster walls of one of the rooms, in my father's house, with rude landscapes, introducing cattle, horses, sheep, hogs, hens and chickens, &c. Those who saw my productions looked astonished, but no farmer had taste enough to have his wall painted in the same way; I waited for patronage in landscape, but not having it, I determined to try my hand at portraits, so I shut myself up in the room I had just painted from top to bottom, and painted the head and shoulders of a man from fancy; I did not care whom it resembled, I only strove to apply the shadows about the eyes, nose and mouth, so as to produce the effect of those I had seen in the Academy at New York. I painted away, and began to be pleased with my work as I advanced, and whistled in time with my feelings; my aged mother hearing me, came and knocked at the door, and said, " you are successful, my son, I know by your whistling." I seldom paint a portrait, or any thing else now-a-days without thinking of the kind voice of my mother on that occasion; it was the first word I had heard uttered to encourage me onward in my new pursuit. I finished the head and drapery all at one sitting down, and then exhibited my work to my family; they seemed surprised, and all of them began to speak kindly to me, (for after my return from New York up to this period my friends were silent. They knew I had spent all my money in the said city, and they seemed to avoid laughing at me, because they pitied me) and so I took courage. The neighbours met the same evening at the school-house, half a dozen of them, perhaps, to talk of hiring a master. I had talked of keeping school myself again, merely because I could not get employ in ornamenting; so I

325 NEW BEDFORD IN 1807; 1857. Painting by William Allen Wall. Courtesy The Whaling Museum, New Bedford, Massa-
chusetts.

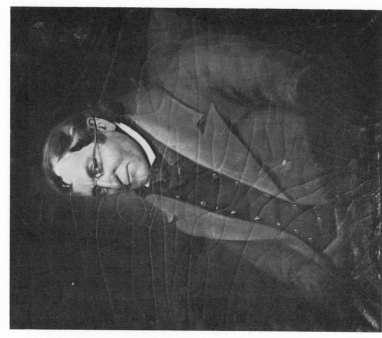

326B ABRAHAM HICKOX, 1837. Painting by Jarvis F. Hanks. *Courtesy Western Reserve Historical Society.*

326A TRUMAN PARMALEE HANDY, c. 1837. Painting by Jarvis F. Hanks. *Courtesy Western Reserve Historical Society.*

went to the school-house with the picture in my hand.
The neighbours were thunderstruck; they praised it, and gazed
at it till the business of the meeting was well nigh forgot; my
brother William gazed steadily at it at least half an hour
without speaking; at length he exclaimed, " well, Frank, if
you paint ten years, you will not paint another so good as
that." I replied *very modestly*, " I have seen better in New
York !" They praised it till I really thought I had done
something wonderful. The next day I called in a ne-
phew of three years of age, and while he leaned upon my
knee, and played about me, I painted his portrait and finished
it all at one *standing*. The day following I took the por-
trait of another nephew, six years old, and I represented him
laughing, and showing his white rows of teeth. I forgot to
mention that I painted the first head named above, which as-
tonished the neighbours, upon the lid of an old chest; it was
off the hinges. I painted the two last mentioned upon pieces
of boards I picked up; the portraits of my nephews were
called excellent likenesses. *My fame had now spread half a
mile in one direction.* I was offered five dollars by a Mr.
Mason (he was my first patron, so I mention his name) to
paint a little miss, full length. I painted her, and they all said
it was a *hit;* then the girl's mother offered me a dollar a-day
to come and paint the rest of the family, half a dozen of
them. I went, and received thirteen dollars for thirteen days !
My fame had now travelled seven miles. I was invited to
Thompson, to paint several families, received three dollars
a-head and my board. As soon as I had earned fifty or sixty
dollars, I returned to New York for instruction in portrait
painting, but I could not obtain it. The old gentleman men-
tioned above, Mr. McKoy, gave me Mr. Stuart's mode of
setting the palette, and Colonel Trumbull lent me two heads
to copy, and treated me with much kindness. The same re-
mark will also apply to Waldo and Jewett, they also lent me
two portraits to copy. After copying the above named por-
traits, and one or two more, I was obliged to go back to
Connecticut, my funds being exhausted. On my return, I
had the boldness to ask eight dollars a portrait, and received
it. I was forced to travel though, from town to town, to find
business. Among others, I painted two in Thompson, which
were sent to Providence to be framed. There they attracted the
attention of the widow of General James B. Mason, she im-
mediately sent to Killingsby for me to come to Providence to
paint her family, promising me fifteen dollars a portrait.
Accordingly I went, and was received into her family, where

I remained five weeks, during which time I painted half a dozen. When I had finished two or three, she took me into her chaise and drove all over Providence exhibiting them, and praising them to her numerous influential friends, and thus she prepared the public to receive me most graciously as soon as I left her hospitable mansion. This same Mrs. Mason died, while I remained in Providence, when I lost one of my most valuable, and *disinterested* friends. I have met with many friends since I took up painting, but among them all, I remember no one who was so zealous, active, and untiring in my behalf as Mrs. Mason, nor any one to whom I am half so much indebted for my somewhat successful career, as to her. You may leave out any thing relative to me, if you will give a short tribute to her memory. I painted two years or more in Providence, and received constant employ, and from fifteen to twenty-five dollars for my portraits. I afterwards came to Boston, bringing a painting of two sisters with me, which I carried to Mr. Stuart for his opinion ; I will give you his remarks, he said that they were very clever, that they reminded him of Gainsborough's pictures, that I lacked many things that might be acquired by practice and study, but that I had *that*, which could not be acquired.

He invited me to come to Boston, and set up as a portrait painter, so accordingly after going home and making the necessary preparations, I returned and commenced painting in that city, where I remained in the full tide of successful experiment until I set sail for Italy, on the 23rd of October, 1831. In Boston I received forty dollars for the head and shoulders, twenty-five by thirty inch canvas, and more according to the size; two years afterwards I received fifty dollars, and seventy-five for the kit-cat size ; these were the prices till I went away. I forgot to mention that Colonel Trumbull gave me a very kind letter to Mr. Stuart, which I presented him when I carried the two sisters for his inspection. I sailed for Genoa, saw the fine paintings there, went to Florence, staid there five or six weeks, renewed my acquaintance with Mr. Thomas Cole, went with him to Rome, roomed with him there three months ; thence we went to Naples together, visited Herculaneum, Pompeii, and Pæstum together, and returned to Rome again in company. This circumstance I mention as a specimen of my good fortune, I have the highest respect for Mr. Cole's character and talents, but it is useless for me to say more of one whom you know how to appreciate. While at Rome I painted the portrait of Miss Harriet Douglas of New York. Sir Walter Scott being there at the time, and an

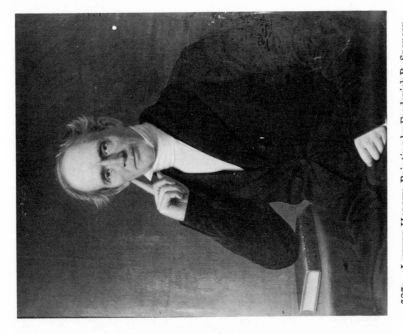

327B LUTHER HALSEY. Painting by Frederick R. Spencer. *Courtesy Princeton University.*

327A UNKNOWN LADY. Miniature by Alfred T. Agate. *Courtesy National Collection of Fine Arts, Smithsonian Institution, Catherine Walden Myer Fund.*

328　Drawing a Bead on a Woodchuck. Painting by John Gadsby Chapman. *Courtesy The Butler Institute of American Art.*

acquaintance of hers, he came with Miss Douglass in her carriage to my studio, where he remained nearly an hour, conversing all the while in a most familiar manner. I had painted an original Magdalen, it was standing on one side of the studio at the time, and Sir Walter moved his chair up within six feet of it; there he sat looking at it for some minutes without speaking: I was all impatience to know what he would say. He turned away with the laconic remark, *"she's been forgiven."* I returned to Florence, staid a few weeks, went to Venice, staid seven months; returned to Rome the following winter, and staid three months more; returned again to Florence, visited Bologna, Pisa, and Leghorn; thence to Paris, staid there twenty days; thence to London, there ten days only, left it in the London Packet for New York, arrived in New York on the 25th August or 24th. After visiting my friends a month or two, I took my old room again here in Boston (Columbian Hall), where I have commenced painting with success, receive a hundred dollars for portraits, have not fixed upon prices yet for more than busts, choosing to recommend myself first, knowing that the good people of our country are willing to pay according to merit.

" Mr. Cole can, perhaps, give you some information about your humble servant, if you desire more. When I was a farmer, I used to go three miles before sunrise to reap for a bushel of rye per day, and return at night. Oh! had you seen me then, winding my way to my labours, shoeless, and clad in trowsers and shirt of *tow*, with my sickle on my shoulder! as you are a painter, you might have given me a few cents to sit for my picture, but you would not have taken any notes for biography. I have written upon a large sheet, and compactly, hoping to have plenty of room, but I might add so much more.

" Yours truly,
" FRANCIS ALEXANDER."

JAMES WHITEHORNE—J. A. ADAMS—W. ALLEN WALL—1826.

Mr. Whitehorne was born the 22nd of August, 1803, in the town of Wallingford, Rutland County, Vermont. With the usual disposition which leads to painting, he became acqainted with an amateur of the art in 1823, who loaned him books and drawings to copy. Biographical notices of eminent painters stimulated him to undertake the profession, and he came to New York, and studied in the school of the National Academy of design, of which he is now a member. He commenced professionally, in 1826: and has a share of the

James A. Whitehorne,
1803–1888.

Joseph Alexander Adams,
c. 1803–1880.

William Allen Wall,
1801–1885.

employment given to portrait painters. The moral conduce
of this gentleman, and his amiable manners, ensure him the
esteem of all who know him.

Mr. Adams has exhibited specimens of wood engravings
entitling him to stand as high any man in America, perhaps in
Europe, in the beautiful art he professes. I believe he is a
native of New York: but to any inquiries he has been silent.

Mr. Allen Wall, the son of an Englishman, who emigrated
to America, was born in new Bedford, May 29, 1821. He
was apprenticed to a clock and watch maker, but when out
of his time, relinquished the business for a profession he more
delighted in. About the year 1826 he commenced portrait
painting, and in 1832 was enabled to visit England, France
and Italy, for improvement. He has returned to his native
country, and is employed in his profession. I have not seen
his pictures.

Jarvis (or Jervis) F. Hanks,
1799–?.

George Washington Tyler,
1803 or 1805–1833.

JERVIS F. HANKS—G. WASHINGTON TYLER, 1827.

Mr. Hanks is a painter of portraits, but his principal em-
ployment is in sign and ornamental painting. He informs me
that he is a native of Pittsford, Otsego county, New York,
and born in 1799. He received a good common school edu-
cation, as a boy, and when but thirteen years of age, enlisted
as a soldier, in the army of the United States; and as such,
did duty at the battles of Chryslers Fields, Chippewa, Lundy's
Lane and Fort Erie. He was discharged in 1815, with a
certificate and recommendation from the officers of the 11th
Infantry, for a cadet's situation, at West Point. It appears
that after the war, Hanks was again at school, and under the
guardianship of his father, who, removing to Wheeling, in
Virginia, in 1817, the youth accompanied him. He, after
this, appears to have wandered from place to place as a sign
painter, and occasionally taught school.

In 1823 Mr. Hanks saw the artists and pictures in Phila-
delphia, and, returning to Virginia, commenced portrait
painting. In 1827 he "found his way" to New York, with
his family, where he could not gain employment sufficient as
a painter of portraits, but has succeeded by adding sign paint-
ing—or rather, making that his principal occupation.

Mr. Tyler was the son of Samuel Tyler, and grandson of
Joseph Tyler, long a favourite on the stage of New York. He
was born in the year 1805, and at the age of fourteen was put
apprentice to a coach painter. George had probably imbibed
a love of painting from seeing a picture of Garrick, by Pine,
in his grandfather's possession, and two or three other por-

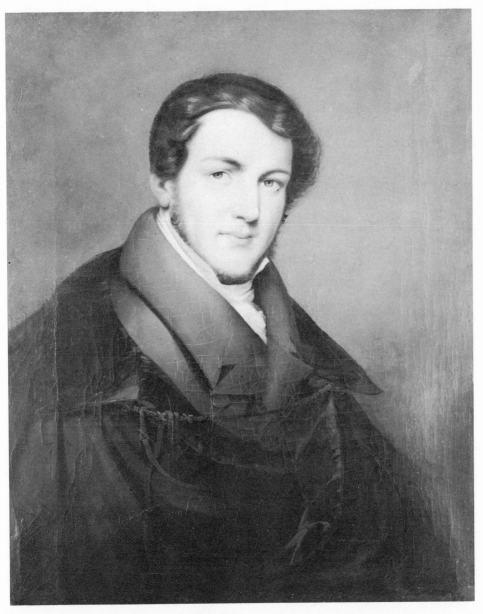

329 HORATIO GREENOUGH. Painting by John Gadsby Chapman. *Courtesy The Boston Athenaeum.*

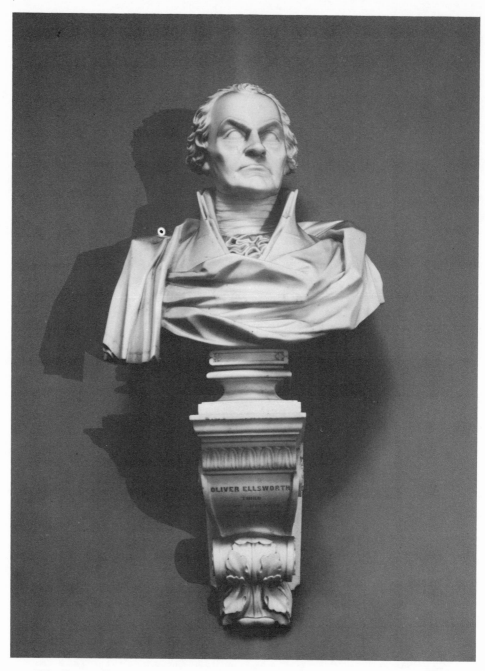

330 OLIVER ELLSWORTH. Sculpture by Hezekiah Augur. *Courtesy Architect of the Capitol.*

traits. The lad soon discovered talent, and executed the prin-
cipal parts of coach painting with peculiar success. He
received instructions from John R. Smith. In 1827, he com-
menced portrait painting; he married, and was apparently
improving in his profession, when he was attacked by disease,
and on the 13th of May, 1833, died, leaving behind him
several pictures of considerable merit, and (of much more
consequence) a name without blemish—a character pure and
amiable.

FREDERICK S. AGATE—ALFRED AGATE—1827.

Frederick Style Agate,
1807–1844.

Alfred T. Agate, 1812–1846.

Frederick S. Agate is a most amiable and rapidly improv-
ing artist, who has recently embarked for Italy to pursue his
studies. He was born in the village of Sparta, West Chester
county, New-York, in the year 1807. He had the usual pro-
pensity for scrawling and scratching figures of beasts, birds,
and " things in general;" and moreover an early ambition to
versify, and might, with Audrey, " thank the gods for making
him poetical." At the age of thirteen he became acquainted
with that excellent old gentleman, Mr. Rollinson the engraver,
and through his influence, and that of the Rev. Mr. Witting-
ham, his grandson, he was removed to New-York, and placed
under the tuition of John R. Smith as his instructer in drawing.
He was afterwards received as a pupil by S. F. B. Morse,
Esq., whose friendship he obtained and still enjoys. In 1827,
Mr. Agate took a room in Broadway and commenced portrait
painter. For a time his efforts appeared timid, but within
two or three years he has felt a just confidence in himself, and
" The Dead Child," " Forest, in the character of Metamora,"
and still later his historical picture of " Ugolino" from Dante,
stamp his character as an artist of genius and power. His
best portrait is a late one of his old friend Rollinson.

By his industry he is now enabled to proceed to Europe for
a term of study, which he limits to two years ; and so well pre-
pared as he is in knowledge and moral worth, two years, I
doubt not, will return him to us an accomplished and first rate
artist.

His brother and pupil *Alfred Agate*, under his instructions
and those of Thomas S. Cummings, Esq., is at this time a
good and rapidly improving miniature painter, with appa-
rently the same amiable character which marks the senior
brother.

FREDERICK R. SPENCER—1827.

This gentleman was born in the town of Lennox, Madison county, New-York, on the 7th June, 1806. His parents were from the New-England states: his father, General Ichabod S. Spencer, from Massachusetts, and his mother from Connecticut. Mr. Spencer experenced the usual boys' inclination for imitating prints, and at the age of fifteen, being with his father in Albany, saw for the first time, a gallery of portraits; they were the works of Mr. Ames. His desire for painting increased, and in 1822 he attempted some portraits of his relations, and evinced his love of art by going frequently from his father's residence to Utica, thirty miles, to see my pictures on scriptural subjects, exhibiting there. I then first saw Mr. Spencer and was pleased with his ardour, as I have since been with his manners and his progress in the art he pursues. He says I at that time gave him some valuable instructions, and has expressed his gratitude. I can freely say that I never withheld the knowledge I possessed from any artist, young or old.

In 1822 Mr. Spencer was placed as a student at Middleburg Academy, in Genesee country, New-York, where he acquired a knowledge of the classics, but was more devoted to the study of mathematics. His father being a lawyer, took him into his office as a student, but yielded to his desire of becoming a painter, and sent him, in 1825, to New-York, where he drew from the casts of the American Academy, and had the favour of the president, and his instruction in the methods he was to pursue. The young painter returned home and painted at his father's house, but in 1827 commenced professionally at a village in the neighbourhood, at from three to ten dollars a head. His uncle introduced him to better business in Albany, and he there painted portraits between two and three years. He likewise painted in Utica, but finally made New-York his head quarters, where he has been in constant employment to the present time, and with increasing reputation.

JOHN G. CHAPMAN—1827,

Was born in Alexandria, district of Columbia, on the 11th of August, 1808. He was intended by his parents for the profession of the law, but like many recorded in this work, his scrawls in his books indicated an inclination to figuring in another line of life. George Cooke (now an artist in New-York) married a connection of young Chapman; and to an

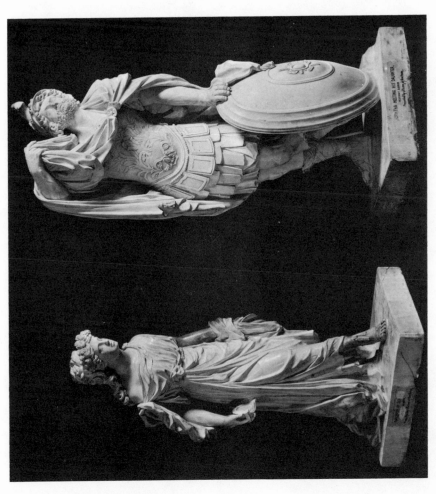

331 JEPHTHAH AND HIS DAUGHTER. Sculptures by Hezekiah Augur. *Courtesy Yale University Art Gallery.*

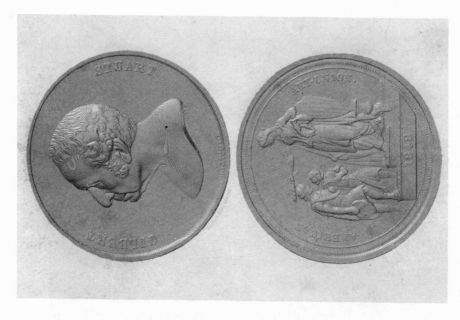

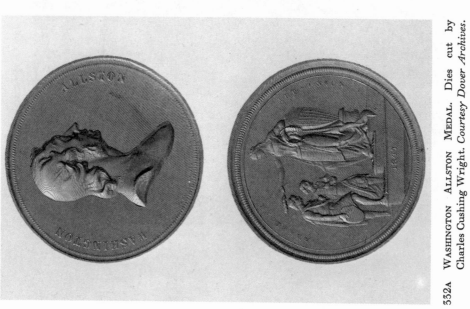

332B GILBERT STUART MEDAL. Dies cut by Charles Cushing Wright. *Courtesy Dover Archives.*

332A WASHINGTON ALLSTON MEDAL. Dies cut by Charles Cushing Wright. *Courtesy Dover Archives.*

early acquaintance with him, Mr. Chapman attributes his devotedness to the arts. At the age of sixteen he made his first attempt in oil painting. From C. B. King, Esq. he obtained some plaster casts and commenced his study of drawing.

In 1827 Mr. Chapman became professionally a painter, leaving home with a determination to enable himself by his art and industry to visit Italy. At Winchester, in Virginia, he commenced his career with success. In the autumn of 1827 he went to Philadelphia, and studied from the casts in the Pennsylvania Academy. He was denied the privilege of painting in the building. By the aid of friends Mr. Chapman was enabled to visit Europe, passed a short time in Paris, then proceeded to Italy, and commenced his studies in the Vatican. Here he met his friend Mr. Cooke. Copying from the old masters, and the study of the naked figure at the academy occupied the student. It was some time, Mr. Chapman has said, before he could appreciate Raphael and Michael Angelo, but he became an enthusiast in his admiration.

Before leaving Rome the young painter selected for the subject of an original picture, " Hagar and Ishmael fainting in the wilderness," now in the possession of John Linton, of New Orleans. The figures of this picture were the size of life. It was engraved as the first representation of American art in the " Giornall di Belle arti," published at Rome, in November 1830. In company with S. F. B. Morse, Esquire, Mr. Chapman visited much of the scenery about Rome and Naples. From Rome he went to Florence, and studied six months, then visited Bologna, Venice, and Milan, and revisited Paris. In 1831 Mr. Chapman returned home, and found employment in his native city, where he opened an exhibition of the pictures remaining in his possession of those copied in Italy, and others painted after his return. Mr. Chapman has painted Mrs. Drake as Lady Macbeth, and a portrait of Mr. Madison, which is now in the hands of an engraver. Silas E. Burrows, of New-York, has a picture painted for him by Mr. Chapman, and James Fenimore Cooper has a copy of Guido's " Aurora." The latter I have seen, and can give my opinion that it is a specimen of Mr. Chapman's skill, which places him above all the copyists of Italian pictures who have recently visited Italy except Messrs. Morse and Weir. It is a fine picture.

A Madonna and child, from Murillo, and a Flora from Titian, are possessed by John Gadsby, Washington city ; a woman tuning a guitar, from Metzu, and an original portrait of Horatio Greenough, belong to the Boston Athenæum.

Mr. Chapman's intention is to fix himself professionally at the seat of the United States government, where, I doubt not, from what I have seen of his works and heard of his merits, he will command the attention of the public servants and national legislators.

Hezekiah Augur, 1791–1858.

H. AUGUR—1827.

Mr. Augur was born at New Haven, the 21st February 1791. His father was a joiner and carpenter, and the boy had an early propensity for handling tools, which the father discouraged; and to lead him into commerce, bound him apprentice at the early age of nine and a half years to a grocer; but the grocer was not all grocer, he was a tool-using animal and handled his awl, so that young Augur had the pleasure of making something, and to make any thing was better with him than to make money by traffic. He attended the *grocery*, and made shoes until the time of servitude expired. His father furnished a capital of $2000 to place him in an eligible company of dry good retail merchants, as they are called in Connecticut; and the young man entered life in the first rank of New Haven society, as a prosperous merchant. His partners have continued such to this time; but by the hocus pocus of trade, bank credits, notes and indorsements, at the end of a few years Mr. Augur's $2000 was lost, and he was declared to be indebted to his partners (or one of them) $7000, and no longer a merchant. His situation reduced him almost to despair. He found himself shunned by former associates, and he shunned them. His manly pride made him determine on exertion to pay the debt, and he felt no reluctance in stooping to any honest employment for that purpose. He borrowed $200 at enormous interest, and hired a small place which he opened as a fruit shop—it succeeded—he bought carver's tools, his old propensity continuing, and made a musical instrument, carving the mahogany frame work in a bold and beautiful manner. This work I have seen and examined. He thus employed himself between the visits of customers to the shop. His old companions pass him, and see him not. One day sitting at his work, he saw two of his former companions stop before his shop-window; one asked the other, "Who has set up a *cookee* shop here?" "Augur," was the reply. "What, Augur the merchant?" "Yes." "He'll break again—he won't pay the rent."

The instrument of music finished, he carried it to a cabinet-maker to have it varnished. His specimen induced an offer for carving the legs of mahogany chairs and things of that kind, which he accepted and earned good wages while attend-

333 ABRAHAM CLARK, 1873. Painting by James Reid Lambdin after John Trumbull. *Courtesy Independence National Historical Park.*

334 BENJAMIN HARRISON, 1873. Painting by James Reid Lambdin after John Trumbull. *Courtesy Independence National Park.*

ing to his fruit store. In two years he paid part of his debt
by means of honourable industry. But his partner creditor
threatened—his fears perplexed, and he sold his shop and
his carving business to secure the means of extricating himself
from debt. He invented and made a machine to manufacture
worsted lace and worsted epaulets for non-commissioned offi-
cers—those branches of worthless worsted which, as Mande-
ville says, makes the stupid animal, man, imagine he is a
hero, and strut as if his shoulders bore the gold or silver
badges of his colonel. This speculation answered—Augur
lived a recluse, paid debt, and seems to have been willing to
make money, provided he was making something else. He
made looking-glass frames and mended old ones—he learned
to gild as well as carve. Employment diverted his thoughts
from the enemy, who had ruined his hopes of fortune, and
after a hard day's work, he slept sound until he could go to
work again. He paid his debt, and no longer feared the she-
riff. His father died and he supported his mother, whose
house he still lives in.

Always desirous of carving the human figure, he had from
childhood looked with longing on the figure heads of the ships
in the harbour. He now was desirous to make a bust in
marble, and encouraged by Mr. Morse, he borrowed a head
of Apollo, purchased a block of marble, and without further
thought commenced metamorphosing the shapeless mass into
a likeness of the sublime form before him. Delighted with
his employment, he forgot the world and was forgotten, until
having finished his bust it was seen, and he was hailed as an
artist—a sculptor—a self-taught genius. Crowds begged to
see the head—all admired—all were desirous of Mr. Augur's
acquaintance, and those who had shunned now courted him.
His ambition was excited, and he wished to become a sculptor.
He wanted money, and some one was found to make a trial of
borrowing a few hundred dollars. But the cold looks return-
ed, and he received excuses.

He found means to procure more pieces of marble, and
chiselled a Washington. He then ventured on a statue, and
produced, seven years ago, (1827) a figure of Sappho, which
was exhibited in Boston and sold there. He then conceived
the design of a group—Jephtha and his daughter, and executed
it. These works he cut directly from the block, without the
preparatory and necessary preliminary of making a model.
This, though adding to difficulty and injuring the work, exci-
ted curiosity in the vulgar, and attention from artists. He
says he had no view in his chiselling but to cheat thought,

occupy his mind pleasantly, and drown reflection by this employment, as others drown the memory of misfortune by the glass and bottle. The Jephtha and daughter has been exhibit-in New-York, and I believe elsewhere. His works are now on exhibition at his house in New Haven. He says he has received abundance of compliments and little money. He has at present an order from Washington city for a bust of Chief Justice Elsworth, and another from Hartford for that of the president of a public institution. Orders for monuments he has several; and I think, from appearances, with his habits and industry, is doing well. He has adopted modelling *before* chiselling, as other sculptors do; and is now engaged in designing, in clay, a statue, whose name or character he at present conceals.*

Charles Cushing Wright,
1796–1854.

CHARLES CUSHING WRIGHT—1827.

This gentleman is well known as an *engraver and die-sinker.* Born in the town of Damascota, fifteen miles east of the Kennebec river, Maine. When only nine months old his father (a Scotchman) died, leaving the family in indigent circumstances. When he was about the age of thirteen, a stranger—Charles Cushing, whose name Mr. Wright adopted —saw and liked the boy, and proposed to educate him. The liberal offer was accepted, and he was sent to a boarding school; but he had not been long there when his friend died, leaving no provision for the boy, who, by this unfortunate bereavement, was deprived of the benefits of an education.

An uncle, a merchant in Wiscasset, took young Wright into his counting-house, and promised, if, after a trial, they liked each other, to bind him an apprentice for eight years, and teach him his calling. After a short stay, however, the conduct of his aunt forced him to leave his uncle, and he did so with as much joy as a prisoner feels when released from thrall. By an unfortunate accident, which happened soon after this, he fractured his leg, and for a year was disabled from working. A great part of this time he devoted to acquiring a knowledge of reading, writing, and arithmetic. Thrown upon his own resources for a livelihood, and thirsting, as young minds often do, to see the world, he resolved to follow the sea; but the embargo and non-intercourse acts had so paralyzed commerce, that he found no opportunity to indulge his inclination.

War with England being declared in 1812, he felt a military ardour, which was checked by his relations, they being

* This notice is given from memory, after conversing with Mr. Augur.

335 ERIE CANAL AND COVERED BRIDGE, 1847. Painting by Walter M. Oddie. *Courtesy Kennedy Galleries, Inc.*

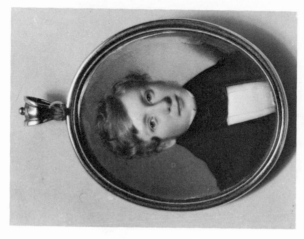

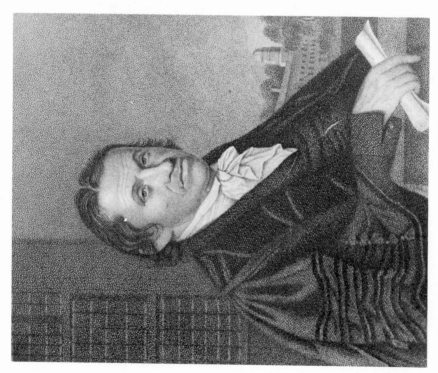

of the party opposed to the war. However, he soon left his native state and arrived in that of New-York, where he attached himself as clerk to a sutler of the 25th regiment, with whom he remained more than a year. During this period he was witness to many of the stirring scenes on the lines, and on several occasions volunteered in them. He was present at the capture of Little York and Fort George, and also in the battle of Stoney Creek, in which action he received a musket wound. Peace being proclaimed, Mr. Wright settled in trade at Sacketts Harbour, where, from his extensive military acquaintance, he was pursuing a profitable business. Unfortunately, however, his prosperous career was checked : a servant of the family in which he resided administered poison in the food, which so injured him that for many a day his life was despaired of, and its effects he felt for years after. On his recovery, the next step in his eventful life was to bind himself an apprentice to John Osborn, a jeweller and watch-maker of Utica, with whom, after a time, he removed to Homer, Cortlandt county. With this gentleman he remained till he was twenty-one years of age, working chiefly at the silversmith's forge.

Not exactly relishing this business, and seeing, accidentally, some books illustrated with plates by Scoles, he became enamoured of the art of engraving : but how to pursue it was the question—all around him were as grossly ignorant of the art as he was. At length he found an encyclopedia in the library of a friend, which contained a short description of engraving. Studying this thoroughly, he determined to commence the business—having made his own tools, and plated out a piece of copper—he engraved a watch-card; which, for want of better material, was printed on the backs of playing-cards.

Before he was twenty-two years of age, Wright had advanced considerably in the art, and then, for the purpose of further improvement removed to Albany, and thence to New York, a perfect stranger, with only five dollars in his pocket. Here he soon became acquainted with a gentleman from Georgia, by whose persuasion he removed to Savannah, and remained there till the disastrous fire of 1820. His shop burned, and the city in ruins, he proceeded to Charleston, South Carolina, where he remained four years. In 1824, Mr. Wright formed a partnership with A. B. Durand and brother, in the bank note business, under the firm of Durand and Wright, and settled in the city of New York.

A die-sinking establishment was offered for sale, which he purchased. Although this was not the branch in which he had been lately engaged, yet it was one in which he had already made great proficiency. While in Charleston, Mr. Wright executed a number of dies and portraits sunk in steel: the first, in 1820, of Charles Cotesworth Pinckney, of South Carolina, being (says my informant) the *first* portrait sunk in steel by a native American artist—a fact worthy to be remembered. At this day there are only two American die-sinkers, Mr. Wright of New-York, and Mr. Gobrecht of Philadelphia. Since then, Mr. Wright has executed many dies for medals; but that branch not affording him sufficient occupation, his time is chifly engaged in one more adapted to the wants of the country—that of xylographic and copperplate engraving, in company with Mr. C. Durand.

The last medal executed by Mr. Wright, was of Edwin Forrest;* a die, which, while it testifies how justly talent and worth are appreciated by the citizens of New York, is a fine specimen of the art, and reflects great credit on the artist.

James Reid Lambdin,
1807–1889.

J. R. LAMBDIN—1827.

This estimable gentleman and artist is now probably the best painter on the western side of the Alleghanies, and a permanent resident in the city of Louisville.

Mr. Lambdin was born in Pittsburg on the 10th of May, 1807. From the age of twelve he devoted all the time he could command to drawing, carving, and engraving on wood. His unconquerable desire to become an artist originated from a visit made by Jer. Paul to Pittsburg, and the exhibition of a full-length Washington by him, as a sign, in the neighbourhood of Lambdin's place of abode.

Early in 1823 young Lambdin visited Philadelphia, and placed himself under the tuition of Mr. E. Miles, having determined on painting as his profession. After six months passed with this teacher, he was received as a pupil by Mr. Sully, and painted under his guidance for a year. He then returned to Pittsburg.

* It having been very generally known, that Edwin Forrest, the tragedian, (a man in whom talents and worth are rarely excelled) was about visiting Europe, it was thought by many of the citizens of New York, a fitting occasion on which to testify to him their high appreciation of his talents as an actor, and his character as a man; and a voluntary subscription was made for that purpose. Designs were made by C. C. Ingham, Esq. N. A. and a die was sunk by Mr. Wright, for a gold medal, which was struck. This medal was presented to Mr. Forrest on the 25th of July, 1834, at a public dinner given to him by the subscribers and others, at which the Vice Chancellor presided.

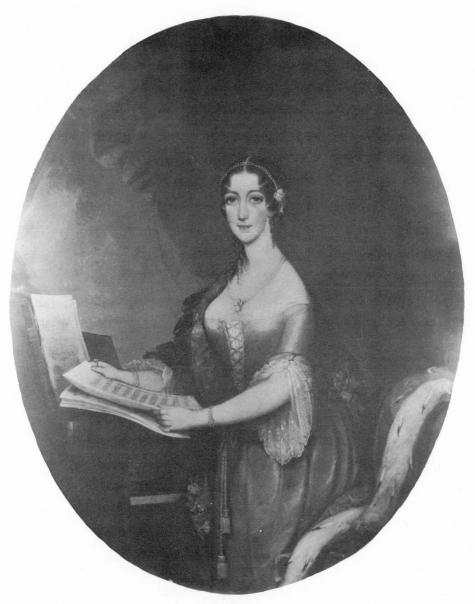

337 CAROLINE MARSH. Painting attributed to Jane Stuart. *Courtesy The Redwood Library and Athenaeum.*

338 BLACK HAWK. Engraving by Abraham John Mason. *Courtesy Dover Archives.*

In 1827, some offers of assistance having been made, to enable Mr. Lambdin to pursue his studies in Europe, he repaired to New-York for the purpose of embarkation; but a failure in raising the requisite funds caused him to return disappointed to his native place; where, soon after, he established the Pittsburg Museum and Gallery of the Fine Arts, the first public exhibition of the works of art in the west. After a trial of four years, Mr. Lambdin removed with his collection to Louisville; where he has found greater encouragement for his exhibition, and more constant employment for his skill, as a portrait painter. His collection is rapidly augmenting, and his prospects of permanent prosperity are daily increasing.— For much valuable information respecting the arts and artists of the west I am indebted to this amiable and enterprising gentleman.

W. M. ODDIE—WM. MAIN—1828.

Walter M. Oddie, c. 1808–1865.

William Main, 1796–1876.

Mr. Oddie, though not a professional artist, is so distinguished as a landscape painter, that I am happy to have the following notice from the pen of a friend who knows him well. " He was born in New-York, about the year 1808, and first indicated a fondness for the arts after his marriage into the family of Henry Meigs, Esq. It was the practice of his father-in-law to amuse himself in the evenings with sketching wild images, such as a *journey to the moon*, with views of the scenery, of the plants, and rare and striking portraits of the *moonites*. These embodied ' whim-whams,' I believe, first induced our friend Oddie to try his hand. He, however, was a lover of the romantic, as indeed he is now; and his themes were cottages and purling streams, with some gentle swain and his true-love strolling through the meadows, or seated beneath the shade of some wide-spreading tree. By the way, trees used to puzzle him, and he generally kept his landscape clear of them, which gives his earlier sketches a somewhat barren appearance. He was frequently advised to get some instruction in the art, but declined, saying, he would battle it out by himself; and in this mood I found him, and soon convinced him, that there were many things he could be taught, in a very short time, which would consume months, and perhaps years, if left to himself to find out; and that, after he had learnt all that could be taught him, he had still enough to learn when left to himself.

" His eyes were opened at the first lesson, and his natural good taste led him on with a rapidity I have rarely seen equal-

led ; and if pursued as a profession, would certainly lead him to excellence and honour.

"*Mr. Main* was born in New-York, but in what year I cannot say ; and was induced to pursue engraving as a profession, from hearing the conversation and seeing the works of a celebrated master, Munro Gondolfi, who made us a visit some years since. On his return to Italy he induced Main to accompany him, and he was to have been his pupil ; but on their arrival at Florence, or in its vicinity, Main arose one morning, and, to his utter astonishment, found his friend had decamped, and left him to shift for himself. In this situation he applied to Raphael Morghen for admission into his studio. He was successful ; and, in a short time, became his favourite pupil. On his return to his native country, he was a long time without employment. Occasionally, he said, he used to get a commission to cut a door-plate or a visiting card, and that was his share of *patronage!* At last he went to Messrs. Waldo and Jewitt, and offered them forty dollars, I think, for the loan of their picture of Bishop Hobart, which was accepted, and he set himself to work to engrave it, as a specimen of what he could do. How well he succeeded every collector and artist can testify. The labour was immense, when it is considered he was doing it merely as a specimen. His health began to give way : but still he consoled himself with the idea that, when finished, he would have his reward and regain all. At last it was completed, but it came to the world still-born : he scarcely sold enough to pay for the copper ; and, I believe, had some idea afterwards of papering his room with the neglected impression.

" Such is the fate of poor Main. His constitution is very delicate, and disappointment and neglect were more than he could bear. He of course declined the door-plates, &c. which the discerning public wished him to execute, and is now turned farmer. His health is returning slowly, and with it, I understand, his fondness for the art, to which he sometimes turns, as to his first love.

George W. Newcombe,
1799–1845.

John Wood Dodge, 1807–1893.

G. W. NEWCOMBE—JOHN W. DODGE—1829.

Mr. Newcombe is an English miniature painter, who arrived in New-York in 1829. He was born on the 28th Sept. 1799. He has pursued his profession steadily in the city which received him, until the present time, with obvious improvement. His conduct, as a man and a citizen, has gained him the esteem of all who know him.

Mr. Dodge was born in New-York on the 4th of November,

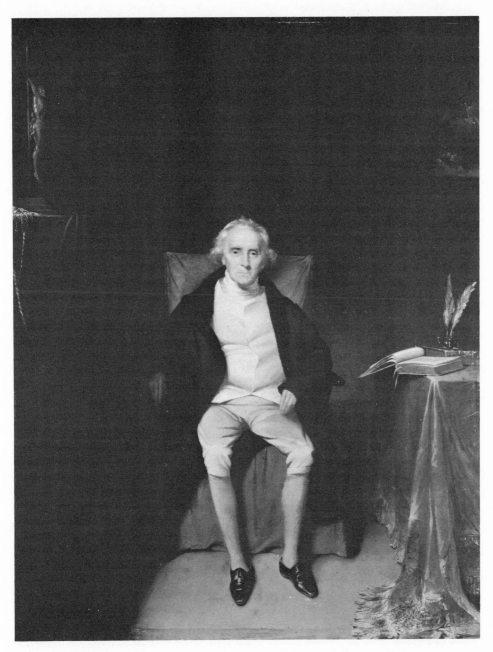

339 CHARLES CARROLL OF CARROLLTON. Painting by William James Hubard.
Courtesy The Metropolitan Museum of Art, Rogers Fund.

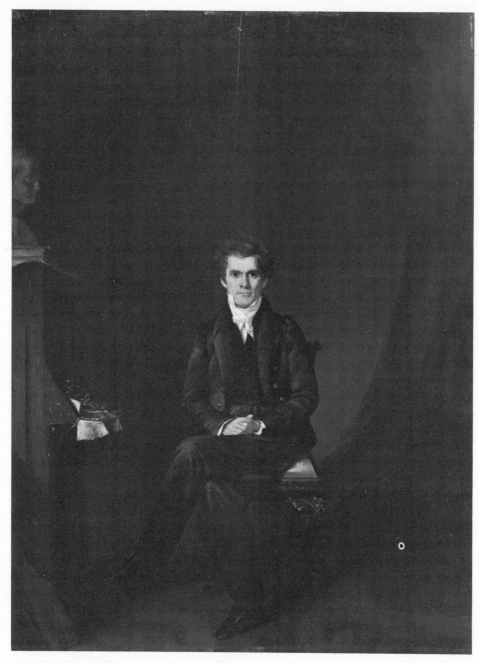

340 JOHN C. CALHOUN. Painting by William James Hubard. *Courtesy The Corcoran Gallery of Art.*

1807. With the common propensity of boys for *making pictures,* he bound himself apprentice to a sign painter at the age of seventeen, who was to instruct him in drawing, but was incapable. Young Dodge, however, instructed himself: and, borrowing a miniature from a friend, succeeded so well in copying it, that he attempted painting from the life, and, as soon as free from his apprenticeship, he commenced miniature painter. He has succeeded by making nature his instructor, and now stands among the prominent professors of the art in New-York.

JANE STUART—1829.

Jane Stuart, 1812–1888.

This lady is the youngest child of Gilbert Stuart, our great portrait painter. She occasionally painted during her father's life, and evinced much talent, but was not encouraged by him. After his death she commenced painting in oil professionally. She has imitated successfully her father's style of colouring, and is improving in her drawing. With attention and encouragement, where she had a right to expect it, from her father, she might have acquired a skill, before his death, that would have made her independent: I hope she has since done so by her own efforts.

Col. Sargent says, " Stuart lost a promising son, whose talent, as an artist, he seemed very proud of: yet he would never give him any instructions ; saying, that if he did he never would be original, and that he thought it best to let young artists find out a road for themselves. Young Stuart would often apply to me for information, which I gave him at second hand. He had also a daughter, who is living : he was very vain of her genius also."

When Mr. Neagle asked him why he did not instruct Jane, he answered, " When they want to know if a puppy is of the true Newfoundland breed, they throw him into the river; if true, he will swim without being taught." Such are the anomalies of man's character when not regulated by early instruction and confirmed by good habits. To most men nothing could appear more obvious than to assist in the improvement of children whose talents they were proud of.

ABRAHAM JOHN MASON—1829.

Abraham John Mason, 1794–?.

This gentleman was born in Goswell Road, London, April 4th, 1794.

He lost both parents before completing his ninth year, and was sent into Devonshire for education in the autumn of 1803. In the course of 1808, paying a premium of one hundred guineas, he was articled to the late Mr. Robert Branston,

wood engraver, for seven years, at the expiration of which time he remained with that gentleman as an assistant for five years more. In the years 1819 and 20, while with Mr. Branston, he was concerned in numerous bank note experiments. Mr. Mason engraved for some months wholly on brass. In 1821 he commenced wood engraving, professionally, on his own account. In March, 1826, Mr. Mason was elected a member of the Royal Incorporated Artists, for the establishment of an annuity fund, in London, to which he still belongs; and in September, 1827, was chosen a member of the committee of management of the London Mechanics' Institution. In February, 1828, he delivered a private discourse to about forty of its members, on the history and practice of wood engraving: in consequence of this he was invited, by the Royal Institution of Great Britain, and London Institution, to prepare a public lecture on the same subject. In the course of preparation for his public lectures he became acquainted with several distinguished scholars and antiquaries. May 15th, 1829, he delivered his first public lecture at the Royal Institution, before the first literati of the country, and the 27th, gave the same lecture before the London Institution. In the months of June and July, he delivered his full course of four lectures at the London Mechanics' Institution; in the intervals of which he lectured also at the London Literary Institution. On the 15th of July, 1829, he was admitted an honorary member of the London Mechanics' Institution; and received, subsequently, votes of thanks from that and other institutions where he had lectured in London.

In November, 1829, Mr. Mason sailed from London with his family for the United States, and arrived at New York December 18th of that year. He brought with him numerous letters of introduction and testimonials from public institutions, and individuals with whom he had been connected: Mr. Brougham, (now Chancellor) Dr. Birbeck, Mr. Loudon, the horticulturist, J. C. Buckingham, the oriental traveller; the late Mr. Northcote, R. A. Professor Pattison; Mr. Wakley; Mr. Ackerman, and others, to Dr. David Hosack, and other scientific gentlemen and professional men. In May, 1830, he was elected an associate of the National Academy of Design, and in April, 1831, delivered his course of lectures to that body. In January, 1832, he repeated his lectures to the National Academy by request; and in June, the same year, he was elected professor of wood engraving to the National Academy of Design. In the autumn of the same year, Mr. Mason received an invitation to lecture in Boston; and in November

341 CHESS PLAYERS. Painting by George Whiting Flagg. *Courtesy The New-York Historical Society.*

342B JOHN MARSHALL. Painting by John Cranch.
Courtesy *Washington University Gallery of Art.*

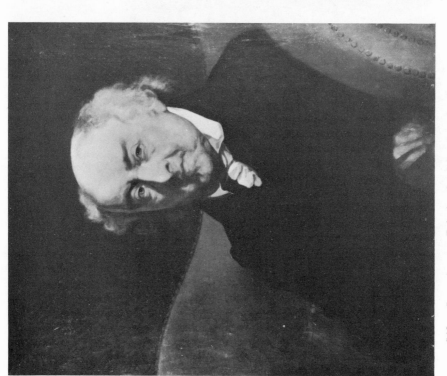

342A JOHN ADAMS. Painting by John Cranch. *Courtesy
Washington University Gallery of Art.*

and December delivered his course to the Society for diffusing
useful knowledge in that city.*

JOHN LUDLOW MORTON—W. J. HUBARD—S. SEY-
MOUR—GEO. W. HATCH—1830.

John Ludlow Morton,
1792-1871.

William James Hubard,
1807-1862.

Samuel Seymour,
c. 1797-*c.* 1882.

George W. Hatch,
c. 1805-1867.

I date the notice of *Mr. Morton* thus late, as at this time
he professed himself an artist, and made designs for our wood
engravers.

He is a native of New York, and son of General Morton.
Mr. Morton was one of the builders up of the National Aca-
demy of Design, a student of it, and is an academician. He
has exhibited an historical picture from Scott's Ivanhoe, which
is, I believe, his only composition in oil colours. Happily
situated in point of fortune, his time is divided between the
arts and agricultural pursuits on the banks of the Hudson.

Mr. Hubard had two very well painted heads in the exhibi-
tion of the National Academy of design, last May (1834).
Robt. W. Weir previously to going to Europe, persuaded
Hubard to try oil painting, and left him his materials for
commencing. I know that he has had the advice of Sully.
He was brought to this country, a boy, as Master Hubard, by
some person or persons, who made money by his ingenuity
as cutter of profiles in paper, at which he was uncommonly
clever. He now, as I am informed, is a portrait painter in
Baltimore.

Mr. Seymour practised engraving and landscape painting
in Philadelphia for several years. He went with the expe-
dition to the Yellow Stone river, with Captain Long, as
draughtsman, " and performed his duty admirably," says my
friend Sully. He is a native of England.

Mr. Hatch is one of our prominent engravers, and designs
with skill, taste, and accuracy. That I am not able to give a
detailed and accurate notice of this very estimable gentleman
is owing to a reserve, on his part, that is to me inexplicable.
He is a native of the western part of the state of New York,
and was a pupil of Ashur B. Durand, our great engraver. Mr.
Hatch resided in Albany, and, I believe, married there. He
has been for some years a resident of the city of New York,
and connected with a company for bank note engraving.—
He began a picture some years ago, which has been favourably
spoken of, but he says he shall not finish it until he has made

* The excellent treatise on wood engraving, in this work, was furnished by
Mr. Mason, and its merits speak louder than my commendations of his know-
ledge in the history, theory and practice of his most valuable art.

his fortune. He is a member of the National Academy of Design, and I have admired his sketches at our sketch club. There is a vignette picture of " The Captors of André," noticed in the Mirror of January last, designed and engraved by Mr. Hatch, as vignette on a bank note plate, issued by Rawdon, Wright, Hatch & Co.

———

CHAPTER XXX.

George W. Flagg—Luman Reed—John Cranch—H. C. Shumway—E. D. Marchant—William Sidney Mount—A farmer's boy—A sign painter—His extraordinary rural scenes—His portraits—Allston's opinion of him—James Freeman. —His revolutionary soldier and portraits—Duncan Ferguson—M. C. Torry Richardson—George W. Twibill—His success in portraiture—William Page—First efforts—Success—His Mezzotinto engraving—John Bisbee—John Crawley, jun —Albert Newsham—S. Watson—James Smilie—Christian Mayr—F. Rawden—Conclusion.

George Whiting Flagg,
1816–1897.

GEORGE W. FLAGG—1830.

THIS youth was born in New Haven, in the state of Connecticut, on the 26th day of June, 1816.

The grandfather of Master Flagg was a native of Newport, in Rhode Island. He entered the continental army as a surgeon, at the commencement of the revolutionary war, and continued in the service until its termination. He was in all the important campaigns in South Carolina and Georgia. After the war, he married Mrs. Allston, the widow of Captain William Allston, of Marion's army, and the mother of Washington Allston. One of the issue of this marriage, is Henry C. Flagg, the father of our subject, who is a native of South Carolina. He was sent to the north for education at an early age, and has resided in New Haven, (where he married) from the age of fifteen to the present time, with the exception of ten years, during which he practised his profession as a lawyer, in Carolina. From the circumstance of his change of location, George has lived several years at the South. In 1830, his father, in consequence of the ill health of his family, contemplated returning to New Haven, and George, who had even then begun to paint, proceeded to Boston with Mr. Bowman, with whom he had commenced his studies in the art.

At twelve years of age, whilst at school at Charleston, he first evinced a taste for his favourite pursuit. It was not encouraged by his parents, or by his grandmother with whom they resided. Possessed of an amiable disposition, and unwilling to give uneasiness, he seldom displayed his pencil in

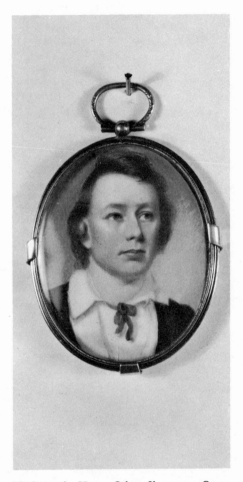

343 JOHN FRAZEE. Miniature by Henry Colton Shumway. *Courtesy The Pennsylvania Academy of the Fine Arts.*

344 FANNY FERN. Painting by Edward Dalton Marchant. *Courtesy Frick Art Reference Library.*

their presence, but sought every private opportunity of indulging his bent. While other boys were engaged in sports, he would be closeted with his drawing materials. All the pocket money he received, was immediately converted into paints and brushes. His first attempt in oil colours, was at the age of fourteen. His first essay of portrait painting was in a likeness of Mr. Babcock, of Charleston ; it was considered a true one, and in the opinion of competent judges, an extraordinary performance for a child of his age. His next effort was in a portrait of Bishop England. This attracted the attention of the original, who is a man of fine taste, as well as an accomplished scholar.

It was useless any longer to restrain him ; from the time of his first successful efforts his whole soul seemed fixed upon a single object. His mind was absorbed in the fascinating art ; he would read nothing which did not tend to that point. He seldom conversed except upon the favourite topic : the company of play-fellows became tedious ; and from that period to the present, he has been the associate of men only—of men from whom he could derive information. It is almost needless to say that he was now permitted to pursue unrestrained the object of his aim. In Charleston, he received every encouragement which could be expected, and soon became a favourite in the first circles.

After his arrival in Boston, for eighteen months he enjoyed the benefit of occasional instruction from his uncle, Washington Allston. From this time his commencement as an artist may be dated. His family was then residing in Charleston : the gentleman, under whose care he had been, soon left this country ; his uncle lived in Cambridge ; and thus situated, without consultation, he opened his room in Graphic Court, and boldly commenced his career in the world as a portrait painter.

In Boston he experienced all the kindness and hospitality for which her enlightened inhabitants have been so long distinguished. Here, also, he became a favourite, and met with all the patronage that could be desired. After eighteen months residence in Boston, he proceeded to New Haven, where he is now residing with his family. He has been established in that place for more than a year, persevering with the same zeal and industry which marked the commencement of his career. His portraits have already attained for him a name without relation to his age, and he has recently finished an original design from Shakspeare's Richard III. which we understand will be brought out at an ensuing exhibition.

It is a representation of the murder of the Princes in the Tower.*

Mr. Allston writes to me, " My nephew, G. Flagg, was with me a few weeks since. He has met with a most munificent patron—munificent for any country.† Not a quid pro quo patron, as I suppose you know. That boy, if I mistake not, will do great things one of these days. A great thing in his favour is, that his heart is as good as his head."

John Cranch, 1807–1891.

Henry Colton Shumway, 1807–1884.

JOHN CRANCH—H. C. SHUMWAY—1829.

Mr. Cranch, the son of the Hon. William Cranch, judge of the district court, Washington city, was born on the 2d of February 1807, and graduated at the Columbian College in 1826 ; at which time he recited a poem of his own composition on painting. He devoted himself to the art, and received instructions from Messrs. King, Harding, and Sully. He commenced painting portraits at Washington in 1829, but, desirous of improvement, went to Italy in 1830. He was a short time in Rome, but, with other strangers, was ordered away as one of the friends of liberty. He went to Florence and resided until July 1832, then visiting Venice and again returning to Florence. Mr. Cranch has recently (1834) re-

* The slightest incidents in the life of one who has attracted public notice sometimes become interesting ; at least to those whose pursuits are similar to his.

We shall here digress for a moment, to relate an anecdote of this young gentleman, which may seem to give some idea of character, and is in keeping with the fact just mentioned.

When but twelve years old, while bathing in the Sampit, one of his companions, who could not swim, ventured beyond his depth ; he sunk in the presence of a number of men, who were at too great a distance to render assistance and could only stand as spectators, petrified by the awful scene. An exclamation of agony burst from the boys----he plunged into the river with perfect coolness, and after a violent exertion of strength, directed with skill and courage, succeeded in bringing the little sufferer safe on shore ; upon landing, he fell exhausted, and was soon after extremely ill. It may not be unworthy of remark, that he was not the herald of this fact to his parents, or to any other person.

† The patron here mentioned, is Luman Reed, Esq., of New York, who is, indeed, a munificent patron of art and artists. He has justly appreciated young Flagg, who under his direction, and supported at his expense, has, within these few days, embarked for Europe to complete his studies as an artist.

Mr. Reed has built a large picture gallery, which, that it may have a proper light, is at the top of his house in Greenwich-street. There already may be seen some of the unrivalled landscapes of Cole, and the same artist is employed in painting several more for him. Mr. Reed has likewise given a commission for an historical picture to Mr. Morse, which will be executed, at least in part, this winter. To our princely merchants, Luman Reed, Esq. has set an example of a mode of expending the gifts of fortune very different from the ostentatious displays of the dining or the drawing room.

345 RAFFLING FOR THE GOOSE, 1837. Painting by William Sidney Mount. *Courtesy The Metropolitan Museum of Art, gift of John D. Crimmins.*

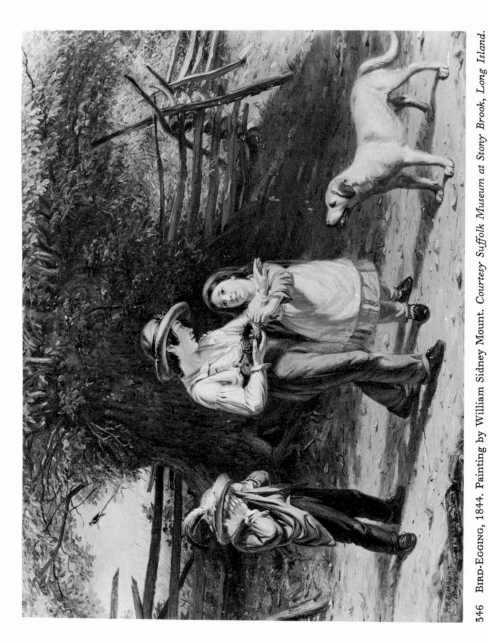

346 BIRD-EGGING, 1844. Painting by William Sidney Mount. *Courtesy Suffolk Museum at Stony Brook, Long Island.*

turned home, with a determination of testing his skill by the composition of an original composition, to be executed this winter. May success attend his efforts.

Mr. Shumway stands in the foremost rank of the miniature painters of New-York. He had the good fortune to be born on the most auspicious day in the year for an American, the fourth of July, 1808. His birth-place is Middletown, Connecticut. Mr. Shumway was intended by his friends for the store or the counting-house; but, like many others, chose a path for himself, and happily has no cause to repent the choice. He came to New-York in 1827, and entered as a student in the National Academy of Design. In 1829 he commenced painting professionally, and soon produced works which are honourable to himself and to the institution which aided his progress.

E. D. MARCHANT—1829.

Edward Dalton Marchant,
1806–1887.

This gentleman has exhibited several portraits of superior merit in the gallery of the National Academy, and one or two groups entitling him to praise in composition. Of prepossessing manners and undoubted abilities, he must succeed in the profession he has chosen.

WILLIAM SIDNEY MOUNT—1829.

William Sidney Mount,
1807–1868.

This young artist, who has displayed uncommon talent both in fancy pictures or compositions of figures, generally rustic and comic, and at the same time in portrait painting, was born at Setauket, Long Island, on the 26th of November, 1807. At the age of seven he lost his father, a substantial yeoman cultivating his own farm, and " to the age of seventeen," he has said, "I was a hard working farmer's boy." An older brother at this time, 1824, sent for him to New-York, and took him as an apprentice to sign painting. This brother, H. S. Mount, was above the ordinary standard of that occupation, and William strove to excel him. He eagerly sought and examined pictures, and West's " Madness of Lear" and " Ophelia" led him to study composition. His selecting these from among the pictures exhibited in the same place is a proof of his discriminating eye and correct taste.

In 1826, he entered as a student in the National Academy of Design. In 1827 he gave up the occupation of sign painting, and for the improvement of his health, returned to his first occupation, the culture of the earth on the paternal soil; but painting could not be forgotten. In 1828 he painted his first picture—a portrait of himself: and in 1829 he com-

menced professionally in New-York as a portrait painter. But he evinced talents of a higher order, and soon produced his first composition picture, "The daughter of Jairus," at the annual exhibition of the academy of which he was a student. This attracted much attention. A rustic dance followed at the next exhibition, still better than his previous pictures, and showing that he had found the path in which he was destined to excel.

Mr. Mount continued to study the antique at the National Academy of Design, and to advance rapidly in his career.— His portraits had progressive merit as well as his composition pictures, most of which were humorous or rustic. In 1833, at the annual exhibition of the National Academy at Clinton Hall, he produced his full-length portrait of Bishop Onderdonk, which elicited a universal burst of applause, and a just tribute of admiration from connoisseurs and artists.

A constant attention and indefatigable application to drawing, from the time he first entertained hopes of becoming a painter to the present time, a profound study of such specimens of colouring as fell in his way, with a devotedness which has led him to the occupation of those hours, even of the night, which many waste in frivolity, to the practice and study of designing, has already been rewarded by skill of an uncommon grade, and must lead to future eminence in his exalted profession.

Mr. Mount's health has not been improved by changing the occupation of an agriculturist for that of a painter. In every other respect his prospects are highly encouraging. From personal knowledge I can speak of him as a young man of the best principles. Such talents as he has evinced, united with probity and industry, must carry him triumphantly through life.

The last works he has exhibited at Clinton Hall, are a group of the table after dinner, very admirable, and a yeoman *husking corn* in the field, still more so.

I was much pleased to receive the spontaneous eulogium of a much better judge than myself in a letter of Aug. 1834, from Mr. Allston, he says :—

"I saw some pictures in the Athenæum (Boston) last year, by a young man of your city—Mount—which showed great power of expression. He has, too, a firm, decided pencil, and seems to have a good notion of the figure. If he would study Ostade and Jan Steen, especially the latter, and master their colour and chiaro oscuro, there is nothing, as I see, to prevent his becoming a great artist in the line he has chosen."

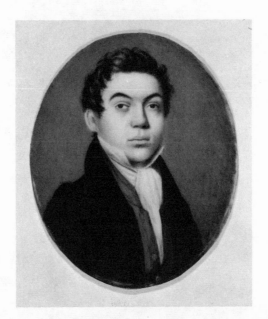

347 SELF-PORTRAIT, c. 1828. Miniature by James Edward Freeman. *Courtesy Museum of the Fine Arts, Boston, Frederick Brown Fund.*

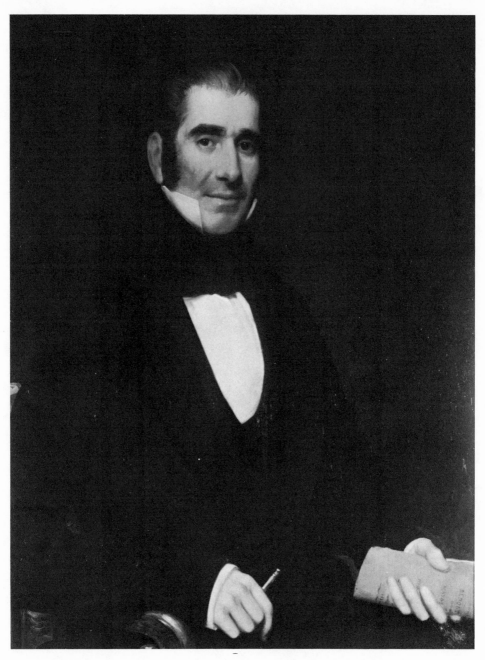

348 GIDEON LEE. Painting by George W. Twibill. *Courtesy Chamber of Commerce, State of New York.*

JAMES FREEMAN—DUNCAN FERGUSON—M. C. TORRY—ANDREW RICHARDSON—1832.

Mr. Freeman was thrown upon his own resources at a very early age. He was born at Grand Passage, Nova Scotia, (whither his parents had removed from the United States,) in the year 1810. At the age of eight he was brought to Otsego county, N. Y. Through difficulties and hardships he made his way to the city of New-York, to gain instruction in drawing and painting. He applied to me for that purpose in 1826, and received freely such as I could give. I have always declined taking a pupil, but never refused my advice or instruction. He entered himself a student of the National Academy, and has worked his way to the honour of being an academician. He attracted much attention by exhibiting the head of an old revolutionary soldier, hired to sit as a model. I remember Henry Inman saying, I should be proud to be the painter of that head. Freeman has since painted larger pictures: but none better. It is in the possession of John I. Morgan, Esq. Mr. Freeman, with perseverance and the preservation of his good habits, must be an eminent painter.

Mr. Ferguson was born in New-York, the son of John Ferguson, Esq., at one time mayor of the city, and at his death, U. S. Naval officer. Duncan was the pupil of his brother-in-law, R. W. Weir, and a student of the National Academy. He has but recently commenced portrait painting, and has only to persevere and follow his teacher and he must succeed.

Mr. Torry is likewise a student of the National Academy of Design. I believe he is a native of New England. The last portrait I saw of his exhibition evinced a power that must lead with application to happy results.

Mr. Richardson is an English gentleman, who has exhibited a number of landscapes at Clinton Hall. I am ignorant of his history.

GEORGE W. TWIBILL—WILLIAM PAGE—1832.

Mr. Twibill was born in the township of Lampetre, Dauphine County, near Lancaster, Pennsylvania. The precise time of his coming to the city of New-York, I do not know. Having chosen painting as his profession, he was for a short time a pupil with Parissien, (the third) but soon found a more efficient teacher in Henry Inman, with whom he placed himself on the 10th of June, 1828. Mr. Twibill was soon a distinguished pupil of the National Academy of Design, of which he is now a member.

James Edward Freeman, 1808–1884.

Duncan Ferguson, *fl. c.* 1832–*c.* 1836.

Manasseh Cutler Torrey, 1807–1837.

Andrew Richardson, 1799–1876.

George W. Twibill, *c.* 1806–1836.

William Page, 1811–1885.

In the year 1832, he commenced professionally, and distinguished himself in a size of oil coloured portraits, too large to be called miniature, but below the size of life. His success has been satisfactory. He early married Miss O'Bryan, a sister of Mrs. Inman. Several of his full lengths of the above size, I have seen and admired.

Mr. Page was born in Albany the 28th of January, 1811, of poor respectable parents. By aid of Dr. E. G. Durnell, he was placed as a pupil with Mr. James Herring in 1825, to learn the art of drawing and painting, and in 1826 became a pupil of Samuel F. B. Morse. He attended the National Academy of Design, and in 1827 received a premium for drawing. The first picture he offered for exhibition was the only one rejected by the *hangers* of the National Academy of Design. His second was placed where it might not be noticed. But these failures stimulated his exertions—he studied assiduously in the Academy, and at his esel, and in less than a year he brought for my inspection the head of a youth, so replete with beauty, that he was asked from what he had copied it. "From nature," and he produced the original. Mr. Page married the sister of Mr. Twibill, and is improving in his profession, both in historical and portrait painting. He has talents of uncommon strength. I have recently seen a specimen of mezzotinto engraving from a full length, small size, of Forrest the tragedian, which I think the best specimen of that mode of engraving, that an American artist has produced. The painting is by himself, from the life.

JOHN BISBEE—JOHN CRAWLEY, Jr.—ALBERT NEWSHAM—1833.

These three gentlemen are good draughtsmen, and have devoted their time and talents to *Lithography*.

Mr. Bisbee I remember as a student, assiduously drawing from the round, and with taste and judgment.

Mr. Crawley is engaged at Endicott's and Swett's establishment, and I have seen some beautiful specimens of this mode of drawing by him. Lithography or drawing on stone, and taking impressions by the aid of acids, transferring innumerable copies to paper, is a very useful invention, and tends to multiply pictures, many of them of a character which diffuses taste and facilitates the progress of art. When practised by a good designer its use is obvious. To be a good draughtsman on stone, requires the same study as to draw well on paper. It is a very pleasant occupation for females, and I have seen specimens from two young ladies, the daughters of Mr. Peter

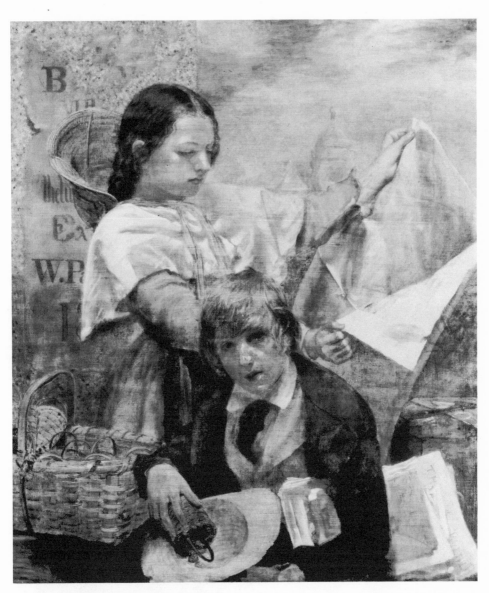

349 THE YOUNG MERCHANTS. Painting by William Page. *Courtesy The Pennsylvania Academy of the Fine Arts.*

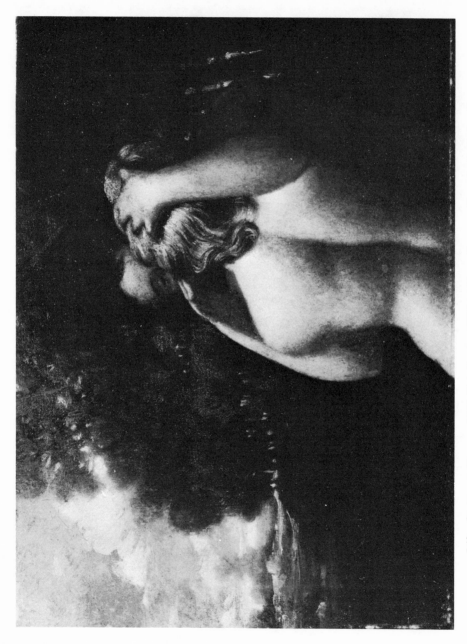

350 CUPID AND PSYCHE, 1843. Painting by William Page. *Courtesy Kennedy Galleries, Inc.*

Maverick, deceased, which I thought ought to command for them an employment that would make them independent with common application.

Mr. Newsham is deaf and dumb, but endowed with much talent. I undestand that he is the draughtsman of the lithographic prints, issued by Childs & Co. of Philadelphia.*

THOMAS U. WALTER—1832.

Thomas Ustick Walter,
1804-1887.

Thomas U. Walter, architect, was born at Philadelphia in the year 1804. He served a regular apprenticeship to the trade of bricklaying and stonemasonry with his father. During his apprenticeship he devoted his leisure hours to the study of architecture, having conceived a strong attachment to that art from his having been concerned in the capacity of bricklayer in the building of the bank of the United States, at Philadelphia, a work in which his father was engaged as a master mason, and at which he laboured with his own hands. He married in 1834.

In the year 1825 Mr. Walter commenced business as a master bricklayer, still pursuing his favourite studies, which were greatly facilitated by a natural talent for drawing, and an acquaintance with the science of mathematics. In the year 1830 he became a pupil of William Stickland, Esq. under whose instructions he devoted his whole attention to the study of architecture and engineering for eighteen months.

In the early part of the year 1832 the designs of Mr. Walter for the new county prison, at Philadelphia, were adopted, and committed to his charge for execution. This extensive establishment is now almost completed, and presents a beautiful specimen of castellated architecture.

Mr. Walter is also engaged as architect in the construction of the "Girard College for orphans," at Philadelphia, a building chaste and magnificent in design and elegant in execution, being a perfect example of the Grecian Corinthian order, the columns of which are each six feet in diameter, and more than 55 feet in height, the portico when finished will extend around the whole building, and support an entablature and roof, all of which will be composed of white marble.

Mr. Walter's designs for this establishment were adopted

* The first lithographic establishment of which I have any knowledge was made amidst many difficulties by *Mr. Imbert,* of New-York. They are now almost innumerable throughout the United States. But however beautiful or perfect the plates are, the credit is transferred to the master of the establishment, and the artist is sunk. This must change. The artist must be announced, and must be the *Master.*

by the city councils in the early part of the year 1833, and on the succeeding fourth day of July, the corner stone was laid with appropriate ceremonies.

The Will's Hospital, for the relief of the indigent, blind, and lame, at Philadelphia, and several other public buildings are the work of this young artist.

Alvah Bradish, 1806–1901.

A. BRADISH—1832.

This gentleman resides at Geneva, state of New-York, and I am assured has proved his talents as a portrait painter to the satisfaction of his employers. He has been invited to exercise his profession at Detroit, owing to his approved skill. I can only speak of him as an intelligent young man, full of enthusiasm for his art, modest in his deportment, and esteemed most by those who know him best.

Stewart (Stuart) Watson, *fl. c.* 1834–c. 1858.

James Smillie, 1807–1885.

Christian Mayr, *c.* 1805–1851.

S. WATSON—J. SMILLIE—CHRISTIAN MAYR—1834.

Mr. Watson is a gentleman who originally painted miniatures in Edinburgh, but has devoted his talents to oil pictures, with success. He has exhibited an historical picture at Clinton Hall, of uncommon merit. Mr. Watson came to this country by way of Canada, with a view of retiring as an agriculturist.

Mr. Smillie is a Scotch gentleman, who came to us likewise through Canada, he arrived in that province bringing with him an aged mother, but was much disappointed in that cold region. In New-York he found difficulty at first in his search for employment, and was on the point of returning, when Mr. Weir invited him to his house, and engaged him to engrave from his picture of the Convent Gate. This led to an introduction to Durand, who gave him employment, and Mr. Smillie's talents once known, secured him a succession of employers and an establishment to his wishes. Removing his parent to our city, he has taken a wife, and is among our most esteemed artists. A plate in one of the annuals (called the Equinoctial Storm) by Hatch and Smillie, is of exceeding beauty, and several of Smillie's steel plates have deservedly attracted public attention.

Mr. Mayr is a German artist, and has shown much talent as a portrait painter. He is said to work with great rapidity. I have seen some groups of his painting which have a merit that must secure him success in his profession.

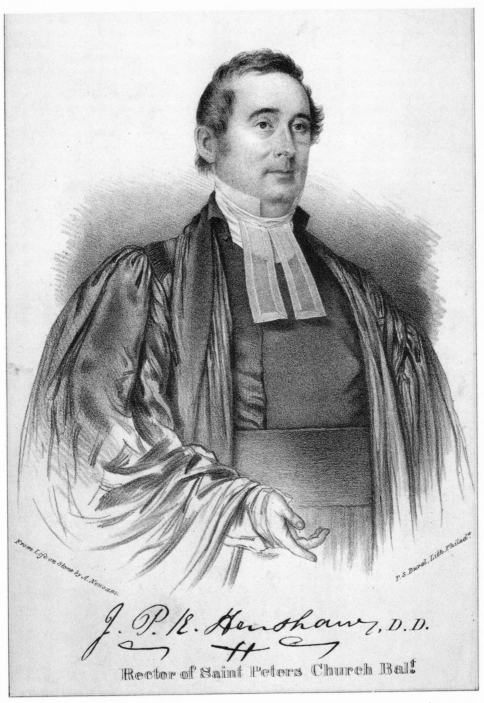

From Life on Stone by A. Newsam.

P.S. Duval, Lith. Philad.

J. P. K. Henshaw, D.D.

Rector of Saint Peters Church Balt.

351 J. P. K. HENSHAW. Lithograph by Albert Newsam. *Courtesy Dover Archives.*

552 GIRARD COLLEGE. Architecture by Thomas Ustick Walter. Engraving by James W. Steel. *Courtesy Dover Archives.*

FREEMAN RAWDON—1834.

Freeman Rawdon, line engraver and designer, is the first partner in the well known firm of Rawdon, Wright, Hatch & Co., New-York. He was born in Tolland, Connecticut, in 1804. Mr. Rawdon's first efforts were under the direction of a brother, an engraver at Albany. Mr. Rawdon's success in designing and executing vignettes gained him the employment of the Commercial Bank at Albany. His powers and skill, my informant says, were tested with those of Gideon Fairman by the New-York Canal Company, and he gained their employment; and in it executed a design emblematic of the union of the lake waters with the Atlantic, much to their satisfaction and his credit. Mr. Rawdon removed to New-York, and has established the present firm of Rawdon, Wright, Hatch & Co. whose works are too well known to call for eulogium.

CONCLUSION.

Collections of Pictures. In our extensive country these are so far asunder, and my knowledge of them so imperfect, that I fear my readers may exclaim, as it regards my account of them, " O lame and impotent conclusion."

I am conscious that every branch of the tree I have endeavoured to rear will be but as a limb for others to graft on : but each may hereafter be made to flourish and bear fruit by some more skilful horticulturist; but to leave metaphors for the plain and simple language of truth, at which I hope I am more worth, I mean not to waste words in apologies for the imperfections of my account of the collections of pictures in the country, but to tell all I know, and leave to others, who are interested in the subject, the pleasure of making it more perfect.

As the first painter in point of time, of whom I have any knowledge, *John Watson*, was found at my native place, Perth Amboy, so *there* was the first collection of pictures I have heard of; and what it was in magnitude or merit is only known by faint and obscure tradition. This existed in 1725. *Smybert's* collection is the second that I can discover through the mists of time, and that, like the first, so indistinctly, as to be little more than a name. The date of this is 1728. Of the *Hamilton* collection we have more positive knowledge. It is mentioned in the biography of West. A Murillo is there spoken of, and it is certain there were other good pictures, but I have no record of them. We may date this collection from 1730 to 40. I have spoken of *Trumbull's* col-

lection of pictures exhibited in the Park theatre, 1804–5.
These were principally works of old masters, which the tem-
pestuous waves of the French revolution threw into his hands,
and with them was exhibited his own splendid painting of the
" Sortie," now in the Athenæum of Boston.* This collection
of old pictures was returned to Europe, and remain there.
The *Steer* collection I have made inquiry after; and Robert
Gilmor, Esq. of Baltimore, gives me this account:—" With
respect to the Ruben's pictures (as you call them) I, perhaps,
can give you better information than most people, as the prin-
cipal descendant of Rubens, (whose private cabinet descended
to his heirs, and was afterwards divided among them) was Mr.
Steer of Antwerp, who came to this country when the French
entered Holland, and brought out with him the greater part of
the cabinet which remained in the family, comprising several
fine heads by Vandyk, Rubens, &c. Mr. George Calvert, of
Bladensburg, married his daughter, and could give you fur-
ther details. The pictures were boxed up, in Annapolis, for
years, and were only once opened, I believe, to be aired.
Stuart went there on purpose to see them, and admired them
much. Mr. Steer afterwards built the present elegant resi-
dence of Mr. Calvert, near Bladensburg, and removed the
pictures there, some of which were hung up in the rooms.
After the peace of Amiens, or rather, I believe, after the re-
volution in Holland, returned he to Antwerp, carrying his
pictures with him, which were afterwards divided in the family.
The famous portrait by Rubens, called the *Chapeau de paille*,
which belonged to the collection, never was brought to Ame-
rica, but was concealed at Antwerp, and as it could not be
divided, it was sold at auction *in the family*, and Mr. Steer as
the eldest representative of the family, was allowed to pur-

* Until my biography of Mr. Trumbull was printed, I had not seen the work
from which the following extracts are made, although published in London in
1825. The coincidence of opinions is striking, as it respects the " Sortie" par-
ticularly. " Arts and Artists, Vol. 3. p. 199."
 " Mr. Trumbull, although an American, studied and pursued his profession for
a long time in this country. He is now President of the New-York Academy,
and is the person whom Congress have employed to paint a series of pictures
connected with certain events of the American Revolution. They are among
the greatest and most unaccountable failures of the age : the President may not
be superannuated, but these pictures are. It is a great pity : every lover of the
art must grieve to see the first efforts of a young country so unhappily misdirect-
ed. There were several painters in America, who would have made a magnifi-
cent affair of that which is handled like a tapestry weaver by Mr. Trumbull.---
Yet Mr. Trumbull *was* a man of considerable power. His well-known " Sortie
of Gibraltar," the original sketch of which has lately been exhibited at the Suf-
folk-street exhibition, was a very fine picture ; but worth, it is true, every thing
else he has ever done. His portraits are no great things : they are bold and
strong, but all of a family."

353 Mrs. Joseph Campau. Painting by Alvah Bradish. *Courtesy The Detroit Institute of Arts.*

Painted by Robert W. Weir.

Engraved on steel by James Smillie.

554 SCHOOL HOUSE, TAPPAN. Engraving by James Smillie after the painting by Robert W. Weir. *Courtesy Dover Archives.*

chase it for fifty thousand francs; this I had from himself, in 1818, when I was at Antwerp, and saw the picture in his possession, as well as such of the other pictures as fell to his share. Mr. Calvert has two or three Flemish pictures left to him by Mr. Steer, but they are not of extraordinary merit."

Portraits by Sir Joshua Reynolds have occasionally reached our shores. I remember one in the *Farmer* family, formerly of Perth Amboy: a beautiful head of Major Jasper Farmer when a youth. Mr. Gilmor mentions "A portrait of old Mr. Carroll, by Reynolds, painted when he was in England; but it is much faded. There are also several portraits by Sir Joshua, at Tulip Hill, West River, the seat of the Galloways, now belonging to Virgil Rexey, Esq. solicitor of the treasury." In Annapolis, Baltimore, and other parts of Maryland, rich collections of pictures are to be found. My limited means, and still more limited health, have not allowed me to explore or examine these treasures. Mr. Gilmor says, " Mr. Caton has two pictures by Lawrence, and one by West, (the Kentuckian). Mr. James Hoffman has a portrait by Lawrence, one by Phillips, and one by Newton. Mr. Riddell has a portrait also by Sir Thomas." The same liberal gentleman, Mr. Robert Gilmor, has, at my request, sent me a catalogue of his valuable collection, which I give.

List of some of the Pictures in the Collection of Robert Gilmor, of Baltimore.

The finding of Moses, a large painting on canvas, brought into Philadelphia by the French emigrants at the commencement of the Revolution. It belonged to Savage the artist.—*Nicholas Poussin.*

A scene on the river Wye, at Amsterdam.---*Ludolph Backhuysen.*

A Fruit Piece, one of his best works.---*John David Latteem.*

Two Battle Pieces, brought into Baltimore by Groombridge.---*Borgognone.*

A small Landscape.---*Wynants.*

The Geographer, a highly finished picture of the Master.---*Ary de Voys.*

A Gentleman holding a Watch. A small Portrait, exquisitely finished, and sent here by one of the first connoisseurs in Holland.---*Ary de Voys.*

A Card Party. The principal figure a lady, with her back towards the spectator. This is one of the finest specimens of the master to be found in any collection, and in admirable preservation. Selected by the same connoisseur.---*Terburgh.*

A Garden Scene, with statuary, flowers, and animals. A brilliant picture, selected by the same connoisseur.---*John Weeninx.*

A Roman Charity. Selected by the same.---*Mechel.*

The Smokers. An engraved picture.---*A. V. Ostade.*

The Sailor. A fine specimen. Both of these selected by the same connoisseur.---*A. V. Ostade.*

The Scalded Boy. Selected by the same.---*Frank Halls.*

Nymphs flagellating a Satyr.---*Vertangen.*

A Calm.---*William Vandevelde.*

His own Portrait, (full-sized, half-length,) holding a lighted candle. This and the following pictures were part of a case of pictures sent by a gentleman in France to his brother in New Orleans; but being shipwrecked on the coast of

Cuba, was sold there to an American Captain at auction, and brought into Charleston, where it was purchased for Mr. G.---*Schalcken*

A Vase of Flowers, equal to Van Huysum. The frame is ornamented with bees, which would authorize the supposition that it had once been Bonaparte's.---*Abraham Mignon.*

A Portrait of one of the Family.---*Gilbert Stuart.*

Another Portrait of one of the Family.---*Jarvis.*

Two Portraits of the Family.---*Sir Thomas Lawrence.*

View on the Rhine.---*J. Vandermeer.*

View of Haarlem, his native place.---*Jacob Ruysdael.*

View of the Leeshore at Scheveling.---*Do.*

Small Landscape.---*Do.*

Cattle and Sheep, in a sunny Landscape.---*Omegank.*

Landscape, with Cattle.---*Vander Leeuw.*

Moonlight View on a canal in Holland.---*Vander Neer.*

Evening Scene on a river, with Cattle (engraved)---*Albert Cuyp.*

View of the Lake of Nemi, near Rome.---*Richard Wilson.*

A Convent at Venice.---*Do.*

River Scene, in the style of Salvator Rosa.---*Pillement.*

The Custom-house at Venice.---*Canaletti.*

Adoration of St. Francis.---*Antonio Balestra.*

A Lady in her Chamber, in conversation with her Cook.---*G. Metszu.*

A Miniature Salvator Mundi, on copper.---*A. Vandyck.*

Two half-length portraits of a Lady and Gentleman. These pictures came from Spain to Mr. H. Hill, of Philadelphia : they had been seventy years in the family.---*A Van Dyck.*

A Pair of Pictures ; a Carousal and a Fair.---*Mischau.*

Sea-shore at Schevelinge, with numerous figures (engraved)---*Van Goyen.*

Scene in Hyde Park, got of Groombridge.---*George Barrett.*

A Mill near Baltimore, painted as a *pendant* to the preceding.---*Groombridge.*

Still Life and Fruit.---*Raphael Peale.*

A Slice of Water Melon.---*Sarah Peale.*

Fruit.---*James Peale.*

A Dead Partridge ; admirably finished.---*F. Wiebke.*

A Battle Piece.---*Bredael.*

A Hunting Scene.---*Old Wycke.*

Interior of the Church at Delft.---*Henry Van Vliet.*

The Augurs ; engraved by Goupy. This fine picture was brought into New-York by the Collector of the Revenue about seventy or eighty years ago ; was sold at his death, and bought by an old picture dealer and frame maker, who kept it for many years, and finally sold it to Mr G. in 1804.---*Salvator Rosa.*

A Magdalen.---*Michael Angelo da Caravaggio.*

Full-length Portrait of William III. when Prince of Orange. Small size.---*Jaspar Nestcher.*

A Bunch of Lilac.---*Van Pol.*

Portrait of a Lady ; small size.---*P. Van Slingelandt.*

A rich Scene, representing the Elements ; finished very highly. Came from the collection of the Prince de Mionaco ---*Breughell and Van Balen*

Two small River Scenes.---*Everdingen.*

Lot and his Daughters : formerly Mr. Bingham's.---*F. Bischay.*

Upright Landscape, with Bathers.---*Zuccarelli.*

Imitation of Bronze.---*Sauvage.*

Portrait of himself, with a drinking glass.---*D. Teniers.*

Judith and Holofernes. The figures are portraits of himself, his wife, and his mother. This picture is in fine preservation : It was brought from Paris to London by Col. Trumbull, and is mentioned in Buchanan's list.---*D. Teniers.*

Small Portrait of a Nobleman ; formerly belonging to Wertmuller.---*Holbein.*

Portrait of a Gentleman : small.---*Metsu.*

View on a Swiss Lake.---*Sachtleven.*

The Holy Family reposing in Egypt : From Da Hante's collection.---*Rubens.*

A very fine copy of Raphael's picture in the Louvre, painted for Francis I.----*Mignard.*

355 GEORGE D. PRENTICE. Painting by Christian Mayr. *Courtesy Louisville Free Public Library. Photograph Frick Art Reference Library.*

356 THE OLD OAKEN BUCKET. Engraving by Rawdon, Wright, Hatch and Smillie after Frederick S. Agate. *Courtesy Dover Archives.*

Two Portraits, male and female.---*De Crayer.*
Portrait of Mr. Coke, Chamberlain to George I.---*Sir Godfrey Kneller.*
Portrait of a Gentleman.---*Govert Flinck.*
Small Portraits of Grotius and his Wife.—*Meervelt.*
Fisherman's Hut.---*Morland.*
A Dutch Market : Large and finely coloured.---*Snyders and Lang Jan.*
The Broken Pitcher ; engraved by the artist.---*T Barker,* of Bath.
A Landscape.---*Ruysdal Barker.*
Three Pictures, with Cattle---*Rosa di Tivoli.*
Three fine Landscapes,---*Thomas Cole.*
Interior of a Kitchen, equal to Gerard Douw---*Martin Zorp.*
Small Landscape---*Hobbima.*
A fine Head of a Monk ; formerly Mr. Meade's---*Velasquez.*
Sick Beggar Boy : sent by the Dutch Connoisseur---*Geernaut.*
Portrait of a Lady, with a Veil---*Maes.*
Landscape--- *Wm. G. Wall.*
River Scene---*A. Waterlo.*
Portrait of a Child---*G. Stuart Newton.*
Architecture--- *Van Delon.*
Repose in Egypt. A fine picture, sent him by Greenough from Florence---*Francisco Albano.*
One of the Heads in the cartoon of Ananias, in Fresco, from the collection of the Corsiglore Galignani at Salerno ; afterwards belonged to Rigaud, the R, A. and brought to New-York by a gentleman sixteen years ago. N. B. The letters of Rigaud the son, and of Bacon the sculptor, go to support its claim to originality---*Raphael.*
Portrait of Miss Kelly, in Julia---*Sully.*

All the preceding are undoubtedly *original.* There are about 130 not mentioned, being either by the same masters, or of doubtful character, or not of snfficient importance to be thus noticed.

A large landscape, with grand Architecture. Brought from France by Vanderlyn for Col. Burr, and sold at Mr. Astor's sale.---*Francisco Mille.*
View of the Plautian Tomb at Tivoli.---*Verboom.*
Boys at Play. Imitation of bas relief.---*Jacques de Witt.*
Nymphs Bathing. Two pictures.---*Poelemberg.*
An English Actor in a Spanish Dress ; unfinished.---*Robert Edge Pine.*
Portrait of the Marquis of Buckingham in his robes, as Lord Lieutenant of Ireland.---*Trumbull.*
A Party Carousing.---*Brower.*
Italian Architectural Piece.---*Berkheyden.*
Satyr and Nymphs.---*B. Graat.*
Himself and his Wife eating a Pie. Sent by the Dutch connoisseur.---*Jan Steen.*
Poultry. Sent by the same.---*Hondekoeter.*
Game Cocks Fighting. A fine specimen. Brought from Europe by Accambal, the French consul, thirty years ago.---*Hondekoeter.*
Portrait of Washington ; painted for me two years before his death.---*Gilbert Stuart.*
St. Francis.---*Cigoli.*
Several Landscapes by---*Thos. Doughty.*
Old Woman pouring Water out of a Pitcher from a Window. Equal to G. Douw. *Van Tol.*
A very fine Landscape, with Cattle ; brought from France by a gentleman of Boston. It is engraved by La Bas Martini.---*N. Berchem.*
Beattie's Minstrel.---*Washington Allston.*
 Besides other works of art, Mr. Gilmor possesses Greenough's Statue of Byron's Medora, said to be of exquisite workmanship.

The collection of *Joseph Bonaparte* **is noted under the biography of** **Thomas Sully,** **with his remarks on some of the**

pictures. Mr. Sully's notice of Abram's collection is better than any thing I can say on the subject, and is before given. Ward, of London, sent out a collection, which was exhibited with loss. But it is impossible, perhaps would be useless, to specify the many collections of paintings brought out from Europe for exhibition. Mr. Michael Paff has long possessed a valuable collection, which varies with the sales and purchases he makes ; but he retains many that he justly values beyond the price which every day purchasers can give. Among these I may specify his "Magdalen," by Carlo Dolce ; but so much superior to any Carlo Dolce within my limited knowledge, that I would fain attribute it to a higher source.

The collection made by Richard Meade, Esq. when in Spain, now, as I believe, in the possession of Governeur Kemble, Esq. of Cold Spring, is extensive, and possesses many valuable pictures by old masters. The original marble bust, by Ceracchi, and other works of art, are attached to this collection. Miss Douglass, of New-York, has a well-selected collection of European and American pictures—the old masters are said to be good.

In 1830 a collection was exhibited in Barclay-street, which possessed many undoubted originals of a high order. A Family Group, by Rubens, and another by Reynolds, were jewels, in my opinion ; while some of Carlo Dolce's sunk into insignificance.

The collection of Doctor Hosack is extensive and valuable, I can only enumerate a part.—" A Madonna and Child, by Corregio—copy of La Belle Jardiniere of Raphael, with variations—copy of Madonna and Child, from Vandyke—two beautiful small Landscapes, near Bath—small Sketches of Lambderg and Golchossa—our Saviour blessing little Children—the Woman taken in Adultery—the Knighting of Wilton and a full-length of Washington, small size—St. John and Lamb, a copy—Contemplation—the Falls of Niagara—all by Trumbull. Several of T. Cole's fine Landscapes ; and many Portraits, by Stuart, Trumbull, Jarvis, Vanderlyn, Sully, Ingham, Dunlap, Wood, and Sharpless."

The catalogue of the collection of Philip Hone, Esq. I give, as furnished by him at my request.

COLLECTION OF PHILIP HONE, ESQ. OF NEW-YORK.

1. Anne Page, Slender and Shallow---by Leslie.
 Shallow. Mistress Anne, my cousin loves you.
 Slender. Ay! that I do, as well as I love any woman in Gloucestershire,
 Shal. He will maintain you like a gentlewoman.
 Slen. Ay, that I will, come cut and long tail, under the degree of a squire.

Shal. He will make you a hundred and fifty pounds jointure.
Anne. Good Master Shallow, let him woo for himself.

Merry Wives of Windsor, act iii, scene 4,

2. The Dull Lecture---by G. Stuart Newton.

These two pictures are among the best productions of the distinguished artists whose names they bear. I am of opinion there is nothing in this country by either of them equal to the above. Connoisseurs are divided in their opinion of their respective merits: each possessing the peculiar beauties of the painter's style, renders it difficult to determine which is best. I certainly hold them in equal estimation. Leslie's is one of the most beautifully finished pictures I ever saw; its details are admirable, and Shakspeare himself did not tell his story more eloquently than does this graphical and fascinating representation of one of his best scenes.

The peculiar excellence of the "Dull Lecture" consists in its brilliant colouring, and the beautiful effects of light and shade; in which I consider it superior to the "Anne Page." The figures are fully equal to those in that picture; and there is a quaintness in the furniture and decorations of the room admirably adapted to the subject. Newton is a more dashing painter, and the general effect of his picture is finer than that of his accomplished rival; but it is not equal in finish and accuracy of detail.

3. The Greek Girl, a beautiful little picture, by G. Stuart Newton: full of expression, and coloured in his best style.

4. The Greek Youth. Painted by Weir, as a companion to the foregoing. One of his happiest efforts, and suffering nothing by a comparison with its Companion.

5. La Baretta; also by Weir; of the same size as last. The subject was suggested by the Greek Girl, and the costume imitated from that picture, which was much admired and studied by Mr. Weir.

6. Portrait of Rubens; copied from the original by Rembrandt Peale, and, in my opinion, an excellent picture.

7. Little Boy and Bird's Nest, altered from one of the Cherubs in Corregio's Danae, by Mr. Peale.

8. Le Billet Doux, a spirited picture, by Le Cœur, a French artist, painted in 1829.

9. Domestic Happiness, by T. Clater, 1828. A fine representation of an English Cottager and his Wife and Children: drawn with great spirit, and superior in colouring to any of the works I have seen of this artist.

10. The Water Gap on the Delaware River, by T. Doughty. The mountains, like all of this artist, very fine; but the outline, in some parts, is very hard, and the water not sufficiently transparent.

11. View of Ravensheuch Castle, on the Firth of Forth; by Thomson, of Duddingtone, the Scottish Claude. This view was taken for me under the direction of a friend in Edinburgh.

12. The Still Lake---Catskill Mountain.

13. The Falls of the Kauters Kill---Catskill Mountain.

These two splendid Landscapes are among the early productions of Cole, and were painted, I believe, before he removed to New-York. They represent the magnificence of American Forest Scenery with the truth and force which characterize all the works of this truly American artist.

14. View of the Black River.

15. Passaic Falls, New Jersey.

16. The Sugar Loaf Mountain, county of Wicklow, Ireland.

17. View on the Jacondaga River.

The four last are water-colour drawings, by Wall, whose productions in water colour have always been distinguished by delicacy and correctness.

18. Castel a Mare. Bay of Naples. By Bennet. A water colour piece—drawn from a sketch made by him on the spot, and among the best of the good things which he has produced.

19. Original Sketch of Lafayette, by Morse. A study for the full-length portrait, painted for the corporation, and now in the Governor's room, City Hall.

20. Portrait of Chancellor Kent, by Morse.

21. Portrait of Thorwaldsen, the celebrated sculptor : an original, taken for me by Mr. Morse. A fine picture, and said to be a perfect likeness.

22. Sketch by Mr. Dunlap, which served as a study for the principal figure in his great picture of "Calvary."

23. View on the Hudson River, above West Point, by Hoyle.

24. Portrait of a Girl, as Hebe, by Newton. One of his early productions--- painted in Boston, before he went to England.

25. A fine copy, by Vanderlyn, of the Female Figure in the fore-ground of Raphael's Transfiguration.

26. Portrait of De Witt Clinton, by Ingham, taken about fifteen years ago.--- A capital picture : the best likeness, and, I think, the only good one extant, of this illustrious man.

48. A Greek, an original portrait, by Miss Stuart, formerly owned by the Rev. Dr. Wainwright.

The above are all the works of artists now living, and I do not know of a finer collection of modern pictures. I have several old pictures, some of which are dignified by the names of celebrated painters; but I do not esteem them suffi- ciently to induce me to furnish you with a catalogue.

Feb. 10th, 1834. *P. H.*

The collection of Gulian C. Verplanck, Esq. at Fishkill, is extensive and valuable. Charles Hall, Esq. has a fine col- lection; and among them several pictures by Alvan Fisher.— Robert Donaldson, Esq. has several by Leslie. Myndert Van Schaick, Esq. has Allston's " Rebecca at the Well," among many others. James Renwick, Esq. has a rich col- lection. Henry Carey, Esq. has several pictures by the old masters, (Both, Guido, Peter Neifs the elder, Gerard Douw) ; and a few pictures by moderns, (Doughty, Weir, &c.)

T. Dixon, Esq. has a collection of modern pictures ; among them many landscapes by Wall. P. Flandin, Esq. has seve- ral good pictures. Francis Winthrop, Esq. of New Haven, has Allston's sketch of " The Angel releasing St. Peter ;" and several pictures by Krimmell. James Hilhouse, Esq. of New Haven, has a collection, among which are several land- scapes by Cole. Of the collections at Boston I can say no- thing, from my ignorance only that the Athenæum possesses a rich treasure. The Trumbull Gallery, at New Haven, is noticed under his biographical sketch. The collection of Luman Reed, Esq. of Greenwich-street, already is rich in works of modern art ; and his munificent spirit is enriching it daily from the pencils of Cole, Morse, and other prominent artists. Governeur Kemble, Esq. has a number of valuable paintings, ancient and modern.

Mich. Paff, Esq. of New-York, has not only been an industri- ous and successful collector of paintings, but has a very great and valuable collection of prints—valuable many of them for their antiquity, and most of them for their intrinsic merit. Mr.

Paff has rivals in this latter branch of the collector's avocation in Mr. John Allen, likewise of New-York, who possesses treasures of the works of the engraver, and Mr. Ithiel Town, whose splendid library I have noticed, has likewise a magnificent collection of prints. Hereafter, if this work shall be found to interest the public, some younger lover of the Arts of Design may add the names of artists, friends to art, and collectors of works of art, which have escaped the view of an aged valetudinarian.

George P. Morris, Esq. editor and proprietor of the New-York Mirror,deserves our notice and thanks as a friend of artists, and the arts of design. By the engravings which ornament this popular work, taste is propagated, and the study of the fine arts in all their branches encouraged. In the very expensive plate of " The Presidents," portrait painters and the first engravers were employed at liberal prices. The designs of several artists in landscapes and other subjects have done honour to the country, and added reputation to those employed.

Notwithstanding the gratitude due to those who bring us the works of the old masters, I cannot but feel, as a *living artist*, that the collectors of the pictures and statues executed by their contemporaries, and those who otherwise give them encouragement and employment, are more entitled to praise than any purchaser of the works of by-gone days. In this point of view I think Dr. Hosack, James Fenimore Cooper, Philip Hone, George P. Morris, Luman Reed, G. C. Verplanck, and many others, more entitled to thanks in these pages, than any collector of the works of antiquity, without denying the utility of such collections or their effect upon art.

I have endeavoured to show the progress of the Arts of Design in the colonies of Great Britain, slowly feeling their way amidst the darkness of ignorance; and their rapid advance as soon as those colonies had become an independent empire, governed by republican principles. I have traced the arts from a dependent infancy, feeble and tottering, to that state of maturity which corresponds with the political state of the country and its unparelleled growth in knowledge and power. Within the short space of one man's life we see arts which were unknown, successfully taught and practised throughout the wide extent of the republic, and in regions which were unexplored by civilized man within half a century.

However discursive I have been in this work, I have had but one object in view : to show the steps by which the arts that place the civilized man so far above the savage, not only in power, but enjoyment, have arisen in America, to a level

with those of any community now in existence—and to an attentive reader I have shown that they are not at a stand, but are on the way to a much higher state of excellence.

I have traced the progress of *architecture* from that period in which if a building was intended for any thing more than mere shelter from the elements, its plan, and even the materials of which it was to be constructed, were necessarily imported from Europe, to that, in which our cities and villages are adorned with edifices towering in splendour and replete with taste in their design, from the plans of native artists: of *painting*, from the time when, if a father, a husband or a friend wished the portrait of one he loved, he must wait the arrival of an artist from Europe, to that, in which skilful painters abound in every district of our country: of *engraving*, from the rude scratching of figures on type-metal, which told their meaning by labels proceeding from their mouths, to that, in which Danforth worthily multiplies the works of Leslie, and Durand astonishes the European, who, when looking at his plates, is told that the artist who rivals any in the world, has never crossed the Atlantic.

I have written in good faith, with a full belief that the Arts of Design are necessary to the well-being of man; and that to encourage them and their students and professors is a good work. I will *conclude* my *conclusion* with the words of Richardson (one of the earliest English writers on the arts) as they appear to me very much to the purpose: "After all, it must be confessed that the arts I have been discoursing of are not so necessary to human life as some others; mankind might indeed subsist without them. Ours is a mixed state, divided between struggling to avoid or to get rid of pain, and positive enjoyment: one is driving *Hannibal out of Italy*—the other making foreign conquests:—the one seems to be superinduced upon the Fall, the other, what was originally intended for us, in Paradise: and accordingly there are arts and employments subservient to us in each of these circumstances; the first kind are absolutely necessary, the other not.

"Let those necessary ones boast of that necessity; they are ministerial to us only as wretched beings; whereas painting and sculpture are of the foremost in the number of those adapted to a state of innocence and joy: they are not necessary to our being; brutes and savage men subsist without them: but to our happiness as rational creatures, they are absolutely so."

APPENDIX.

———

My limits are exceeded, and I can only notice in ān Appendix, the artists of whom, or from whom, I could obtain but slight information. Very many are doubtless altogether omitted.

ARCHITECTS,

John Haviland, an English artist, now in Philadelphia.

Martin E. Thompson, New-York.

Hoban, Washington, D. C., gained the premium for the plan of the President's House. *George Hadfield,* Washington, gave the plan for the Executive Offices, and the plan of the City Hall, same place: died 1826.

William Small, Baltimore, is now the architect of the Exchange Hotel in that city.

Peter Harrison, of Newport, 1760.

Robert Carey Long, built the Union Bank, and St. Paul's Church, Baltimore.

John Lenthall, great grandson of the ci-divant president of the parliament, under Richard Cromwell. This gentleman was employed by Latrobe in the public buildings of Washington and highly valued.

Dr. William Thornton, a man of rare genius, who deserves a more ample page than I can give him. He designed the Capitol at Washington.

Charles Bullfinch, was appointed surveyor of the public buildings at Washington on the resignation of Latrobe in 1818, he finished the rebuilding of the capitol. I have no memoir of this gentleman.

John H. B. Latrobe, the oldest son living of B. H. Latrobe, is a lawyer of Baltimore, but an amateur architect, draughtsman and painter.

B. H. Latrobe, the youngest son of the celebrated architect, is professionally an architect, and has already distinguished himself as such.

Henry Sellen Boneval Latrobe, the oldest son of B. Henry Latrobe, was born in 1793, and gave early proofs of extraordinary talents. He was instructed, after graduating at St. Mary's College, Baltimore, by Mr. Godefroi, in civil and military architecture, and then entered his father's office, finished his education with him, and assisted in the public works at Washington. Sent to New-Orleans to carry his father's plans into execution, as above mentioned, his labours were interrupted by the invasion of the English, against whom he served as assistant engineer to Major Latour, and signalized himself by his skill and gallantry. In 1815, he was appointed a commissioner for the erection of a lighthouse. His design for this structure is thought one of the most simple and beautiful of the kind. In 1816 all his works for the bringing water to New Orleans were destroyed by fire, and while endeavouring to remedy the mischief, he was seized with fever, and died in August after an illness of five days.

Mr. Stone of New Haven, a promising young architect, is just rising to notice in that city.

SCULPTORS,

Cardelli an Italian, in America about 1818, only remembered as leaving two casts from modellings by himself of Mr. and Mrs. Trumbull.

Causici, an Italian who sculptured the Washington for the monument at Baltimore, and several subjects for Congress at Washington : he died at the Havana. In 1816, a subscription was opened to raise one hundred and fifty dollars for a model of Washington to be placed in the Pennsylvania Academy. He modelled an equestrian statue of Washington at New-York. The corporation granted him a place to work in, and the statue was exposed in the park. It was put up on the 2d of July, 1826. Causici called himself a pupil of Canova : but Mr. Weir asked a nephew of the sculptor if he remembered him. He replied, "I was with my uncle from infancy to the time of his death. I never heard of the man."

Persico, an Italian.

Ball Hughes, an Englishman, executed a group as a monument for Bishop Hobart, and several busts, and undertook other work : he was the pupil of Baily of London.

Robert E. Launitz, I believe an Italian and now in New-York, connected in business with John Frazee.

Mrs. Lupton modelled, and presented a bust of Governor Throop to the National Academy of Design.

Capellano, an Italian : executed the statue on the column of the Battle Monument at Baltimore, and the basso relievos on the shaft.

Augustin Chevalier, a native of France, executed the basso relievos of the Union Bank, Baltimore, and designed the Façade of the Maryland Insurance Office in South-street.

Appendix to the biography of John Frazee.

See page 268, Vol. II. Frazee got rid of his partner, but incurred debt which induced hard work among the tombstones, his only employment, and strict economy. So ignorant was he at this time, that he had never heard of the American Academy of Fine Arts at New-York, and when told that it was an exhibition of pictures and statues, he was puzzled to know how that could constitute an academy. Conscious of ignorance, and thirsting for knowledge, Frazee applied assiduously to books for instruction. In 1815, he lost his oldest child, a son, and on his tomb-stone made his first attempt on the human figure—it was a representation of "Grief." At this time, Frazee employed himself in carving for the cabinet-makers in the evening : he likewise cut letters in steel for branding. Removing to New-York, Frazee in conjunction with his brother William, opened a marble-shop in Greenwich-street, the first of May 1818. Statuary marble costs in the block $22 per cubic foot. Two thousand dollars have been paid in nine months by Frazee for this article. Mantel-pieces and tombstones occupied Frazee for some years, and from 1819 to 1823, his principal study was lettering, which he carried to high perfection. To this was united monumental memorials in marble, which our churches may long be proud of. It was not until the year 1820, that Frazee saw the casts in the old academy. His child's model caused an introduction to Trumbull, who told him that nothing in sculpture "would be wanted in this country for yet a hundred years." Frazee says in all his conversation, he was "cold and discouraging respecting the arts, and exclaims, "Is such a man fit for a president of an Academy of Fine Arts?" In 1825 he finished his first bust in marble, John Wells, Esq. This bust he modelled from an imperfect picture, and then executed it in marble without teacher or instruction. He contrived a machine for assisting him to transfer the likeness of the model to the marble. The monument and bust cost $1000. At the instance of the Hon. G. C. Verplanck, Congress appropriated $500 in 1831, for a bust of John Jay, and Frazee executed it much to the satisfaction of his employers, and his own fame. The bust of Nathaniel Prime opened his way to Boston. In 1833, Thomas W. Ward, of that city having seen it, induced his friends to order busts of Daniel Webster and Dr. Bowditch—it grieves me that I cannot relate the anecdotes of Frazee

respecting the sittings of these eminent men. Webster at the request of the sculptor, delivered a congressional speech while Frazee modelled. In addition to what I have said, I will give the names of some of the portraits he has modelled more recently, "Judge Story—Judge Prescott—Thomas H. Perkins and John Lowell." In 1831, Frazee entered into a partnership with Robert E. Launitz, who had for two years before worked with him as a journeymen at ornamental sculpture. Mr. Frazee is determined to execute the "whole figure," as he says, without visiting Italy. I conclude this brief notice of my very ingenious countryman of New-Jersey, by mentioning his family. His first wife died in 1832, leaving him with five children, (having lost five) and he is married to a second; Lydia, daughter of Thomas Place of New-York. Notwithstanding the prophesy of Mr. Trumbull, Mr. Frazee is in full employment, and the demand for sculpture in our happy country is daily increasing.

ENGRAVERS,

OF WHOM MY LIMITS WILL NOT PERMIT A MORE DETAILED NOTICE.

S. Jocelyn of New-Haven, and now in New-York, is, I believe a designer of vignettes for bank notes, and engraver of them.

J. W. Cassilear, has distinguished himself as a draughtsman, and by the plate of the seven presidents, engraved for the New-York Mirror. He is a pupil of the National Academy, and of A. B. Durand.

Cheney, of Connecticut, is in London, and stands high among the engravers for the Annuals.

C. Childs has long been established in Philadelphia.

Underwood is spoken of as distinguished for talent. *Harris* engraved in Boston, 1798.

S. H. Gimber is an English artist of merit, and designs as well as engraves.

E. Wellmore is the engraver of Longacre's portrait of the Hon. Edward Livingston, for the National Portrait Gallery.

W. Humphries is the engraver of Trumbull's portrait of General Putnam, for the same.

T. B. Welsh engraved Governor Cass and Bishop White from Longacre, for the same.

J. B. Forrest engraved Jarvis's McDonough for the same.

T. Woolnoth engraved Daniel D. Tompkins, Vice President of the United States, from Jarvis, for the same.

Edward Scriven engraved General Moultrie from Trumbull for the same.

Illman, an English engraver, executed the portrait of Thomas Eddy the philanthropist, from Dunlap.

R. W. Dodson, engraved General Jonathan Williams for the National Portrait Gallery, from Sully.

James Wood, of Charleston, S. C. *Charles Simons,* of Charleston, S. C. : both directors of the South Carolina Academy of Fine Arts.

Nease, engraver and die-sinker at the mint of the United States, Philadelphia, 1833.

Reich, once die-sinker at Philadelphia, employed by the mint, was the best artist in his line Philadelphia has had. He was passionately fond of music. Ill health obliged him to retire to the west, where he died.

Cassali, New-York. *G. Parker.*

J. P. Harrison was the first engraver who practised west of the Alleghanies : he was established in Pittsburg, 1817.

T. B. Freeman, Esq., was for a long time the principal encourager of the arts, by publishing engravings in Philadelphia. In a list of artists employed by that gentleman, recently received from Mr. Neagle, I find *George Isham Parkyns,* aquatinto engraver, 1795 : *Graham,* mezzotinto engraver, same date, both from England : *Houston,* a red chalk engraver, from Ireland.

One of the instructors of *Alonzo Hartwell,* an engraver on wood, was *O. H. Throop,* a copperplate engraver of Boston.

William Hoagland engraved on wood in Boston with *Mr. Abel Bowen,* and Mr. Hartwell acknowledges obligation to him.

C. Toppan, designer and bank note engraver, Philadelphia.

J. Sartain, an engraver of great merit, Philadelphia.

Tracy Edson, engraver, New-York.

J. Paradise, pupil of A. B. Durand, son of John.

Gobrecht, engraver and die-sinker, Philadelphia.

Neagle, a good engraver of Philadelphia.

Archibald Dick, New-York. *Sweet,* New-York.

Draper, engraver, Philadelphia.

Peter Rushton Maverick and his son *Peter Maverick* are both recorded in the body of this work, but I have found certain dates which I preserve here. The father was born April 11, 1755, and died December 11, 1755. The son was born October 22, 1780, and died June 7, 1831.

William Harrison, an English engraver, arrived in America in 1794, but was only skillful in letter engraving, which he practised and taught; particularly to Peter Maverick the second : his sons *William Harrison* and *Charles P. Harrison* are both among our engravers.

Cone. I have seen very good specimens of this gentleman's work : Philadelphia.

A. Clark, born at Cooper's Town, Otsego, now engraving in New-York.

A. Halbert, engraver of Hannah More's portrait in Harper's edition. If these publishers will give such specimens of engraving, there will be no just cause of complaint respecting their decorations.

Robert Scott and M. Poupard. Both these gentlemen were engravers, and both belong to an early part of the first volume of this work, as they were among our first artists in point of time.

Mr. Scott had been originally a watch-maker in his native country, England ; but preferring the graver, he had the honour of being pupil to a man from whose school we received the eminent engraver Robert Strange. Mr. Scott came to America about the year 1788, and was employed in Philadelphia by Dobson, for engraving the architectural plates of his Encyclopedia, they are well executed. Mr. Alexander Lawson, my informant, says : "He first drew in all his work with a point, and then cut it with the graver. He had no knowledge of animals or figures. He engraved a whole length of Washington, after C. W. Peale, certainly not very flattering to so handsome a man. He was chosen die-sinker to the Mint, which office he filled for many years," (probably after 1793,) "with very little credit to himself or the country. An attempt was made to engage an eminent French artist : he demanded a high salary, which would have been given him, but he would only engage to stay in the country three years, so Scott got the place, and we got vile coinage, nor is there any hope of amendment now he is gone. Scott was the master of *Alardice,* who was about as good as the rest at this time; Scott died in middle age. *Shallow* was his pupil also, who certainly was a very shallow artist. Mr. Draper was also with Scott, and Ben Jones with Alardice, both alive," (1833.)

M. Poupard was an engraver in Philadelphia about 1790. Lawson says; "He had been a player in Martinique, but the creoles not duly appreciating his merits, he came to the United States, and turned his hand to engraving on type metal. He married a woman with some property, who was a fanatical methodist, and Poupard, when with her, seemed as far gone as herself—when away from her, he was a very merry fellow, and amused his companions by reciting and acting." I quote from notices of his contemporaries, with which Mr. Lawson has favoured me, as I have perfect confidence in his statements and opinions.

PAINTERS,

OF WHOM MY LIMITS WILL NOT PERMIT A MORE DETAILED NOTICE, OR WHO HAVE REFUSED INFORMATION, OR, LASTLY—HAVE PASSED INTO OBSCURITY.

Shays was a pupil of Jarvis, of uncommon talent, but he sunk to vicious courses, and died a common sailor in a foreign land.

Buddington painted portraits in New-York, 1798.

William Hamilton, a Scotch artist, who was in New-York about a year, and exhibited several clever pictures in 1832.

Mr. Rand, now studying in Europe.

Miss Charlotte Denning, miniature painter of Plattsburg.

Madamoiselle Tiebout, from Paris ; miniature painter New-York; *Miss Breton* ; New-York ; *Miss O'Hara,* miniature painter, New-York.

S. Osgood, portrait painter, Boston ; *Charles Hubbard,* Boston.

Edward Troy, animal painter, New-York ; *James G. Clonney,* miniature painter, New-York ; *Coyle,* an excellent scene painter and designer from England, died in New-York, 1824.

John Blake White, a native of Charleston, South Carolina, born 1782, studied under B. West. Originally intended for the law, he resumed its study in 1804, and has practised as an amateur. He had a picture of merit exhibited in Boston in, 1833, called the " Grave Robbers."

McLellan, a native of Ulster county, who studied in Italy about 1825, and is now painting in the United States.

Bowman, born in Pennsylvania, by trade a carpenter, made himself a painter through many difficulties, and visited Europe for improvement. He is now a portrait painter, as I believe, in Boston.

Gustavus Grunewald painted landscapes in 1832, in Bethlehem.

G. W. Conaroe paints portraits in Philadelphia.

Mr. Earle (probably a relation of the Earles heretofore mentioned) has painted portraits in London, and is now in the service of the United States. The portrait of General Jackson, in Cassilear's plate for the Mirror, is from his painting.

Mr. Bamborough is a portrait painter at Shippen-port, Ohio.

Street, of Philadelphia, aimed at historical composition, and died in Washington city.

G. Oakley, an English amateur painter, who has exhibited several original compositions of merit in the National Academy.

J. Grant painted portraits in Philadelphia, 1829.

Mack, a miniature painter in New-York. *H. Muller*, landscape painter, New-York, 1828.

Meer, enamel painter, Philadelphia. *J. H. Mifflin*, portrait painter, Philadelphia, 1832. *N. Monachise*, painter of history and portraits, 98 Locust-street, Philadelphia, 1832. *F. Monachise*, ornamental painter as above.

In 1796 *T. B. Freeman* employed a young portrait painter of the name of Bartello. *J. Grimes* studied with Jouett, and is settled in the west. *Parker* is mentioned incidentally in Stuart's life.

Thomas Sully, junior, (the son of the celebrated artist) now exhibits for the first time with the artists of Philadelphia, and is painting at Norfolk. (1834)

Jane Sully, his sister, has been longer known as an artist of merit; she is now Mrs. Darley.

Greenough, a brother of the celebrated sculptor, is painting in London.

Jennings painted in London 20 years ago; from Philadelphia.

M. Vanderchamp, a French artist, painted in New Orleans from 1830 to 34, and went home with $30,000.

Welfare, of North Carolina. *Daniel N. Dubois*, portrait painter, New-York.

Drexel painted portraits in Philadelphia, 1818. *Persico*, miniature painter, Philadelphia.

John Clarendon Darley, an artist of merit, Baltimore.

J. J. Mapes, an amateur miniature painter and friend to the Arts of Design.

Pietro Ancora, an Italian painter and drawing master; taught Mr. Neagle to draw in Philadelphia, and still resides there.

Edward C. Potter, a student of the National Academy, who died in youth—a most amiable man and promising artist.

H. L. Forham, New-York. *W. Goodacre*, New-York.

Miss Goodrich, miniature painter, I believe in Boston. Her pictures have much merit. Her portrait of G. Stuart is engraved for the National Portrait Gallery by Durand, and is thought like by Stuart's family.

Peter Grain, New-York. *Leibanau*, New-York.

Woodsides, of Philadelphia, paints signs with talent beyond many who paint in higher branches.

Jones, of Boston, painted landscapes and signs, and died in Philadelphia.

Jones, scene painter in Boston, from England, draws well and is a good landscape painter.

James Irvine, a Scotchman, now resident in Rome, visited this country in 1818.

Percival, Philadelphia, 1832.

Middleton, Charleston, South Carolina.

Drucez, a Flemming, painted miniatures in New-York in 1805.

A. Rider, Philadelphia, painted miniatures in 1813. He is a German and was the friend of Krimmel.

J. W. Hill, landscape painter New-York.

Drake, an English artist, visited New-York in 1821, and exhibited a full-length of Bonaparte, on the deck of the Belerophon. He went to Canada and painted successfully there.

R. A. Salmon, South Boston, 1829.

Mr. James painted in New-York twenty-five years ago, and afterwards in Quebec. He was a native of New-York.

Mr. Eddie painted portraits in New-York some years back.

Alfred Miller, born in Baltimore, and son of a grocer of that city. He showed such decided talent for historical painting that his father was prevailed upon to send him to France and Italy. He is now (1833) in Europe.

Bordley, now painting in Baltimore.

Milbourne was the first good scene painter who visited this country; he was from London in 1792; engaged by Thomas Wignell.

Madame Planteau painted in Washington about 1820.

Wm. Hilyer, portrait painter, New-York *Thomas W. Hope*, portrait and miniature painter, New-York. *Mrs. Horner*, New-York.

James Coxe came from England in 1794 to Philadelphia, and taught drawing, being then the only drawing master in the city. In London he coloured prints for Boydell. He drew flowers well. He was living in Philadelphia in 1833.

Rosalba Torrens is mentioned by Ramsay in his history of South Carolina as a painter of landscapes, and is said to have devoted a portion of her time daily, to the study of the art in Charleston, 1808.

Eliza Cochran (born Torrens) is mentioned by the same author with the same praise.

Miss Mary Murray, of New-York, has painted in water-colours and in crayons, and executed many portraits, size of life, in a style deserving commendation; and *John R. Murray* has long stood among our amateur artists as a painter of landscape.

Bamborough was painting portraits in Shippenport in 1830. An Englishman.

Greenwood and *John M. Furnass*.—These gentlemen have been neglected in their chronological order; for Greenwood followed immediately after Blackburn, in Boston, and preceded Copley; and Mr. Furnass painted portraits in Boston in 1785, as we know by the Columbian Centinel, of the eleventh of May of that year, where may be found an advertisement informing the public that he has taken a large and commodious chamber at Mrs. Sheaf's, nearly opposite Mr. Carter's writing school, formerly improved by Mr. Smybert and lately by Mr. King, limners. This is the same room in which Trumbull studied in 1777-8.

The "*Mr. King*" is probably Mr. S. King, afterwards resident at Newport, and mentioned under the heads of Mr. Allston and Miss Hall; he is there described as an old gentleman.

Frederick Phillip is a young gentleman of distinguished talent, who was a pupil of the National Academy of New-York, where he was born, and exhibited in 1833 several pictures of merit. He is now pursuing his studies in Europe.

Mr. Mercer, the nephew of General Mercer, was a miniature painter, instructed by C. W. Peale.

Thomas Hilson.—This gentleman, one of the first comedians England has sent us, was likewise an amateur painter, a very skilful draughtsman, especially in landscape with blacklead pencil.

Lawrence Sully, the elder brother of Thomas, was a miniature painter by profession.

Matthew Sully.—This gentleman, in addition to his histrionic talent, was a skilful draughtsman in water-colours.

Lehman painted landscapes in Philadelphia 1830. *Samuel S. West* painted portraits in Philadelphia 1830.

J. Pringle, portrait painter, New-York. *Mrs. Seager* and *Miss Seager*, miniature painters, New-York. *J. H. Shegog*, New-York. *A. Smith*, *W. Swaim*, *C. Weinedell*, *T. H. Wharton*, *G. Winter*, (all painting in New-York 1834)

E. H. Darley, portrait painter, Philadelphia. *Jamieson*, a very ingenious artist in cameos, New-York. *Jos. W. Badger*, miniature painter, New-York. *Henry K. Brooks*, New-York. *Richard Burlin*, New-York.

Knight, a miniature painter in Philadelphia. *A. Vignier*, painted landscapes in Philadelphia in 1811.

A. B. Rockey was born in Mifflinburg, Pennsylvania, and commenced painting in Philadelphia in 1825, where he still exercises his pencil.

Captain Johnston painted portraits with success in Boston from 1789 to 1805. He was an officer of the revolutionary army, and a man of wit and talents. He painted Governor Phillips and family.

The National Academy of Design has received a present from Wyatt, the English sculptor at Rome, who now rivals Thorwalsden the Dane, of a nymph entering the bath, which will bear comparison with the best works of antiquity.

NOTE A.

This extract from a letter written by Mr. Latrobe to Wm. Jones, Esq. then secre- . tary of the navy, on the occasion of his resigning his situation of superintendent of the works at the Navy Yard, admirably illustrates many parts of Mr. Latrobe's character, and shows the difficulties that he was obliged to contend with. It is a satisfactory vindication too against the charge that was so often made against him of extravagance; and in every particular does equal credit to his head and his heart.

" I take this opportunity of asking you to devote a few moments of your valuable time to an explanation respecting myself, which is called for only by a wish that you should in all respects think well of me.

" There is, perhaps, among all the persons holding employment under government, not one so unpopular as myself. That I should be so, is a thing quite of course. It results from the habits of my early life, which I cannot change by any effort that I can make. Having acquired the knowledge, and been for some years in the practice of my profession in Europe, I believe I have the despotism of manner, which belongs to all artists, and appears to be inseparable from some degree of public reputation. My efforts to lay aside a haughtiness of deportment, which I am accused of, while treating of professional subjects, are awkward, because *studied*, and unnatural; and they cannot of course be consistent. Employed in procuring convenience to the course of legislative proceedings, and often personal accommodation to the members of the legislature, I have been justly accused of going on my own course, without consulting the wishes, or even informing the curiosity of those who are most interested in what I was doing; of sacrificing every thing to the interests of my reputation hereafter; of keeping aloof from the members of congress in private association, and in general of acting as if in the performance of my public duties, I did not acknowledge, in any degree, the right of the legislature to direct my operations according to their humour, even if contrary to my wishes and judgment.

" That this should be my character before the public, is as much a necessary result, even of my unbending honesty, (and of *honesty* I may boast, without, I hope, forfeiting my claim to modesty,) as it might be of an irrational pride. My time has been fully employed. I have had no assistance in the most laborious parts of my operations. My family has been my greatest and almost my only scene of short relaxation and of enjoyment. I could only have devoted my evenings to the members of congress, scattered through an extent of four miles in length, had I the talent or inclination to visit or entertain them. But in truth, I neither felt the wish nor the propriety of *appearing* to consult any one on my designs, or the mode of my operations, while I felt myself competent to perform my duty without any assistance; and still less could I bend to solicit votes for the passage of laws, as if I had a personal interest in the appropriations required, which the public good did not point out as necessary.

" My unpopularity, therefore, has arisen from circumstances belonging to the invariable effect of personal character on public measures, rather than from the charge which is in every body's mouth, and which is the only *acknowledged* charge against me, that of *extravagance*. Of want of skill, or want of the very humble virtue, pecuniary integrity, my bitterest enemies have never accused me. But I am extravagant. And yet these very men erected the north wing of the capitol at the expense of $330,000, a building half finished only, of lath and plaster, and rotten wood internally, paying four and a half dollars for stone, per ton and five to six dollars per thousand, for bricks, while the south wing, in quantity and quality, of materials of three times the value, vaulted throughout, sculptured and painted, stone costing from six to ten dollars per ton ; bricks from seven to eight dollars per thousand—was built by me for $274,000. The fact would be proved on investigation both here and in Philadelphia, that my works are the *cheapest* yet erected in the United States. Their appearance is against them. They have a more magnificent *look*, of course a more expensive *look* than others.

" There is another subject which I do not touch upon without regret, I mean the positive instructions of Mr. Jefferson in respect to design, and to *calls for money*, which he afterwards, when censure ensued, did not *publicly* justify, leaving me to hear the blame of extravagance and of inadequate estimates. Of this kind were his positive orders that I should introduce Corinthian columns into the House of Representatives, and put one hundred lights of plate glass into the ceiling, contrary to my declared judgment, and earnest entreaties and represen-

tations. In other respects, however, the honour which the friendship of that great man has done me, obliterates all feeling of dissatisfaction on account of these errors of a vitiated taste, and of an imperfect attention to the *practical* effects of his architectural projects. I will mention only one other cause of my unpopularity.

"When I was appointed surveyor to the public buildings, all the persons formerly employed had been dismissed. My system was totally in opposition to that formerly established. Every step I have taken for ten years past has been watched and reported, and the members of congress have been besieged in detail with complaints of my arbitrary extravagance. The federal newspapers have been filled with abuse of me. I have been too proud and too innocent to defend myself. By little and little that which is often repeated becomes established as a truth.

"But my works speak for themselves. They will live after me, and my children will have no reason to be ashamed of their father. As to my personal character, those who know me intimately may judge of it. Knowing too much of my difficult art to believe myself a *great* man in it; looking up to many others with a deference to their abilities and acquirements which precludes a hope of equalling them; more sensible of my inferiority, and of the humbleness of my attainments than those who calumniate me, I still have learned by the success of twenty-five years active service of the public, that I am not too ignorant to be very useful. That I have been *useful*, and that I have brought others to be so, is my *legitimate* pride. Nor shall I disgrace myself at my age by forfeiting my right to be thus proud.

"In a few months I shall be no longer in the service of the United States. In this letter I have no further object to answer but to retire from it, with the hope that nothing you may hear against me will deprive me of your confidence and of your kindness. I shall, I confess, leave the service of the department, of which you are the head, with regret; but I shall feel a patriotic joy, that your station is filled, not only by honour and moral worth, but by talents improved and perfected to an extent adequate to the exigences of our country."

NOTE B.

Copy of a letter from Mr. Latrobe to Mr. Jefferson, on resuming his office of superintendent, at Washington, after the destruction of the public buildings by the British.

"Permit me now to assure you that the confidence you are pleased to express in me, as to the future conduct of the public works, from your experience of my former services, is to me, by far a more gratifying reward than I could possibly have received from any emolument or any other commendation. It is not only because you are certainly the best judge of the merits of an artist, in the United States, but because you certainly know me better as an artist, and as a man, than any other, that your good opinion is valuable to me. And why should I say so to you, who have forever retired from the seat from which honours are to be dispensed, and to whom adulation would be an insult, if I were not most sincere in what I express on the subject. You will remember, that if I committed an error in executing the trust you reposed in me; it was not by blindly yielding my professional opinions to yours, or in executing, without even remonstrance sometimes, what was suggested, in order to win your favour. My thanks therefore for the kindness with which you express your approbation of what I have formerly done, are offered with sentiments of the sincerest attachment.

"Some details respecting the state of the ruins of the buildings may perhaps be new, and not unpleasant to be received by you; and may perhaps find you at leisure to read them, as your library is no longer around you.

"The south wing of the capitol was set on fire with great difficulty. Of the lower story nothing could be burned but the sashes and frames, and the shutters and dressings, and the doors and door cases. As all these were detached from one another, some time and labour were necessary to get through the work. The first thing done was to empty into buckets a quantity of the composition used in the rockets. A man with an axe chopped the wood work, another followed, and brushed on some of the composition, and on retiring from each room, the third put fire to it. Many of the rooms, however, were thus only partially burned, and there is not one in which some wood does not remain. In the clerk's office, the desks and furniture, and the records supplied a more considerable mass of combustible materials than there was elsewhere, and the fire burned so fiercely that they were obliged to retreat and leave all the rooms on the west side en-

tirely untouched, and they are now as clean and perfect as ever. Two other committee rooms have escaped, and the gallery stairs have none of their wooden dressings injured. Above stairs, the committee room of Ways and Means, and accounts, is uninjured, and the whole of the entrance, with all the sculptured capitals of the columns, has fortunately suffered no injury but in the plastering, and that from the wet and frost of the winter. In the House of Representatives the devastation has been dreadful. There was here no want of materials for conflagration, for when the number of members of Congress was increased, the old platform was left in its place, and another raised over it, giving an additional quantity of dry and loose timber. All the stages and seats of the galleries were of timber and yellow pine. The mahogany furniture, desks, tables and chairs, were in their places. At first they fired rockets through the roof, but they did not set fire to it. They sent men on to it, but it was covered with sheet iron. At last they made a great pile in the centre of the room of the furniture, and retiring set fire to a great quantity of rocket-stuff in the middle. The whole was soon in a blaze, and so intense was the flame, that the glass of the lights was melted, and I have now lumps, weighing many pounds of glass, run into mass. The stone is, like most free stone, unable to resist the force of flame, but I believe no known material would have been able to resist the effects of so sudden and intense a heat. The exterior of the columns and entablature, therefore, expanded far beyond the dimensions of the interior, scaled off, and not a vestige of fluting or sculpture remained around. The appearance of the ruin was awfully grand when I first saw it, and indeed it was terrific, for it threatened immediately to fall, so slender were the remains of the columns that carried the massy entablature. If the colonnade had fallen, the vaulting of the room below might have been beaten down, but fortunately there is not a single arch in the whole building which requires to be taken down. In the north wing, the beautiful doric columns which surrounded the Supreme Court room, have shared the fate of the Corinthian columns of the Hall of Representatives, and in the Senate Chamber, the marble polished columns of fourteen feet shaft, in one block, are burnt to lime, and have fallen down. All but the vault is destroyed. They stand a most magnificent ruin. The west end containing the library, which was never vaulted, burned very fiercely, and by the fall of its heavy timbers, great injury has been done to the adjoining walls and arches, and I fear that the free stone is so much injured on the outside, that part of the outer wall must be taken down; otherwise the exterior stands firm and sound, especially of the south wing; but of about twenty windows and doors, through which the flames found vent, the architraves, and other dressings are so injured, that they must be replaced. All the parapet is gone.

"The most difficult work to be performed was to take down the ruins of the Hall of Representatives. Our workmen all hesitated to touch it; to have erected a scaffold, and to have risked striking the ruins with the heavy poles necessary to be used, was not to be thought of; an unlucky blow against one of the columns might have brought down one hundred ton of the entablature, and of the heavy brick vault which rested upon it. It therefore occurred to me, to fill up the whole with fascines to the soffit of the architraves: if any thing gave way then, it would not fall down; the columns would be confined to their places, and the fascines would furnish the scaffold. The commissioners approved the scheme, but as time would be required to cut the fascines from the commons, Mr. Ringold most fortunately recommended the use of cord wood, which has been adopted, and most successfully. Four fifths of the work is done, and the remainder is supported, and will be all down in ten days. The cord wood will sell for its cost. It required five hundred cord to go half round; it was then shifted to the other side. I have already nearly completed the vaults of two stories, on the west side of the north wing, according to the plan submitted by you, with the report to Congress in 1807. I need not, I hope, apologize to you for this long detail. An alteration is proposed and adopted by the president, in the Hall of Representatives. I will send you a copy of my report, as soon as time will permit."

Note C.

Extracts from a letter of Mr. Latrobe, after visiting Mount Vernon, in 1797.

"On the 6th of July I set off, having a letter to the president from his nephew, my particular friend, Bushrod Washington, Esquire. Having alighted at Mount Vernon, I sent in my letter of introduction, and walked into the portico, west of the river. In about ten minutes the president came to me. He wore a plain blue coat; his hair dressed and powdered. There was a reserve, but no hauteur in his manner. He shook me by the hand, said he was glad to see a friend of his nephew's, drew a chair, and desired me to sit down. Having inquired after the

family I had left, the conversation turned upon Bath, to which they were going. There was no moroseness in his observations; they seemed the well expressed remarks of a man who has seen and knows the world. The conversation then turned upon the rivers of Virginia. He gave me a very minute account of all their directions, their natural advantages, and what he considered might be done for their improvement by art. He then inquired whether I had seen the Dismal Swamp, and seemed particularly desirous of being informed upon the subject of the canal going forward there. He gave me a detailed account of the old Dismal Swamp Company, and of their operations—of the injury they had received from the effects of the war, and the still greater which their inattention to their own concerns had done to them.

"After many attempts on his part to procure a meeting of directors, (the number of which the law provided should be six, in order to do business,) all of which proved fruitless; he gave up his hopes of any thing being done for their interests, and sold out his shares in the property, at a price very inadequate to their real value. Since then his attention has been so much drawn to public affairs, that he had scarcely made any inquiry into the proceedings either of the Swamp or of the Canal Company. I was much flattered by his attention to my observations, and his taking the pains, either to object to my deductions, where he thought them ill founded, or to confirm them by very strong remarks of his own, made while he was visiting the swamp.

"This conversation lasted above an hour, and as he had at first told me, that he was endeavouring to finish some letters to go by post, upon a variety of business, 'which, notwithstanding his distance from government, still pressed upon him in his retirement,' I got up to take my leave, but he desired me, in a manner very much like Dr. Johnson's, to "keep my chair;" and then continued to talk to me about the great works going on in England, and my own objects in this country. I found him well acquainted with my mother's family in Pennsylvania. After much conversation upon the coal mines, on James' River, I told him of the silver mine at Rochester. He laughed most heartily at the very mention of the thing. I explained to him the nature of the expectations formed of its productiveness, and satisfied him of the probability that one might exist there. He made several minute inquiries concerning it, and then said, "it would give him real uneasiness, should any silver or gold mine be discovered that would tempt considerable capitals into the prosecution of that object, and that he heartily wished for his country, that it might contain no mines but such as the plough could reach, excepting only coal and iron."

"After conversing with me for more than two hours, he got up and said that, 'we should meet again at dinner.' I then strolled about the lawn, and took a few sketches of the house, &c. Upon my return I found Mrs. Washington and her grand-daughter, Miss Custis, in the hall. I introduced myself to Mrs. Washington, as the friend of her nephew, and she immediately entered into conversation upon the prospect from the lawn, and presently gave me an account of her family, in a good-humoured free manner, that was extremely pleasing and flattering. She retains strong remains of considerable beauty, and seems to enjoy good health and as good humour. She has no affectation of superiority, but acts completely in the character of the mistress of the house of a repectable and opulent country gentleman. His grand-daughter, Miss Eleanor Custis, has more perfection of form, of expression, of colour, of softness, and of firmness of mind, than I have ever seen before.

"Young La Fayette, with his tutor, came down some time before dinner. He is a young man of seventeen years of age, of a mild, pleasant countenance, making a favourable impression at first sight.

"Dinner was served up about half-past three. It had been postponed half an hour in hopes of Mr. Lear's arrival from Alexandria. The president came into the portico a short time before three, and talked freely upon common topics with the family. At dinner he placed me at the left hand of Mrs. Washington, Miss Custis sat at her right, and himself next to her. There was very little conversation at dinner. A few jokes passed between the president and young La Fayette, whom he treated more as a child than as a guest. I felt a little embarrassed at the silent reserved air that prevailed. As I drink no wine, and the president drank but three glasses, the party before long returned to the portico. Mr. Lear, Mr. Dandridge, and Mr. Lear's three boys soon after arrived, and helped out the conversation. The president retired in about three quarters of an hour. As much as I wished to stay, I thought it a point of delicacy to take up as little time of the president as possible, and I therefore ordered my horses to the door. I waited a few minutes till the president returned. He asked me whether I had any very pressing business to prevent my lengthening my visit. I told him I had not, but that as I considered it an intrusion upon his more important engagements, I

thought I could reach Colchester that evening by daylight. 'Sir,' said he, ' you see I take my own way. If you can be content to take yours at my house, I shall be glad to see you here longer.'

" Coffee was brought about six o'clock ; when it was removed, the president addressed himself to me, inquiring as to the state of the crops about Richmond. I told him all I knew. A long conversation upon farming ensued, during which it grew dark, and he then proposed going into the hall. He made me sit down by him, and continued the conversation for above an hour. During that time he gave me a very minute account of the Hessian fly, and its progress from Long Island, where it first appeared, through New-York, Rhode Island, Connecticut, Delaware, part of Pennsylvania, and Maryland. It has not yet appeared in Virginia, but is daily dreaded. The cultivation of Indian corn next came up. He dwelt upon all the advantages attending this most useful crop, and then said, that the manner in which the land was exhausted by it, the constant attention it required during the whole year, and the superior value of the produce of land in other crops, would induce him to leave off entirely the cultivation of it, provided he could depend upon any market for a supply elsewhere.

" He then entered into the different merits of a variety of ploughs, and gave the preference to the heavy Botheram plough, from a full experience of its merits. The Berkshire iron plough he held next in estimation. He had found it impossible to get the iron work of his Botheram plough replaced in a proper manner, otherwise he should never have discontinued its use. I promised to send him one of Mr. Richardson's ploughs, of Tuckahoe, which he accepted with pleasure.

Mrs. Washington and Miss Custis had left us early, and the president left the company about eight o'clock. We soon after retired to bed.

" I rose with the sun, and walked over the grounds ; I also took a view of the house. The president came to the sitting room, about half past seven o'clock ; here all the latest newspapers were laid out. He talked with Mr. Lear about the progress of the works at the great falls, and in the city of Washington. Breakfast was served up in the usual Virginian style—tea and coffee, cold and broiled meat. It was very soon over, and for an hour afterwards, he stood upon the steps of the west door, talking to the company who were collected around him. The subject was chiefly the establishment of the university at the Federal city. He mentioned the offer he had made of giving to it all the interests he had in the city, on condition that it should go on in a given time ; and complained, that though magnificent offers had been made by many speculators, for the same purpose, there seemed to be no inclination to carry them into effect. He spoke as if he felt a little hurt upon the subject. About ten o'clock he made a motion to retire, and I requested a servant to bring my horses to the door. He then returned, and as soon as my servant came up with them, he went to him and asked him if he had breakfasted. He then shook me by the hand, desired me to call if I came again into the neighbourhood, and wished me a good morning.

" Washington has something uncommonly majestic and commanding in his walk, his address, his figure, and his countenance. His face is however characterized more by intense and powerful thought, than by quick and powerful conception. There is a mildness about its expression, and an air of reserve in his manner which lowers its tone still more. He is sixty-four, but appears some years younger, and has sufficient vigour to last many years yet. He was frequently entirely silent for many minutes, during which time an awkward silence seemed to prevail in the circle. His answers were often short, and sometimes approached to moroseness. He did not at any time speak with remarkable fluency ; perhaps the extreme correctness of his language, which almost seemed studied, prevented that effect. He appeared to enjoy a humorous observation, and made several himself. He laughed heartily several times, and in a very good humoured manner. On the morning of my departure, he treated me as if I had lived for years in his house, with ease and attention ; but in general, I thought there was an air about him as if something had vexed him."

I am requested to correct my notice of Mr. Otto Parissien. He was not from France, but Prussia ; and did not paint miniatures. He designed the ornaments of the silver-ware he dealt in, being a silversmith. (See Vol. I. page 160.)

Index

Volume Two, Part One contains pp. 1-275. Volume Two, Part Two contains pp. 276-477. Plates 1-118 are in Volume One. Plates 119-242 are in Volume Two, Part One. Plates 243-356 are in Volume Two, Part Two. **Boldface** is used to indicate the major biographical entry.

479

Dover Books on Art

Dover Books on Art

GREEK REVIVAL ARCHITECTURE IN AMERICA, T. Hamlin. A comprehensive study of the American Classical Revival, its regional variations, reasons for its success and eventual decline. Profusely illustrated with photos, sketches, floor plans and sections, displaying the work of almost every important architect of the time. 2 appendices. 39 figures, 94 plates containing 221 photos, 62 architectural designs, drawings, etc. 324-item classified bibliography. Index. xi + 439pp. 5⅜ x 8½.

21148-7 Paperbound $3.50

CREATIVE LITHOGRAPHY AND HOW TO DO IT, Grant Arnold. Written by a man who practiced and taught lithography for many years, this highly useful volume explains all the steps of the lithographic process from tracing the drawings on the stone to printing the lithograph, with helpful hints for solving special problems. Index. 16 reproductions of lithographs. 11 drawings. xv + 214pp. of text. 5⅜ x 8½.

21208-4 Paperbound $2.25

TEACH YOURSELF ANTIQUE COLLECTING, E. Bradford. An excellent, brief guide to collecting British furniture, silver, pictures and prints, pewter, pottery and porcelain, Victoriana, enamels, clocks or other antiques. Much background information difficult to find elsewhere. 15pp. of illus. 215pp. 7 x 4¼.

21368-4 Clothbound $2.00

THE STANDARD BOOK OF QUILT MAKING AND COLLECTING, M. Ickis. Even if you are a beginner, you will soon find yourself quilting like an expert, by following these clearly drawn patterns, photographs, and step-by-step instructions. Learn how to plan the quilt, to select the pattern to harmonize with the design and color of the room, to choose materials. Over 40 full-size patterns. Index. 483 illustrations. One color plate. xi + 276pp. 6¾ x 9½. 20582-7 Paperbound $2.50

THE ENJOYMENT AND USE OF COLOR, W. Sargent. Requiring no special technical know-how, this book tells you all about color and how it is created, perceived, and imitated in art. Covers many little-known facts about color values, intensities, effects of high and low illumination, complementary colors, and color harmonies. Simple do-it-yourself experiments and observations. 35 illustrations, including 6 full-page color plates. New color frontispiece. Index. x + 274 pp. 5⅜ x 8.

20944-X Paperbound $2.25

LANDSCAPE GARDENING IN JAPAN, Josiah Conder. A detailed picture of Japanese gardening techniques and ideas, the artistic principles incorporated in the Japanese garden, and the religious and ethical concepts at the heart of those principles. Preface. 92 illustrations, plus all 40 full-page plates from the Supplement. Index. xv + 299pp. 8⅜ x 11¼.

21216-5 Paperbound $3.50

DESIGN AND FIGURE CARVING, E. J. Tangerman. "Anyone who can peel a potato can carve," states the author, and in this unusual book he shows you how, covering every stage in detail from very simple exercises working up to museum-quality pieces. Terrific aid for hobbyists, arts and crafts counselors, teachers, those who wish to make reproductions for the commercial market. Appendix: How to Enlarge a Design. Brief bibliography. Index. 1298 figures. x + 289pp. 5⅜ x 8½.

21209-2 Paperbound $2.00

WILD FOWL DECOYS, Joel Barber. Antique dealers, collectors, craftsmen, hunters, readers of Americana, etc. will find this the only thorough and reliable guide on the market today to this unique folk art. It contains the history, cultural significance, regional design variations; unusual decoy lore; working plans for constructing decoys; and loads of illustrations. 140 full-page plates, 4 in color. 14 additional plates of drawings and plans by the author. xxvii + 156pp. 7⅞ x 10¾. 20011-6 Paperbound $3.50

1800 WOODCUTS BY THOMAS BEWICK AND HIS SCHOOL. This is the largest collection of first-rate pictorial woodcuts in print—an indispensable part of the working library of every commercial artist, art director, production designer, packaging artist, craftsman, manufacturer, librarian, art collector, and artist. And best of all, when you buy your copy of Bewick, you buy the rights to reproduce individual illustrations—no permission needed, no acknowledgments, no clearance fees! Classified index. Bibliography and sources. xiv + 246pp. 9 x 12.

20766-8 Paperbound $4.00

THE SCRIPT LETTER, Tommy Thompson. Prepared by a noted authority, this is a thorough, straightforward course of instruction with advice on virtually every facet of the art of script lettering. Also a brief history of lettering with examples from early copy books and illustrations from present day advertising and packaging. Copiously illustrated. Bibliography. 128pp. 6½ x 9⅛.

21311-0 Paperbound $1.25

THE HISTORY AND TECHNIQUE OF LETTERING, A. Nesbitt. A thorough history of lettering from the ancient Egyptians to the present, and a 65-page course in lettering for artists. Every major development in lettering history is illustrated by a complete aphabet. Fully analyzes such masters as Caslon, Koch, Garamont, Jenson, and many more. 89 alphabets, 165 other specimens. 317pp. 7½ x 10½. 20427-8 Paperbound $2.25

LETTERING AND ALPHABETS, J. A. Cavanagh. An unabridged reissue of "Lettering," containing the full discussion, analysis, illustration of 89 basic hand lettering styles based on Caslon, Bodoni, Gothic, many other types. Hundreds of technical hints on construction, strokes, pens, brushes, etc. 89 alphabets, 72 lettered specimens, which may be reproduced permission-free. 121pp. 9¾ x 8. 20053-1 Paperbound $1.50

THE HUMAN FIGURE IN MOTION, Eadweard Muybridge. The largest collection in print of Muybridge's famous high-speed action photos. 4789 photographs in more than 500 action-strip-sequences (at shutter speeds up to 1/6000th of a second) illustrate men, women, children—mostly undraped—performing such actions as walking, running, getting up, lying down, carrying objects, throwing, etc. "An unparalleled dictionary of action for all artists," AMERICAN ARTIST. 390 full-page plates, with 4789 photographs. Heavy glossy stock, reinforced binding with headbands. 7⅞ x 10¾. 20204-6 Clothbound $10.00

ANIMALS IN MOTION, Eadweard Muybridge. The largest collection of animal action photos in print. 34 different animals (horses, mules, oxen, goats, camels, pigs, cats, lions, gnus, deer, monkeys, eagles—and 22 others) in 132 characteristic actions. All 3919 photographs are taken in series at speeds up to 1/1600th of a second, offering artists, biologists, cartoonists a remarkable opportunity to see exactly how an ostrich's head bobs when running, how a lion puts his foot down, how an elephant's knee bends, how a bird flaps his wings, thousands of other hard-to-catch details. "A really marvellous series of plates," NATURE. 380 full-page plates. Heavy glossy stock, reinforced binding with headbands. 7⅞ x 10¾. 20203-8 Clothbound $10.00

BASIC BOOKBINDING, A. W. Lewis. Enables both beginners and experts to rebind old books or bind paperbacks in hard covers. Treats materials, tools; gives step-by-step instruction in how to collate a book, sew it, back it, make boards, etc. 261 illus. Appendices. 155pp. 5⅜ x 8. 20169-4 Paperbound $1.75

200 DECORATIVE TITLE-PAGES, edited by A. Nesbitt. Fascinating and informative from a historical point of view, this beautiful collection of decorated titles will be a great inspiration to students of design, commercial artists, advertising designers, etc. A complete survey of the genre from the first known decorated title to work in the first decades of this century. Bibliography and sources of the plates. 222pp. 8⅜ x 11¼.

21264-5 Paperbound $2.75

ON THE LAWS OF JAPANESE PAINTING, H. P. Bowie. This classic work on the philosophy and technique of Japanese art is based on the author's first-hand experiences studying art in Japan. Every aspect of Japanese painting is described: the use of the brush and other materials; laws governing conception and execution; subjects for Japanese paintings, etc. The best possible substitute for a series of lessons from a great Oriental master. Index. xv + 117pp. + 66 plates. 6⅛ x 9¼.

20030-2 Paperbound $2.25

PAINTING IN THE FAR EAST, L. Binyon. A study of over 1500 years of Oriental art by one of the world's outstanding authorities. The author chooses the most important masters in each period—Wu Tao-tzu, Toba Sojo, Kanaoka, Li Lung-mien, Masanobu, Okio, etc.—and examines the works, schools, and influence of each within their cultural context. 42 photographs. Sources of original works and selected bibliography. Notes including list of principal painters by periods. xx + 297pp. 6⅛ x 9¼.

20520-7 Paperbound $2.50

THE ALPHABET AND ELEMENTS OF LETTERING, F. W. Goudy. A beautifully illustrated volume on the aesthetics of letters and type faces and their history and development. Each plate consists of 15 forms of a single letter with the last plate devoted to the ampersand and the numerals. "A sound guide for all persons engaged in printing or drawing," Saturday Review. 27 full-page plates. 48 additional figures. xii + 131pp. 7⅞ x 10¾.

20792-7 Paperbound $2.25

PAINTING IN ISLAM, Sir Thomas W. Arnold. This scholarly study puts Islamic painting in its social and religious context and examines its relation to Islamic civilization in general. 65 full-page plates illustrate the text and give outstanding examples of Islamic art. 4 appendices. Index of mss. referred to. General Index. xxiv + 159pp. 6⅝ x 9¼. 21310-2 Paperbound $2.75

HAWTHORNE ON PAINTING. Vivid re-creation, from students' notes, of instructions by Charles Hawthorne at Cape Cod School of Art. Essays, epigrammatic comments on color, form, seeing, techniques, etc. "Excellent," Time. 100pp. 5⅜ x 8.
20653-X Paperbound $1.25

THE HANDBOOK OF PLANT AND FLORAL ORNAMENT, *R. G. Hatton.* 1200 line illustrations, from medieval, Renaissance herbals, of flowering or fruiting plants: garden flowers, wild flowers, medicinal plants, poisons, industrial plants, etc. A unique compilation that probably could not be matched in any library in the world. Formerly "The Craftsman's Plant-Book." Also full text on uses, history as ornament, etc. 548pp. 6⅛ x 9¼.
20649-1 Paperbound $3.50

DECORATIVE ALPHABETS AND INITIALS, Alexander Nesbitt. 91 complete alphabets, over 3900 ornamental initials, from Middle Ages, Renaissance printing, baroque, rococo, and modern sources. Individual items copyright free, for use in commercial art, crafts, design, packaging, etc. 123 full-page plates. 3924 initials. 129pp. 7¾ x 10¾.
20544-4 Paperbound $2.50

METHODS AND MATERIALS OF THE GREAT SCHOOLS AND MASTERS, Sir Charles Eastlake. (Formerly titled "Materials for a History of Oil Painting.") Vast, authentic reconstruction of secret techniques of the masters, recreated from ancient manuscripts, contemporary accounts, analysis of paintings, etc. Oils, fresco, tempera, varnishes, encaustics. Both Flemish and Italian schools, also British and French. One of great works for art historians, critics; inexhaustible mine of suggestions, information for practicing artists. Total of 1025pp. 5⅜ x 8.
20718-8, 20719-6 Two volume set, Paperbound $5.00

BYZANTINE ART AND ARCHAEOLOGY, O. M. Dalton. Still most thorough work in English on Byzantine art forms throughout ancient and medieval world. Analyzes hundreds of pieces, covers sculpture, painting, mosaic, jewelry, textiles, architecture, etc. Historical development; specific examples; iconology and ideas; symbolism. A treasure-trove of material about one of most important art traditions, will supplement and expand any other book in area. Bibliography of over 2500 items. 457 illustrations. 747pp. 6⅛ x 9¼.
20776-5 Clothbound $8.50

FOOT-HIGH LETTERS: A GUIDE TO LETTERING, M. Price. 28 15½ x 22½″ plates, give classic Roman alphabet, one foot high per letter, plus 9 other 2″ high letter forms for each letter. 16 page syllabus. Ideal for lettering classes, home study. 28 plates in box.
20239-9 $600

A HANDBOOK OF WEAVES, G. H. Oelsner. Most complete book of weaves, fully explained, differentiated, illustrated. Plain weaves, irregular, double-stitched, filling satins; derivative, basket, rib weaves; steep, broken, herringbone, twills, lace, tricot, many others. Translated, revised by S. S. Dale; supplement on analysis of weaves. Bible for all handweavers. 1875 illustrations. 410pp. 6⅛ x 9¼.
20209-7 Clothbound $7.50

JAPANESE HOMES AND THEIR SURROUNDINGS, E. S. Morse. Classic describes, analyses, illustrates all aspects of traditional Japanese home, from plan and structure to appointments, furniture, etc. Published in 1886, before Japanese architecture was contaminated by Western, this is strikingly modern in beautiful, functional approach to living. Indispensable to every architect, interior decorator, designer. 307 illustrations. Glossary. 410pp. 5⅝ x 8⅜.
20746-3 Paperbound $2.50

THE DRAWINGS OF HEINRICH KLEY. Uncut publication of long-sought-after sketchbooks of satiric, ironic iconoclast. Remarkable fantasy, weird symbolism, brilliant technique make Kley a shocking experience to layman, endless source of ideas, techniques for artist. 200 drawings, original size, captions translated. Introduction. 136pp. 6 x 9.
20024-8 Paperbound $2.00

COSTUMES OF THE ANCIENTS, Thomas Hope. Beautiful, clear, sharp line drawings of Greek and Roman figures in full costume, by noted artist and antiquary of early 19th century. Dress, armor, divinities, masks, etc. Invaluable sourcebook for costumers, designers, first-rate picture file for illustrators, commercial artists. Introductory text by Hope. 300 plates. 6 x 9.
20021-3 Paperbound $2.00

VITRUVIUS: TEN BOOKS ON ARCHITECTURE. The most influential book in the history of architecture. 1st century A.D. Roman classic has influenced such men as Bramante, Palladio, Michelangelo, up to present. Classic principles of design, harmony, etc. Fascinating reading. Definitive English translation by Professor H. Morgan, Harvard. 344pp. 5⅜ x 8.
20645-9 Paperbound $2.50

HANDBOOK OF DESIGNS AND DEVICES, C. P. Hornung. A remarkable working collection of 1836 basic designs and variations, all copyright-free. Variations of circle, line, cross, diamond, swastika, star, scroll, shield, many more. Notes on symbolism. "A necessity to every designer who would be original without having to labor heavily," ARTIST AND ADVERTISER. 204 plates. 240pp. 5⅜ x 8. 20125-2 Paperbound $2.00

THE UNIVERSAL PENMAN, George Bickham. Exact reproduction of beautiful 18th-century book of handwriting. 22 complete alphabets in finest English roundhand, other scripts, over 2000 elaborate flourishes, 122 calligraphic illustrations, etc. Material is copyright-free. "An essential part of any art library, and a book of permanent value," AMERICAN ARTIST. 212 plates. 224pp. 9 x 13¾. 20020-5 Clothbound $12.50

AN ATLAS OF ANATOMY FOR ARTISTS, F. Schider. This standard work contains 189 full-page plates, more than 647 illustrations of all aspects of the human skeleton, musculature, cut-away portions of the body, each part of the anatomy, hand forms, eyelids, breasts, location of muscles under the flesh, etc. 59 plates illustrate how Michelangelo, da Vinci, Goya, 15 others, drew human anatomy. New 3rd edition enlarged by 52 new illustrations by Cloquet, Barcsay. "The standard reference tool," AMERICAN LIBRARY ASSOCIATION. "Excellent," AMERICAN ARTIST. 189 plates, 647 illustrations. xxvi + 192pp. 7⅞ x 10⅝. 20241-0 Clothbound $6.50

AN ATLAS OF ANIMAL ANATOMY FOR ARTISTS, W. Ellenberger, H. Baum, H. Dittrich. The largest, richest animal anatomy for artists in English. Form, musculature, tendons, bone structure, expression, detailed cross sections of head, other features, of the horse, lion, dog, cat, deer, seal, kangaroo, cow, bull, goat, monkey, hare, many other animals. "Highly recommended," DESIGN. Second, revised, enlarged edition with new plates from Cuvier, Stubbs, etc. 288 illustrations. 153pp. 11⅜ x 9. 20082-5 Paperbound $2.50

VASARI ON TECHNIQUE, G. Vasari. Pupil of Michelangelo, outstanding biographer of Renaissance artists reveals technical methods of his day. Marble, bronze, fresco painting, mosaics, engraving, stained glass, rustic ware, etc. Only English translation, extensively annotated by G. Baldwin Brown. 18 plates. 342pp. 5⅜ x 8. 20717-X Paperbound $2.75

Dover Books on Art

ARCHITECTURAL AND PERSPECTIVE DESIGNS, Giuseppe Galli Bibiena. 50 imaginative scenic drawings of Giuseppe Galli Bibiena, principal theatrical engineer and architect to the Viennese court of Charles VI. Aside from its interest to art historians, students, and art lovers, there is a whole Baroque world of material in this book for the commercial artist. Portrait of Charles VI by Martin de Meytens. 1 allegorical plate. 50 additional plates. New introduction. vi + 103pp. 10⅛ x 13¼.
21263-7 Paperbound $2.50

PRINTED EPHEMERA, edited and collected by John Lewis. This book contains centuries of design, typographical and pictorial motives in proven, effective commercial layouts. Hundreds of the most striking examples of labels, tickets, posters, wrappers, programs, menus, and other items have been collected in this handsome and useful volume, along with information on the dimensions and colors of the original, printing processes used, stylistic notes on typography and design, etc. Study this book and see how the best commercial artists of the past and present have solved their particular problems. Most of the material is copyright free. 713 illustrations, many in color. Illustrated index of type faces included. Glossary of technical terms. Indexes. 288pp. 9¼ x 12.
21037-5 Clothbound $15.00

DESIGN FOR ARTISTS AND CRAFTSMEN, Louis Wolchonok. Recommended for either individual or classroom use, this book helps you to create original designs from things about you, from geometric patterns, from plants, animals, birds, humans, landscapes, manmade objects. "A great contribution," N. Y. Society of Craftsmen. 113 exercises with hints and diagrams. More than 1280 illustrations. xv + 207pp. 7⅞ x 10¾.
20274-7 Paperbound $2.75

ART AND THE SOCIAL ORDER, D. W. Gotshalk. Is art only an extension of society? Is it completely isolated? In this delightfully written book, Professor Gotshalk supplies some workable answers. He discusses various theories of art from Plato to Marx and Freud and uses all areas of visual arts, music and literature to elaborate his views. "Seems to me the soundest and most penetrating work on the philosophy of art to appear in recent years," C. J. Ducasse, Brown Univ. Addenda: "Postscript to Chapter X: 1962." Bibliography in notes. Index. xviii + 255pp. 5⅜ x 8½.
20294-1 Paperbound $1.75

PRINCIPLES OF ART HISTORY, H. Wölfflin. This remarkably instructive work demonstrates the tremendous change in artistic conception from the 14th to the 18th centuries, by analyzing 164 works by Botticelli, Dürer, Hobbema, Holbein, Hals, Titian, Rembrandt, Vermeer, etc., and pointing out exactly what is meant by "baroque," "classic," "primitive," "picturesque," and other basic terms of art history and criticism. "A remarkable lesson in the art of seeing," SAT. REV. OF LITERATURE. Translated from the 7th German edition. 150 illus. 254pp. 6⅛ x 9¼. 20276-3 Paperbound $2.25

FOUNDATIONS OF MODERN ART, A. Ozenfant. Stimulating discussion of human creativity from paleolithic cave painting to modern painting, architecture, decorative arts. Fully illustrated with works of Gris, Lipchitz, Léger, Picasso, primitive, modern artifacts, architecture, industrial art, much more. 226 illustrations. 368pp. 6⅛ x 9¼. 20215-1 Paperbound $2.50

METALWORK AND ENAMELLING, H. Maryon. Probably the best book ever written on the subject. Tells everything necessary for the home manufacture of jewelry, rings, ear pendants, bowls, etc. Covers materials, tools, soldering, filigree, setting stones, raising patterns, repoussé work, damascening, niello, cloisonné, polishing, assaying, casting, and dozens of other techniques. The best substitute for apprenticeship to a master metalworker. 363 photos and figures. 374pp. 5½ x 8½. T183 Clothbound $8.50

SHAKER FURNITURE, E. D. and F. Andrews. The most illuminating study of Shaker furniture ever written. Covers chronology, craftsmanship, houses, shops, etc. Includes over 200 photographs of chairs, tables, clocks, beds, benches, etc. "Mr. & Mrs. Andrews know all there is to know about Shaker furniture," Mark Van Doren, NATION. 48 full-page plates. 192pp. 7⅞ x 10¾. 20679-3 Paperbound $2.50

ANIMAL DRAWING: ANATOMY AND ACTION FOR ARTISTS, C. R. Knight. 158 studies, with full accompanying text, of such animals as the gorilla, bear, bison, dromedary, camel, vulture, pelican, iguana, shark, etc., by one of the greatest modern masters of animal drawing. Innumerable tips on how to get life expression into your work. "An excellent reference work," SAN FRANCISCO CHRONICLE. 158 illustrations. 156pp. 10½ x 8½. 20426-X Paperbound $2.75

Dover Books on Art

ART ANATOMY, Dr. William Rimmer. One of the few books on art anatomy that are themselves works of art, this is a faithful reproduction (rearranged for handy use) of the extremely rare masterpiece of the famous 19th century anatomist, sculptor, and art teacher. Beautiful, clear line drawings show every part of the body—bony structure, muscles, features, etc. Unusual are the sections on falling bodies, foreshortenings, muscles in tension, grotesque personalities, and Rimmer's remarkable interpretation of emotions and personalities as expressed by facial features. It will supplement every other book on art anatomy you are likely to have. Reproduced clearer than the lithographic original (which sells for $500 on up on the rare book market.) Over 1,200 illustrations. xiii + 153pp. $7\frac{3}{4}$ x $10\frac{3}{4}$.

20908-3 Paperbound $2.50

THE CRAFTSMAN'S HANDBOOK, Cennino Cennini. The finest English translation of IL LIBRO DELL' ARTE, the 15th century introduction to art technique that is both a mirror of Quatrocento life and a source of many useful but nearly forgotten facets of the painter's art. 4 illustrations. xxvii + 142pp. D. V. Thompson, translator. $5\frac{3}{8}$ x 8. 20054-X Paperbound $1.75

THE BROWN DECADES, Lewis Mumford. A picture of the "buried renaissance" of the post-Civil War period, and the founding of modern architecture (Sullivan, Richardson, Root, Roebling), landscape development (Marsh, Olmstead, Eliot), and the graphic arts (Homer, Eakins, Ryder). 2nd revised, enlarged edition. Bibliography. 12 illustrations. xiv + 266 pp. $5\frac{3}{8}$ x 8.

20200-3 Paperbound $2.00

THE HUMAN FIGURE, J. H. Vanderpoel. Not just a picture book, but a complete course by a famous figure artist. Extensive text, illustrated by 430 pencil and charcoal drawings of both male and female anatomy. 2nd enlarged edition. Foreword. 430 illus. 143pp. $6\frac{1}{8}$ x $9\frac{1}{4}$. 20432-4 Paperbound $1.50

PINE FURNITURE OF EARLY NEW ENGLAND, R. H. Kettell. Over 400 illustrations, over 50 working drawings of early New England chairs, benches, beds, cupboards, mirrors, shelves, tables, other furniture esteemed for simple beauty and character. "Rich store of illustrations . . . emphasizes the individuality and varied design," ANTIQUES. 413 illustrations, 55 working drawings. 475pp. 8 x $10\frac{3}{4}$. 20145-4 Clothbound $10.00

THE FOUR BOOKS OF ARCHITECTURE, Andrea Palladio. A compendium of the art of Andrea Palladio, one of the most celebrated architects of the Renaissance, including 250 magnificently-engraved plates showing edifices either of Palladio's design or reconstructed (in these drawings) by him from classical ruins and contemporary accounts. 257 plates. xxiv + 119pp. 9½ x 12¾. 21308-0 Clothbound $10.00

150 MASTERPIECES OF DRAWING, A. Toney. Selected by a gifted artist and teacher, these are some of the finest drawings produced by Western artists from the early 15th to the end of the 18th centuries. Excellent reproductions of drawings by Rembrandt, Bruegel, Raphael, Watteau, and other familiar masters, as well as works by lesser known but brilliant artists. 150 plates. xviii + 150pp. 5⅜ x 11¼. 21032-4 Paperbound $2.00

MORE DRAWINGS BY HEINRICH KLEY. Another collection of the graphic, vivid sketches of Heinrich Kley, one of the most diabolically talented cartoonists of our century. The sketches take in every aspect of human life: nothing is too sacred for him to ridicule, no one too eminent for him to satirize. 158 drawings you will not easily forget. iv + 104pp. 7⅜ x 10¾. 20041-8 Paperbound $1.85

THE TRIUMPH OF MAXIMILIAN I, 137 Woodcuts by Hans Burgkmair and Others. This is one of the world's great art monuments, a series of magnificent woodcuts executed by the most important artists in the German realms as part of an elaborate plan by Maximilian I, ruler of the Holy Roman Empire, to commemorate his own name, dynasty, and achievements. 137 plates. New translation of descriptive text, notes, and bibliography prepared by Stanley Appelbaum. Special section of 10pp. containing a reduced version of the entire Triumph. x + 169pp. 11⅛ x 9¼. 21207-6 Paperbound $3.00

LOST EXAMPLES OF COLONIAL ARCHITECTURE, J. M. Howells. This book offers a unique guided tour through America's architectural past, all of which is either no longer in existence or so changed that its original beauty has been destroyed. More than 275 clear photos of old churches, dwelling houses, public buildings, business structures, etc. 245 plates, containing 281 photos and 9 drawings, floorplans, etc. New Index. xvii + 248pp. 7⅞ x 10¾. 21143-6 Paperbound $3.00

Dover Books on Art

MASTERPIECES OF FURNITURE, Verna Cook Salomonsky.
Photographs and measured drawings of some of the finest examples of Colonial American, 17th century English, Windsor, Sheraton, Hepplewhite, Chippendale, Louis XIV, Queen Anne, and various other furniture styles. The textual matter includes information on traditions, characteristics, background, etc. of various pieces. 101 plates. Bibliography. 224pp. 7⅞ x 10¾.
21381-1 Paperbound $2.50

PRIMITIVE ART, Franz Boas. In this exhaustive volume, a great American anthropologist analyzes all the fundamental traits of primitive art, covering the formal element in art, representative art, symbolism, style, literature, music, and the dance. Illustrations of Indian embroidery, paleolithic paintings, woven blankets, wing and tail designs, totem poles, cutlery, earthenware, baskets and many other primitive objects and motifs. Over 900 illustrations. 376pp. 5⅜ x 8. 20025-6 Paperbound $2.50

AN INTRODUCTION TO A HISTORY OF WOODCUT, A. M. Hind. Nearly all of this authoritative 2-volume set is devoted to the 15th century—the period during which the woodcut came of age as an important art form. It is the most complete compendium of information on this period, the artists who contributed to it, and their technical and artistic accomplishments. Profusely illustrated with cuts by 15th century masters, and later works for comparative purposes. 484 illustrations. 5 indexes. Total of xi + 838pp. 5⅜ x 8½. Two-vols. 20952-0, 20953-9 Paperbound $5.50

ART STUDENTS' ANATOMY, E. J. Farris. Teaching anatomy by using chiefly living objects for illustration, this study has enjoyed long popularity and success in art courses and home-study programs. All the basic elements of the human anatomy are illustrated in minute detail, diagrammed and pictured as they pass through common movements and actions. 158 drawings, photographs, and roentgenograms. Glossary of anatomical terms. x + 159pp. 5⅝ x 8⅜. 20744-7 Paperbound $1.50

COLONIAL LIGHTING, A. H. Hayward. The only book to cover the fascinating story of lamps and other lighting devices in America. Beginning with rush light holders used by the early settlers, it ranges through the elaborate chandeliers of the Federal period. illustrating 647 lamps. Of great value to antique collectors, designers, and historians of arts and crafts. Revised and enlarged by James R. Marsh. xxxi + 198pp. 5⅝ x 8¼.
20975-X Paperbound $2.00

Dover Books on Art

AFRICAN SCULPTURE, Ladislas Segy. 163 full-page plates illustrating masks, fertility figures, ceremonial objects, etc., of 50 West and Central African tribes—95% never before illustrated. 34-page introduction to African sculpture. "Mr. Segy is one of its top authorities," NEW YORKER. 164 full-page photographic plates. Introduction. Bibliography. 244pp. 6⅛ x 9¼.
20396-4 Paperbound $2.25

CALLIGRAPHY, J. G. Schwandner. First reprinting in 200 years of this legendary book of beautiful handwriting. Over 300 ornamental initials, 12 complete calligraphic alphabets, over 150 ornate frames and panels, 75 calligraphic pictures of cherubs, stags, lions, etc., thousands of flourishes, scrolls, etc., by the greatest 18th-century masters. All material can be copied or adapted without permission. Historical introduction. 158 full-page plates. 368pp. 9 x 13.
20475-8 Clothbound $10.00

A DIDEROT PICTORIAL ENCYCLOPEDIA OF TRADES AND INDUSTRY. Manufacturing and the Technical Arts in Plates Selected from "L'Encyclopédie ou Dictionnaire Raisonné des Sciences, des Arts, et des Métiers," of Denis Diderot, edited with text by C. Gillispie. Over 2000 illustrations on 485 full-page plates. Magnificent 18th-century engravings of men, women, and children working at such trades as milling flour, cheesemaking, charcoal burning, mining, silverplating, shoeing horses, making fine glass, printing, hundreds more, showing details of machinery, different steps in sequence, etc. A remarkable art work, but also the largest collection of working figures in print, copyright-free, for art directors, designers, etc. Two vols. 920pp. 9 x 12. Heavy library cloth.
22284-5, 22285-3 Two volume set $22.50

SILK SCREEN TECHNIQUES, J. Biegeleisen, M. Cohn. A practical step-by-step home course in one of the most versatile, least expensive graphic arts processes. How to build an inexpensive silk screen, prepare stencils, print, achieve special textures, use color, etc. Every step explained, diagrammed. 149 illustrations, 201pp. 6⅛ x 9¼.
20433-2 Paperbound $2.00

STICKS AND STONES, Lewis Mumford. An examination of forces influencing American architecture: the medieval tradition in early New England, the classical influence in Jefferson's time, the Brown Decades, the imperial facade, the machine age, etc. "A truly remarkable book," SAT. REV. OF LITERATURE. 2nd revised edition. 21 illus. xvii + 240pp. 5⅜ x 8.
20202-X Paperbound $2.00

Dover Books on Art

THE STYLES OF ORNAMENT, A. Speltz. The largest collection of line ornament in print, with 3750 numbered illustrations arranged chronologically from Egypt, Assyria, Greeks, Romans, Etruscans, through Medieval, Renaissance, 18th century, and Victorian. No permissions, no fees needed to use or reproduce illustrations. 400 plates with 3750 illustrations. Bibliography. Index. 640pp. 6 x 9. 20577-6 Paperbound $3.00

THE ART OF ETCHING, E. S. Lumsden. Every step of the etching process from essential materials to completed proof is carefully and clearly explained, with 24 annotated plates exemplifying every technique and approach discussed. The book also features a rich survey of the art, with 105 annotated plates by masters. Invaluable for beginner to advanced etcher. 374pp. 5⅜ x 8. 20049-3 Paperbound $2.75

EPOCHS OF CHINESE AND JAPANESE ART, E. Fenollosa. Classic study of pre-20th century Oriental art, revealing, as does no other book, the important interrelationships between the art of China and Japan and their history and sociology. Illustrations include ancient bronzes, Buddhist paintings by Kobo Daishi, scroll paintings by Toba Sojo, prints by Nobusane, screens by Korin, woodcuts by Hokusai, Koryusai, Utamaro, Hiroshige and scores of other pieces by Chinese and Japanese masters. Biographical preface. Notes. Index. 242 illustrations. Total of lii + 439pp. plus 174 plates. 5⅝ x 8¼.

Two-volume set, 20364-6, 20365-4 Paperbound $5.00

OF THE JUST SHAPING OF LETTERS, Albrecht Dürer. This remarkable volume reveals Albrecht Dürer's rules for the geometric construction of Roman capitals and the formation of Gothic lower case and capital letters, complete with construction diagrams and directions. Of considerable practical interest to the contemporary illustrator, artist, and designer. Translated from the Latin text of the edition of 1535 by R. T. Nichol. Numerous letterform designs, construction diagrams, illustrations. iv + 43pp. 7⅞ x 10¾. 21306-4 Paperbound $1.25

DESIGN MOTIFS OF ANCIENT MEXICO, J. Enciso. Nearly 90% of these 766 superb designs from Aztec, Olmec, Totonac, Maya, and Toltec origins are unobtainable elsewhere. Contains plumed serpents, wind gods, animals, demons, dancers, monsters, etc. Excellent applied design source. Originally $17.50. 766 illustrations, thousands of motifs. 192pp. 6⅛ x 9¼.

20084-1 Paperbound $2.25

Dover Books on Art

THE COMPLETE BOOK OF SILK SCREEN PRINTING PRO-DUCTION, J. I. Biegeleisen. Here is a clear and complete picture of every aspect of silk screen technique and press operation—from individually operated manual presses to modern automatic ones. Unsurpassed as a guidebook for setting up shop, making shop operation more efficient, finding out about latest methods and equipment; or as a textbook for use in teaching, studying, or learning all aspects of the profession. 124 figures. Index. Bibliography. List of Supply Sources. xi + 253pp. 5⅜ x 8½.
21100-2 Paperbound $2.75

A HISTORY OF COSTUME, Carl Köhler. The most reliable and authentic account of the development of dress from ancient times through the 19th century. Based on actual pieces of clothing that have survived, using paintings, statues and other reproductions only where originals no longer exist. Hundreds of illustrations, including detailed patterns for many articles. Highly useful for theatre and movie directors, fashion designers, illustrators, teachers. Edited and augmented by Emma von Sichart. Translated by Alexander K. Dallas. 594 illustrations. 464pp. 5⅛ x 7⅛.
21030-8 Paperbound $3.00

CHINESE HOUSEHOLD FURNITURE, G. N. Kates. A summary of virtually everything that is known about authentic Chinese furniture before it was contaminated by the influence of the West. The text covers history of styles, materials used, principles of design and craftsmanship, and furniture arrangement—all fully illustrated. xiii + 190pp. 5⅝ x 8½.
20958-X Paperbound $1.75

THE COMPLETE WOODCUTS OF ALBRECHT DURER, edited by Dr. Willi Kurth. Albrecht Dürer was a master in various media, but it was in woodcut design that his creative genius reached its highest expression. Here are all of his extant woodcuts, a collection of over 300 great works, many of which are not available elsewhere. An indispensable work for the art historian and critic and all art lovers. 346 plates. Index. 285pp. 8½ x 12¼.
21097-9 Paperbound $3.00

Dover publishes books on commercial art, art history, crafts, design, art classics; also books on music, literature, science, mathematics, puzzles and entertainments, chess, engineering, biology, philosophy, psychology, languages, history, and other fields. For free circulars write to Dept. DA, Dover Publications, Inc., 180 Varick St., New York, N.Y. 10014.